1998

A Fine Romance . . .

Five Ages of Film Feminism

In the series

CULTURE AND THE MOVING IMAGE

edited by Robert Sklar

A Fine Romance . . .

Five Ages of Film Feminism

PATRICIA MELLENCAMP

TEMPLE UNIVERSITY PRESS
PHILADELPHIA

FRONTISPIECE:
Quentin Crisp in Sally Potter's *Orlando*, courtesy of Adventure Pictures Ltd.

Temple University Press, Philadelphia 19122

Text design by Publishers' WorkGroup

The paper used in this publication meets the minimum requirements of American National Standard for Information Sciences—Permanence of Paper for Printed Library Materials, ANSI Z39.48-1984

Printed in the United States of America

Library of Congress Cataloging-in-Publication Data
Mellencamp, Patricia.
 A fine romance— : five ages of film feminism / Patricia Mellencamp.
 p. cm. — (Culture and the moving image)
 Includes bibliographical references and index.
 ISBN 1–56639–400–7 (hbk.: acid free). — ISBN 1–56639–401–5 (pbk.:
acid free)
 1. Women in motion pictures. 2. Feminist film criticism. 3. Feminist
motion pictures. I. Title. II. Series.
PN1995.9.W6M46 1995
791.43′652042—dc20 95–33540
 CIP

Contents

Contents

Acknowledgments

Ginger Rogers died in 1995. Although her body had grown heavier and her face fuller since she first danced on film with Fred Astaire, her hair color and style, make-up, and evening finery remained the same for sixty years.

Whenever I watched Fred Astaire and Ginger Rogers dance together in their 1930s RKO musicals (even in Woody Allen's *The Purple Rose of Cairo*), I always looked at her, rarely at him. The lilt of her upturned wrist, the folds of her evening gowns, the sureness of her step always captivated my attention. But critics said that Astaire was the great one, not Rogers. That she lucked out, that Astaire's genius (and his choreography) made her look better than she was. But I think there was more to Ginger Rogers' dancing, and to her characters, than Fred Astaire. She was an independent woman, she spoke up and took action. She played clever, honest, feisty women, and although wearing the garb of the upper class, was at heart a working girl. I loved her energy, the look in her eyes that said she was nobody's fool, the no-nonsense walk that declared self-sufficiency. She worked hard, particularly at making it all look so gracefully easy.

The title of this book comes from a song Rogers sang in *Swingtime:* "A Fine Romance," followed by the ironic phrase, "with no kisses." Subtitled "A Sarcastic Love Song," the lyrics were by Dorothy Fields and the music by Jerome Kern. George Stevens directed the 1936 film. Penny Carroll is frustrated and fed up with "Lucky" Garnett's games, his equivocations, and tells him so in "A Fine Romance." Fred fends off Ginger's advances, as she boldly expresses her desire for him in a scene of clever role reversal. Here's the first verse:

> A fine romance, with no kisses;
> A fine romance, my friend this is.
> We should be like a couple of hot tomatoes,
> But you're as cold as yesterday's mashed potatoes.
> A fine romance, you won't nestle.

ix

A fine romance, you won't wrestle.
(A fine romance with no quarrels,
with no insults, and all morals.)
I've never mussed the crease in your blue serge pants.
I've never had a chance.
This is a fine romance."

For me the lyrics, and Roger's intonation, describe the dance of feminism with Hollywood movies—yes, it's love but exasperated love.

I owe a debt to the women on screen for their endurance, in spite of the odds, and to women behind the scenes. Janet Francendese at Temple and Joan Catapano at Indiana are editors who have contributed immeasurably to my profession, supporting good work and good women.

The ideas in this book were first presented at academic conferences. The Hawaii International Film Symposium and Film Festival (November, 1990) was the luxurious setting for the "The Consumer and *The Cheat.*" My thanks to Wimal Dissanayake, the organizer of that wonderful yearly event, and the editor of *East/West Film Journal,* which published a version in Volume 6, Number 1 (January 1992). Sydney, Australia was the next glorious location. I am grateful to Laleen Jayamanne and the Dissonance conference (September 1991) where I gave an initial sketch of the "Five Ages of Film Feminism" which will appear in *Kiss Me Deadly,* edited by Jayamanne for Indiana University Press.

But most of my thoughts come from home base, from the University of Wisconsin in Milwaukee and my invaluable colleagues and friends at the Center for Twentieth Century Studies. In fact, my debt to the Center is incalculable—interest has accumulated for twenty intellectually rich years. At a conference entitled "Visual Culture" (April 1992), I gave a talk on Tracey Moffatt and Laleen Jayamanne's work. I thank the conference director, Patrice Petro, for her generosity, and for so wisely editing my remarks for her terrific collection, *Fugitive Images* (Bloomington, Indiana: Indiana University Press, 1995).

I wish I knew how to truly thank Kathleen Woodward, Director of the Center, for all her encouragement and good counsel (specifically on my essay on Moffatt and Julie Dash she edited for Discourse 16.2 [Winter 1993–94], with a revised version edited by *Frontiers,* Volume XV, Number 1 [1994]). But some debts can only be repaid with respect and love.

For the past twenty-five years, I have gone to the movies with my brilliantly perceptive children, Rob and Dae Mellencamp (who suddenly are in their mid-twenties). They love the movies as much as I do. Their insights illuminate and clarify my thoughts and my life.

For my mother, Mary Margaret Jewson, with love and gratitude.

To Begin with . . .

In her autobiography Dorothy Hewett, an Australian poet and playwright, wonders: "What are we like, my generation of 1941?—romantic, idealistic, fiercely partisan about politics and equality of the sexes, determined to change our world."[1] She tried romance, politics, and marriage, where she was frustrated every time. Until she found herself in her work, in writing.

The film feminists of the 1970s were also "romantic, fiercely partisan." We wanted to change film history, its past and future, to treat women as equal subjects, to break open the realm of production. We succeeded, to a degree. Feminist film theory opened academia's eyes to the inequity of *white* women—on screen and in audiences. Our premises became apparent in late 1980s films like *Thelma and Louise* and *Silence of the Lambs*, which portrayed women who did not define themselves through men's eyes or male desire. In the 1990s, more and more women knowledgeable of feminist theory—Jane Campion, Sally Potter, Julie Dash, Tracey Moffatt, Martha Coolidge, Kathryn Bigelow—are directing and producing feature films. They see women through women's eyes, telling stories from women's point of view—women of all colors.[2]

In Jane Wagner's *The Search for Signs of Intelligent Life in the Universe,* a history of the U.S. women's movement (1970–84) is contained in the diary of Lyn. She recalls "the 'Women's Strike for Equality' march [1970]. . . . Betty Freidan saying: 'We, today . . . have learned the *power* of our Sisterhood!' And we did! . . . It was worth risking our lives. . . . We're going to form a consciousness-raising group just like thousands of women all over the country are doing."[3] (The solution of "consciousness-raising" groups gets a big laugh from young feminists.)

Lyn ages. The political oppositions of the 1970s become the social contradictions of the 1980s, the passion of being single becomes the exhaustion of being a single parent. Marriage and motherhood don't match their promises or our expectations. Opposition and clear choice are replaced by

contradictions and double binds. "It's hard to be politically conscious and upwardly mobile at the same time. . . . To think there was a time when we actually thought we were going to change the system" (193). The single-minded fervor of youth has become the double vision of middle age.

Lyn's last scene, fourteen years later (1984), is a garage sale. She is an unemployed, middle-aged, single mother with a history of marriage, child-birth, divorce. She has experienced activism, meditation, and entrepre-neurship. To her doctor's diagnosis of pre*men*strual syndrome, Lyn replies that she and her mother are both getting divorced, "I'm raising twin boys. I have a lot of job pressure—I've got to find one. . . . My husband is involved . . . with this woman . . . who's quite a bit younger than I am. And you *think* it's my *period* and *not* my life?" (191).

Monique Wittig's sober materialism,[4] her call to move away from sex-ual difference and to "destroy the categories of sex in politics and philos-ophy," and the economics and factual logic of Virginia Woolf's *Three Guineas*, a piercing argument akin to Wittig's, have also inspired these re-marks.[5]

The thoughts of these diverse writers, across time (1938 to 1992) and continents, parallel periods of my life. They interrogate language, espe-cially personal pronouns. But this is not deconstruction, that pleasure of men which always finds more, whether more exists or not. This is demoli-tion, a frontal attack on everyday politics and economics, which is reduc-tive. For women, no matter what the country, decade, class, race, or edu-cation, there is usually less than meets the eye. Despite the distance of irony—a key tactic of these writers—emotion is palpable, from controlled rage (Woolf) to humor (Tomlin), passion (Hewett), and cool rationality (Wittig). Life and thought merge and speak with us. These women have been there.

But what is the next move? Feminist film theory will soon be a quarter of a century old. It has known the euphoria of the 1970s, experienced the con-tradictions of the 1980s, and glimpsed the reversals and political gains, which include women of color, of the 1990s. Women are in charge of the U.S. budget (Alice Rivlin, Laura Tyson) and the law of the land (Janet Reno). Television's Lisa Simpson (*The Simpsons*, Fox) is a brilliant spokesgirl for feminism. On *Northern Exposure* (CBS), everyone is a fem-inist of one kind or another.

Conversely, feminism has become a scandalous event, bracketed with Lorena Bobbitt or a celebrity catfight, Camille Paglia versus Gloria Stei-nem. Feminist books have become popular best-sellers and celebrity mak-ers, as evidenced by the rise of Susan Faludi, Katie Roiphe, and Naomi Woolf. Feminism stretches from the political left to the right, with the *Wall*

Street Journal and Rush Limbaugh endorsing the 1994 *Who Stole Feminism.*[6]

That feminism comes in many versions and sells is a good thing—it never was a uniform position, popular only with crusty academics and angry women. In its broadest meaning, feminism talks about women and addresses women. Feminism notices that women were, and are, here, in representation, in audiences, in life. Then it asks for equality and respect, privately, publicly. Within its vast scope, there are *many* theoretical and political variances. Who ever imagined "feminism" as a single entity—as Roiphe assumes in her popular book?[7] What woman in her right mind would want to adhere to a doctrinaire position, a singular line? Whether defined by their bodies or their essence, this lumpen conformity is what women have been running from for centuries.

Some women call this the age of postfeminism—as if there were no more need for activism. One glance at a televised session of Congress or the O. J. Simpson televised trial or 1994 scholarly books by men reveals that women are still barely visible.[8] Thus I don't agree with satisfaction or quiescence. I refuse to accept the boredom that has come from repeating the same weary thoughts.[9] I want to ascertain where we've been, what has changed, and what needs to be done. The twenty-five year rediscoveries of the women's movement in the twentieth century (i.e., 1915, 1940, 1965, 1990) make one thing very clear: women cannot afford to rest on their laurels (which are significant). Rather than losing and then regaining the same ground, we must stake out new territory. Rather than disparaging feminists, we can relish women's right to disagree. Unlike men, women have rarely been granted the right to disagree with each other and still remain on speaking terms.

What Cinderella and Snow White Forgot to Tell Thelma and Louise

ONCE UPON A TIME

Like the aging crones and silent princesses of fairy tales, I was trained to see myself as others see me. Fortunately, I was cross-eyed at the age of one, so I always had double vision. Sight was never natural, rather a convention that I learned with each six-week change of glasses. I saw myself seeing. I was the seer, not the seen. I also talked fast and had a big mouth. In fact, my nickname in high school during the rock-and-roll 1950s was "The Mouth." I talked back and spoke up.

When I was a young girl, I wanted to be a boy—because of everything boys were encouraged to do, particularly sports and comedy. I wore blue jeans before they were fashionable (and sold for women) and baggy shirts, sat with my legs apart, and told jokes. I climbed fences, trees, buildings, and roamed the neighborhood at night, looking for adventure. I was too restless and impatient for femininity, which was quiet, unobtrusive, dull. Girls behaved. Boys misbehaved. I did both.

Boys moved through space. Girls stayed in place. Boys never looked back. Girls waited. Sports and comedy meant noise, action, and, like "I Love Lucy" in the 1950s, rebellion. Dolls meant a panic boredom where even the air was stifling. Passivity and acquiescence were not in my nature. I wanted to be the leader, to climb the highest tree. But I never wanted the responsibility of followers. Freedom, not power, attracted me.[1]

My heroes were Babe Didrikson Zaharias, the Olympic athlete and golfer, and Amelia Earhart. They had done what they wanted, entered men's worlds of sports competition and aviation. They were heroic, had fun, and wore slacks. But at the movies during the 1950s, there were Debbie Reynolds and Doris Day, feisty if perky females. Inevitably, they were won over in each film's end. These female options vacillated. Perhaps the butch/femme dualities these women represented are styles and values that

1

portray the contradictions of my generation.[2] I note that masquerade, flirting, "playing hard to get," and the other ploys of romance came from fairy tales and then the movies. But so did dreams of adventure and freedom.

I knew all the big rules of romance by thirteen (I am my body; I need a guy; I sacrifice my life for my kids; and then I die). I was taught that to be without a guy is to be alone (female friends didn't count), lonely, and unattractive, a fate worse than death. I was taught that good mothers sacrifice themselves for their children, and men sacrifice themselves for their country.[3] "If you are born black or poor or a woman, it is an impossible world to live in; if you are gifted, if you have a passionate, questioning intellect, it is a vicious world that blocks every avenue" (Hewett, 89).

To the restrictions of being a girl, add the indelible paranoia that marked the cold war in the 1950s United States, the emigration of white women and "the white family" to suburbia, and the economic anxiety of upward mobility. Upward mobility in the United States was a dream, a reality, and a process of conformity. It prescribed a decorum of middle-class respectability and a set of unspoken rules. The cardinal rule was that men, not women, economically supported the family. The woman staying home with her children was a sign of *his* success and masculinity. If women had careers, they should conceal them. My mother was a dedicated nurse, but few of my parents' friends knew she worked. She always left parties at 10:30 P.M., going straight to her night shift at the hospital. Because I couldn't tell my friends, I thought her profession was something shameful. I learned much later that she loved her career.

For me, a foreboding Catholicism (which battled atheistic Communism along with sex) divided the female body into zones, many of which were off limits or top secret. Pregnancy was a fear and scandal. Sex was a sin. So was kissing for longer than eight seconds. Femininity, like the female body it shaped and the mind it curtailed, had set in—as an imposture, a problem, or a contradiction.

I was strong, but shouldn't show it (but I did); I was smart, but shouldn't use it (but I did). I was independent, but shouldn't be. The most detrimental prohibition was never overtly say what you needed or wanted. Others should know, if they love you. This guessing game rebounds; eventually, I didn't know what I wanted or needed. Over time, I relented and tried to settle for less. But rather than use femininity duplicitously, as clever girls were trained to do, I ignored it, or just endured it. Yet the illogic haunted me. Eventually, I internalized the external standards—as a contradiction of which I was uneasily aware. (Even in the mid- to late 1960s, when feminism began to transform sex from sin to liberation, from marriage to desire, from dependence on men to independence from men, the double standard endured, particularly within the economics of work.)

What I wanted to be and what I was supposed to be coexisted. My self-image and the mirror image were often at odds. I believed I was fat, with a huge nose and head, although old photographs document that I was tall, not fat, and that my head was rather small. I learned that the female body was a problem which could be cured—by makeup, fashion, dieting, and surgery. Recently, aging was added to the agenda, yet another double standard. Women can now be fifty, but they must look thirty—chronology disavowal.[4] I learned that youth is more beautiful than age, particularly for women. But I don't believe this any more than I think I am fat.

I used to think that these illusions belonged to the 1950s. From my daughter and women graduate students, I have learned that the main rules have not changed—although in each decade, some more than others, women continue to refuse to play the game.

It is precisely this misrecognition, a real alienation effect—woman divided against her inadequate self, body versus mind, mother versus daughter or son, woman versus woman—that must be overcome. After all, the body is an image *and* a sack of flesh; it is a historical, personal fiction or style as much as a reality. Certainly, the body is neither self nor identity nor value; we are much more, much greater, than our bodies. Sex and the body don't grant identity, as Michel Foucault said over a decade ago, yet we keep looking there for answers.

After college (and in retrospect), romance frightened me into marriage, to a lawyer. This forced dependence didn't suit me. Neither did prescribed roles. (Did he think I believed that women, unlike men, were born to vacuum?) Of course, nothing and no one could have met the outside standards of romance. Simply stated: Now, at last, my life would be meaningful *and* exciting, through him and his accomplishments. For me, romance doomed marriage before the wedding. Two children and six years later, I was in an unconscious trap of my own making but didn't know how to break out.

I was financially dependent, a stifling ingratitude, without a full time job, and afraid. I still didn't believe I could economically make it on my own, to say nothing of handling all the work involved with children. I couldn't speak my discontent and I couldn't endure the suffocation. Insanity seemed to be the only solution to the economics of marriage, as apparently it was for the famous suicides, the dead heroes for my generation—Sylvia Plath, Anne Sexton, and even Virginia Woolf. In the end, the contradictions and double standards must have crushed them. Because I didn't understand that I was giving my self away, I couldn't change; I could only leave, and then barely, and with trepidation. It took me years to realize my own strength (and accept my limitations). I *could* support myself.

There is another version of Jacques Lacan's divided subject. Dorothy

Hewett, whose verve reminds me of the Australian cultural critic Meaghan Morris, perfectly describes it: "I can't remember the exact moment when I became conscious of the divided self. There is the girl who moves and talks and rages and loves and there is the writer who watches and writes it down, who even in her most passionate moments is saying, 'Remember this'" (Hewett, 90).

THROUGH THE WOODS TO GRANDMOTHER'S HOUSE

But there I was in 1974, just after the Vietnam War protest, in the midst of the women's movement and sexual liberation, getting divorced, raising two children as a "single parent" on a paltry amount of money,[5] teaching eight film courses per year, and discovering Lacan's subject divided in language, with woman as lack . . . through, of all people, film feminists![6] This is comedy! The split subject of Lacan might have been news to men, but to working/single mothers? Working through his inscrutable prose, in this U.S. era before day care, I had little to learn that I hadn't already experienced as inequity and constraint. But I didn't know this right away.

In retrospect, the elegant patina of theory[7] made (white) women, and talking about (white) women, legitimate. Psychoanalytic theory, combined with semiotics and Marxism, gave feminist film theory an edge, arousing the very fear and intimidation in men that Freud's model analyzed. (Jean-Louis Commolli and Christian Metz even compared going to the movies to castration!) But Freud made sense of "the family," which then (and even now) included the subordination of women. Freud let us see the contradictions we were living. We began to bring the inequities and double standards to the surface.

However, Freud accepted and perpetuated women's status and "nature," while feminist film theorists used Freudian theory to unravel systems, including Freud's own sexism and blind spots. Like many men, Freud didn't listen to women. In his famous discovery of the Oedipus complex, the "Little Hans" case, he paid no attention to the mother, talking only with the father. No wonder psychoanalysis is mainly a boy's story. Still, we can learn from Freud without accepting his conclusions (including the reduction of everything to "infantile sexuality").

Freud and Jacques Lacan, the French theorist who interpreted Freud through linguistics, are not the same thing. The difference is more than adding linguistics. For Lacan, "woman" means "lack;" women are defined negatively in comparison to men. But Lacan also showed me how easily women can be made absent. (Never did I imagine that our presence and

our work in film in the 1970s and even the 1980s would be forgotten, without mention in the recent film textbooks. Feminist thought is everywhere in the 1990s, authorless. Our work is uncredited, as if we never existed.) The irony of women turning to Lacan for answers *and* for legitimation still can make me cringe, although the practice is not new (or over). We still "second-class" our experience and thought and even our work. What ensued was predictable: films by radical film-making mothers, starring their children and titled "The Mirror Phase," after Lacan. Women scholars, talking Lacan and sex, became titillating, then tenured.

I suspect that, despite famous exceptions, theories of femininity and masquerade—held to appearance, mystery/glamour, and the body, as they are—like conspiratorial, envious ladies-in-waiting, have kept the rest of us under power's wraps and within romance's sway, undervalued, underpaid, *even as we unraveled them.* When you think about the symbolism, hetero or homo, piled upon women's bodies in art, in theory, and in life—particularly breasts, blobs of various sizes of measured fat, flattened into pancakes during a mammogram—it's very funny. But this is not comedy. This fetish can be crippling or deadly. (Feminist film theory, however, talked Oedipus and castration. As we argued over penis or phallus, we were still talking about male subjectivity.)

During my daughter's college graduation from Brown University in June 1991, I saw Jane Fonda videotaping her daughter. I wanted a closer look at her new, implanted breasts. I wanted to ask what they meant to her. Fear of aging? Youth? Desirability? Ted Turner? Why had she done it? Would I eventually want them? (No!) Were they silicone implants? I used to want to look like Fonda, perhaps be Fonda, a courageous woman protesting the Vietnam War—although her history of bulimia gives pause, just as leaving her profession in 1990 for love and marriage makes me wonder. Yet marriage *is* the fashion trend of the 1990s, and via CNN, Ted Turner is definitely in style. (Fonda has been the bellwether of lifestyle trends for my U.S. generation.)

In 1991 my friend Fay—who had silicone injections twenty years ago during a brief stint as a Playboy Bunny—had a double radical mastectomy. The silicone had leaked into her immune system, causing it to simulate symptoms of several exotic diseases, including lupus, crippling her joints with a false rheumatoid arthritis. Her skin turned thick, scaly like a reptile's. The diseases were simulated; the pain and effects were real. (Fay was one of the first women to be diagnosed, well before silicone implants were taken off the market.) After the mastectomy, the plastic surgeon asked when she wanted to schedule reconstructive surgery with new and improved silicone implants. Fay laughed, incredulous at his callous stupidity.

Two years later, women sued the manufacturers. They denied all charges, holding up scientific evidence. Women continued to sue. Surgeons defended the products. Women won. Silicone implants were taken off the market. The companies are, in 1994, paying out millions—but money won't help Fay.

Twenty years ago, this beautiful woman had implants for men. Male desire, a foreign agent implanted in her body *as* her, was nearly lethal. Her body turned on her. The story of women sacrificing themselves to male desire of the theoretical or the marital kind is not new—and it is neither simple nor clear. Romance has been the scenario of most U.S. popular culture, the tale of most movies. Romance is the grand illusion by which most women and men live, whether or not they consciously know it.

While it may be denied in their writing, even feminist critics live the belief that their ultimate definition comes, or would come if possible, from a relationship with a man, or a woman or a baby (or a career of mastering men's theory)—and if not a relationship, then at least sex; that unto themselves, they are inadequate, "lacking," not good enough, or just not enough. In all cases, meaning comes from the outside, from sex, from another; happiness is tied to desire, to attachment. Romance asks us to make another (lover or spouse or partner) our focus, to sacrifice our selves (and our salary), to become less. This should not be confused with love. One is addicting and self-defeating, the other liberating.

Overcoming bodily and romantic constraints that figure a confusing-to-addictive lifestyle of martyred masochism called vanity, "love," or motherhood has been no small task. For me, feminism initially is an undoing, then a learning that replaces self-hatred with self-regard, worship of men's ideas and men with respect for women's thoughts and for women *and* men. The standards of regard are internal rather than external. They have nothing to do with guilt or shame or desire or the approval of others.

But back to my academic story.[8] Semiotics and linguistics were not royal roads paved with golden nuggets of knowledge about women. Like Scylla and Charybdis, they were tests of stamina, akin to being trapped between a rock and a hard place. Plucky feminists explored male subjectivity, male desire embedded in obscure words. The new language of theory was a mixed blessing: theory (Barthes, Foucault, Deleuze) broke open academia along with the text, letting women into the debates; and theory took us as objects, even as absence (Lacan). Go figure.

Yet although many women end up at the same place, our histories do not have the same chronology. We come to feminism at different times, from different places. As Meaghan Morris recently said, "In the 70s, I learned very little from British feminist film theory; I was not interested in psychoanalysis, and so my own work looked instead to Gilles Deleuze and

Michel Foucault."[9] For most U.S. and British feminists, Foucault was endorsed much later, while Deleuze is still held in abeyance or scorned.

In the 1970s United States, only the stalwart and sturdy, such as Mary Ann Doane, Kaja Silverman, and Teresa de Lauretis (who all argue with *rigorous*, Aristotelian logic), survived the prickly thorns of semiotic's terms. For many, terminology was terminal or led nowhere. As Susan Dermody puts it to 1970s and early 1980s film theory: "An unassailably authoritarian voice speaks to you from the margins, from oppression. . . . It now seems completely unpalatable." She adds, however, a respectful "yet . . . "[10] Postmodern film "theory" written by women was sometimes confused with feminism—which to me concerns women's thoughts and actions more than men's thoughts about women's inaction. (No wonder women's history repeats every twenty or thirty years. Freud's Dora keeps walking out of analysis, only to return twenty years later with the same problem. Somewhere, in an attic, is "The Portrait of Dora Gray." Of course, Freud blamed Dora for his refusal to listen. What would Oscar Wilde have said?)

I was fainthearted—I never finished Umberto Eco's thick semiotics and didn't venture very deeply into the thickets of Jacques Derrida. I noticed, however, that many of the emperors were at least seminaked. While looking outside, at great male systems, for answers, I eventually saw that even the frog prince of theory, film theory, had a brazen history of ignoring women—unless they were femmes fatales or pinups. Andre Bazin spoke of pinups, perhaps imitating Siegfried Kracauer and his analysis of female chorus lines and techniques of capitalism. Even Sergei Eisenstein, the eclectic, populist theorist of my dreams, ignored women, although he did give us the fabulous and feisty female hero of *Old and New* (USSR, 1929), Marfa (a.k.a. Martha). Roland Barthes and Michel Foucault followed suit but elegantly showed me the path through the forest.

Gradually, like Dorothy home from the exoticism of Oz or the wilds of the Prague School, and with Foucault's guidance, I realized that the answers were right in front of my eyes, in women's everyday lives, in my history. I just couldn't see them because they were covered up by Art and Theory (particularly theories of vision) or were framed as both- and contradictions, a logic that I had learned as a girl. ("Gradually" is a bit of an understatement; this took me almost twelve years to notice.) Many women, even the brilliant Claire Johnston, thought that male subjectivity would provide the answers for them, if they could only decipher the clues.

They were dead wrong. Or, as in *Thriller* (Sally Potter, U.K., 1979) and so many Hollywood films, including *Vertigo* (Alfred Hitchcock, Paramount, 1958), they, like Johnston, were just plain dead. Women had only two endings—married or dead.

HAPPILY EVER AFTER?

What did Cinderella and Snow White forget to tell us? The answer is simple. The young beauties forgot to tell us what comes *after* "The End," after the wedding to the prince. Women's stories stop after the prince—unless, of course, one is Liz Taylor and remains a princess by replacing the prince and ball gown every few years. But a sixty-year-old princess is as silly as limiting most movie women's lives to, say, thirty years. It's not the prince who is necessarily the problem but giving him so much power over our lives. What does "happily" mean for women? What does "ever after" cost women?

Thelma and Louise (Ridley Scott/Callie Khouri, 1991) questions living "happily ever after." Or to put it another way: To her great surprise, Rapunzel was not taken to a palace and a life of luxury, as "kingdom" would imply; she was dumped in the suburbs and named Louise. Rather than airy white spaces, her house is cramped, brown, cluttered. Instead of servants catering to her every pleasure, she waits on the gold-chained prince, now a salesman. She does only what he wants and, according to him, does nothing well. How did this happen? She used to have a mind and a body of her own, didn't she? She can't remember. Happily ever after, after all, has turned out to be a prison of her own making. She saw herself through his eyes and gave her life, her body, mind, and soul away.

Thank God, the sorceress Thelma, now working as a waitress at a diner, is her close friend. Thelma's life hasn't been perfect either—particularly a rape about which she won't speak and an Elvis-type lover who can barely speak. Within the first five minutes of the film, Thelma and Louise leave for a weekend at a cottage. Little did they know that lecherous wolves, and Louise's own confused desire, would dog their every move. Little did they expect that this short trip would become a journey to freedom and that they would become heroes. Or that the film would become an event, a debate of pro and con, feminist or not, and that "thelmad and louised" would become a phrase for violent action.

The film struck a social cord, and no wonder. Escaping the trap of "happily ever after" and all that "once upon a time" implies has been no small task for women. This fairy-tale scenario is the story we are taught to make of our lives. Fairy tales became expectations *and* limitations. (It's not finding the prince [or marriage or relationships] that is the problem; it's believing that the prince [or princess] is the answer to self-definition and the source of happiness. "He" or "she" or "true love" can never succeed in this impossible promise, whether straight or queer.) *Snow White* was my first encounter among thousands of versions of this fairy tale. (Released on video in 1994, this 1937 film, Disney's first animated feature, had boffo

profits, with advance orders at twenty-seven million!) This book will trace that fiction through twenty years of feminist film theory—from the mid 1970s to the mid 1990s.

FIVE AGES

My five ages of film feminism trace a twenty-year period. They are historical (from the early 1970s through the 1990s), personal (through the decades of *my* professional life), and descriptive (the taxonomy derived from what I perceive to be tactics of feminist film critics). The ages are ongoing, overlapping, and simultaneous, but for me they have also been chronological. They might be generational or, as in Shakespeare (who gave Jaques seven ages),[11] comprise stages of passage. Unlike life and like the movies, they can run in reverse—although this has not happened to me, thank God. I shudder when I imagine reading semiotic theory again!

The first three ages—intellectual feminism, irascible feminism, and experimental feminism—emphasize sexual difference. They rely on male theories of subjectivity and vision, emphasize "desire" (which I see sharing traits with obsession and addiction), and are often indebted to psychoanalysis. Intellectual and irascible feminism focus on heterosexuality—women's bodies and men's thoughts. The first is cool, impersonal. The second is angry thus no longer impersonal.[12] Both presumably speak of public, not private, knowledge.

Experimental feminism addresses other differences, other bodies— sometimes older, of various colors, increasingly lesbian—and other desires. Our experiences (life and work) begin to enter, first as theory, then as evidence or history, and finally as story. This age critically shifts the point of view to women, including women of color. The intimacy of address opens up private spaces—perhaps private because overlooked—in which women lived and worked.

The fourth age, empirical feminism, moves from sexuality to history, from desire to thought, from sexual liberation to personal and collective freedom, and includes sound along with theories of vision. The fifth age, economical feminism, emphasizes the money economy, women's work, along with bodies and sexes, the sexual economy. But it is more than this. We know that time is precious and must not be wasted. This is the age of mediation, of fearless action, of compassion. From differences we have learned the beauty of diversity and the power of unity. Thus both can cut through the superficial divides of nation, race, age, gender and the dualities of thought to focus on multiplicity *and* sameness. Public realms merge with private thoughts and behaviors, going beyond materiality to ethics.

The fragmented dyad of mind and body is restored to wholeness, a triad of mind, body, and spirit.

To be sure, the ages that overlap and structure this book are idiosyncratic. They are particular to my life and thought. Teresa de Lauretis, Mary Ann Doane, Linda Williams, Judith Mayne, Tania Modleski, Kaja Silverman, Laura Mulvey, Claire Johnston, Sally Potter, Valie Export, and the contributors to *Camera Obscura*, particularly Constance Penley, are first-generation film feminists I worked with from 1975 to 1982 in Milwaukee. Five years later came Meaghan Morris and Kathleen Woodward; and from the next generation, Patrice Petro. In the 1990s, Laleen Jayamanne and Tracey Moffatt have been influential (as have the films of Julie Dash and the writings of bell hooks and Michelle Wallace). My allusions to all of these brilliantly feminist thinkers are direct and indirect. I am profoundly grateful that such luminous, trailblazing figures have been part of my everyday life.

My terrain is not *feminism* but an eccentric figuration that I call *film feminism*. I fostered and even starred this intellectual model at several international film conferences in the late 1970s. Feminism was integral to these events (which also imported contemporary European theory) but hardly united. Debates raged over the pertinence of psychoanalysis for feminism. Julia LeSage, for example, rejected Freud, while Mary Ann Doane and then Teresa de Lauretis, following Claire Johnston, Laura Mulvey, and Juliet Mitchell in England, reclaimed psychoanalysis *for* U.S. feminism.

And within feminism at large, disciplines proceed out of step with one another. For example, art history took up film's theoretical work on "the gaze" much later, then virtually dropped the psychoanalytic framework. The same time lapse occurred with the intellectual history of Michel Foucault. In the 1990s, film scholars are turning away from theory to art history, invoking iconography. Literary criticism, in contrast, was in sync with, or a step ahead of, film, as was history and, to a lesser degree, sociology.

Economics, however, is another story, one that is just beginning for feminism.[13] I wonder why. Is money, and a field mapped by numbers, presumed to be neutral? Or too symbolic for women? Within film, economic history has been written from within both market and Marxist premises. Rarely are these biases noted, even by feminist econo-historians—to say nothing of positing a feminist economic history of cinema.

Even about film feminism, my thoughts are partial, in no sense imagined to cover this rich terrain. I no longer have the patience or stamina to finish every book. I prefer knowledge that has relevance for my present life

and some respect for women's history. Shifting registers from the personal to the academic, this book is biased and irregular. But I consider this a strength, not a weakness. Why spend years gathering knowledge if not to use it in everyday life, in the world? I have never understood why "experience," at least women's experience, didn't count as proper knowledge. From here on, however, autobiography is minimal, except for my love for movies which colors everything.

"A Fine Romance" is about an unrequited love affair between feminism and Hollywood cinema. Dorothy Fields' clever lyrics (and Jerome Kern's lovely music) portray this relationship better than I can. Sing along to her words—this book's epigraph.

> A fine romance, with no kisses;
> A fine romance, my friend this is.
> . . .
>
> I've never had a chance.
> This is a fine romance.

AGE ONE

Intellectual Feminism

Rita Hayworth in *Cover Girl*

"A Fine Romance, With No Kisses": Discourse, Not Intercourse

A 1950S FILM—A 1970S PARABLE

In *Vertigo* (Alfred Hitchcock, Paramount, 1958), the inscrutable Kim Novak as Madeleine/Judy lures us and the story on a false trail—into the mysterious secret of female sexuality and identity. The film goes first to the art museum for clues and then to art historians and the bookstore for answers. Jimmy Stewart as Scotty Ferguson tracks the victim of his desire to an art museum. Kim/Madeleine poses, presumably unaware of surveillance, transfixed by a painting of a woman. A dramatic series of shots of Scotty looking and interpreting is elaborated, exaggerated by Hitchcock's point-of-view editing. This is a false trail, a setup. Madeleine is the lure who possesses knowledge, not Scotty. (Paradoxically, the film's title shots of a woman's eye and mouth told us everything.)

However, we know this only in retrospect. For now, we are *led* to believe that the secret, which is both cause and effect, question and answer, is sex, that the woman's sexual identity, her story, lies in the painting and perhaps in psychoanalysis. So off to a rare bookstore and a scholar for answers: the painted woman is Carlotta Valdez, an enigma of Spanish eroticism, Madeleine's heritage, a figure that is both mysterious and mentioned only in passing.

What is critical is that women's history and identity, and maybe scholarly answers, mean absolutely nothing to the story. The trick is to make us believe women are significant while the only thing that matters is obsessive male desire. This is the con artist's shell game or the magician's sleight of hand. In fact, Madeleine is not who she appears to be—something we learn late in the film. She can be only a masquerade, only what he wants her to be. Madeleine exists because of men. By herself, as herself, she doesn't matter. She has no identity. Along the way, a wife is murdered; even at

the inquest, nobody cares. Male obsession/desire drives the film; female sexuality is only a screen, neither cause nor effect nor explanation.[1]

When she was very young, Dorothy Hewett wrote, "Sexuality has taken the place of intellect. I resent his power over me but can't keep away. . . . While I share his obsession, these experiences hardly rate a mention in my diary. It is still full of unconsummated romance."[2]

From the early 1970s into the 1990s, from Mulvey, Modleski, and de Lauretis to Doane and Williams (and countless others), feminist film critics looked in Hollywood movies for women's desire, women's pleasure, and rarely found it. (We found male obsession but didn't recognize it.) The investigation of female subjectivity looked to Hitchcock films; Hitchcock was to feminist film theory what Edgar Allan Poe was to French deconstructionists. Feminist film theory begins with Judy/Madeleine, luminous and revolutionary work in its time but a blind alley, a brilliant dead end for the future—in spite of gay and lesbian film critics' recent analyses of Hitchcock as the site of homosexual subjectivities.[3] (Given Hitchcock's often literal attention to psychoanalysis, sexual proclivities and other Freudianisms in his films should not come as a surprise.)

Intellectual feminism continued *Vertigo*'s quest for glamour girls via the secret of sex, looking in the same pages of the *Standard Edition*, Lacan's mirror, Hitchcock films, and other 1940s Hollywood film genres, particularly film noir and melodrama. (Recently, feminists have been fascinated with glamorous, sensuous, hard-bodied women who kill without regret or sentiment, usually after great sex, in classier versions of the horror/slasher film genre. More on this trend later.) Historically, this inscription of female subjectivity, particularly in the debates over female spectatorship, was an astonishing and radical move, albeit color-blind. Nowhere that I can find in the history of film theory are women, white and of color, mentioned as subjects—extraordinary, given the power and presence of white female stars and white women in the audience and the marginality and absence of black women, on-screen and in segregated movie theaters. What now seems so apparent to any undergraduate in the 1990s had been overlooked for eighty years in the early 1970s. Whether white and present or black and absent, women were there to serve.

Thus to add female subjectivity, albeit with a white exclusivity, to the agenda, along with noticing the absence of women from so many historical accounts, was a great and brilliant move. Theories of sexual difference and vision, on the plane of the body, modeled the then-radical argument. However, the tenets of heterosexual romance linked to all this male desire and pleasure lurked offscreen yet remained unspoken for many women.

MADE IN THE FADE

Since 1906, Hollywood has been the central agent of romance, what is known in the trades as the "love interest." In 1980, for an international film theory conference in Milwaukee, "Conditions of Presence," I labeled the technique of movie romance "Made in the Fade."[4] These conventions of the continuity style are historical, tied up with cinema's censorship codes and social prohibitions. For me, the last scene of Buster Keaton's great film *Sherlock Junior* (1924) said it all, and more.[5] Keaton, the movie projectionist, proposes marriage to the "Girl" by imitating the actions of the debonair movie hero starring in *Hearts and Pearls*—the film within the film.

The hero on-screen and Keaton in the projection booth position their respective "girls"; each then slips a ring on her finger and kisses her. During these actions, Keaton looks directly out at the movie screen (which is out at us), while "the Girl," who earlier figured out and solved the crime of the film, looks down and waits for his moves. She occupies what de Lauretis has called "the empty space between the signs, where no demand is possible."[6] After the kiss, however, the film fades to black. In the next shot, the on-screen couple has babies! Cut back to Buster, the projectionist, who scratches his head, amazed by the fade that means sex, kids, family—the "Made in the Fade" of my title. (See pages 18, 19, 20.)

Most films end with the kiss. But here, and in most of his features (and in his short *Cops* [1922]), Keaton questions not only the technical conventions of cinema but how they are tied up with narratives of romance. In several brief but powerful shots at the conclusion of his feature *College* (1927), Keaton interrogates romance, going beyond the "happily ever after," which films rarely do. After the couple's marriage, the film concludes with a brief epilogue. The couple is shown reading separate newspapers in middle age, then separate and bickering in old age. The last shot is of their gravestones. "All of this effort for that?"

The endings of Keaton features question the premises of the film itself—the tenets of romance that propel the Keaton protagonist to heroic deeds in order to win the girl in marriage.[7] And Keaton's films aptly summarize the status of women: Like the consumer courted by capitalism, woman is absolutely essential and supremely worthless. In so many ways, women are depicted as everything and nothing.

Classical cinema (from 1906 through the 1960s and into the 1970s), a fine romance indeed, is sealed by a narrative/marital contract, historically without intercourse and, for women, recourse. Since the 1980s, sex has been more real than implied, as much on-screen as off. But this was not

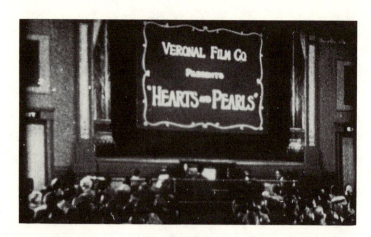

Sherlock, Junior

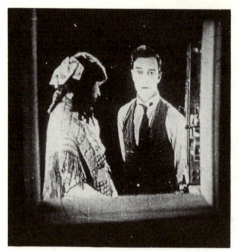

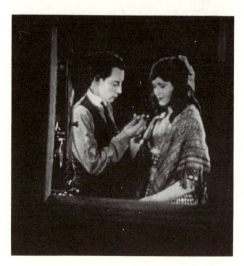

always the case; hence conservatives can yearn for the good old days of "good" movies. Within the historical boundaries of the classical text, cinema is an everyday machine of familialism. It is an institution that constructs objects of desire, finally conscripted into the family through film's endless creation of new, youthful couples. The representation of the erotic, promenaded female body, then the denial and containment of the dangerous eroticism by death or marriage in "The End," is both the paradox and obsession of classical film.

This film discourse of sexuality parallels Foucault's *History of Sexuality*.[8] Although Foucault's writing was central to my thought in the late 1970s and early 1980s, I was also wary. The original version of this essay

has a lengthy cautionary warning to feminists about the uncritical adoption of Foucault. I agree with Meaghan Morris, who so archly wrote that feminists who sent love letters to Foucault were in no danger of reciprocation.[8] (Then he was still alive and attending conferences; we met at the University of Southern California. I met Morris several years later; Foucault had just died.) Although he ignored women almost completely, I loved his modeling of contradiction, particularly of the logic applied to sex: "What is peculiar to modern societies, in fact, is not that they consigned sex to a shadow existence, but they dedicated themselves to speaking of it *ad infinitum* while exploiting it as *the* secret" (Foucault, 35).

In classical film, the secret is in the fade to black, protected by the closure of "The End." This is a purloined-letter logic, where the secret is hidden right in front of our eyes. We just can't see it until someone points it out; then it is obvious. Arguing against Freud's repression hypothesis (the virtual basis of early feminist film theory), Foucault defines sexuality as "the name that can be given to a historical construct . . . one relay of which is the body that produces and consumes" (Foucault, 195). The on-screen female body is produced, in the classical text, as a representation for male consumption. This is done through the narrative and through the eyes/gaze of the male protagonist.

Foucault further describes this body, from the eighteenth century on, as a class body: "One of the bourgeoisie's primary concerns was to provide itself with a body and a sexuality, the endogamy of sex and the body. . . . The bourgeoisie blood was its sex" (Foucault, 124). The family was the location of what Foucault calls sexuality and alliance, anchoring sexuality, wealth, and reproduction within the same sphere. (For historical royal families these functions had been split, something Prince Charles and Princess Di tried to bring back but failed in.) As an example, in *Cover Girl* (Columbia, 1944) the glorious body of Rita Hayworth/Rusty Parker, in gold lamé (the deployment of sexuality) is coupled in the end to Gene Kelly's middle-class body (the deployment of alliance).

This collapse of two formerly separate systems within the family, enacted in the conclusion of so many films, including *Gold Diggers of 1933* (Warner Brothers, 1933), occurs because mechanisms of power and knowledge are now centered on sex. Foucault's analysis of power is of particular interest in relation to classic cinema. He defines "power" as "a multiplicity of force relations, a process . . . a chain . . . with domination and subordination as its terminal form" (Foucault, 86). In his construct, power is tolerable only on the condition that it mask a substantial part of its operations: "Its success is proportional to its ability to hide its mechanism" (Foucault, 86). This depiction of an apparatus of sexuality matches analy-

ses of the technical and narrative mechanisms of classical films, as well as the relations between on-screen male and female protagonists

In the late 1970s, Kristin Thompson/David Bordwell and Stephen Heath's work on Hollywood continuity style overlapped, in spite of being derived from vastly different sources: Bordwell/Thompson took their lead from the *American Cinematographer*, a professional trade journal, and Heath began with continental theories of literary narrative and Lacanian psychoanalysis.[10] Continuity style referred to a set of technical and narrative principles that cut across Hollywood cinema—its genres, directors, studios, and decades.

The primary principle is that the formal properties of film time and film space are subordinated to the narrative. When we buy our movie ticket, we buy a story, not a formal, aesthetic experience. Aesthetic innovation can be a bonus, but it is not a prerequisite. And if "art" is there, as it is, for example, in the big box office films of Tim Burton, Quentin Tarentino and James Cameron, the formal elements must not overshadow the story, although they can comprise the story, for example, in science fiction or fantasy films, and even stand out as extraordinary.

No matter what the artistry and invention, film's major and profitable commodity is story—which relies on stars, usually a young heterosexual couple. Although minimal in plot and characters and very redundant, the story must have a certain duration, longer than one and not more than three hours, although we pay the same admission price no matter what the length or quality or cost. Going to the movies involves a quantity of time as much as, or more than, the quality of experience.

The continuity system is remarkably repetitive, and the film world sparsely populated—usually only the central couple matters. This destined pair is given center frame, closeups, star lighting, and most of the dialogue. It is these conventions which contribute to our seeing stars as more powerful, beautiful, and attractive.

Along with duration, repetition, and the centrality of the couple, the narrative adheres to a cause-effect logic, usually chronological, wherein every action is foreshadowed and motivated, and then repeated several times on both sound and image tracks until we get it. The repetition of elements is symmetrical, with the end mirroring the beginning. For example, the end of *Citizen Kane* returns to the beginning, panning down the gates of Xanadu. We have seen the glass ball, "rosebud," several times throughout the film (for example, in the Colorado snow scene of separation, in Susan Alexander's rooming house, on the dresser, and later in her bedroom in Xanadu), each appearance accompanied by its mournful four-note theme. Thus, when the sled, rosebud, is burned at the end, the theme crescendos, and we feel an emotional satiation. For the film audience, unlike the

reporter, Thompson, the search for the meaning of rosebud, Kane's last word, has been completed, through repetition and symmetry on both the sound and image tracks.

During the story's progression, every item is used up—there are no loose ends or unexplained actions or characters. Thus, the film *makes* connections for us, while we imagine ourselves doing the detecting. Furthermore, we usually know the ending when the film begins, yet we disavow, or suspend, our knowledge to play the narrative game.

A series of well-known techniques serve continuity's seamless purpose of repressing the formal elements of space and time: concentration on center frame, usually occupied by a human character; shooting in depth to create Quattrocentro perspective; and reframings and camera movement to keep the characters in center frame. Thus, neither the margins nor the mise-en-scene, no matter how spectacular, will dominate the action or characters. Characters and objects are given this precious space only if they serve a function in the film—either indicative of character psychology or to be used in the narrative action. Nothing within center frame is incidental to the narrative.

Another technique is graphic continuity—within each scene, between scenes, and throughout the entire film. No matter how many apartments, restaurants, book stores, we visit in *When Harry Met Sally*, the style, decor, colors, and lighting are remarkably similar. Films are highly designed, each with their own look.

Conventions of editing shots together to minimize the abrupt cuts and switches of locale, along with movements through time, have evolved. Matching action by cutting on character movement, eye line and point of view shots (cut to character looking, then to what or who they see, then back to character looking), shot-reverse shot conventions for dialogue scenes and countless other principles of editing are familiar to every movie goer. We know when screen direction is not maintained, when continuity is broken, when the 180 degree invisible line of editing is crossed and characters appear on the wrong side of the screen. Or, the 30 degree rule that prevents the perception of "jump cuts." We call these "errors." But they are merely conventions of Hollywood's continuity style.

The sound track has its own artifice which audiences take for real. Sound involves close-miking; no matter how far away a speaker moves, they talk right in our ear. Sound cuts are staggered with visual cuts, carrying sound from one scene to another, smoothing the continuity. Like the central and supporting characters, there is a hierarchy to sound. First comes the spoken voice, then sound effects, and music. Speech must always be in sync and intelligible.

What is not noticed often enough is that not only does this narrative

portray women as subordinate to men, but that the talking figures in center frame, the protagonists who move the narrative, are mainly white and the women young. The continuity style represents (and has created) a double standard of gender, race, and age, with different conventions of lighting, make-up, speech, and even action for men and women.

In this early work, Heath and Thompson/Bordwell didn't discuss sound or the function of gender, race, and age—the way these political issues determine technique. Nor did they mention that the narrative is usually a story of romance, no matter what the genre, director, studio, or year. The one-hundred years dominance of this story of the couple coupling has had cumulative significance, and, I would argue, major cultural impact. For Hollywood has created the story many little girls and women believe they must make of their lives.

Sometimes this fairy tale becomes a horror story. The Susan Smith murder trial is a perfect example. She must have believed that without a man, the wealthy boss's son, she was nothing, that without a man, nothing mattered, even her children. Dependency on men can, like any addiction, become deadly. In fact, within the syndrome of martyrdom and self pity, her children could even be blamed, then drowned. The sensational case resembled a woman's melodrama of the 1940s, turned into a tragedy of the 1990s through the use of home video recordings of her young sons.

To the male scholarly model of the continuity style, I want to add figurations of gender, race, and age. To do this, I will simply point out what is there to be seen yet paradoxically rarely noticed.

To place eroticism within the family, and consequently, to put women in their place of subordination within that family, is often "The End" of the classical film. (Whether the women of *Gold Diggers of 1933* and films of the 1940s are subordinate is open to question.) It is not insignificant that to accomplish this task of power, the apparatus must be masked.

For Foucault, a parallel tactic to concealment is accentuation or excess (particularly apparent in musicals, which foreground the cinematic apparatus). Foucault locates one of power's four major strategies as the "hysterization" of women's bodies, an apt concept for Busby Berkeley's visions. This strategy constructs the female body as "thoroughly saturated with sexuality":

> In the process of hysterization of women, "sex" was defined in three ways: as that which belongs in common to men and women; as that which belongs par excellence to men and hence lacking in women; but at the same time, as that which by itself constitutes women's body, ordering it wholly in terms of the functions of reproduction and keeping it in constant agitation. (Foucault, 153)

A history of cinema could be written as an agitation of women's bodies. The highlighted, halo-haired, feathered, furred, airbrushed-by-technicolor

concoction circulates through eighty-nine minutes of the film and is then contained/possessed in the privileged seconds of the end, usually by a middle-class male/husband. The moment of metamorphosis from sexuality to alliance, the trajectory of romance, used to be an immaculate conception, for years keeping cinema's virginal censorship code intact in the unseen and the unheard of the fade to black—the secret, or nonsecret, that is sex.

Talk about double-whammy logic! Sex "by itself constitutes women's body" and yet is "lacking in women." We are everything *and* nothing, full of sex *and* lacking sex. This is a logic of contradiction, a both-and logic of creation/cancellation. Angela Carter describes the paradox: "In the celluloid brothel of the cinema, where the merchandise may be eyed endlessly but never purchased, the tension between the beauty of women, which is admirable, and the denial of the sexuality which is the source of that beauty but is also immoral, reaches a perfect impasse."[11] What happens in the 1990s is that sexuality as source is proclaimed, not denied—quite a switch—and sometimes, as in *Basic Instinct* (Joe Eszterhas/Paul Verhoeven, 1991), not contained by "The End." But whether overt or covert, the aftereffects or fallout is the same.

Carter's historical position echoes Foucault in another sense: speaking about sex constantly while maintaining it as the secret. (Now popular culture just speaks of sex constantly!) Film's solution—fade/family—keeps the secret of sex in the dark of censorship or the light of romance. The couple's passage through the film into the fade and then "The End" (the family) literalizes Foucault's analysis: "It is through sex—in fact an imaginary point—that each individual has to pass in order to have access to his own intelligibility . . . to his body . . . to his identity" (Foucault, 22).

Foucault was not giving us advice, he was criticizing this belief. The conflation of sex and identity was a ruse. But sex still is figured as the key to identity and perhaps to politics, even radical politics. For women, sex as power/subversion is, in reality, imaginary. In *The Last Seduction* (Steve Barancik/John Dahl, 1994), Linda Fiorentino as seductress knows that sex is merely a lure, a trick; the key to power is money, not sex.

Via romance or thrill, cinema places us within the family, constructing a discourse historically without intercourse (with the exception of pornographic films). As Roland Barthes so aptly wrote: "The dramatic narrative is a game . . . nothing has been shown . . . what is shown is shown in one stroke, and at the end; it is the end which is shown."[12] The happy ending meant coupling—kiss, fade, "The End." The consequent marriage was rarely represented, let alone depicted as "happy."

Perhaps even more than the screwball comedy, the musical comedy is a form that literalizes the conventions of romance of the classical film in general. *The Dolly Sisters* (Twentieth Century Fox, 1945) and *Cover Girl* map out the collapse of sexuality and alliance in cinema. In "The End," the

The Dolly Sisters

glamorous pinups (Betty Grable and Rita Hayworth, who used to be at least slightly scandalous but now represent the good and pure old days) are coupled to average "good guys." Presumably, the successful women, both showgirls, have quit their jobs, relinquishing fame and profession. This "happy ending" comes after portraying the women's rise to fame. (In fact, there are two parallel stories: the women's career success and their love story.) (See page 26.)

Both films begin with opening sequences that dramatize the look of a male at the erotic female body—sexed at first sight. The "girls" then move up, from burlesque to Broadway and the Ziegfeld Follies. Later looks at this now high-class body of fashion and wealth are less personal but more

legitimate because of the class/wealth of the male lookers and the fetishized respectability of designer clothes. In one sense, the pinups become high-class performers—now respectable enough for marriage. In another sense, they have reached the pinnacle of their careers.

The female entrance into the spectacle of glamour, fashion, and the upper class, with the monetary rewards of fame and success, is at the same time a move away from the possibility of true love or alliance, thereby prolonging the romance narrative by interruptus. Women's professional success endangers their chance at happiness—that is, at marriage, the *only* source of happiness. They must be chastised before they can be forgiven.

Not surprisingly, women are not responsible for their achievements. In both musicals the women are literally made by men. In *The Dolly Sisters*, Betty Grable and June Haver are costumed and glamorized by Harry Fox, who then plays the piano for them in their hotel suite as they perform—or strip—for Oscar Hammerstein, the producer. What really makes them, along with makeup and costumes, is the technicolor cinematography of Ernest Palmer. Like *Cover Girl*, this film has a makeup number, with women dressed as lipstick, rouge, Patricia Powder/Patsy Powder Puff, and mascara. They are singing, parading fashion models, resembling strutting phalluses in their plumed, tall headdresses. (See page 27.)

In *Cover Girl*, Rusty Parker/Rita Hayworth tells Danny McGuire/Gene Kelly about losing a magazine-cover contest: "They didn't like my face." He replies, "You're gonna be a great star, Rusty, but you gotta get there on your feet, not your face." Rusty was wrong—about the story. She wins the cover spot. *Cover Girl* then dramatizes the glamour process: John Coudair, the wealthy publisher; Noel Wheaton, the Broadway producer; makeup men; photographers; and costumers all conspire to make the beautiful Rita Hayworth more beautiful. (See pages 29, 30.)

But Danny was wrong, with regard to this film and film history. The female face was and is everything. In his recently reissued book *Lighting*, John Alton tells us: "For a beautiful close-up, good make-up is absolutely essential. Perhaps make-up is the wrong expression, 'cover-up' would be more appropriate."[13] He then remarks that "very little make-up is used today by men" (96). A double standard in physical, technical conventions was based on age and established early in film history. Women had to be beautiful and young; men just had to be men. To quote Alton again: "Close-ups of Hollywood stars are known for their exquisite beauty. They should . . . be photographed with lenses especially designed for the purposes of beautifying" (85).

Regarding the economics of the face shot, the close-up, Alton says that "there are two main groups, feminine and masculine. . . . In feminine close-ups, we strive for beauty, in masculine pictures it is the character of the

Cover Girl

29

individual that we accentuate" (95–96). Women are beautiful, men have character, including lines in their faces "which they have earned." "The lines on a man's face are like a soldier's stripes, well earned. They signify character; therefore we must not try to eliminate them." (113) "Feminine close-ups or portraits should always be beautiful . . . they are the jewels of the picture. . . . (97) For the purpose of beautifying, the camera can be made to lie. Such lies, by means of which a person can be made to look much prettier and younger than *she* [my emphasis] really is, are . . . desir-

able" (87). Only "she" must be "younger" and "prettier"; as herself, she is not good enough. Regarding the soft-focus close-ups, the rule for wiping out wrinkles and other details on women's faces is "heavy diffusion in close-ups, especially feminine portraits." Diffusion "is recommended especially for love scenes" (89).

Thus diffusion, in tandem with the feminine close-up, has come to mean "love at first diffused sight." (The opening minutes of *I.Q.* (1994) put these rules into play.) The lighting apparatus it takes to achieve this is significant. It necessitates that women not move. (Marlene Dietrich perfected the art of sensuous, provocatively minimalist movement.) To walk away from the light would be to reveal wrinkles and collapsed cheekbones. Thus women often are static within scenes, while men walk about. This technique is a further explanation for Laura Mulvey's distinction between men as active and women as passive. The technical effects of diffusion explain why cinematographers rarely shoot female faces in depth. These lighting effects are exaggerated in the glamour shots for publicity, usually filmed by a still photographer.

After the makeover of Hayworth/Parker, the "Cover Girl" musical number begins by lowering a gigantic still camera onto a sumptuous, huge Broadway stage set and then parading and optically printing real 1940s cover girls beside their respective magazine covers, each with a reference to World War II. In the grand finale (more like unconsummated climax), Rusty Parker, in clinging gold lamé, slips out of her robe, descends from the heavens down a spiral, vaginal ramp, dances with a male chorus of photographers, and returns to the heavens. Foucault described this process: "By creating the imaginary element that is 'sex' the desire to have it . . . to discover it, to liberate it, to articulate it, to formulate it . . . it [the deployment of sexuality] constituted "sex" itself as something desirable" (Foucault, 156). (See pages 32, 33.)

Just when Rusty Parker is about to marry Noel Wheaton, who supports her career, romance (in tandem with the center-framing conventions of the star system, so we always know who the proper central couple is) kicks in. At the last minute Rusty aborts her wedding (along with her career) and returns to Danny McGuire/Gene Kelly.

In *The Dolly Sisters*, Jenny Dolly's salvation is more extreme. She also suffers for love—or is punished for success. While eloping with a European count, she is first assaulted by the soundtrack, a musical memory of Harry Fox's song, "their song." As the song becomes louder, Jenny covers her ears with her hands (taking them off the steering wheel of the car) and drives off a cliff, demolishing her perfect face. Plastic surgery, like masquerade, restores her face to its former beauty, however, and you know the rest. (See pages 34, 35.)

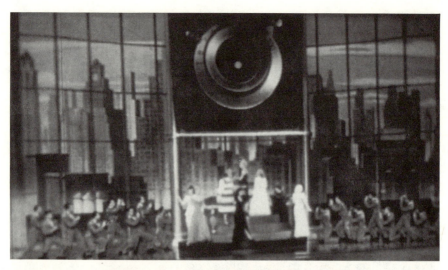

Cover Girl

The Dolly Sisters

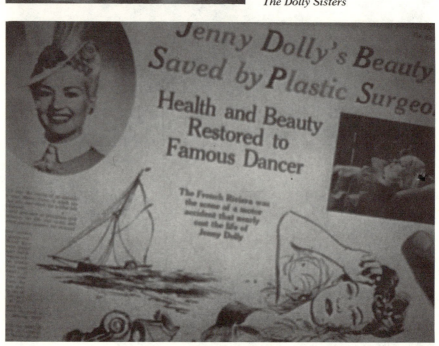

At the end of each film, the narrative closes in on the couple, the family, and contains the threat of female sexuality/wealth/professional achievement. The pinups have been brought down to earth and made respectable by men, working- or middle-class men. Along the way, men rescue women from the effects of a career: alcoholism (*Cover Girl*) and loneliness (*The Dolly Sisters*). Her career must never be more profitable or successful than his career. The final and inevitable return to the first male is a double con-

tainment, both economic and sexual, of sexuality for the family and of women within the home/family and away from the labor market. For women, romance means negation—not to earn more money, not to be more famous, not to have an identity or work of one's own. What Foucault does not say is that the simultaneous proclamation and containment of women's sexuality is also the curtailment of their earning capacity (which is reversed by Madonna and Camille Paglia and so many other postmodern women who have capitalized on sex).[14] In the "happy ending," men gain something; women give up something. Sometimes we don't even

notice the high cost of "true love." Why? Because only women pay the price.

In the last sequence of *Million Dollar Mermaid* (MGM, 1952), Annette Kellerman (Esther Williams, playing the famous Australian swimmer-athlete) is paralyzed after an accident during a swimming performance on stage in a tank. She is lying in her white hospital bed, unable to move. Her swimming and silent movie careers are over. However, her first love and former manager, Jimmy Sullivan/Victor Mature, now the owner of Rin Tin Tin (and before Annette, a boxing kangaroo), has returned. (He, of course, left as her career became increasingly successful and lucrative. As I suggested in the Introduction, one stringent convention of postwar cinema was that *women could not be more economically successful than their mates.* Women's monetary success was represented as selfish and castrating. It would inevitably lead to their unhappiness; ergo, sacrifice was a good thing for women.) In an extreme close-up, he slips a diamond engagement ring on her finger and then kisses her. After a slightly disturbing medium shot of Annette looking out the hospital window, followed by a shot of her view of the ocean, "The End" is imprinted. She might never walk or even move again, but this is a happy ending. The couple has been restored (and she cannot work, her life as a professional athlete is over). Applause. (See pages 37, 38.)

But this wasn't the only way Williams was made to suffer. In this and other films, Williams's male co-star had to be taller and bigger than she was. To make her look less muscular and smaller, the furniture was specially constructed to be oversized. This rigid Hollywood convention of women being shorter, smaller, and thinner than their male counterparts is so common as to appear "normal" or "natural." But size has determined film history, casting, and the star system perhaps as much as anything else. (Yes, I also know the stories about Alan Ladd standing on boxes.) Women have internalized this blatant, idiotic standard, turning their superior height into a flaw, not a virtue. Like economics, women's strengths have been transformed into negative qualities that can be debilitating. I love the story of Katherine Hepburn wearing her highest heels when she met with the heads of the studio, and then towering over them by standing up and leaning over their desks.

Romance crippled women for the narrative resolution of the happy ending. The happy ending was a strategy adopted in the early years of cinema to attract a middle-class audience, particularly women. Happy endings are profitable endings. Like "And they lived happily ever after," the happy ending appeared to tie up any loose narrative ends. Actually, however, it covered up the film's economic contradictions *and* made money.

Perhaps the biggest stretch was conscripting Marlene Dietrich into the

Million Dollar Mermaid

Million Dollar Mermaid

middle-class family in *Blonde Venus*. In this 1932 Paramount picture, directed by Josef Von Sternberg, Dietrich is cleverly disguised as mother and dutiful wife. To save her radium-poisoned husband, the deeply repressed Herbert Marshall, she gets a job as an entertainer. Thus Helen Faraday moves from the ruffled-curtained domestic space of stitchery and child and husband care to the erotic spectacle, becoming Helen Jones. In her first performance Dietrich strips from a gorilla costume, an extraordinary sequence. Fortunately for the film, her husband goes off to Europe for a cure with the three hundred dollars she earned.[15] (Earlier he had tried to raise the money by selling his body to science, only to be rejected.)

As Helen Jones, Dietrich supports her real object of desire, her young son, Johnny. The film is filled with water imagery, for example, bathing Johnny as maternal love. Upon the return of her now-cured and jealous husband, she is accused of infidelity and admits it, thereby becoming an unfit mother. Helen flees with her son to the South, accompanied by an African American maid. In a series of lap dissolves (one scene melding into another; rather than cutting or fading to black, the scenes thus overlap), her husband, the police, and finally a judge in a courtroom find her guilty, and Johnny is taken away from her by the law. She has been investigated by the narrative and proven guilty, found to be sexual and therefore not maternal. In a powerful metamorphosis, she dons a man's suit, resplendent in white top hat and tails, patting chorus girls and shaking hands with the patrons. Every gesture declares female power, female assertiveness, the sheer pleasure of independence. It is one of the great moments of cinema. (See page 40.)

But this is a "woman's" film. Oedipus always wins in the end. Wearing one of Adrian's most dramatic gowns and hats, the glamorous, glorious Helen returns to the dull, drab family, to Johnny's crib. The difficulty of containing Dietrich within middle-class respectability and the family is demonstrated by the high contrast of this scene. But it can be done. The visual codes conspire to make her repentant. She sits beside the crib while Herbert Marshall stands; her eyes are downcast; she is properly subservient. If not truly subordinate to a man, then a son will serve the purpose of keeping a woman in her place. Taking women out of the spectacle (and public space) and into the family, away from the sphere of economic independence and self-assertion, is the happy ending. (See pages 41, 42.)

Women's real "lack" has been monetary, economic, not sexual; economic lack is a constraint, an instrument of power. In *Out to Work*, Alice Kessler-Harris describes the two-hundred-year logic, from the 1730s through the 1960s, that kept women out of the job market and in the home.[16] Amazingly enough, the early colonists' logic lasted into the 1970s and, I would

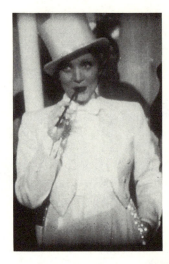

Blonde Venus

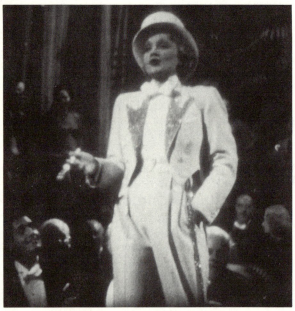

argue, has reemerged in the 1990s: "Marriage was the natural and desirable role for white women and their economic subordination assured the colonists that most women would follow this path" (4). Conversely, money "carried with it possibilities for independence that undermined women's subordinate and secondary position in society" (37). The letters and diaries of wage-earning women reveal that they loved the independence of "having cash in one's pocket" and experiencing "a sense of choice" (34).

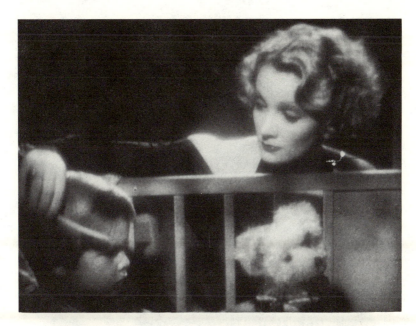

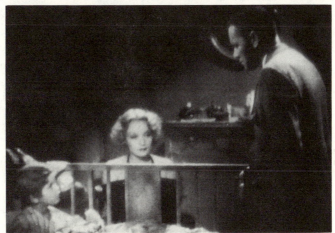

Blonde Venus

Out to Work also portrays the even more difficult situation of black women. "Excluded by their sex from skilled jobs, and harassed because of their race, free black women" had the most "onerous jobs" (47).

Kessler-Harris describes the schism between middle-class and working-class women, seriously at odds over working outside the home for wages. Their divide was between the sexual economy and the money economy. "From 1868 through the first World War, non-wage earning women wanted to focus struggle around gender-related issues, while wage earners insisted on the primacy of economics" (95). These two sides fell apart over suffrage, with the ballot and the vote becoming a middle-class issue. Working-class women argued differential pay, lack of skills, and opportunity. This divide explains cinema's strategy of "middle-classing" working-class women through marriage.

The domestic code of the middle-class idealized the family. It assumed that "wage earning women neglected their families" and "flirted with sin." Focusing on the "morality of wage work," middle-class activists encouraged women to retreat to the home and to learn "feminine" graces. Boarding houses taught "genteel values and modest dress" to young women. When homemaking became professionalized, women were trained for it, not for paying jobs. Idealizing the family forced women to have reasons for working. Furthermore, "for his wife to be earning income, meant the husband had failed" (51). In this logic, woman is measured only by the man. Her "self-realization, ambition, and independence were nowhere to be found" (51). What is startling is that a century later, the same values were taught to me.

"Piety, purity, and submissiveness became the ideal" (50). "Womanhood" came to represent "higher moral and ethical values," distinct from business and the marketplace. In 1910 the government began to study working women, compiling statistics that turned social codes which sep-

arated the sexual economy from the money economy, the home from the market, into government policy. Compilations of data revealed that "unmarried working women threatened to undermine the family" and that "working women were the cause of men's low wages" (98).

The solution was to get women out of the labor market. Married women should not work, and unmarried women should get married, perhaps by going west and lassoing cowboy husbands, as Judy Garland did in *The Harvey Girls* (MGM, 1945). In effect, working women, with low wages and few opportunities, were blamed not only for adverse social conditions but for men's low wages. Women who worked were seen as greedy, taking money away from men; low wages were not the employers' fault but the fault of "women who did not need to work" (99), women workers being seen as "frivolous" (98). This was a contradictory logic of blaming the victim. When jobs became scarce, as they did during the Depression of the 1930s (and post–World War II), married women were fired from the civil service, from the railroad, teaching, and even nursing (257). Women necessarily saw themselves as temporary workers (173).

"The job market denied women . . . self-directed ambitions toward upward mobility. Everywhere cultural attitudes emphasized marriage and family as goals. . . Women were encouraged to adopt those forms of thought that would lead to marriage." (128) She calls these "forms of thought" "the ideology of woman's place." (142) Thought was inculcated in many unconscious ways, particularly through popular culture and the movies.[17] Psychoanalytic criticism gets at these tactics by focusing on the unconscious.

Clara Bow

Clara Bow's story demonstrates how crippling this logic can be. After being involved in three scandals, including a publicized court trial, she retired from the movies to be a wife and mother and live on a ranch. It was 1933; Bow was in her twenties. As David Stenn writes, "Clara had sacrificed her sexual autonomy and professional achievement for marriage in the belief that it would be her reward and salvation. Instead, it became her undoing."[18] She became a hypochondriac and an insomniac, fearful of the night and dependent on barbiturates. Predictably, Bow also become dependent on her husband (by then a politician) and feared that he would abandon her. She avoided social life and his political scene, blaming her husband for not fulfilling her dreams (322).

The promises of the family as the source of women's happiness failed her. But she felt as if she had failed her husband and sons and attempted suicide. The "ideology of woman's place" had turned on Bow. She didn't belong there but thought she had few options; suicide was one option that

she tried. Eventually she lost her sons and her husband and lived alone, leaving her house only to see her doctor or go Christmas shopping.

In 1949 Bow checked into a psychiatric institute where she was diagnosed as schizophrenic. Sessions went back to her mother's prostitution (no other work was available for her mother) and Clara's being raped by her father after her mother died. But I think she was escaping from her present more than her past. At fifty she moved back to Los Angeles, with a live-in nurse for her schizophrenia. Seeing only her psychiatrist, she lived as a recluse, rarely venturing out in public. She read, swam, watched television, and attended drive in movies. She died in 1965. When Marilyn Monroe, her favorite actress, committed suicide, Bow said, as if explaining herself, "A sex symbol is a heavy load to carry when one is tired, hurt, and bewildered" (278).

At the end of *Out to Work*, Kessler-Harris acknowledges that she has described the "mechanism" that "locked women into place," but we are still without explanations for "why women are willing that it should be so." The urgent question becomes: "For how long would women continue to work without recognition of their contribution on the job?" (Kessler-Harris, 301). Only in the 1960s did this recognition begin to emerge on a large scale. "The freedom that had been demanded by a few daring women in the twenties and pursued in the fifties became in the sixties an objective sought by many" (Kessler-Harris, 311). Each step along the way "exposed social attitudes that preserved women's attachment to the home" (Kessler-Harris, 315). Feminist film theory, informed by psychoanalysis, goes a long way toward addressing these issues.

The story of the capture and containment of strong, beautiful, and powerful women, told in film after film, glamorously illustrates the singular priority of marriage and the family. Again and again, in a repetition with infinitesimal variation, the movies reinforced the cultural cliché that not only was woman's place in the home but this was the only place she wanted to be. Bow must have believed her own movies.

Feminism and Family:
Little Women **versus** *My Brilliant Career*

A substantial difference between the politics of the 1970s and of the 1990s is the attitude toward the family. In the 1970s marriage and the family were seen as problems, as limitations, particularly for women. For many feminists in the 1990s, marriage and the family are the goals. The problem has become a solution (or both problem and solution)—albeit one demanding outside help and therapy.[19] At the same time, women occupy places of real power in the 1990s.

Because we believed in the 1970s that the Hollywood movie worked through concealment, a strategy akin to women's masquerade, it became our job to reveal its working, to look beneath the surface. (Many Hollywood movies, including *Singin' in the Rain* [MGM, 1952], are being "queered" through such close analysis of "unconscious" structures. In this update for the 1990s, Cosmo and Don are the central, hardly repressed couple; they dance together throughout the film.) But culture operates differently today, telling us up front what it is doing, hiding its work right in front of our eyes. Meanwhile, our theory chugs along obliviously, seemingly unaware that the political ground has shifted beneath it.

Thus *Little Women* (1994), a Hollywood film shot in Canada and directed by the Australian director Gillian Armstrong, can easily be updated for 1990s feminism, or what *Vogue* recently labeled the "postsensitive, neofeminist nineties."[20] While declaring independence and the importance of women's professional, volunteer, and domestic work throughout, the film (determined by the still-popular nineteenth-century novel) couples all the "little women" in the end. However, women have a spectrum of choices, the most independent among them becoming a writer *and* a wife. The space of domesticity, very clearly female space, is one star of the film, which portrays love among women.

Susan Sarandon has a supporting role as Marmee, a feminist and the mother of four daughters. In a simultaneous release, Sarandon starred as a mother of six sons. *Safe Passage* (Robert Ackerman, 1994) begins with a disorganized suburban house cluttered with moving boxes. It concludes when the domestic space is orderly and everyone is home. Sarandon, who looks great in her motherly male garb, particularly her outfits for delivering the morning newspaper, discovers in the end what Marmee always knew: mothers are heroes, albeit unsung, capable of wrestling attack dogs to the ground when their children are in danger. Instead of leaving her hysterical but attractive husband, played by Sam Shephard (afflicted with bouts of blindness whenever he is home, rather like the wounded war-veteran father who is absent through much of *Little Women*), and pursuing a civil service career, she recognizes the comfort of her marriage and sleeps with her husband just before the end.

Although it can be difficult to impossible, the message is that family grants meaning to women's lives. The terrifying mother's nightmare of losing a son, presented in the film's opening dream sequence (followed by a close-up of Sarandon's beautifully middle-aged face, a repeated shot that threads the film together), gradually turns into the image of a reunited family. Along the way, the five sons (one is missing in the Persian Gulf War) who have returned home to wait for news clean the house. The hus-

band's hysterical symptom, his blindness, is discovered to be an allergy. *It's a Wonderful Life* for the 1990s, and for women!

The film is a portrait of the safe passage of the son through war and of women through the minefield of marriage and motherhood. The period of waiting for news of dead or alive becomes psychodrama, on-site family therapy. Everyone works through their "issues." The insularity of the home and of this family is quite remarkable, like being at the eye of a storm, at the center of group therapy. Sarandon is the film's pleasure—we see things, including men, through her eyes, and we see a middle-aged intelligent woman who has as many unanswered questions as do her grown sons. She is strong, assertive, and unsure.

In *Little Women*, Sarandon as mother is a supporting character but the voice of wisdom and authority. The point of view belongs to a younger generation, to Jo, the writer played by Winona Ryder. The film begins in voice-over with Jo saying, "My sisters and I remember, poverty settled on our family. Somehow in that dark time, our family, the March family, created its own light." The film is filled with close-ups of the sisters' and mother's faces, alone and in family portraits, singing, playing the piano, performing plays in the attic. These scenes of domesticity, of love, are linked by impressionistic landscape shots—the changing seasons, the passage of time, the coming to maturity.

Dialogue about marriage and money, making a living, and knowing what one wants stands out. Marmee gives quiet firm advice: "I won't have my girls being silly about boys." She mentions the stricture of corsets, the use of slave labor in the silk industry, and reminds her girls that "time erodes beauty, time cannot erode your mind. I know you'll make the world a better place." Jo wants to live a life of adventure, to go to college, to travel in Europe: "If only I could be like father and go to war. I want to do something different." Men can own property and vote and are "not so easily demeaned." She wonders: "Why must we marry at all? Why can't we stay as we are?"

This is a key question that the film proceeds to answer. Initially, Jo does refuse a marriage proposal from the ideal boy next door, who is wealthy and kind: "I just can't go and be a wife." He replies by foreshadowing the film's conclusion: "Someday, you'll meet some man and you will love him tremendously and you will live and die for him." Historical feminism unites with true romance, fashioning a feminism for the 1990s.

With Marmee's blessing "Go and embrace your liberty," Jo goes off to the big city and her career—her *successful* career. As a writer she is patronized, advised to try the ladies' magazines. Jo meets a European professor, Friedrich, an older man, a poor philosopher. After intellectual conversations about women's rights and her work, they fall in love in the wings

of the opera as he translates the lyrics. She has found her teacher. "You should be writing from your life; there is more to you than this, if you have the courage to write it."

But Jo's being a published writer and starting a school is not a happy enough ending for the 1990s (or for any decade, for that matter). Thus, after bringing her the manuscript, along with the publisher's acceptance, Friedrich proposes, they kiss, and, voila! "Happily ever after." Everyone, with the exception of the dead Beth, is coupled. And we've had a feminist history lesson along the lovely way in a film directed by a feminist, Gillian Armstrong, and produced by Denise Di Novi, who worked on *Heathers* (1988) and *Batman Returns* (1992).

The story of the film's making, beginning in 1982, documents the changing role of women within the Hollywood film industry. The initiators were women: Amy Pascal, a Columbia executive, and screenwriter Robin Swicord. About the novel Swicord said: "It said girls could be great. You could go out and make the dream come true, band together and survive just fine. It was a recognition of the female spirit."[21] Swicord speaks perceptively about the 1990s appeal of the film: "So much of contemporary culture has been about the cult of the bad. A lot of people just don't feel like being all that bad. I love that Marmee unabashedly says, 'Service to others,' 'Let's be kind.'" Yes, indeed! The film is set against the materialist grain of the 1980s and early 1990s. Accomplishment, independence, selfless love, and service are not bad goals and practices for the 1990s.

Both 1994 films, however, reveal significant changes within feminism. Contrast the endings of *Safe Passage* and *Little Women* with the ending of Gillian Armstrong's *My Brilliant Career* (1979). I can vividly remember the scene: against all my narrative expectations (and lurking but denied fairy-tale dreams), Judy Davis turns down the prince's (the young Australian Sam Neill, leading a white horse!) proposal of marriage. Not only is he wealthy and handsome, but he had waited for her for two years. The last two shots are of Davis leaving the family home and carrying her big, wrapped book manuscript to be posted, followed by a reverse angle that silhouettes her figure against the landscape at sunrise, with the printed information that her novel was published in Edinburgh in 1901. In 1980 this was a triumphant ending, a *feminist* ending. Marriage was a choice that precluded other choices.

Despite the vast divergence between the endings of *My Brilliant Career* and *Little Women*, there are uncanny similarities between the projects, separated by fifteen years, and continents apart. Both films portray the completion and publication of a woman's book, the fulfillment of women's dreams to become writers, to gain their voices, their *authority*; and to base their writing on their lives, their experiences, intellectual *and* personal.

The projects also share, in addition to Armstrong's sure sensibility and stylistic brilliance, the historical setting; the central role of family (which is also a constraint); the dreams of a strong female storyteller; a female point of view and voice-over narrator; the presence of feminist principles; a reverence for mise-en-scène, landscape, nature, and detail; and a production team led by women.

My Brilliant Career was produced (Margaret Fink), written (Eleanor Witcombe), and designed by women. Judy Davis as Sybylla Melvyn begins this 1897 Australian tale in voice-over: "This story is going to be all about me. Here is the story of my career, my brilliant career." Although living with her family on a small, poor cattle ranch in the Australian bush during a drought, Sybylla has dreams that don't include being either a wife or a governess, as her family wishes. "I want to do great things, not be a servant. Don't you want to meet people, to talk about words and have visions?" she asks her sister.

Sybylla is sent off to Grandmother's estate for proper marriage training, for feminine transformation. This is a genteel, wealthy world of servants, china and linen, lush greenery, and old women/mentors. Sybylla is a serious problem, with unruly, wild hair, rough skin, and uncomely habits such as driving the horse and wagon, riding up front with the men, singing pub songs, and generally rebelling against being married off. "I'm not marrying anyone. I'm having a career in music, art, literature. I haven't made up my mind yet." Even after the scenes of female makeover, Sybylla's soul is still too restless for femininity and marriage.

Sybylla is in many ways as strong a character, as spectacular and exuberant, as the landscape. From the opening shot on, she is shown with the landscape in depth. She is constantly drawn outside, into the world, into space. Her body cannot be still or confined. Her restless, untamed spirit is akin to the land. She wants the freedom, the adventure, represented by open spaces rather than the confinement, the entrapment, represented by domesticity (and codes of femininity). This close connection between women and open spaces is, at least for U.S. films, quite unusual. On the surface the film is one in the tradition of glorious portrayals of the Australian landscape, its scope, beauty, and power. Ross Gibson calls landscape "a leitmotif and a ubiquitous character."[22] And it is true that, along with Davis and Neill, the landscape is the film's third star. But I think it is intricately tied to Sybylla, to her longing. Hence landscape portrays a very different story, as it does in *Thelma and Louise*.

Enter true love, fantasies of rescue—the handsome, wealthy neighboring ranch/estate owner Harry Beecham. Although, like princes in general, he can have the princess of his choice, he chooses Sybylla, despite her lack of beauty, for her spirit, perhaps for her resistance to his charms. The film

seesaws between her desires for herself and her desires for Harry, for her own life and for a married life. For Sybylla, the two are not compatible: "Maybe I'm ambitious, selfish, but I can't lose myself in somebody else's life until I've lived my own. . . . I want to be a writer. I've got to do it now and alone." He responds, "I thought you loved me." Women's dilemma is the choice between taking care of oneself or being taken care of by someone else.

Armstrong ups the ante by gradually taking away Sybylla's options, eventually depositing her in the outback as the governess to a filthy, muddy, unruly lot. When she returns home, it is to more mud and little money. Meanwhile, the perfect prince has been waiting. When Neill comes to rescue her, she is completely muddy. But surprisingly, in the end, she chooses her life, her work, and refuses marriage. She turns down the white horse, the big house, the safe life, and courageously chooses the unknown. Her goal is becoming . . . a writer.

The film represents old age with elegance and grace. Sybylla's grandmother and Harry's strong mother are forceful, direct, and wise, albeit conservative, women. They rule their respective domains with style. They are powerful women who speak their minds and run the show. In fact, women are in charge of most of the film's spaces, including the landscape. But there is a flip side to all this strong female presence: both women try to lead Sybylla into marriage with Harry, seeing no other options. To Sybylla's assertion "I don't want to be part of anyone" her aunt, abandoned by her husband, responds, "Loneliness is a high price to pay for independence."

Why do women, then and now, imagine independence being lonely instead of gratifying, thrilling? Why does female independence coincide with sacrifice? Why is it a loss, not a gain? Why don't women view freedom as positive, as Armstrong does in her elongated ending, where Sybylla's life and destiny stretch infinitely before her? Why do women give their lives away before they even try to live them? One answer is familial economics: Sybylla's family can no longer afford her, thus marriage is her work, her economic obligation. For *Gold Diggers of 1933*, the economic necessity was the Depression. But what of 1995?

Sexual Economics: "Gold Diggers of 1933"

CONTAINING SOCIAL TURMOIL— CONTAINING WOMEN

On October 24, 1929, the U.S. stock market crashed. The crash resulted in a 1932 estimated unemployment figure of 13 million, out of a population of 123 million. Wages were 33 percent lower than in 1929. In spite of this decline in income, movie attendance was estimated at between 60 to 75 million per week.[23] The regular audience was attracted to codified genres (as well as sequels, series, and remakes) and the distinct styles of the five major studios.

To paraphrase one critic:

> At Warner Brothers . . . films were made for and about the working class. Their musicals, born of the depression, combined stories of hard-working chorus girls and ambitious young tenors with opulent production numbers. . . . Lighting was low key. . . . Cutting corners became an art. Stars were contracted at low salaries. . . . Directors worked at an incredible rate, producing as many as five features per year. The basic film at Warners . . . was a melodrama . . . which ran for 70 minutes. Pace was more than Warner's trademark—it was a necessity.[24]

If one momentarily accepts the undocumented assertion that Warner Brothers's films were made "for and about the working class," raising issues of address and enunciation, then labor's struggle to organize in the 1930s would be a critical context for reception.

Therefore, a few details are in order. Unions were just beginning to gain power and demand benefits. This was the era before Social Security, unemployment and health insurance, minimum wage, and other labor laws that prescribed working hours and conditions. Demonstrations by the unemployed occurred around the country, often involving violent encounters with the police. For example, thirty-five thousand demonstrators for un-

employment insurance in New York were attacked by police, as were ten thousand protesters in Cleveland. On March 7, 1932, three thousand protesters marched on the Ford factory, demanding jobs. Police, armed with pistols and machine guns, fired; four protesters died and were declared Communists. In Toledo a large crowd of the unemployed marched on grocery stores and took food.[25]

The fear of the overthrow of capitalism, like the "red scares" of the twenties, was real. The Soviet revolution had occurred less than two decades earlier. The New Deal, with such versions of socialist practice as federally funded corporations (e.g., the Tennessee Valley Authority), helped to elect Franklin D. Roosevelt president. He enacted Social Security in 1934–35. Unions gained benefits, with collective bargaining granted in 1935.

The signs of economic chaos and poverty (like street people in the 1990s) visibly exposed the gap between rich and poor. An estimated seventy thousand children were homeless, living in shantytowns. William Wellman's film *Wild Boys of the Road* (Warner Brothers, 1933) portrayed their plight. Rather than interpreting these events as economically and socially determined, thereby questioning capitalism, some members of Congress viewed them as personal—inspired and instigated by Communists—and created a committee to investigate radical activities. Thus began the House Un-American Activities Committee, which would investigate Hollywood, particularly the screenwriters' guild, in the 1940s under its infamous acronym, HUAC. (It should be pointed out that Hollywood unionized early and thoroughly, with the exception of studio executives and producers; by the mid-1930s, there were guilds for writers, actors, directors, and cinematographers. Along the way, Prohibition was repealed in 1933, and the Catholic Legion of Decency was founded in 1934 to "select" [censor] movies for Catholic audiences.)

The 1933 Warner Brothers film *Gold Diggers of 1933* was listed by *Motion Picture Herald* as the second top moneymaker of 1933 (another Ruby Keeler/Dick Powell/Busby Berkeley extravaganza, *42nd Street*, was third). *Gold Diggers* is symptomatic of these issues of unemployment and homelessness. To start, there is the irony of the first spectacle, the musical number "We're in the Money." This is followed by the initial apartment sequence of unemployed chorus girls with the montage of unpaid bills and the theft of milk.

The film concludes with the "Remember My Forgotten Man" spectacle, which takes us on a theatrical 'Hale's Tour' of recent U.S. history. In this number, demarcating wipes, like stage curtains, separate the acts of history. Scenes of soldiers marching off to war transform into war's aftermath of wounded, bleeding, bandaged veterans of World War I, then segue into the breadlines and soup kitchens of the postwar years. This number explains the

Gold Diggers of 1933

Depression as a product of World War I. As Carol (Joan Blondell) sings: "Remember my forgotten man. You put a rifle in his hand. You sent him far away. You shouted hip-hooray. Just look at him today." (See pages 52, 53.)

The film begins with the erotic spectacle of women as interchangeable with money in "We're in the Money": "Gone are my blues and gone are my tears. I've got good news to shout in your ears. The long lost dollar has come back to the folds. With silver you can turn your dreams to gold". It concludes with the dark blues of "Remember My Forgotten Man" and its backlit, tiered set of marching soldiers (which rhymes the women's silhouetted dressing rooms in "Pettin' in the Park"). (See page 55.)

Other signs of social unrest strangely permeate the opulently surreal world of the film. The circulating presence of police throughout the film is, perhaps, the most displaced image. The sheriff interrupts (censors) and stops "We're in the Money." This initiates the narrative pattern of interruption and delay of both story and show. He and his men literally strip the women of their costumes. Policemen are the roller-skating male chorus of "Pettin' in the Park," with Trixie, the comedienne (Aline MacMahon), cross-dressed as a policeman (although wearing a flower in her lapel). A policeman on the stage of "Forgotten Man" confronts a "bum," whom Carol reveals to be a war veteran. Near the end of the film, Barney, the producer, reveals the sheriff to be an out-of work actor. Thus police are rendered harmless, their image contained but still suggestive.

Alluding to Prohibition, Gigolo Eddy's guitar case (which is, like the violins in "Shadow Waltz," a female emblem) contains booze, which he dumps behind a backstage flat when the sheriff interrupts "We're in the Money." Two prohibitions are equated: women's bodies and sex with the illegality of alcohol. The speakeasies where Trixie and Carol seduce J. Lawrence Bradford and Fanuel Peabody also refer to Prohibition. Once the Legion of Decency began to condemn certain films for Catholic audiences in 1934, the scanty costumes and virtual nakedness of the "Pettin' in the Park" sequence were censored in the film's sequel.

Like classical Hollywood film and musical comedy in general, the film operates to proclaim, then contain, female sexuality. It moves from single women (and men, separated by class) to a triad of perfectly paired, married (classless) couples. This process takes women out of the erotic spectacle (and perhaps also the labor market) and into marriage and respectability. There is a moral for women in the last sequence: without men (or capitalism), women (the working class), including a black woman singing the blues, will be old, haggard, alone, and poor. For women, being without a man is indeed a barren fate, worse than death or high-contrast German expressionist lighting. For women, "alone" means living without men. Female friendship doesn't count.

Gold Diggers of 1933

Together and united, as they are in this film, women are not enough. They do not have access, except through sexual wiles, to the means of production, in this case financing for the show. They have the talent and the brains but not the bucks or the power. As the lyrics of "Remember My Forgotten Man" inform us: "And once he used to love me. I was happy then. He used to take care of me. Won't you bring him back again? 'Cuz ever since the world began, a woman's got to have a man. Forgetting him, you see, means you're forgetting me, like my forgotten man." Warner Brothers's explanation for social and economic ills resembles Congress's conspiracy theory, only with rampant female sexuality (elided with the effects of World War I on the family) rather than Communism as the guilty party.

Therefore, the film's solution to the Depression, unemployment, and unbridled, anxiety-provoking female sexuality is the family. This is narratively figured as marriage to Back Bay Boston investment bankers. Upper-class men save the show from bankruptcy with Brad's critical check of fifteen thousand dollars and his reluctant agreement to perform in the spectacle. This is paralleled by J. Lawrence's ten-thousand-dollar payment to Carol for nonsex, a check later transformed into a wedding gift. Thus the inequities of both class and gender are collapsed into marital salvation. The film equates marriage and the couple—the happy ending—with capitalism. By uniting the working-class chorus girls (Polly [Ruby Keeler] tells us in the upper-class nightclub scene on the balcony that her father was a postman) with upper-class, inherited wealth in a backstage triple whammy of Polly and Brad, Trixie and Fanuel, and Carol and J. Lawrence, presumably the nation will be restored.

Within the film's economy, the only significant "difference" is sexual difference. Other cultural, social differences—the inequities of class, race, politics, economics, and age—are secondary. While the female lead characters are represented as working-class, one must question the film's address to the working class; but the film addresses itself differently to women and men. Choreographer Berkeley's spectacles are addressed to the male spectator, literally a voyeur or fetishist, whereas the narrative sections directed by Mervyn Leroy demonstrate the pleasures of female friendship, the solidarity among Trixie, Carol, and Polly. These lively friends are infinitely more interesting, idiosyncratic, and clever than the wimpy men, particularly Warren William (who, as J. Lawrence, has top billing, albeit less screen time) and the eager tenor William Powell, in this instance portraying Brad Roberts or Robert Bradford. (That the two investment bankers are parodied must also be taken into account. J. Lawrence and Fanuel are naive and inept, hardly savvy corporate scions. They are shown at their club, not at work. They are the representatives of in-

herited rather than earned wealth. What the film does value through the chorus girls and the character of Brad Roberts is working for a living.)

While the narrative is propelled by these fast-talking, inventive women, in the spectacles (which freeze the story's advance) they become identical, anonymous, Freudian symbols. In fact, their masquerade serves to make them so identical that Ruby Keeler, the film's star, is unnoticed in the anonymous chorus line of "We're in the Money." In one reading, the end functions as a resolute, albeit "logical," containment of women, which includes separating them. Or one can imagine marital rescue after a spending spree on luxury items as a fantasy of the historical women in the audience—with few other options available to them in the 1930s. The women use men's false (stereotypical) notions about women's character to get what they want. Masquerade and the double standard become story, with the audience keyed in on the deception, told from the women's point of view. The marital inevitability is manipulated by the women for economic pleasure and gain as much as, or more than, romance.

The narrative is thus an address and an appeal to women—who are let in on the joke, which is on J. Lawrence and Fanuel. These chorus girls are not stupid, inexperienced characters, particularly Trixie: "It's the Depression, dearie." However, knowledge, which the women have about men, is not power; money is.

Women as Commodities

The sexual economics of *Gold Diggers* exchanges women's bodies as emblems of plenitude, interchangeable parts in an era of assembly-line mass production. Women are infinite, available, luxurious commodities (suggesting that there is no scarcity, no deprivation; in a word, no Depression). First these bodies are celebrated/flaunted, then denied/contained. The female body is both desirable and terrifying—at least to Freud, Fanuel, and J. Lawrence.

In Busby Berkeley's fantasies, the secret that is sex becomes a loud proclamation. I repeat Foucault's definition of sexuality as "the name that can be given to a historical construct . . . one relay of which is the body that produces and consumes" (Foucault, 195). The on-screen female body, a "class body," "the endogamy of sex and the body," is produced as a representation for male consumption (1) by the narrative and (2) through the eyes of the male protagonist. (However, one must complicate this by the now-accepted division of pleasure; women have always comprised a large audience for cinema, presumably not going to the movies only for displeasure.)

Lucy Fisher's 1976 essay on *Dames* (Warner Brothers, 1934), emphasizing the wit of Berkeley's literalism ("Thus, in the Berkeley numbers the

Gold Diggers of 1933

notion of women as sexual objects takes on a deviously witty relevance"), concludes that the film concerns "the image of woman as image" (awareness and hence, via reflexivity, excess), celebrating not her presence "as much as her synthetic, cinematic image."[26] But this image of women is also economic. Women's bodies are exchangeable, abstractions like money. In *Gold Diggers*, J. Lawrence calls Carol and Polly "cheap and vulgar gold diggers." "We're in the Money" equates women's bodies with coins, which are strategically and fetishistically placed costumes, turning into waves, circles, with pans over identical, infinite smiling faces—there, available. Women's sex is money, women's gold standard, their only marketable asset.

Berkeley's rendition is so blatant, so over the top, that the equation of women with money seems out of style, camp, history. However, the equation of women's bodies with money/sex is still prime currency. According to journalists in 1993, women were plying an old trade, selling their bodies for money—Julia Roberts in *Pretty Women* (Buena Vista/Touchstone, 1990) went for $3,000 (called by male critics, "traditional romance"). Uma Thurman fetched $40,000 in *Mad Dog and Glory* (John McNaughton), and Sarah Jessica Parker got $65,000 in *Honeymoon in Vegas* (Andrew Bergman, 1992). Demi Moore was the big winner, rating $1 million for *Indecent Proposal* (Adrian Lyne). She will be paid twelve million in 1995 to strip, in *Strip Tease*, literalizing what has usually been a metaphor. For Callie Khouri (screenwriter of *Thelma and Louise*), "Hollywood is trying to re-sexualize its women back into submission. This whole idea that women are powerful because they're sexy is a crock. Sex isn't power. Money is power. But the women who do best . . . are complacent . . . in the role of sexual commodity, be it Madonna, Julia Roberts of Sharon Stone."

The equation of women with sex/money has a serious downside. According to the Screen Actors Guild, "men earn twice as much as women and grab 71% of all roles." Unlike the acclaim for aging men like Clint Eastwood and Jack Palance, women over 40, known as Hollywood's "pariah category" are "in less than 9% of all film and television roles." Women make up just "10% of the Directors Guild of America." Adding assistant directors and production associates, "the figure grows to only 18%." The article concludes that 1968 was the last year for great women's roles. But even ten years ago, four women were among the Top 10 box office draws. In 1993, there was only Julia Roberts. (Quoted from John Horn in *The Milwaukee Journal*, Sunday, March 28, 1993, E6.) At least in *Basic Instinct*, Catherine Trammell knew, if the critics didn't, that the money was her power more than her sex.

The lower economic status of women was dramatically illustrated at the 1993 Academy Awards—"Oscar Celebrates Women and the Movies." The program was titled "The Year of the Woman," a proclamation of women's

absence on and off screen. Tellingly, "the five Best Actress films have earned only $36 million" in North America. *Howards' End* has made less in a year than *Batman Returns* did in its first weekend. As Molly Haskell puts it, "men are now playing all the roles. They get macho roles *and* the sweet-sensitive roles, and they play the sexual pinups too. The best woman's role of 1992 was in *The Crying Game*, and that was played by a man."

It would appear that women actresses fared better during the Depression. But to return to Berkeley's opening number in the *Gold Diggers*. The camera dollies in (with a brief loss of focus) on Fay Fortune's face (Ginger Rogers), then closes in on an extreme close-up of her lips singing in pig Latin, nonsense, outside language, as Lacan would analyze it. (Recently a student told me that pig Latin was women's private language; rarely did men understand it. This would change the Lacanian analysis, a bad thing, into a good thing, but we cannot find the historical source of this tidbit.) After the voyeurism of "Pettin' in the Park," signaled by the leering midget/baby who raises the curtains of the women's dressing rooms, there are intercuts of women's assets: legs, ankles, and breasts seen through transparent costumes. In the next spectacle, "Shadow Waltz," the gold-digging strippers, encased in chastity-belt-like metal costumes—their virginity undone by the men's can openers—are transformed into petals of a flower, playing Freudian violins. The hardened gold diggers have become softened symbols of more legitimate, upper-class feminity. (See pages 58, 59.)

Before marriage can occur, the film cleans up the image (and presumably the class) of women, making them respectably sexual. Berkeley took Freud very literally, agitating women's bodies into fetishistic excess or surplus voyeurism. In the end, except for Carol, the Parisian-garbed prostitute wailing a blues song about the depression, the exhibitionist women are gone.

Fetishism, Sadism, and Masochism

This Foucauldian analysis elicits results similar to Laura Mulvey's oft-cited psychoanalytic construct in "Visual Pleasure and Narrative Cinema." Mulvey draws on Freud's *Three Essays on Sexuality*[27] particularly "The Sexual Aberrations," his very short elucidation of fetishism, and Lacan's writing on the mirror phase and narcissism. (Because there are no footnotes in her essay, I have deduced these primary sources.) Mulvey's essay, predicted on an analysis of Hitchcock films, has determined feminist film theory for almost twenty years. Her premise, the divide between men and women in narrative, a divide which also splits the gaze into active/passive, male/female, reiterates Freud's assessment of scopophilia: "In these perversions the sexual aim occurs in two forms, an *active* and a *passive* one"

(Freud, S.E. 157). Although she doesn't quote this source, what Mulvey did was link these oppositions to vision and from there, to narrative.

Like Freud, Mulvey sexually differentiates these roles: "Women in their traditional exhibitionist role are simultaneously looked at and displayed, with their appearance coded for strong visual and erotic impact." In both story and spectacle, what counts is what the heroine provokes; she functions as an erotic object for the characters within the film and for the spectator within the auditorium, as the now very famous "bearer rather than maker of meaning." In this bipolar system the man forwards the story and is the bearer of the look of the spectator—the possessor of power.[28]

In almost every page of Freud, woman as the sign of sexual difference embodies the threat of castration, which, as Freud never tires of telling us, evokes original anxiety—J. Lawrence says to Peabody: "I'm afraid . . . that woman is fascinating. We don't have to give in, do we?" Mulvey argues that turning the woman into a fetishized object is one way to control male anxiety. Busby Berkeley spectacles are the quintessential examples of this "technology of gender," to paraphrase the title of deLauretis' book. The other avenue lies in ascertaining guilt, asserting control, and subjecting the guilty women through either punishment or forgiveness. This means of control, sadism, is suited to a story, dependent on making something happen, forcing a change. The story of Carol and J. Lawrence which interrupts and postpones the spectacles is an example of this tactic.

However attractive and perfectly applicable Mulvey's dichotomous system is to this film, as it is to most classical texts, the "either/or" analysis has limitations. A model of contradiction, a "both/and" logic, might be more pertinent, particularly for women. Other readings, including female bonding, female pleasure, and even the gendered techniques of duplicity, simulation, and masquerade, are possible. Although they must manipulate men in order to do so, the women of *Gold Diggers* make things happen. In fact, an opposite case to Mulvey could be made regarding this film, at least on first glance: that the women get what they want, including the security and respectability that rich, upper-class men provide *and* close friendship with each other; that the women move the narrative forward, finding a backer for Barney's show and husbands for themselves, albeit through manipulation, trickery, deceit, and seduction (including the pretense of sex after getting J. Lawrence drunk). However, a cautionary note is added to this celebratory interpretation if, as does Freud in the paragraph following his discussion of sadism, masochism is added to the techniques of sadism (and fetishism).

Masochism might more aptly describe J. Lawrence and the extreme anxiety of Fanuel Peabody, his cohort. As Sonja Rein-White has so lucidly argued in an unpublished seminar paper, "What is important in maso-

chism is the desire to return to the mother. . . . Thus, the masochist demands that he be beaten in order that the image of his father in him . . . is diminished."[29] The scene in which Carol gets J. Lawrence drunk, strips him of his clothes, and puts him in her bed, under the pretense of having had sex, like their entire story and that echoed by Trixie and Fanuel, could be read as a masochist scenario.

Furthermore, as Rein points out, "what is important for Deleuze is the nature of the agreement made between the masochist and his torturer. . . . The contract functions . . . to invest the mother image with the symbolic power of the law." (Think of Trixie garbed as a policeman.) In the concluding "Forgotten Man" sequence, Carol is mother, invested "with the symbolic power of the law" in her connection to the policeman.

Critically, the masochist manipulates the mother image, with the victim's consent; and thus, according to Deleuze, the masochist, the victim, "generates the contract." (That a contract has been made is suggested by the character of Fay, who constantly threatens to upset the agreement. More generally, the question of who is the victim and who is the torturer is a crucial one for feminist analysis. Within this model of masochism, even the torturer, if female, is under male control, acting for his pleasure.) Rein argues that even within masochism, "woman is man-made": "In Deleuze's scenario, women are by no means powerful. What power they do possess is only conferred by the man and is specified by him; women act solely in his interests and most definitely not in their own." In whose interest Carol and Trixie act is, again, open to question or interpretation.

However, this model goes a long way toward explaining the war spectacle of the film's conclusion. "As Deleuze suggests, in both masochism and sadism there is the formation of the mother-image, but in the former she is appropriated as the ideal image while in the latter she is tortured and cast out." Masochism makes sense of the last scene's various images of mother and war as a spectacle of masculinity, with the suffering of the soldier-victims as masochistic, male pleasure.

TECHNO-FREUD: SPECIALIZATION, STANDARDIZATION, SEDUCTION

Psychoanalysis permeates *Gold Diggers*, particularly the symbolism of Berkeley's scenes. This is not surprising for 1933, given the influx of German and Austrian expatriates who were moving to Los Angeles and into the film industry. Many films had personal psychiatrists as consultants, often listed in the film's credits. Going to an analyst became de rigueur in the industry. The role of Hollywood (and Hitchcock) in popularizing psycho-

analysis is incalculable, second only to that of feminist film theory and Woody Allen.

Taylorism, so important to studio business practices (as Janet Staiger's essays have shown), also resonates throughout *Gold Diggers*. Taylor's functional, scientific efficiency studies of management included timed descriptions of the body as (working in tandem with) a machine. The film echoes the assembly line, an invention of mass-production technology, in the symmetrical rows of matching chorus girls and the parading soldiers on conveyer belts in "Forgotten Man."

Like the Hollywood studio structure, with the vertically integrated monopolies of the Big Five, factory principles of standardization (and for the studios, specialization) operate in Berkeley's female formations of assembly-line symmetry, harmony, anonymity, perfection. The chorus lines are a combination of Freud's sexual fetish and Marx's commodity fetish, linking up with mechanical studies of human labor but taken into pleasure and leisure, like the history of cinema itself--popular culture as the flip side of industrial culture. The representation of women (and men) as types, for the show within the film and as characters, details the process of specialization: Polly, the sweet, young ingenue; Trixie, the older comedienne; Carol, the tough, ageless, sexy woman with the heart of gold; and Fay, the true gold digger. The changing physical fashions of women's bodies in the nineteen-twenties, thirties, and forties document the standardization of these types. The three couples represent three stages of romance, a marital typology that accords with character traits: Polly and Brad represent young, innocent, virginal love; Carol and J. Lawrence, middle-aged sexual desire and skepticism; and Trixie and Fanuel, asexual, older companionship.

Significantly, because all the women are young, the age of the man defines each relationship, suggesting that our interpretation of the women is, to a degree, determined by the men. The film upholds the double standard of chronological difference: women must forever be young, while men can vary in age and even grow old. The pairing of the older man and the younger woman is the norm for cinema, rarely the reverse.

Specialization also describes the film's (and Hollywood's) conditions of production, detailed in the credits according to department heads (design by Anton Grot and Carl Jules Weyl; costumes by John "Orry" Kelly; camera work by Gaetano Gardio, Barney McGill, and Sol Polito; music by Harry Warren and Al Dubin—mentioned in the film by Barney), with direction divided between Mervyn Le Roy, a contract studio director (like the rest of studio employees, on a monthly salary) who made over fifty films in eight years, and Berkeley. Standardization operates in the conventions of classical Hollywood style and genres, in this case the conventions of the musical comedy (with motifs and figures circulating through-

out both spectacle and narrative segments, gluing them together despite their vastly different 'styles'). I examine this later in greater depth.

That these are capitalist, corporate practices is not without implication. In fact, the Berkeley sequences are spectacles of the glories of capitalist technique and hence visual demonstrations of the narrative—salvation via investment bankers. (This is a reference to and parody of the role such investment bankers as Waddill Catchings played in Warner Brothers's massive and expensive conversion to sound in 1927–28). Siegfried Kracauer argues this connection in a 1931 essay (whose thesis is later picked up in Andre Bazin's essay on pinups), "Girls and Crisis":[30]

> In that postwar era, in which prosperity appeared limitless and which could scarcely conceive of unemployment, the girls were artificially manufactured in the USA and exported to Europe by the dozens. Not only were they American products; at the same time they demonstrated the greatness of American production. . . . When they formed an undulating snake, they radiantly illustrated the virtues of the conveyor belt; when they tapped their feet in fast tempo, it sounded like business, business; when they kicked their legs with mathematic precision, they joyously affirmed the progress of rationalization; and when they kept repeating the same movements without ever interrupting their routine, one envisioned an uninterrupted chain of autos gliding from the factories into the world, and believed that the blessings of prosperity had no end. (63–64)

Regarding the Rockettes and their sanitized routines, perhaps Kracauer is right. Equally, in the midst of the real and the film's Depression, Berkeley's scenes suggest that "prosperity had no end." Rather than operating technology, women are cogs of and for technology; like the machine they are submissive, dominated, usually by a male leader who can mold many into a singular uniformity. Although often treated as idiosyncratic and unique, Berkeley's girls were not new or unique. However, their B-movie versions demonstrate just how good and complex Berkeley's kaleidoscopic infinities are. Just see, for example, the chorus in *Stand Up and Cheer* (Fox, 1934): lead-footed chorus girls strut in costumes that just hang rather than reveal, awkwardly trying to move, let alone dance, with frontal, static, mid-height camera placement, virtually no moving camera shots, and editing void of any metric or rhythmic patterns.

Berkeley's scenes also celebrate technologies other than the body (or the female body as technology, a technology of gender in perfect historical harmony with cinema technology), including, in "Shadow Waltz," electricity in the neon-lighted violins and huge violin formation. Along with turning women into objects fraught with a Freudian symbolism so crassly obvious as to become parody and camp, his scenes depict the wonders of

film technology and its ability to transform space and time—a very modern concern of painters, novelists and philosophers in the early twentieth century. As Fischer writes: "If the geography of the numbers is unchartable, their temporality is unmeasurable" (Fischer, 4). Berkeley combines the oldest technology, sex, with the modernist technology par excellence, cinema.

Carolyn Marvin argues in "Dazzling the Multitude" that around the turn of the century, engineers and entrepreneurs believed that electricity, particularly in manufacturing and transportation, would "heal the breach between classes . . . democratize luxury and eliminate conflict based on competition for scarce resources."[31] (The breach, it was at that time argued, was fostered by the inequities of steam power. The modernist belief that technology will bring social progress is an old and ongoing argument that can ignore social and political issues.) Along with its role in industry, electricity, like the automobile and cinema, was a novelty, spectacle, and a medium of entertainment. Electrical light shows were popular outdoor events, with elaborate performances against the sky at world's fairs and expositions.

However, even more directly pertinent as a forerunner to the electrical virtuosity of cinema is Marvin's description of the 1884 Electric Girl Lighting Company. They offered "to supply illuminated girls" for occasions and parties. These "fifty-candle power" girls were "fed and clothed by the company" (260) and could be examined in the warehouse by prospective customers seeking waitresses or hostesses. Electric girls, their bodies adorned with light, made appearances at public entertainments as "ornamental objects" and performed electrical feats in revues. The term *ornamental* echoes Kracauer's use of the concept of mass ornament in relation to mass culture (a model arguing the existence of a mirroring relationship between the spectacle and the spectator).

What is intriguing to me is the persistent contradiction between yoking the female body to either nature or technology, presumably opposite interpretations. As I argued in 1981 regarding *Metropolis* (Fritz Lang, Germany, 1926), the historical equation of the female body with technology, including sex, represents the female body as a special effect, one that suggests both the danger and the fascination of spectacle, an aberration that must be held in check. However, whether as old-fashioned nature or modern high tech, the technology of gender functions to keep women in line, to serve their masters.[32]

As in most musicals, Berkeley combined techniques of the stage with cinematic technique. His girls were the modern, abstracted, often faceless descendants of revues, vaudeville (for example, Earl Carroll's "Vanities"), and, in England, music hall. Their exhausted reincarnations parade today

at the Folies Bergère in Paris, aging women with sagging breasts; strut as imitations in glitzy Las Vegas shows; perform energetic holiday shows for families at Radio City Music Hall; do TV commercials for Leggs pantyhose; and appear on old TV reruns as the June Taylor dancers with Jackie Gleason.

As the story is told by John Lahr, the Rockettes were the U.S. version of England's Tiller Girls. They first performed in St. Louis in 1925 as the Missouri Rockets: "Sixteen dancers were strung out across the stage like beads on a necklace: thirty-two hands, thirty-two legs moving as one."[33] This sounds remarkably like Berkeley, as quoted by Fischer: "My sixteen regular girls were sitting on the side waiting; so after I picked the three girls I put them next to my special sixteen and they matched, just like pearls" (Fischer, 4). Russell Markert was the inventive, U.S. entrepreneur who "put the shortest dancers at the outside of the line and the tallest in the center to create the illusion of uniform size" (Lahr, 83). Installed in 1927 at the Roxy, the number of girls expanded to the thirty-two Roxiettes. When they moved to Radio City Music Hall they were renamed the Rockettes. Conformity was their forte; their "style was efficient, dehumanized, perfect, the last vestige of Twenties Bauhaus design in human form" (Lahr, 83).

The key was group discipline and submission. The worst thing a Rockette could do was "kick out," literally "step out of line." "If any girl got wide in the hips or thigh, I'd have the costume department measure her size. . . . I'd tell her to reduce back to her original Rockette measurements" (Lahr, 83). Rockettes were not allowed to tan and were of the same color, white. Markert was the coach until he retired in 1971; the dance, with the trademark kick that still elicits applause, is the same, as is their rigid, upright posture and style of movement. They don't bump or wriggle (Lahr, 83). Berkeley's "girls" did not need to dance: "I never cared whether a girl knew her right foot from her left so long as she was beautiful" (Fischer, 6).

Interestingly enough, the analyses of various dance-line daddies are almost identical fantasies of power over women; their commentaries are as uniform as the precision female lines they order. A 1940 interview with Earl Carroll, remembering his "Vanities," could have been spoken by Markert or Berkeley (quoted in Fischer's opening epigram: "I love beautiful girls and I love to gather and show many beautiful girls with regular features and well-made bodies"):

> I soon realized that the most exciting thing one could put on a stage was a breathtakingly beautiful girl. She did not need to know how to dance or even sing . . . there were no talent requirements. . . . They are assembled on the stage and then segregated according to height. Then in lines

of twenty, they step forward, count off, make quarter turns and face forward. . . . The following points of beauty are given careful consideration: color and texture of hair, brilliancy and size of eyes, regularity of teeth, general coloring, texture of skin, formation of hands and feet, posture and personality. . . . There are times (and this was particularly true during the war) when it was necessary to engage girls who do not have all the necessary qualifications. We replace them when it is possible.[34]

Carroll details an inch-by-inch ideal: a six-inch wrist, a twelve-inch neck, a nineteen-and-a-half-inch thigh, and a nine-inch ankle. He was also, in his way, a cultural historian: "Turnover is much greater than it used to be; those with talent go on to the films and those less gifted soon settle down into a quiet matrimony." As in the films, women have two choices: show-girl or wife and mother.

There is something truly perverse about creating beauty through precision control that abstracts women's bodies. I am reminded of Freud's remarks on beauty derived from vision, stated just prior to his discussion of scopophilia (the sexual pleasure of sight), and the relation between scopophilia with its active/passive components and Foucault's model of the panopticon with the see/seen dyad:

> The progressive concealment of the body . . . keeps sexual curiosity awake. This curiosity seeks to complete the sexual object by revealing its hidden parts. [Think of the midget raising the curtain on the striptease in "Pettin' in the Park," the peeking intercuts of women dressing, changing costumes, backstage or in their apartments.] It can, however, be diverted (sublimated) in the direction of art, if its interest can be shifted away from the genitals on to the shape of the body as a whole" (Freud, 156).

This perfectly describes *Gold Digger's* structure.

Men transform female sex into art as an excuse, a cover-up for male desire. The film shifts from an emphasis on the women's genitals, the strategic coin placements of "We're in the Money," to the abstract shape of the female body as a neon violin, collectively bowed in "Shadow Waltz." The process of the film legitimizes, as art, a sublimation, making respectable what was illegal, uncivilized (at least for Freud and Berkeley)—women, female sexuality. Berkeley verges on real perversion, which, in history, has turned to parody in its excess. Now this film is just an example of the kind of movies "they" used to make.

Foucault's concepts of the surveyed, docile, disciplined body in *Discipline and Punish: The Birth of the Prison* are perfectly apt. He outlines tactics for subjecting bodies, taking his model from the military and pedagogy: "The individual body becomes an element that may be placed,

moved . . . a fragment of mobile space . . . in order to obtain an efficient machine. . . . The body is constituted as a part of a multi-segmentary machine . . . [which] requires a precise system of command."[35] The contemporary version of precision dancing is aerobics, now step aerobics, with its emphasis on taut, exercised buttocks rather than breasts.

The conventions of the classical text also function via the disciplinary techniques of repetition and difference. Moving inevitably to resolution through an intricate balancing of symmetry and asymmetry by constant repetitions and rhymings on the sound and image tracks, classical narrative meticulously follows the disciplined rules of its game. The spectatorial play of these shared conventions provides pleasure: relays of anticipations and delays alternately create expectations and provide gratification for the audience.

Rhyming and repetition within *Gold Diggers*, as in many classical texts, is intricate. For example, Barney closes his office door "before the acrobats and midgets" arrive, which rhymes with the real midget of the "Pettin' in the Park" sequence. I have already mentioned the character of Gigolo Eddy and his guitar case containing booze; he appears in Barney's office while they await Brad's fifteen-thousand-dollar check. He is seen backstage rubbing alcohol on the "aging juvenile's" back. His guitar case is replicated by the Kentucky Hillbillies and is transformed into the neon image of women as violins. (The violin symbol is taken from vaudeville to the legit stage, from a lowly image to a lofty image.) In "Shadow Waltz," Polly wears a blond wig, resembling Carol; backstage we briefly glimpse her holding her blond wig. Through repetition with a difference, the work of the film is done for and with us. Like aerobics, repetition and careful instruction are as essential as the move toward closure and conclusion. From the very beginning, we await the pleasure of the end.

The narrative of musical comedy coincides with classical narrative.[36] In fact, musicals depict a literal version of "family romance," a theme often embedded within another story in other genres. Musicals virtually reenact the ritual of re-creation/procreation of privileged heterosexual couples. As in classical narratives, the work of musicals is the containment of potentially disruptive female sexuality, a threat to the sanctity of marriage and the family. However, musicals, and particularly Berkeley sequences, are set apart from other genres by the coded presence of spectacles, enclosed units within the larger narrative, set off by a system of visual and aural brackets. These spectacles mirror the narrative, have beginnings and endings, and presumably might rupture the filmic illusion of reality and halt the forward movement of the story.

First and foremost, spectacles are bracketed by complete musical scores. Thus it is significant that "We're in the Money" is not completed; it

remains an interrupted spectacle. Music is a foregrounded code that symmetrically reoccurs as functional scoring in the narrative segments and under titles, thereby either anticipating or recalling the spectacle. "We're in the Money" occurs under the opening titles, then in the Fay Fortune spectacle; is played slowly during the "no jobs" montage, just prior to the decision to take the boys for an expensive ride; and is last heard when the orchestra plays it in the fancy nightclub. "Shadow Waltz" first emerges through the cute, cloying window when Brad plays it on the piano for Polly (the fun couple), resurfaces as a motif when they speak through the backstage door during the interruption of "Pettin' the Park" and then at the speakeasy, and later plays at the nightclub in a medley following "We're in the Money" and finally in the "Shadow Waltz" spectacle.

"I've Got to Sing a Torch Song" is played under titles; then Brad sings it in the apartment for Barney and the girls, and Trixie sings it in the bathtub before the first entrance of J. Lawrence and Fanuel Peabody. The melody is next heard on the balcony while J. Lawrence and Polly discuss her past and then in the apartment during the kissing sequences between Carol and J. Lawrence. Reportedly, this was another production number for Ginger Rogers (as Fay Fortune), just beginning her climb to stardom and top billing, here seventh in the credits. It was subsequently cut from the released version. It is the only song that does not have its own spectacle.

Brad first plays "Remember My Forgotten Man"; the song is repeated through the window and heard backstage when Brad is reluctantly assuming his place in the show, as well as at the end in its own spectacle. It is obviously a key thematic song, but more importantly, it is a stammer, a stutter; the film cannot end until Brad writes the lyrics. The conclusion, as in all good classical films, works via delay, with the end reiterating the beginning, circling back and tying up all the loose ends.

Remember the apartment scene with Barney and the girls. Brad Roberts says, "I've got something about a forgotten man, but I don't have the words to it yet. . . . I got the idea for it last night. I was down at Time's Square, watching those men in the breadlines, standing there in the rain waiting for coffee and doughnuts, men out of a job, around the soup kitchen." In one of my favorite moments of cinema Barney says, "That's it! That's it! That's what the show is about, the Depression, men marching, marching in the rain, doughnuts, men marching, jobs, jobs! In the background, Carol, the spirit of the Depression, a blues song, no, not a blues song, but a wailing, a wailing! And this gorgeous woman singing a song that will tear their hearts out. The big parade, the big parade of tears! That's it! That's it! Work on it! Work on it!" When Brad writes the lyrics, the film can end. The end of this number shows us what is denied in the lyrics of "We're in the Money": "We've never seen a breadline, a breadline today."

Singing and dancing are the usual performance modes but not a necessary component of the genre. After all, Berkeley's girls neither danced nor sang—they smiled, walked, existed. Because music is the dominant code, the performer could sing, dance, skate, swim, tumble, or have sex to its rhythms. (Pornographic films resemble the musical's relation between spectacle and narrative, a point that Linda Williams develops.) Editing, camera work, and stupendous mise-en-scènes did the rest. Hence the term *musical comedy:* when the music concludes, so does the spectacle—and the movie.

The opening and closing musical notes are re-marked by another system of mirrored, bracketing shots. Identical shots of theater stages, curtains rising, orchestras and conductors, and on-screen audiences open and close the spectacles. This theatrical iconography refers both to the origins of the genre and to the spectator in the movie theater (which often contained a proscenium stage with an insert screen). The erotic messages of the spectacles, however subdued by Hollywood convention and regulation, are celebrations of body, voice, and cinema, intensified by the interaction and duplication of visual and aural codes. Mise-en-scène, camera movement, editing, and sound rhythmically and vertically re-mark one another with a high degree of redundancy.

These bracketed and rhythmically marked spectacles, set in and apart from the overall movement of the narrative, make explicit and even exhibit certain operations that other genres work to suppress. The spectator is clearly alerted to filmic illusion, as well as to the spectator's own immobility in the dark movie theater. Spectacles can be considered as excessively pleasurable moments in musicals; ironically, the moments of greatest fantasy coincide with maximum spectator alertness. These breaks displace the temporal advance of the narrative, providing immediate, regular doses of narcissistic gratification, satiating the spectator with several "ends."

However, spectacles are ultimately contained (like the interruption of the sheriff) by the process Stephen Heath has called "narrativisation." Spectacles mirror rather than rupture, at once anticipating and delaying the resolution of the narrative. They thus function as a striptease—a metaphor that is apt for the *Gold Diggers*. (Coitus interruptus is another.) "Pettin' in the Park" is a striptease, as are the many shots of women (un)dressing. Fay Fortune is stripped of her dress, to be used as a lure for Barney: "Remember to stand in the light, Carol." Carol and Trixie strip J. Lawrence and put him to bed.

In a sense, the film is foreplay for the end, the Broadway show, with interruption narratively enacted: first the interruption of "We're in the Money"; then the delay of "Pettin'" while Brad, threatened with the re-

sponsibility for creating prostitutes, decides to enter the spectacle; the "intermission," with a shot of the playbill at the end of "Pettin'"; then the postponement of "Remember My Forgotten Man" while the marital crisis is resolved backstage. Fay continually breaks into the narrative and is kicked out by Trixie—in the apartment with the girls, in the apartment scene with Barney, in the speakeasy, and finally in the nightclub. Like her missing production number, she is a loose end, a real gold digger (and a source of female envy and competition) who threatens to unbalance the film's symmetry.

A triple seduction outlines the filmic body: of on-screen couples, of the dating couples in the audience, and of the critic by the film. Cinema traces "around bodies and sexes not boundaries not to be crossed, but perpetual spirals of pleasure" (Foucault, *History of Sexuality*, 45). These "spirals of pleasure" include film's very materials, textured figures of light and sound. Next are figurations of the human body, seduced and captured by the narrative's move to closure—the implied consummation of the couple in the brief seconds before "The End."

The dating ritual of going to the movies, cinema's second seduction, tactilely and tacitly conducted in the anonymous, discreet dark of the movie theater, replays the film's foreplay. Darkness is not only the essential condition of the film's visibility, but for Roland Barthes, "it is also the color of a very diffuse eroticism," and the movie theater "a place of disponibility, with the idleness of bodies that best characterizes modern eroticism."[37] Barthes further describes the movie theater as "urban darkness, a cinematographic cocoon" in which "the body's freedom luxuriates." He then extends the sexual (or sleep/dream) metaphor of moviegoing: "How many spectators slip into their seat as they slip into bed, coat and feet on the seat in front of them?" (3).

The actual conditions of film exhibition portray, as I tried to show in my initial remarks, a historical rather than timeless audience, one that includes women. Going to the movies used to include live performances, prologues, orchestras. Bank nights and other giveaways (the various movies' versions of radio and late TV game shows) were instituted during the Depression, along with double and triple features. The performances included a genre mixture of cartoons, news, travelogues, shorts, and features. In the 1930s the introduction of food and drink, particularly popcorn, as well as the pleasures of air conditioning and plush decor, added to the experience. First-run theaters had an intense darkness (before recent fire codes) that required ushers, garbed in pseudomilitary uniforms and carrying flashlights, to guide us to our seats. Sumptuous movie palaces had lavish "ladies rooms" and lounges. Women went to the movies not (consciously) for punishment, not to identify with men, and not just

for a single narrative but for multiple pleasures, including the luxuries of the upper class.

However, cinema's pleasure contract is negotiated prior to the movie theater. It is the result of recycled fictions, familiar conventions, activated and differentiated by advertising, gossip, the star system, and facial fashion. For the feature film, the contract has one condition: the film must narratively "make it" for us, producing a satisfying resolution, a sense of closure that ties up all the enigmas—until the next time, the next movie.

To prolong this pleasure, classical narrative's absence of sexual intercourse was replaced for film theorists with terms of sexual discourse— thereby perpetuating the narrative/marital contract. This is cinema's last seduction—of the theorist by the rhymed, obsessive perfection of Hollywood's continuity style. As the bodies make it, we make it. The film bodies, at least for a few moments, "live happily every after." Fade. The End.

Romantic Delusions

Recently romance became legit, i.e. considered a man's job, when scientists, not courtiers or sad poets, discovered it.[38] The emergence of women scientists is cited as one reason that "the amount of research expended on the tender passion has never been more intense" (*Time*, 41). In 1993 romance headlined the NBC Nightly News, the *Wall Street Journal*, and a *Time* cover.[39] Advancing the idea that romance "is bred into our biology" (as it appears significant in 147 of the 166 cultures studied), scientists are overturning the "love-as-cultural-delusions argument" (*Time*, 48), along with the hypothesis that its origins lie in recent Western thought.

Lovers in most cultures are "literally flooded by chemicals" (dopamine, neoneprine) causing euphoria, a "natural high," which, alas, doesn't last forever. Romantic love is short-lived. As with any amphetamine (or addiction), the body builds up a tolerance to (and a need for) the drug. Thus it takes more of the substance to produce love's special kick. "After two to three years, the body simply can't crank up the needed amount of PEA. . . . Fizzling chemicals spell the end of delirious passion." This is particularly true of "attraction junkies," who crave the "intoxication of falling in love so much that they move frantically from affair to affair as soon as one infatuation fades" (50).

The "heated infatuation of PEA" is very different from endorphin-prolonged attachments. Lasting love, explained by "a daily hit of narcotics," is produced by "soothing endorphins, natural pain-killers which give a sense of security, peace, and calm."[40] *Time*'s conclusion that we have a "love map," a record of our ideal mate "imprinted in our brain," supports another Hollywood convention, love at first sight (51).

JACQUES LACAN MEETS
BARBARA CARTLAND

Men in film theory have also rediscovered romance—vis-a-vis Lacanian theory verging on biology. Although he reiterates but does not mention "Made in the Fade," David Shumway in contrast to my argument of pervasiveness sees romance as a *genre* of Hollywood cinema, the screwball comedy that continues to fascinate male more than female critics.[41] His analysis depends on a paraphrase of Juliet Mitchell: "Romance seeks an idealized object, and when that object is attained, love ceases to be romantic." Thus "romance must occur outside of marriage, and marriage must be the end of the movie" (11). For Shumway, the central paradox of screwball comedies is also the double whammy of Lacanian desire: marriage can satisfy desire and is also the death of desire. This desire belongs to men. "The submission of women is required for the romance to be consummated" (15).

In 1992, Robert Lapsley and Michael Westlake commandeered the Lacanian notion of lack and absence,[42] turning it into "romantic love," which, for Lacan, can never be fulfilled.[43] For Lapsley and Westlake, lack is taken literally to mean no sex; abstinence becomes no "sexual rapport."[44] "We" (men) make good the "lack" through romance (46). Male characters have several cinematic options for responding to lack. The first is narcissism, the Arnold Schwarzenegger maneuver of self-sufficiency. The next is violence toward either a villain or a woman who can be beaten or killed, as in *True Romance* (Quentin Tarentino/Tony Scott, 1993). The third, like the first two, comes from Freud's fetish and then Lacan through Mulvey in 1975: "idealized" figures who mask lack—for example, Kim Novak in *Vertigo* (36). In the third scenario, women have to perform for men (as masquerade or simulation), pretending they are something they are not. Thus male fantasy "uses women as a metaphor for what does not exist" (46).

(Hmmmmm. I must interrupt their line of reasoning. The meaning of "what does not exist" is unclear to me. Is it sex? Love? Real women? Or something historically unseen? Perhaps I, too, should take Lacan biologically and speak of penises, not phalluses. What are women pretending? What are they "simulating"? If it is orgasm or pleasure, as in *When Harry Met Sally* [1989], perhaps "lack" applies to men. Perhaps "lack" is a male fear blamed on women. To compensate for men's fear of inadequacy, of impotence, of small penises, women cover up lack with romance. This serves men's pretense that they are big heroes, or just big—maybe *Big* [1988]. Women, then, make men more than they are. In turn, men attribute lack to women, making them less than they are. Where is the logic of that?)

The authors have taken over the 1970s feminist critique (particularly Mulvey's, almost verbatim)[45] and transferred it to "romance."[46] Strangely, in this analysis, men experience little pleasure in romance, unlike women. This startling conclusion is the opposite of that of feminist film theory, which grants at least visual pleasure to men. (Perhaps Dorothy Hewett's distinction between men's obsession with sex and women's with romance and sex explains the difference.) Comparable to "Made in the Fade," they assert that the resolution, which can only be sex, "is deferred to an imaginary time outside the text," setting the sexual relations "in the text's future" (43). They conclude that women are nothing and everything, thereby restating the very contradiction uncovered by feminist film theory. This grand-scale appropriation without citation of women's work is a cautionary reminder that 1970s feminist film theory did focus on male subjectivity, seeing women through men's desire.[47] Now all that is left of this brilliant work is male desire.

After dismissing men's pleasure, Lapsley and Westlake unwittingly reiterate Freud, wondering, "What do women get out of it?" (47). Good (but very old) question, indeed. Their answer, drawn from Janice Radway and particularly Tania Modleski[48] is the *pleasure*(!) of contradiction—romance "simultaneously challenges and reaffirms traditional values" (48). As if women had a choice. As if women enjoyed being pulled in opposite directions.[49] Romance is a fiction that keeps women captive. Romance is a genre, theme, and story primarily defined by male desire—unless, of course, it's *Forbidden Love* (Aerlyn Weissman/Lynn Fernie, Canada, 1992), which I will discuss later.

Tarentino Romances: *True Romance, Reservoir Dogs, Pulp Fiction*

True Romance, a 1993 film written by Quentin Tarentino and directed by Tony Scott, is a lusty romance for men and a masochistic answer to the question of male pleasure. In the film's prologue, we first hear the loud rockabilly sounds of Elvis. Cut to Clarence (Christian Slater) in a smoky, seedy bar, mumbling like Elvis to a blonde prostitute: "Rock 'n' roll, livin' fast, dyin' young, and leavin' a good lookin' corpse. I watched that hillbilly and I wanted to be him so bad. . . . Elvis was prettier than most women." Clarence would have "fucked Elvis." Elvis (Val Kilmer) appears to Clarence whenever he looks in the mirror in bathrooms. (For this film and *Pulp Fiction* [1994], the bathroom is a place of male introspection, of moral philosophy.)

Romance for men is narcissism, love of men, not desire for women. The film is filled with long, eccentric, violent cameos by film actors with reputations for explosive, perverse characters: Gary Oldham, Christopher

Walken, Dennis Hopper, and Brad Pitt. Kilmer as Elvis advises Slater in bathrooms, Oldham inflicts pain on Slater (and vice versa), Walken tortures Hopper (who plays Slater's father)—true romance as brutal sadomasochism.

It is a high-style film. The surface is glossy, the underbelly is seedy. Over the image of Detroit, stark black-and-white night turns to gray day, with shots of homeless men standing around a fire. Caribbean music, the sound of marimbas, is incongruously on the soundtrack. A female voice-over (Patricia Arquette) speaks with old-fashioned naïveté: "I had to come all the way from the highways and byways of Florida to Detroit to find true love. I never would have guessed that true romance and Detroit would ever go together."

Cut to Clarence in a movie theater watching a Kung Fu triple feature. Alabama (Arquette) spills her popcorn on him; later that night they have sex, confess, then profess true love. That Alabama was a prostitute (it was only for four days) only makes Clarence love her more. (Fortunately, she still dresses in the same skimpy way.) They get married the same day. But she is a just a beard, a cover-up, concealing the film's true love. Sexy women enable men's denial or repudiation of homoeroticism.

The rest of the film, its action, mise-en-scène, and editing, reenacts the stylized choreography of Hong Kong movies. A series of violent scenes begins when Clarence slaughters Alabama's pimp (Oldham, in an unbelievably gruesome scene) and takes by mistake a suitcase full of uncut cocaine that belongs to a mob boss. The couple leaves for Hollywood, pursued by the mob and later the law. Along the way they encounter a drug-dealing Hollywood producer and two nebbish male actors, both wimps. (So much for the pathetic masculinity of the film industry!) The romantic couple miraculously survives the gory spectacles, dances of brutal death (particularly the beating of Alabama), that punctuate the chase. Male violence in the series of brutal fight scenes is choreographed (tribal) ritual. Everyone is dead except the bloody couple, on their way to Cancun with a suitcase full of drug money, and a stoned, brain-fried hippie (Brad Pitt in a druggy cameo).

The film's last scene echoes and reverses the opening. The "once upon a time" of the opening has led to living "happily ever after." We again hear the sounds of the marimba. The couple is on a beach, flanked by blue sea and golden light. Alabama is watching Clarence play on the shore with a little sun-drenched boy. Her voice over says: "I look back and I'm amazed. . . . I was so clear-headed. . . . All I kept saying was 'You're so cool' . . . I named our son Elvis." Cut to the family of three, walking on the beach. The last shot is a huge setting sun. Marimba music increases. Romance and the couple frame this film, act as motivation, and serve the narrative—which

is really about men's romance with tough men, set up in the opening bar scene about Elvis. For men, romance is sex and violence, the real turn-on.

The masochistic rituals of romance are bound up with a male code of honor that was illustrated in *Reservoir Dogs*, a 1992 film written and directed by Tarentino. After a bungled robbery, two gunmen flee; one is shot. During their car escape they talk and bond, revealing a secret—a personal name. For the rest of the film the wounded man lies on a warehouse floor, bleeding to death (in an ever-expanding pool of blood, the oozing mark of the passage of time and almost unbearable suspense) and talking, while the other (Harvey Keitel) protects him to the death. The film is all about waiting, about narrative time, about talking—hearing, auditory pleasure. Bits of the story are told in flashback. A captured policeman loses an ear in a torturous scene that revises the opening eye slash of Luis Buñuel and Salvador Dali in *Un Chien Andalou* (France, 1928), through Roman Polanski (*Chinatown*'s nose [1974]) and David Lynch (*Blue Velvet*'s opening ear [1986]).

After the revelation in the end that the guy slowly bleeding to death is an agent, an informer, everyone kills everyone else; everyone is true to the code of honor, and everyone is dead. All of this male honor is funneled through Tarentino's technical flourishes of long takes, exceptional framings, and shots in depth, along with temporal reversals—what J. Hoberman calls "looping back"[50]—and a machine-gun flow of incessant words, eclectic topics.

Tarentino's smart style, so indebted to Jean-Luc Godard and, indeed, film's history of tough male directors *and* actors, is fascinating, captivating. Hoberman says that Tarentino has a "gift for abruptly raising the stakes." Anything can happen while we look at his technique, a tactic like the shell game or the magician's sleeve. Words tell us one thing, actions another. The words lull and soothe us with normalcy, while the actions are those of deeply disturbed men. Just an average day in the life of a working (and working-class) psychopath.

Style itself has taken on all the obsessive, perverse power of the fetish, which works through disavowal. Tarentino's fetish is cinema history—that of a film buff or collector. His technique's brilliance and obsessive intensity enable us to deny the barbarous actions, the brutal language, the vacuousness of values and any vestiges of humanity. The highly intellectual *and* affective surface tension of both sound and image covers up emptiness of the spirit. Postmodern Style justifies watching brutal acts, accompanied by a rapid-fire, pop-psychology verbal track. *Fetishism*, a term feminists, including myself, casually toss off to describe going to the movies, is taken to its real violent effects, its deathly conclusion, by Tarentino. It's not the fetishist's *pleasure* but the *perversity* that is so attractive.

For me, the horror of Tarentino's films comes much later than the aesthetic shock of watching and listening. The horror comes from the emptiness at the core of all his characters' lives—covered up by the extraordinary performances he elicits from his actors. It makes sense that David Letterman extolled Tarentino's next film; Dave's jokes and riffs are the same, all surface, all style, with no core, no content, no good reason—which is what makes them so hip, slick, and cool. The technique is not merely an envelope for the content; it is everything. But I'm not surprised that at the core of a Godardian existentialism, at least for women, is nihilism.

Tarentino also wrote and directed *Pulp Fiction* (1994), a celebration of sado-masculinism and -masochism, love and honor between men. Two thirds of *Pulp Fiction* are about an affectionately bickering couple—Vincent Vega (John Travolta) and Jules (Samuel Jackson), two hit men who have worked together for a long time. At any moment their everyday routine of work (killing) can be interrupted by offhand violence, in close-up, in unusual angles. Cameos by Tarentino's regulars—Harvey Keitel and Christopher Walken playing father figures—along with a starring role by Bruce Willis as a boxer on the run with his "foreign" girlfriend, create a collage of masculinity with inflections of male characters in European art-house films. (Female characters are direct copies of "art film" women.) Tarentino includes himself among this Euro-macho film company, appearing in a small but unsettling role of a homeowner who worries about the bloody car and body now in his garage and the return of his wife. But despite being a henpecked husband, his white character bosses Jackson/Jules, the black man, around.

Tarentino figures masculinity in *Pulp Fiction* as high lowbrow style. Male toughness and bonding are made arty (1) by having more than one central star; (2) by telling the story from multiple points of view that intersect; (3) by derailing chronology (beginning the film with a coffee-shop prologue that will become the scene of the third and concluding story; killing off a major character, Travolta, who returns in the final scene, thus not concluding the film with the last temporal action); (4) by further segmenting the film with long fades to black, then holding on the black surface of the screen while the dialogue continues; and (5) by filming conversations about morality and philosophy in long duration.

Fast, overlapping talk is as central to Tarentino's films as it was to Godard's films in the 1960s but is speeded up with a touch of rap and pop psychology. And it is a particular kind of talk, one that mixes up serious conversations with street toughness—an articulate inarticulateness. For example, in the opening riff in the car, on their way to a killing, Vincent tells Jules about being able to drink beer in Amsterdam movie theaters and

about McDonald's in Europe. They mention TV, which Jackson/Jules doesn't watch, and discuss "pilots." Once inside the building, they debate whether "it's right to kill someone for a foot massage," discussing the original fetish and the finer points of morality, mixed in with quotes from the Bible and burger remarks. Later on, Vincent talks to himself in the bathroom about being with the boss's girl, seeing his dating assignment as "a moral test."

With Godard we saw this verbal and visual eclecticism as pastiche, mixing up art with popular culture, the vernacular with the violent—as identified by Peter Wollen's linkage of Godard to William Burroughs's drugged collage style.[51] I suspect that the drug culture more than intellectual culture, Burroughs more than Godard, and TV more than film have influenced Tarentino's frenetic, fragmented pace. With Godard we saw this style as postmodern, filled with references—to Hollywood movies, to Vietnam, to TV, to the history of art. In *Pulp Fiction*, the presence of African art and surveillance cameras in Mia's (Uma Thurman's character, Marcellus's wife) apartment might reference Michel Foucault and modern art, but I doubt it. Tarentino is true to the spirit of Godard, but without the latter's intellectual bent and political questions.[52]

For example, much as Godard's dropouts and petty criminals debated philosophy, particularly existentialism, Jackson's character, Jules, has a spiritual rebirth. In the film's last scene, Jules discusses his miracle: in an earlier killing, returned bullets had miraculously missed them both, a part of the scene we see later. (Tarentino breaks up the cause–effect links of the continuity style, rearranging chronology yet holding onto the feeling of continuity.) "I felt the touch of God. God got involved." He decides to be like *Kung Fu* and walk the earth." This is Christian revivalism, inflected by New Age religion and the U.S. television series *Kung Fu*. Meanwhile, the film enacts the opposite: Jules's partner, Vincent, *is* killed the next time, just as unexpectedly, as he comes out of the bathroom.

Hoberman sees 1970s action movies as precursors of *Pulp Fiction*—blaxploitation, vigilante sagas like *Dirty Harry* (1971), violent movies "steeped in moral confusion." To these precursors I would add the stylistic techniques of art cinema and series TV, an elision of Robert Bresson with Steven Bochco. Television awaits the unexpected interruption of death and disaster and then predictably cuts to a burger commercial. It is a medium of incessant and banal talk, derailed chronology, and mixed genres, including movies on TV. It has made pastiche an everyday style. Thus the *Pulp Fiction* scene in the restaurant of 1950s impersonators (Buddy Holly, Ed Sullivan, Martin and Lewis, Ricky Nelson, Marilyn Monroe, and Mamie Van Doren) is an ode to, not a critique of, TV culture and the 1950s. With Douglas Sirk steak, along with Durwood Kirby Burgers,

shakes and Cokes, and Vinnie Barbarino doing the twist, it's *Happy Days* with a difference: all this nostalgia is made thrilling by cocaine scenes.

While talk is a steady horizontal stream, akin to a drug high (not a stream of consciousness), acts of brutality vertically intersect and momentarily interrupt the flow, like Burroughs's cut-up, fragmented style. These moments of horrific shock include the killing of the young men in the apartment, the drug overdose and the needle plunged into the woman's heart, the homosexual rape scene in the basement, the accidental shooting in the backseat of the car. We are attacked by technique in shots, cuts, and sounds that come at us, blindsiding us. But at the same time these are everyday events, nothing out of the ordinary. Mixed in with these brutal scenes are depictions of the mechanics of crime work and the codes of tough-guy honor. Harvey Keitel makes a cameo turn as the efficient, professional cleanup man for the bloody, botched, accidental car shooting, treating the hit men like high school boys after a senior prank, dressing them like dorks, geeks.

As I said, the film is a love story—of the unspoken bond between Jules and Vincent. When they are cleaning up the blood-splattered car, they fight like a couple that has been together too long. Their bickering is the sign of their closeness. These are the scenes that most reviewers have remembered. But in the middle of the film is a heterosexual love story, a literal reprise of Oedipus, and a tale directly tied to Vincent's story.

After Vincent takes Mia back to her apartment, the film fades, to open again on a cartoon. Butch, a young boy, is watching TV. A soldier (Christopher Walken) who was a prisoner in Vietnam with his dead father is bringing him his father's watch. After close-ups of the watch, which his father "hid in his ass," the now-grown Butch, Bruce Willis, wakes from this dream. Next comes the intertitle, "The Gold Watch." This story is *Pulp Fiction's True Romance* (or *They Drive by Night* [Warner Brothers, 1938]), a tale of the couple on the lam with the money. They make love, talk about Bora Bora and Tahiti, ride on a motorcycle, until Butch discovers that she didn't pack the watch! On his Oedipal mission he returns to the apartment, with subjective tracking shots through fields and close-ups of doorknob, key, and his face, to retrieve his father's watch. When he stops to make a pop-tart in the toaster, Vincent comes out of the bathroom with a gun. Butch kills him. The proper love story censors the improper story.

However, as if the homophobia/ -philia were not yet clear enough, Butch then runs into Marcellus while driving away. They are both captured and then locked into a basement torture chamber right out of Sade, replete with a chained, hooded, black-leather figure. Butch/Bruce Willis escapes from his S/M gay torturers, only to return wielding a samurai sword(!) to rescue his worst and black antagonist, Marcellus, from a ho-

mosexual rape. Butch saves Marcellus from rape, they understand each other, and Butch gets the girl and, presumably, lives happily ever after. (The watch "hidden in his father's ass" echoes the homosexual rape.) Unlike Vincent, Butch has made it through the Oedipus complex. Heterosexuality has blown away real and suggested homosexuality.

By mixing up genres, derailing chronology, talking, and including homosexuality, Tarentino has updated Oedipus for the 1990s, reducing women to bit players in the triangle. *Pulp Fiction* is filled with long close-ups of men's faces and scenes of long duration that hold on male actors acting. The postmodern riddle of the Sphinx is strictly man to man. Thus the film's brutal attack on African American men and homosexuality is the fetishist's disavowal. (Like the fetish, the film gets it both ways.) True love is Tarentino's for cinema as a history of masculinity, figured through film's formal qualities and narrative conventions. Cinema is an imaginary and historical place where male fantasies of power and honor and love for other men can be realized at a safe distance. This is voyeurism par excellence, where men watch men, where exhibitionist men are simultaneously objects and subjects of their own desire. In this world women are no longer necessary.

Vogue calls the film the "best written, best directed, and most enjoyably acted American movie this year." However, the review concludes with an equivocation: "He's easily the best filmmaker of his generation, but what does it say about American movies that *Pulp Fiction* sometimes appears to be made by the world's most brilliant teenager?"[53] The defining feature of U.S. culture in the 1990s is its takeover by male adolescence: on TV, Tim Allen, David Letterman, Beavis and Butthead, Jerry Seinfeld and company; in business, Bill Gates of Microsoft; and in film, Jeffrey Katzenberg and Stephen Spielberg, now of DreamWorks SKG, and Tim Burton. This neomasculinity—of the formerly unpopular but now powerful—is the real and economic revenge of the nerd, the dork, the geek, through the obsessiveness and style of the fan/buff/collector.

True Lies

All three scenarios of Lapsley and Westlake—narcissism, violence, idealization—figure in Tarentino's work. There, idealization concerns men, perhaps even more than women. All three tactics also are present and even compete in *True Lies*, James Cameron's 1994 film with Arnold Schwarzenegger. It is close to a Harlequin romance, with a key difference: the story is not from the woman's point of view. *She* becomes the sex object he always wanted, while *he* is Arnold, secret agent, with a good buddy, Tom Arnold. The two Arnolds spend much of the film together; Arnold's most intimate relationship is with the other Arnold, who, like a good wife, waits

around and does his bidding. Arnold even takes his verbal and physical aggression out on his comic sidekick, thus eliciting sympathy for the actor and the character.

At the same time, Arnold Schwarzenegger is a Harlequin's bored-wife fantasy—a dull computer salesman who in actuality is a hunky secret government agent, devoted to his wife, (Jamie Lee Curtis). Throughout the first half of the film, interspersed with the action/effects scenes, chases, explosions, and rescues, Arnold is miserable, jealously suspicious that his wife is having an affair. He confides in his partner, Tom Arnold. They stage a fake agency kidnapping and lock her in a room, eventually eliciting a confession of "true love" from her. (This also adds excitement to her dull wife-and-mother life.)

But the cross-examination is not enough punishment for her flirtation (with a used-car salesman impersonating a secret agent). Arnold and the film subject her to a humiliating striptease "for her country." He sits in the dark and watches, and we watch. Despite the comedy of the strip, her eagerness to please, her lack of knowledge and self-awareness, and the film's fragmented editing of her body made me feel her humiliation. The narrative says, "This is comedy, she's his wife!" But the scene was embarrassing—like the embarrassment one feels for the clueless brunt of a joke. Curtis remains clueless throughout. She plays the same anomaly in every film, a smart bimbo who tries too hard to be one of the guys. One thing is certain in all of Curtis's films: she will inevitably show us her worked-out body.

But this is a 1990s film. *True Lies* is framed by "family," unhappy in the beginning, happy in the end, reflected in mirroring dinner conversations: no talk in the beginning and exuberant talk, even games, in the end. The action genre unites husband and wife. In fact, Arnold rescues and saves his family. After almost crashing and burning in a speeding car, the bored, mousy wife becomes his partner in spy work. Mom becomes sexy, self-assured, and confident. And the obnoxious teenage daughter (who lies, steals, and is sullen), after her harrowing scene hanging from a skyscraper crane, then from the nose of a plane, high over the city, until rescued by Dad, becomes a nice person. Dad's job is no longer mysterious to his family, as is many men's work. Dad is a real hero. And so is Mom! This is the 1990s.

Like Lapsley and Westlake, Steve Neale finds contradiction central to what he calls the "new romance."[54] Drawing on *Big* (Twentieth Century Fox, 1988), Neale concludes that the "new romance" exposes "contradictions" fundamental to romantic comedy and also strives to "render them compatible with each other." The most important feature is the "endorsement" of "old-fashioned romance" (295), including the containment of

eccentricity in characters. The result is that the films counter any "'threat' [interesting term; what does women's freedom "threaten"?] of female independence," conscripting women into traditional roles in the end.

For Neale, *Big* (where Tom Hanks plays a twelve-year-old) is an example of the genre's infantilism (more precisely, the male character's perennial adolescence), the contradiction between childlike eccentricity and an adult relationship (299). *Big,* along with *Three Men and a Baby* (Touchstone/Silver Screen III, 1987) for Tania Modleski and its French progenitor, *Three Men and a Cradle* (Coline Serreau, 1985), for Lucy Fischer, points to women's lowly status in comedy. In fact, Modleski argues, as does Fischer, that women are missing.[55] For Fischer, "The figure of the mother is largely absent, suppressed, violated, or replaced."[56]

Groundhog Day

Groundhog Day (Harold Ramis, 1993) lends itself to contrary readings. The first, negative one, coincides with the above mentioned critics: the guy wants to get the woman into bed and keeps scheming until he does, which is just before the end of the film. To accomplish this mission, he will use every phony trick in the book of romance and sleaze. He will say and do anything and mean none of it. The second reading, a positive one, is that the film is about transformation.[57] The male cad, interested only in sex, becomes a loving human being who respects and cares for others. Manipulation is replaced by sincerity. Romance and false trappings are replaced by love and inner change. Perhaps this film illustrates Neale's arguments: new romances are "old-fashioned" and contradictory. But then again, so are "old romances."

Groundhog Day is seen from a TV weatherman's viewpoint. The blue skies (in the opening credits) of love songs are only blue screens for TV weather maps (before the second opening credits). This is the prologue, which begins with cloudy blue skies and segues into the TV studio, with the weatherman gesticulating in front of the blue screen. Phil Conners (Bill Murray) is a cynic, a real scumbag. Like Bill Murray's persona from *Saturday Night Live* and previous films with Ivan Reitman, Conners embodies mocking insincerity. He turns people into buffoonish objects and conscripts the audience into the joke. This character is not the clever innocent of Buster Keaton or the love-struck innocent of Charlie Chaplin. Neither is he the bumbler/philosopher of Woody Allen. He treats everyone with disdain and disrespect, particularly the residents of Punxsatawney, Pennsylvania, where he has been sent to record the annual Groundhog Day ceremony. Phil scorns others and mocks life, which he finds amusing but empty.

However, a blizzard keeps Phil, Rita (Andie McDowell), and Chris, his cameraman (Chris Elliot), in Punxsatawney. Phil wakes up the next morn-

ing to the same day. It is 5:59 A.M., passing to 6:00. Sonny and Cher are singing "I've Got You, Babe," and the morning radio anchors are cheerfully talking about the weather and Groundhog Day. The film repeats Phil's actions of the previous day, actually the previous sequence. Phil is first incredulous, then panicky; then he begins to take advantage of his foreknowledge. Thus the film initiates its general pattern: repetition with a comic difference. Like continuity style, the joke depends on our remembering the previous scenes. Cause–effect logic of Hollywood films becomes Phil's game, once he figures out what is happening.

In the first part of the film, he realizes he can do anything. There will be no consequences! He eats rich food without gaining weight. Phil asks big questions: "What if there is no tomorrow?" He wonders about déjà vu. Unlike the other characters, he has memory. And he is one step ahead of the film spectator, who also anticipates what's coming next. He has memorized each detail of his twenty-four-hour life—when every bird will sing, every dish will drop, every car will pass, along with names and histories of each passerby. Because he knows what will happen next, he can move through events quickly, anticipating them. By timing the movements of the guards, he robs a Brinks truck, unnoticed. He easily manipulates people by finding things out one day and then using the information the next—same—day. Thus he seduces Nancy Taylor by questioning her and then, when the day repeats, using what he knows. He pretends he went to high school with her. Anything that works, even telling her he loves her and wants to marry her, for sex—even this old scam.

He begins his conquest of Rita by using the ploys of romance to seduce her. Some work, such as quoting French poetry in French. But he is insincere. His actions might be different, but his heart is still the same. After almost succumbing, Rita senses his cynicism and slaps his face, which is repeated in shorter duration. Days, perhaps years or decades, pass with each abbreviated, intercut slap.

In the second section, Phil is morose. He knows all the right questions (which are answers) on TV's *Jeopardy,* but so what? He ups the ante, challenging death. He steals the groundhog and drives a truck off the edge of a ravine, plummeting to a fiery death. He commits suicide by electrocution, stepping in front of a truck, and jumping off a building. We see his corpse in the morgue. Yet the next morning, at 5:59, Sonny and Cher sing, it's Groundhog Day, and Phil wakes up. Phil is trapped in his life, trapped in the same old behavior, trapped in repetition and time—a deathly boredom where nothing important changes and nothing means anything.

After our glimpse of his corpse, there is a shift, a turning point. Phil is once again in the restaurant with Rita; he is developing some awareness. "I'm a god, not 'the' God, I'm immortal." He knows about everyone in the

restaurant and introduces Rita. "Maybe the real God has been around for so long he knows everything." He says to Rita: "I've never seen anyone who is nicer to people than you are." Rita treats everyone with respect. Earlier in the film, she had praised the townsfolk; he called them morons. Later that night she stays with him, with no sex. While she sleeps, he quietly professes his love for her.

But most important, he gives money to the ragged, old street person he had passed every morning. Later he tries repeatedly to save him, but the old man dies anyway, in spite of Phil's intervention. Death has given him a glimpse of something greater than his petty ego, and he begins to see people and his life differently. The purpose becomes to serve rather than to manipulate humanity. He takes coffee to his coworkers, begins piano lessons, and rescues a falling child and a choking husband. He becomes a small-town hero and the life of the party by playing the piano. He lives in the present and says, "I'm happy now, the rest doesn't matter."

In an inversion (usually women are made over for men), Phil transforms himself into what the woman, Rita, his producer, wants. She doesn't seek the falsity of romance. Her list of qualities in the ideal man includes humility, intelligence, humor, kindness, gentleness, love of animals and children, and the ability to play an instrument. Phil becomes a good person rather than the jerk he was.

Just as the story of romance has been told countless times at the movies, this film remakes itself, until Phil and the movie get it right. Although the film appears to advance, progress is slow. The form of the film is like repeated takes after flubbing a scene or analogous to continuity style itself, dependent on repetition with a difference and expectation. Each repeat is cleverly varied. (Repetition and expectation are also central to comedy, particularly comic characters.) In the middle of the film the character tries different endings, several suicides, knowing that the next day, at 6:00 A.M., the same day, Groundhog Day, will repeat itself, just like the weather. What is intriguing is that the character learns from his experience. He moves from crassness to manipulation to transformation, from cynicism to sincerity. Only then can the next day, a new day, come.

After being stuck in the same behavior, repeating the same actions, with always the same results, the film advances. The structure suggests the process of recovery—all of Phil's defensively rude qualities are peeled away until the being at the core of the character is uncovered. The end, sex, comes with love and transformation. The narcissistic male has turned his attention to the woman—"Is there anything I can do for you today?"— who, in many ways, has controlled the terms of his action.

More significantly, however, *Groundhog Day* values everyday kindness and respect as heroism. In the first scene with his former classmate, Ned

the nerd insurance salesman, Phil (and the audience) laughs at Ned; in the repeats, Phil mocks him and punches him. The audience laughs. In the conclusion, Phil buys insurance from Ned and shakes his hand. The same sweet transformation occurs in Phil's treatment of his landlady. First he (and we) laughs at her gullible banality; then, in tandem with Phil, we mock her behind her back. Near the end, Phil thanks her for her gracious hospitality. Small things such as greetings matter. If we change ourselves internally, we will change our world. No matter where we are—even in a small town in Pennsylvania—we will be content.

Forrest Gump

These qualities—with sensitivity minus intelligence, plus success as an athlete, soldier, and entrepreneur—all belong to *Forrest Gump* (Robert Zemekis, 1994). He represents old-fashioned virtues in their purest form: honesty, loyalty, tolerance, compassion, courage, discipline, generosity. This simpleminded man with an IQ of 75 (and a bad haircut, deliberate pronunciation, and awkward fashion) is also the outsider, shunned and taunted by the other kids. He steadfastly remains in love with the blonde, beautiful Jenny for the entire film, despite her many affairs and drug use (explained by a drunken father and sexual abuse). She gives him friendship and even sex in return. In the end, Jenny rewards him with his son who, unlike his Dad, is smart. Rather than ending up with the woman, he has a son, a smarter, normal version of himself. Forrest grows up to be the good father he never had. In fact, Forrest will be the perfect father. The new romantic hero might just be Dad, which shouldn't amaze 1970s feminists.

Jenny embodies the history of the counterculture—which is all negative. She wears hippie bad fashion, takes drugs, works as either a stripper or a waitress, accepts abuse from a radical activist, has sex with lots of men, goes off with strangers, and finally contracts a "virus." She is a liberated woman. (A feminist? Yikes!) Forrest, in contrast, plays sports in college (and meets the president), fights in Vietnam (and meets the president), and becomes first a corporate millionaire (through shrimp) and then an emblem of the fitness movement, featured on magazine covers. No matter what he does, he is successful, famous, and celebrated. Through it all he remains loving and loyal—particularly to his mother (Sally Field), but he is also kind and open with strangers he meets at bus stops. (Most of the film is in flashback, a story told while sitting at a bus stop. Forrest is waiting for the bus to take him to Jenny's apartment. In fact, Forrest is waiting for the end—when he will meet his son.)

Romance is a form and a content cutting across genre and decade in Hollywood movies. In *Forrest Gump*, history itself becomes the setting for romance. Popular culture, from fan to women's magazines and the novel,

reiterates these fictions, which become personal values and goals. There is, however, a significant difference between forms of romance, dependent on point of view. In this regard, *Groundhog Day* and *Forrest Gump* are truly old-fashioned: whether cynical or sweet, smart or not, the male is the hero of the fiction, controlling all the events, particularly life, death, and his own destiny—just like director-writer-producer Harold Ramis and director Robert Zemekis. We see everything, every person, from the male protagonist's omnipotent (but limited) point of view. Given that the business of making films (production, distribution, exhibition), particularly comedy, has been dominated by men (which is changing), Hollywood's romances are often from men's points of view, unlike romance novels and soap operas, less respectable forms, which are told from women's points of view.

The authors of the book *Romantic Love* describe romantic love as predictable, definite, with two "major components": "Love conquers all and one should marry for love."[58] Another study cited finds five "basic beliefs: love at first sight, one true love for each person, love conquers all, true love is perfect," and partners should be chosen for love, "not practical reasons" (61). That these are the narrative conventions, operative premises, of many Hollywood films is not surprising. Virtually all studies have "revealed that men were more romantic than women." And men make most of the movies.

But it's not as simple as this. As we know from feminist film theory, the gaze is bound up with desire. Thus the second (and for me, key) question after point of view, is "Whose desire matters?" Women also can see male desire, not women's, as definitive.

TURNING CONTRADICTIONS INTO OPTIONS

In "Representing Romance," Mimi White analyzes earlier films—*American Dreamer* (1984), *Desperately Seeking Susan* (1985), *Thief of Hearts* (1984), and *Romancing the Stone* (1984).[59] While she agrees that contemporary popular culture is indeed "an arena for expressing contradictory positions" (54), her conclusion is very different from that of many male critics, including Steve Neale and Frank Krutnik.[60] Unlike Charlotte Brunsdon's analysis of 1970s films, wherein ambiguity closed down women's choices through a neither-nor logic, White assesses that films of the 1980s offer a both-and logic. Thus romance *and* marriage become "satisfying choices for a female protagonist," able to remain independent no matter what option (43). Rather than being punished for being strong and assertive, as women often were in Hollywood films, or being forced to make sacrifices, "the new heroine is not forced to submit to restrictive choices" (45). If White is right, things might be looking up for women in comedy.

Punchline

Punchline (David Selzer, 1988) could be called a dark movie; in fact, the mise-en-scène is the style of film noir. But it multiplies the point of view. The star role is split between two stand-up comics, Leila (Sally Fields) and Steven Gold (Tom Hanks). Leila is a wife and mother, and Steven is a medical student who want to make it in stand-up. They meet at a downtown comedy club, where performers try out their acts. (Like *This Is My Life* [1992], zany comics are intercut throughout the film. In *This is My Life*, all the intercut bits are by white comics, as sitters. *Punchline* includes various club routines—by an African American, a Latino, a gay man cross-dressed, and an old vaudeville performer.)

Leila's middle-class family, her husband (John Goodman) and daughters, wants her to remain home as a wife and a mom. Steven's father, a doctor, wants medical school for his son, but he flunks out. Steven's struggle is an Oedipal one. He chooses stand-up and goes on to an appearance on the *Tonight Show*. Leila's choices are more complicated than those of Oedipus (which is, after all, an old story). She doesn't just choose one *or* the other. As she tells her formerly critical family, "I want to be a wife, a mom, and a comedienne." Why? Because "I love being able to make people laugh." While Steven only had to have one career, thereby making himself happy, Leila must choose three careers, making her entire family happy.

For these characters, romance and sex are secondary to comedy, which is the source of their respective identities and pleasure. In other words, their work, stand-up performance, matters more than their love lives. As Steven says to Leila, "I'll say anything to a woman and not mean it. I'll tell her I love her. I don't mess around with funny." Laughter (not sex), which is approval and identity, is the big emotional payoff, making even their sought-after stardom almost secondary.

Love and friendship are valued more than romance. Leila rejects Steven's proposal to run off with him. (Actually, she is too mature for him.) She remains happily with her family, her most important audience. It is their approval, their love, that matters. When Leila's husband is angry, he bellows at her departing figure, "This woman is *not* funny!"—the worst insult. In the film's last sequence, a stand-up contest for the late-night TV appearance, Leila's husband is in the audience, applauding, laughing. He has accepted and values her career, even suggesting material for her routine.

The Hanks character and performance add another dimension to the film—of comedy not as domestic love but as defense, aggression, potential failure and breakdown. (The film is not classified by video vendors under "Comedy," but under "Drama.") Anxiety, more than laughter, is produced by many of the routines (including Steven Gold's noir rendition of Gene

Kelly's "Singin' in the Rain" number). Reaction shots of the audience determine response. When the audience laughs, the circuit is complete and the act successful. When the onlookers don't laugh, anxiety is palpable, as failure. The mood of the film is unsettling. The mise-en-scène is dark, hazy; the streets glisten with rain at night. The set is a smoke-filled club downtown. In the opening scene, buying jokes is staged as buying drugs.

Like so many men in contemporary films, Steven is transformed by his friendship with Leila. He starts off as rude, obnoxious, brilliant but coldly calculating. Looking out only for himself, he pays no attention to anyone. After his onstage Oedipal crisis when he sees his father in the audience, he breaks down. Oedipus is not funny. Leila comes to his emotional rescue. Their romantic evening consists of him teaching Leila the ropes in comedy clubs: Steven feeds her lines, teaching her how to do stand-up. At the end of the film, he even helps an old comedian who is ill. Gold is still a wiseass, but a caring one, no longer a complete narcissist or cynic.

Leila, too, is transformed. Although she has the heart and values of a good mother, she initially lacks a sense of fashion and comedy. Her jokes and her clothes are out of style at first, tasteless, unsophisticated. She wears a plaid coat with a fuzzy fur collar and dark glasses. Her hair is dyed red, in honor of Lucille Ball. She tells bad Polish sex jokes that she bought from a joke dealer. With the middle- to upper-class Steven's tutelage, Leila becomes fashionable and funny, taking her comedy from her life (as will Dottie Engels in *This Is My Life*). In the last scene, her hair is short, its natural brown. She is real, a natural, wearing basic black, pearls, and no glasses. Leila is no longer a frumpy housewife but a poised comedienne who writes her own material.

By turning housewifery into stand-up comedy, she has brought wife, mother, and comedienne together. Or has she? The ending can be taken in different ways. Leila wins the contest but gives her TV spot on Johnny Carson to Steven in return for his expert teaching. Initially, this sacrifice of comedic fame irritated me. On second thought, it was a generous and ethical choice. After all, Leila tells us that she has plenty of time for fame, which, I have discovered, is indeed true.

Nora Ephron's Voices: *This Is My Life, Sleepless in Seattle, When Harry Met Sally*

In *This is My Life* (1992), the star is a mother, Dotty Engels (Julie Kavner), who has two young daughters: Erica, a teenager, and Opal, who is nine or ten. Along with being a good mother, Dotty wants to be a stand-up comic. And almost immediately we learn that father is absent, that his daughters don't even remember him. (Father is later revealed as an unfeeling jerk, irrelevant and uninteresting.) The screenplay, written by Nora and Debra

Ephron, is from a novel by Meg Wurlitzer. The film was produced by Linda Obst and directed by Nora Ephron, with music (very dominant) by Carly Simon. The voice of the film is collective—a women's production about a dialogue between mother and daughter.

The film splits the voice-over between the mother, Dotty, and the teenage daughter, Erica. "This is my life" is heard in Dotty's voice and then Erica's. After their move from Queens to an apartment in Manhattan, Dotty's voice-over says, "So that's how I started." Erica: "She went off to the comedy club." Dotty: "I went off to the comedy club." Mother, daughters, and sisters are interconnected throughout the film—by the doubling of the voice-over, by showing the same event from two viewpoints, and through the many telephone conversations. As Dotty says in one of her "life lessons" (which so irritate her daughters), "We're only two phone calls away from anyone in the world." But their viewpoints can be at odds, as when Dotty calls home from Los Angeles: "Steve Martin came backstage. . . . It's really happening." Erica, from Manhattan: "When are you coming home?"

The ultimate career goal, as in *Punchline*, is an appearance on the Johnny Carson show. The film's initial scenes of Dotty, the cosmetics salesperson, become material for her stand-up act. Her life—makeovers, the death of her aunt in Loehmann's dressing room, her experiences with her daughters in Queens—becomes the basis of her comedy. Dotty finds an agent and success, moving from nightclubs to TV talk shows, traveling to Los Angeles and the main stage of Las Vegas.

As Dotty's career takes off, she is away from home more and more. Her daughters watch her on television. When she is home, she is never alone with her daughters. They feel left out, frustrated: "She was completely revolting." Dotty asks, "Isn't this what we wanted? Don't I get a turn?" They have a door-slamming fight and the daughters run away to their long-absent father, who rejects them instead of rescuing them. Although all three females experience romance or sex—Dotty with her new manager (Arnold Moss/ Dan Ackroyd, the big reason for the trauma of the daughter's train trip to visit their father), Erica in her first sexual experience, and Opal in a crush on a sound technician—the greatest love is between mother and daughters.

After the daughters' miserable and funny trip to Dad's, the homecoming with mother in the train station is shot like the climactic love scene of a Hollywood melodrama. The three see each other, run, meet, and embrace. The camera circles the threesome in close-up. Carly Simon's song "You're the Love of My Life" wells up. Rapid editing of hugs, kisses. "I love you." "I'm sorry." The music crescendos. Group hug, fade out.

Fade in. The three are together in bed, as in the opening. Erica speaks

in voice-over: "So we made up." Dotty: "I lost my mind. I'm not going to be away so much. We'll work this out." They plan a TV sitcom about a "woman who works at the makeup counter in Queens." The happy ending is the mother–daughter ending.

While the film documents Dotty's rise to success, the story is shared with her daughters. The point of view remains more with the daughters in their New York apartment. The film is about relationships, about love, and is tied to audiences. The central audience for Dotty is her children. During Dotty's performances, first in clubs and then on TV, the film cuts to close-ups of them watching, laughing, loving their mother. During Dotty's try-out club performance, the daughter's voice-over is superimposed over Dotty's act: "I was so nervous. It was my mom, but it wasn't." The commentary about comedy and love, approval and support, is wonderful.

This Is My Life is schmaltzy, particularly with Simon's scoring.[61] But I loved it and empathized with the tug between children and work and children and dating, along with the pain of separation and the freedom of being away. Love, not romance, determined Dotty's choices. The mutual love and support between mother and daughters (and in my life, daughter and son) was so strong and so real I could feel it.

Ephron also wrote and directed *Sleepless in Seattle* (1993), with Linda Obst as the producer. This time the subtext is Hollywood film, the famous Twentieth Century Fox melodrama *An Affair to Remember* (with Deborah Kerr and Cary Grant).[62] Re-creations of this 1957 tearjerker, particularly the missed meeting of the couple on top of the Empire State Building, run throughout the film, even in the end. At first it emerges with Annie (Meg Ryan) and her friend, played by Rosie O'Donnell, watching the movie on TV, mouthing all the dialogue, sobbing. "Men never get this movie." Sob. Then it resurfaces through Sam's (Tom Hanks) friend at the dinner table; Sam's son, Jonah's precocious girlfriend; the guard at the Empire State Building (the movie is "his wife's favorite"); and finally replays the crucial scene from *An Affair to Remember,* at the Empire State Building.

But the original film didn't end there. The meeting was missed because of Deborah Kerr's accident. Turning this into a happy ending is the goal, and the end, of *Sleepless in Seattle*—melodrama turned to romance, perhaps romantic comedy. Along with the tearful re-creations of *Affair* is a comparison between real life and the movies. Hanks justifies sleeping with the icky woman with the horrid, cackling laugh to his son, Jonah: "This is right, this is real, the other is what happens when you watch too many movies." Annie's friend tells her, "You don't want to be in love. You want to be in a movie." Only when they behave "like in the movies" can they find each other. Why? Because "true love" becomes their only motivation.

As she did in her screenplay for *When Harry Met Sally* (1989) and *This*

Is My Life, Ephron doubles the point of view and shares the voice-over. The world is divided into men's spaces, women's spaces; men's talk, women's talk; men's films, women's films; Seattle, New York; Sam and Annie in *Sleepless in Seattle.* The separate spaces are crosscut throughout and finally united in the end. Ephron uses editing as a metaphor of single and apart, then coupled and together. Like all editing, she uses these cuts through disparate spaces to make thematic statements.

Unlike the Deborah Kerr character who played the martyr, not talking until Cary Grant noticed she couldn't walk (an unbearably tense scene!), Annie pursues Sam, setting events into play. Although she is engaged and planning her wedding to Walter (the perfect man, right out of Howard Hawks's *His Girl Friday* [1940]), she travels to Seattle to find a perfect stranger, on an intuition. They look. It's love. But they don't speak. The dialogue mentions women looking for men, which is what this film is about. Sam is a desirable target for hundreds of women who sent letters after hearing Jonah's sad story on talk radio.

Sleepless is about love as destiny, fate versus accident. Mom tells Annie (Meg) the story of her "first time": "I knew." "What?" "Magic. I knew we'd be together forever and that everything would be wonderful." This "first time" is repeated by Sam, speaking of his dead wife on talk radio: "I loved her for a million tiny things, I knew it the first time I touched her, I knew it, like magic." (Ray Charles sings "Somewhere Over the Rainbow.") The sign that fate is the right answer comes with a detail: his dead wife and Annie can both "peel an apple in one, long, curly strip." Cuts to the stars twinkling is another sign; there is a higher power indeed. In fact, the stars are the last image of the film.

Although the songs are old love songs—"As Time Goes By" (Jimmy Durante), "Stardust" (Nat King Cole)—and the setting is Christmas and New Year's Eve, the nostalgia is inflected by the New Age 1990s: twelve-step group therapy (letting go of the past) meets Eastern philosophy; there are no accidents. Fate's (or "magic's") vehicle is national talk radio and, as in *Forrest Gump,* a son. However, the greatest difference is that romantic love now includes children. The goal is to be a family, not just a couple. Being a perfect mother and a perfect father are now requirements for perfect love. In fact, Jonah picks Annie intuitively. Fortunately, Annie and Sam have a lot in common: both have exquisite taste and money; both are young professionals—he is an architect, she is a journalist.

Rob Reiner, the director of (and inspiration for)[63] *When Harry Met Sally,* makes a cameo appearance in *Sleepless,* advising Sam on dating: "First you have to be friends, then you neck, for years, then you have sex, with a condom. Think Cary Grant." Both films are about relationships—dating, breaking up, marriage—with inflections of therapy talk. Everyone talks

about relationships all the time, even on the telephone. Old songs also fill the soundtrack of *When Harry Met Sally*, which opens and closes on "It Had to Be You" (a big song in Woody Allen's *Annie Hall* [1977]). There is a climactic conclusion on New Year's Eve. Harry (Billy Crystal) runs through the New York City streets to Sally (Meg Ryan), just as Annie (Meg Ryan) runs through New York streets on Valentine's Day to the Empire State Building and Sam in *Sleepless*. The concluding scenes in both films are big endings—sound, image, then more love songs, close-ups, and, finally, twinkling stars. Ephron knows how to stretch an ending to the emotional maximum. *Casablanca* (Warner Brothers, 1942) is the movie both characters love in *When Harry Met Sally*, whose philosophical point is friendship versus relationship, sex versus love. Men want sex, women want commitment. Both Ephron scripts have staged scenes of women's passion (and their ability to simulate it); in the earlier film, it is Sally's famous orgasm re-creation in the diner.

When Harry Met Sally, like *Reds* (Warren Beatty, Paramount, 1981), has intercut scenes of happy, "real" couples speaking to the camera about the "first time" they met. These are tales of love at first sight and happily ever after, which include Harry and Sally twelve years later, remembering their wedding. Ephron, raised in the Hollywood industry, might be the female counterpart to the great male directors of romantic comedy. However, even *Sleepless* was labeled "a chick's film," like *An Affair to Remember*. Why? The answer is apparent. Her films allow women to speak for themselves in a way that other directors have not, particularly Woody Allen. While Ephron and Allen both like big cities, old love songs (especially "It Had to Be You"), and endless discussion of relationships and love, the oppositions are telling.

While on the surface *When Harry Met Sally* is a generational update of *Annie Hall* (romance in the 1980s and 1970s, respectively), there are significant differences. Ephron celebrates popular culture and women's intelligence, while Allen undermines both, talking philosophy and art. Ephron talks pop psychology while Allen quotes, lives, and reenacts psychoanalysis. Ephron gives us boffo together endings, while in Allen's endings, the protagonist is often alone. Ephron multiplies point of view; Allen hogs it.

In *Annie Hall*, for example, Allen (Alvie) has the point of view, voice-over, and direct address to the audience. He avoids marriage and commitments. Alvie refers to art movies by Marcel Ophuls, Ingmar Bergman, and Federico Fellini. Like all of Allen's characters, he is obsessed by sex and Freudian psychoanalysis. *Annie Hall* opens with Alvie, in direct address, quoting Freud's book on jokes and the Marx Brothers. It's a story in the past tense, "Annie and I broke up," followed by scenes from his child-

hood—restaging psychoanalysis, including his repeatedly stated fears of inadequacy.

But the real key to Allen is his ambivalence toward women—pure Freud, with women loved *and* feared, worshiped *and* disdained. Annie refers to herself throughout the film as stupid. Alvie/Allen denies it while the film illustrates it. Smart, articulate female characters in Allen's films are caricatured.[64] But why, then, do I like his movies of the 1970s and 1980s? And why do I love Buster Keaton's films? Perhaps the cleverness of the comedy overcomes my dismay at the representation. (Allen's last five films have seemed sad to me, with nothing to laugh about. Perpetual male adolescence is not a pretty sight. How exhausting to measure oneself, woman after woman, in inches instead of ideas. A life spent calculating sexual prowess, and then trying to prove it, is an empty life.)

I.Q., French Kiss

"I always imagined heaven to be one enormous library, but you can't take out the books." What academic could resist a film with this line, spoken during the big, concluding love scene? The script is smart *and* healthy, although the narrative, and the film, bogs down with the midway introduction of a bad President Eisenhower impersonator. I loved the opening line of Janet Maslin's review in the *N.Y. Times:* "The nice thing about *I.Q.* (1994/95) is that the intelligence doesn't stop at the title."[65]

Taking a cue from Ephron's success with narratives of karma, destiny, and true love, *I.Q.* (Fred Schepisi, 1994) adds Einstein's discoveries, along with Einstein himself, and ponders the relationship between randomness and fundamental order in the universe. A gang of four delightful old men, all retired physicists at Princeton University, with Albert Einstein (Walter Matthau) as the uncle/father figure, create the film's context and move the narrative, with almost equal time given to the central couple. Working as one, they bring together a mechanic who loves astrology, Edward Walters (Tim Robbins), and a physicist, Einstein's niece Catherine Boyd (Meg Ryan), engaged to a psychology professor (another character who resembles Walter from *His Girl Friday,* the Howard Hawks 1940 film).

The four physicist friends relish old age, their intelligence, and their friendship. They help Edward Walters impersonate an intellectual, with one outfit they concoct for him eliciting the comment "You look like a French impressionist." They advise him, when he is asked scholarly questions, to "smoke a pipe or change the subject." Through a series of hilarious body noises and gestures, they give him the answers to a public multiple-choice exam. But their real function in the film is to emphasize the heart over the head. In the film's conclusion, Einstein gives Edward his compass and this advice: "Don't let your brain interfere with your heart."

Love at first sight is the film's triggering incident. Intercut closeups of Edward looking at Catherine, cut back to Ed, then Catherine. "I'm gonna marry her. She looked at me. I looked at her. It was electric. . . . Then I kissed her. . . . Time and space got all mixed up . . . past, present and future time were together." His reverie is of love as destiny, preordained. The lighting is diffuse, golden. Fortunately, she leaves a watch behind at his garage, which he returns, encountering Einstein and his cronies. They banter about the nature of time, age, and gravity. When Edward tells them, "When she came into the garage, everything slowed down, everything became clear," he might be describing the film scene, but this convinces the elderly cohorts that this working-class auto mechanic is better for the brainy Catherine than the professor she is engaged to.

And maybe he is. Her professor/fiancé cares only about his career, not about hers. Edward, by contrast, reinforces Catherine's intellect. To her apologies about talking too much about science he replies, "You're not babbling. If I had a mind like yours, I wouldn't stop talking." Catherine: "I'm just going to be a housewife." Edward: "I think you are more than that." During the conclusion, as they watch a comet coming, he tells her: "I hope you can truly believe how extraordinary you are." Catherine falls in love with a man who respects her intelligence. Amazing! Wa-hoo, wahoo! The film concludes with a shot of Edward and Catherine, Einstein, and then, like *Sleepless*, the stars twinkling. In all three films Meg Ryan has a career—she is a journalist in *When Harry Met Sally* and *Sleepless*, and in *I.Q.*, an academic—an attractive, not dumpy, portrayal.

Meg Ryan produced *French Kiss* (1995; Prufrock Productions), and Lawrence Kasdan directed. This film is a far cry from Kasdan's bellwether of another generation, *The Big Chill* (1983). Yet the films have more in common than Kevin Kline. Like Kasdan's 1980s collective anthem of college friends bonding amidst a backdrop of rebellious ennui, radical angst and free love (or sex), this film, particularly Ryan's character, Kate, also represents the values of the current generation, the 1990s—which *appear* to be more traditional, more conservative.

French Kiss begins with "I Love Paris" (in the springtime) and ends with Louis Armstrong's *La Vie en Rose*, setting the movie in the quintessential scene of romance—Paris and the south of France, specifically Cannes and the wine country. Like *Sleepless in Seattle*, Kate is busy planning her wedding to the wrong man (Timothy Hutton as Charlie) and is very involved with family, here Charlie's parents. The homey decor of the scenes is middle class, middle American comfort. We quickly learn that Kate wants to settle down immediately, and has saved $45,000 to buy a house in suburbia—a conservatism which makes Charlie uneasy. When her fear of flying

(a great comic performance of therapy staged in a mock plane in the film's opening) prevents Kate from going to Paris with Charlie, he meets a French, high-heeled, sultry woman. He dumps Kate on the telephone, telling her that he loves this "goddess" "like a sonnet, or in the movies."

But Kate doesn't take this news sitting down (actually, she does slump to the floor). She takes action and goes after what she wants, with determination and trepidation. On the plane to Paris, she meets and argues with Kevin Kline, playing the French Luc Tessier, about romance versus sex. He makes cracks about her sexuality, her virginity. She asserts that "a kiss is where the romance is." "Do you believe in love, the kind that lasts forever, of one man for one woman?" He replies that this is a question "of a little girl who believes in fairy tales." Although this petty and charming thief (actually the son of a wine-making, land-owning family in the south of France, a true prince) finds her desire for Charlie bewildering ("You come here so he can humiliate you again, in your face?"), and through a series of farcical, convoluted coincidences and misplaced objects, Luc becomes her accomplice in recapturing Charlie's heart.

Meanwhile, the film was a U.S. spring release, giving the audience a lovely tour of Paris as the feisty couple bicker their way past the Eiffel Tower and the Arch de Triumphe. Following Charlie to Cannes, they take the train to the south of France, where Kate spends a lovely afternoon at the country house of Luc's warm, eccentric French family—who owns a huge vineyard.

Although her conversion to French culture begins here, Kate has been getting in jibs at French snobbery and anti-Americanism, particularly in her run-ins with the concierge at Charlie's hotel in Paris. In fact, Ryan performs wonderful physical comedy bits in this film, for example, her fear of flying scenes (with the camera holding on her amazing and malleable face), staging a lactose intolerance scene on the train after eating French cheese (echoing the orgasm staged in the restaurant in *When Harry Met Sally*), and falling on the dessert carts in a Cannes hotel restaurant when spying on Charlie. It's rare that such a beautiful woman has risked and been so adept at physical comedy—for women a trait not equated with sexual attractiveness.

With Luc's tutelage, including a sexy makeover signalled by an exhibitionist shot, she wins back Charlie by pretending to be involved with another man (Luc has taught her that men want what they don't already have, great Lacan), and by turning herself into a sexual object. This shot stands out in high contrast to the other representations of Kate; it flaunts her body as the camera pans up her legs to her face. She poses as the passive object of the male gaze, a sexual object, not the active subject. She is

shot in the same objectifying way as Charlie's French goddess. In contrast to this other woman (an unsettling contrast between French and American women), Kate is the active subject, modest, understated, reliant on her brains not her body.

But after her sexual victory, she doesn't want Charlie any more (ah, the ubiquity of Lacanian desire! and dreams of upward mobility with Luc in the south of France.) But Luc cannot speak his love for her (he was completely smitten at first kiss on the train, while she was sleeping, and we know this because the kiss was followed by a long closeup of his face), and she cannot speak her love for him. So, in a clever ruse, she uses her $45,000 house fund to save Luc from jail for his theft of the diamond bracelet and gets on the plane for the U.S. Fortunately, a kind hearted detective has been following Luc, and in fact, is his friend and benefactor. He tells Luc of her generous actions, beginning with "Would you like to know a true love story?" Luc asks "Does it have a happy ending." Well, you know the rest. Love at the movies must have a happy ending. The last shot is of them kissing in their French vineyard outside Cannes. In the end, Kate finds not just a man but a family and a home right out of *Architectural Digest*, just like Annie and the Seattle ocean cottage of Sam, the architect, in *Sleepless in Seattle*.

Ann Snitow's 1983 essay on romance novels sketches a code of values quite unlike *The Big Chill* (same year, 1983) but applicable to *French Kiss*. As Snitow points out, "Virginity is a given here; sex means marriage and marriage, promised at the end, means, finally, there can be sex." (248) Like Meg Ryan's characters, "The heroine gets her man at the end because she is an old fashioned girl" ("a code for no premarital sex.") (249) At the same time, the differences are significant; the Harlequin heroine is infinitely more passive, she "waits for the hero's next move," she is "not involved in any overt adventure" beyond responding to "male energy without losing her virginity." (248) Critically, she doesn't do comedy, particularly physical comedy, which Ryan's heroines do so well.

Kate is a smart, stylish, honest, forthright, funny, clutzy, even goofily adorable history teacher. Although her body is beautiful, sensuous, she uses it in an off-handed, even awkward manner, wearing baggy clothes and relying on her luminous smile and blue eyes. Although she plays blond, soft, and even cute, Ryan's women have strength of character, along with a savvy intelligence. Often she knows more than she immediately lets on, or than we give her credit for.

Meg/Kate is an update of Katherine Hepburn's fashionably zany characters in her films in the 1940s, with significant variations—class: Ryan is as thoroughly middle-class and midwestern as Hepburn was upper-class

and eastern. Both actresses represent friendship more than sex. Both play confident women (Ryan less so) with professions who are also looking for the perfect relationship. They inevitably find it and him through romance (with discussions about love and romance in the dialogue). Thus, the films, and the characters get it both ways: true love and a career, romance and a critique of romance. Their portrayals of "liberated" or "career" women also validate old fashioned ideals.

Thus, these films that focus on friendship and on families not on sex may be more traditional. But more traditional than what (the belief that sex is liberating) and for whom (sex was hardly liberating for women)? At the same time, they are also less traditional, at least when it comes to the representation of women. In *French Kiss*, Kate initiates action, makes jokes about Luc's temporary impotence, knows more than he does (even about himself), and gets what she wants, through honesty, modesty, generosity, and comedy. Not bad attributes for women in the 1990s, including not being defined by their bodies.

But whether seen as traditional or not, Ryan's films are emblematic of the 1990s. In October, 1994, "the first comprehensive survey since Kinsey smashes some of our most intimate myths," declares the cover story on *Time*. (62) Against all expectations and media evidence, Americans' sex lives were found to be "as exciting as a peanut-butter-and-jelly sandwich" (64). Americans are mainly monogamous ("with one or zero sexual partners a year. Over a lifetime, a typical man has six partners; a woman, two."), "don't go in for kinky sex," are rarely adulterous, and have more sex when married then single. (64) As *Time* points out, the new report is "remarkably conservative . . . and concentrates on the heartland: where life, apparently, is ruled by marriage, monogamy and the missionary position" (70).[66] Just like Meg Ryan's films.

Just a few months later, *Time*'s cover story charts "the growing movement to strengthen marriage and prevent divorce."[67] It begins from this premise: "Working on a relationship, of course, is an activity that everyone—save for perhaps the most wildly romantic and misguided among us—has come to regard as a sometimes thrilling, sometimes infuriating, but always necessary exercise" (49). Although the presence of women in the work force has changed the economics of marriage ("People don't have to stay married because of economic forces now" [50]), divorce is no longer seen as a positive solution due to the monetary and social toll on children and on women. Thus, in the 1990s, marriage, and maintaining it, is in high style while divorce is out of fashion. Not surprisingly, marital therapy is a booming business, while divorce lawyers are under siege.

ROMANCING THE TEXT

Feminist scholars, including the central and now axiomatic work of Modleski and Radway, have focused more attention on other forms of romance, setting lowly romance against more respectable forms, the novel (and men) against romance (and women). For Laurie Langbauer, romance is yoked to women and linked to "consolation."[68] Romance is "constructed within the male order . . . as marginal and secondary . . . to secure the dominance of men." But Langbauer also points to romance's importance for women: to "inscribe female structures and stories into a male order that has no room for them. Curing woman of romance" might end the story. She suggests that "the collusion of romance and women could be a generative one . . . from which they might speak" (84–85).

Directors Allison Anders and Nancy Savoca have both used romance—Anders in *Gas Food Lodging* (1992) and Savoca in *True Love* (1990). Both films are from women's point of view, about women's domestic lives. Both focus on working class characters—unusual for contemporary U.S. cinema. The films address younger women, speaking to the desirability of marriage as women's goal. In a July 1994 interview in *Entertainment Weekly,* Anders declares that while her career is going well, what she really wants is to get married. Then her life would be great. This goal drives *Gas Food Lodging* and its three characters, a working mother and two daughters who live in a trailer park. Finding the right guy would solve their problems and change their bleak lives.

The teenage daughter is desperate to get away from her mother. She uses sex as her way out, failing with the high school jock but succeeding with the traveling geologist (who unfortunately dies while on an expedition). The younger daughter fixes up her mother with a married man with whom she already had an affair. Then there is the satellite installer in the trailer park (for Mom) and the Hispanic guy (for the younger daughter). Any male who appears on the scene is fair game. Any man is better than no man. Any man is better than any woman. Most critics raved about the film, beginning with its reception at the Sundance Film Festival. I disagree, but with the caution that I represent another generation and have much to learn from the young women of the 1990s.[69]

True Love begins with an Italian, working-class engagement party for Michael and Donna, recorded on videotape. They plan the wedding, chat, eat junk food. Michael goes off with his male buddies. The couple fights. Michael needs to hang out with the guys in bars. He is an adolescent; she doesn't know she can make choices. Rather than dumping him, she blames him for her unhappiness. The film ends with wedding photographs and videotape. They don't talk, they stare.

In both films the stultifying boredom of women's lives, going nowhere, without hope, is palpable, particularly on the soundtrack of endlessly repeated arguments, bickering, whining, and complaining. None of the women sees any future except through men. None of the women looks to herself or to other women for answers. When they talk, they fight or discuss guys. While this singular focus or obsession might be true for women (these films assert this for working-class women), I doubt it. And if it is the case, it can still be pointed out as either one among several options or as a limitation or fantasy that could at least recognized by the filmmakers.

These films depict Langbauer's conclusion. The inscriptions of women's lives and viewpoints are "consoling fictions. Women and romance collapse back into the male order, repeating and confirming it" (92). For Langbauer, the genre does not "empower women." On the contrary, "it may even redound on them" (5). As for Foucault, contradiction is the "dynamic that enforces order by providing the (specious) appearance of dissent" (7).

For Ann Barr Snitow, romance novels produce a "pathological experience of sex difference"—Monique Wittig's analysis with a twist: women are subjects; men are objects, mysterious, unknowable.[70] The heroine waits for the hero's next move, occupying her time with tourism and consumerism, wondering what to wear, and existing in a constant state "of potential sexuality." She has only one thing on her mind: *him.* "Pleasure for women is men." (253) However, this is not pleasure but anxiety. Romance verges on obsession: "The pleasure lies in the . . . waiting, anticipation, anxiety." (250) The heroine waits, fears, and speculates, in a "fever" of "antierotic anxiety." (261)

Women's great adventure is romance, the one they are socially sanctioned to seek and to which they constantly "return in imagination." The transcendent moment, as TV soaps and now science so well know, is the first phase of love. "Unlike work, which leads to development, advancement, romance depends on passivity, on not knowing. . . . Once the heroine knows the hero loves her, the story is over. Nothing interesting remains." (250) Fade. The End.

However, some of these stories have become films.[71] Harlequin Enterprises, a unit of Torstar Corporation, a Toronto publishing concern (Harlequin has 3.4 billion copies of novels in print, with 155 million sold in North America in 1993, and publishes sixty new titles every month in twenty-three languages), hooked up with Alliance Communications, a Toronto corporation, to make TV films of six favorite books. Each film was budgeted at $3 million apiece, with several shooting in Europe. Alliance has international rights and CBS the U.S. broadcast rights. After film broadcast, the videocassette was to be marketed like the books—on racks

in supermarkets and through book clubs by including video coupons in the books.

Four TV movies were shown on CBS in October 1994—*against NFL football on Sunday afternoons.*[72] CBS lost its football rights to Fox early in 1994 and used women to combat sports. Producer Susan Minas claimed, "This is Jane Austen. This is *Wuthering Heights.* What is *The Piano* but a form of Harlequin romance?" (36). One thing is, however, presumably different: "The new Harlequin heroines may find themselves in the center of the action—leaping into helicopters, being swept down rivers," and performing other physical feats. (*True Lies* also put the formerly bored, mousy housewife, Jamie Lee Curtis, into action scenes, including a helicopter, but not before first squeezing her body into a skintight short dress with a low neckline—great for helicopter rescue shots. Arnold, of course, rescued her in the end.) This new action female might be just another male fantasy. But the address to women and production *by* women of the TV movies might change some things, as will the small budget. Tippi Hedren co-starred with Emma Samms in the first film, *Beauties*—Hitchcock does *Dynasty.*

But whether action or just passion was her mode, the romantic heroine in print and on film has been white, until recently. The summer of 1994 was the launch of Arabesque, romance novels featuring African-Americans.[73] (B1) "The difference between black and white romances can be found in the details," for example, "curly brown locks" for "cascading blond hair." The books also refer to the "music, foods and traditions of African-American culture." However, the main attraction, "a love story filled with conflicts but with a happy ending" remains the same. (B1) The decision to target African-Americans (along with other white niches—aging baby boomers, single parents, divorced or widowed people, and sci-fi fans), was a marketing one, based on these profitable facts: romance novels account for "almost half of all paperback sales;" black book sales have recently climbed almost thirty per cent while white purchases declined; and some romance fans buy up to forty books per month. (B6)

For years, the lesbian audience has been addressed in romance novels. One historical variation is striking: often the ending was not a happy one. For Helen Taylor, the premises of heterosexual romance are not unlike lesbian romance novels: "They *feed* certain regressive elements in the female experience."[74] Taylor prefers Radway's reading of audiences to either Modleski's or Snitow's analysis. She argues that there is a feminist reworking of "romance novels" and "a growing market for new lesbian romances." For Taylor, like Snitow, romance speaks to women's fantasies, desires, and longings.

Forbidden Love

Forbidden Love, a 1992 film by Aerlyn Weissman and Lynn Fernie, funded by the Canadian Film Board, ties the memories of "first love" to romance novels. This 16 mm film is women's history that intercuts the recollections of older lesbians (from Toronto, Vancouver, Montreal) with photomontage: lesbian romance book covers (*Women and Evil*, *Satan's Daughters*, *Women Barracks*, *Girls' Dormitory*, a few of many great examples), newspaper stories about lesbians, and black-and-white photographs of these women in their youth. The third element is a brilliant, melodramatic recreation/revision of a 1950s lesbian romance. The fiction is segmented into episodes, each with its own rock-and-roll song, threaded through the film.

In the first episode (with Connie Francis's "I was such a fool to fall in love with you"), the blonde Laura says a teary farewell to her girlfriend, who remains behind with her boyfriend, and takes the train to the city. "Her need to be with other women was stronger than her fear." At a lesbian bar, she meets the woman of her dreams, the dark-haired Mitch. Each episode ends with a freeze-frame of the actors looking out at the audience, dissolving into a pulp book cover with a voice-over question: "Would there be a next time?" In the second episode at Mitch's apartment (with Connie Francis's "Stupid Cupid"), a photograph of Amelia Earhart is on the wall. The couple dance. They embrace. Kiss. Freeze-frame. Look out. Book cover.

The last scene of the film is sex and the morning after. (The song is "Come Softly to Me," by the Fleetwoods.) "Her wildest dreams had come true. Now she knew what she was . . . a lesbian." The film equates sex and identity. Sexual liberation is political. Because there is no male desire in this film, the subject/object of heterosexual romance is revised. Context transforms 1950s popular songs into lesbian love songs. Connie Francis's addressee becomes female, revising the song lyrics.

This perfect romance is intercut with direct-address interviews with lesbians in their sixties, who remember their lives as young lesbians, particularly their "first experience." Their memories, primarily of sex, also include lesbian romance novels, which overlap with their stories. An author, Ann Bannon, describes what she calls the golden age of lesbian publishing in the 1950s and 1960s. She notes that formula constrained writers: "Retribution was essential at the end. One of the women had to die or be shipped out of the country or undergo some calamity." While the seductive covers of Bannon's books and others refer to lesbianism as "a great curse," a "perversion," her "women didn't die. Some of them even won." Another interview subject, Reva Hutkin, remembers her past like a romance novel: "Butch meets femme . . . they fall in love. The ending is

tragic." Bannon went to Greenwich Village, which became the setting of many of her books. Hutkin recalls re-creating a Bannon romance by traveling to "the Village," dressed as butch and her partner as femme, in search of "the Lesbians" but not finding them. Romantic fiction and personal life meet in these memories.

After this collapse between lesbian romance and lesbian experience, the women recall their first sexual experience, which they all remember with tenderness as an extraordinary experience of love. The first time is also a moment of relief and self-acceptance, self-love. Most of the women were in their teens. The object of their desire was older, sometimes a teacher. They equate the first time, recalled in intimate detail, with identity and ecstasy. The memories have all the trappings of romance—love letters, exchanged photos, high risk, necking at the movies, the thrill of the illicit, adolescent sex, and then more sex. In fact, the women's memories sound as if they were taken from novels: "She was twenty, young, vibrant. I thought about her for a long, long time. . . . 'Shangri La' was playing on the jukebox. When I came out, she was at the club . . . my three-year fantasy come true." Later, this now-mature woman speaks with the same romantic premises about the pain of breaking up. Carol Ritchie's memories and photographs of going to gay beaches with picnic baskets in the summer and to posh bars downtown are right out of F. Scott Fitzgerald. "You went with a man and you dressed." Photographs of Carol, a beautiful young woman in her twenties, are intercut throughout her sections.

The second stage of the film shifts to the bars, seedy places like the Vanport and the New Fountain set amid the hookers and addicts, all remembered with fondness. Most of the women were butch, with tattoos and swaggers. Lesbians had to choose, butch or femme. The odds were ten to one, butch to femme, with the butches protecting their territory. The women remember the ensuing bar fights as the good old days, with everyone cheering. Just beneath the nostalgia are brief glimpses of harsh reality, other forms of repression: "I became the femme, the heterosexual wife. . . . We were just women who were acting like heterosexuals. I did the cleaning, the dutiful little wife who never opened her mouth, only talked to other femmes, never butches."

Black-and-white re-created footage of police raids briefly reminds us that the times were perilous: "The police arrested women, raped them, beat them. There was no one to complain to." A French black woman and a Native Canadian woman talk about their respective, and different, experiences. The black woman wishes that women still desired her now that she is older. The Native Canadian was on the streets. Beneath the rosy sur-

face of memory is pain and danger, addiction and prostitution. For some, the times were exciting: "Flaunting the law . . . it was forbidden, illicit, and that was attractive." The times also took courage. The women were strong. "You had to, to be gay then."

Despite subtle disagreements, all the women profess the belief in love at first sight, remembering their first love with detail and immediacy more than forty years later. The first time is a primal scene of liberation, of identity, of the centrality of sex. And herein lies the source of both the similarity and the difference between lesbian and heterosexual romances: sex and romance are collapsed, but in *Forbidden Love* female desire defines the moment, despite mimicry of male desire and imitations of heterosexual behavior. The first time is remembered as empowering—a feeling experienced and shared by the audience. The film's reception at the Milwaukee Lesbian Film Festival was energetic, filled with applause, laughter, hoots of shared recognition. One lovely and feisty former professor's remark almost received a standing ovation: "I don't think men should run the world. They're like boys. I think postmenopausal women should run the world."

No matter what the divergences and interpretations, I see romance as inscribing desire—desiring and being desired—at the core of women's lives, with sex intertwined with identity (which in this film is political, an important distinction). The goal of *Groundhog Day* is to fall in love *and to have sex*. The pleasure of *Forbidden Love* is to fall in love *and to have sex*. The end of *Groundhog Day* is the discreet pan from the couple in bed. Ditto for *Forbidden Love*, another story that is interrupted by retellings, another critique of the conventions of romance. "Made in the pan" (not in the fade). For both films, sex/romance means progress, perhaps maturity—perhaps one's very identity. This is also the story of the independent lesbian feature *Go Fish* (director Rose Troche, starring Guinevere Turner, 1994). All the film's wonderful characters, including women of color, focus on "the couple coupling," talking ceaselessly in close-up about whether or not, when, and how the couple will get together. As charming as the portrayals are and as courageous as the film is, particularly the intelligently sensitive voice-over of the central character, having sex and a coupled relationship constitute the film's story and central value. The end, through the voice-over, professes that true love, the right girl, is out there.

Herein is the kinship of romance with both intellectual feminism and irascible feminism, which emphasize theories of desire and sexual difference. There is, of course, a defining difference in *Forbidden Love*: these women fell in love with themselves. That's why they can remember "the first time" with such precision and immediacy. Love of the self is

empowering. And love for women undermines systems of power, predicated on codes of heterosexuality. This love of women for women might be romance, but it is not accepted, not reassuring to most of the population, and not traditional.

Fatal Attractions and Obsessions

Romance can also operate through envy or obsession—fatal attraction. Anxiety is the affect. Romance is what Thelma and Louise escape, first through the knowledge and strength that comes from friendship and adventure, then through death, a refusal to be in yet another prison. (The end can be taken as heroism or as tinged with romanticism.)

Like obsession, romance is not always an innocent, empowering pastime. It teaches us relentlessly to define ourselves by outside standards, making our central measure of self being desirable for someone else or being in a constant state of desiring. As it moves toward obsession, it takes up more and more time, to the exclusion of other concerns. Pop psychologist Anne Wilson Schaef, Ph.D., distinguishes love and romance addiction from sexual and relationship addiction:[75] "Love and romance addicts get their buzz, their fix, from romance, not from sex, not from relationships" (46). Male critics equate sex, love, and romance; female critics do not. "The romance addict is in love with the *idea* of romance." She (it could be "he") is an "expert in illusion, in fact, lives in illusion." (This sounds exactly like Lapsley and Westlake.) The belief that "some day my prince (or princess) will come is not a fantasy. It is a real expectation."

Romance addicts (RAs) seek the trappings of romance; "candlelight, flowers, romantic settings and faraway places are the stuff of romance addiction" (47). Form becomes a fix; addicts are "talented in movielike settings, with background music, dim lights, *and* illusion" just like Hollywood, our training ground along with TV. Like all addicts, RAs live in the future and operate according to denial—holding to the belief that in spite of experience, relationships can be like "fairy tales." They depend on "superficial appearance," but "no matter what romance addicts have, it is never enough and it is never as good as the illusion" (48). Lacan seems to be the problem for which we need a cure.

Whether fiction novels or screwball comedy, romance is considered a

particular genre or form of popular culture. I see the tenets of romance, linked to desire, as more widespread. To me, romance is the cornerstone of the Hollywood continuity narrative. Regardless of whether the point of view is male (as in Hollywood) or female (as in romance novels and soap operas), male desire is central, determinant. Thus romance is usually a fantasy that serves men and modernism. Perhaps the tenets of romance are at the base of Lacanian psychoanalytic theory (and ironically, feminist film theory). The endlessness of Lacanian desire resembles an obsession; romance shares mechanisms with obsession.

Paradoxically, intellectual feminism, so reliant on psychoanalysis, has paid scant heed to Freud's work on obsession, about which he wrote more than any other topic, devoting fourteen major papers to it. His first was in 1894; his most famous in 1909, "Notes upon a Case of Obsessional Neurosis" (the Rat Man, [a.k.a. Dr. Ernst Lanzer]), in which rats are equated first with money, then with children; *Beyond the Pleasure Principle* and "The 'Uncanny'" in 1919; and in 1926, the substantial and, for women, important revision *Inhibitions, Symptoms, and Anxiety.* For Freud, "Obsessional neurosis is unquestionably the most interesting and repaying subject of analytic research" (74).

One explanation for the oversight of this work is the emphasis of feminist film theory, derived from male theories, on vision more than on sound or thought. Freud linked hysteria to *visual memory,* while he tied obsession to *thoughts,* to words. *Studies in Hysteria* states that whereas memories of hysterical patients usually return in pictorial form, the memories of obsessionals return as thoughts.[76] By *Totem and Taboo* (1913), Patrick Mahoney points out, hysteria is a "gesture language" and obsession a "thought-language," (169) with hysteria "similar to the picture-language of dreams"[77] (170)—hence a logical basis for a film theory predicated on vision (and equated with knowledge: "to see" as "to understand").

The differences between the logics of hysteria and obsessional neurosis are instructive. Hysteria satisfies opposing impulses simultaneously, and obsession satisfies opposing impulses through sequential acts. As Freud argued in the case of the Rat Man, in "hysteria two birds are killed with one stone. In contrast, a contiguity marks the diphasic obsession, acts where a first activity is undone by a second" (57). At the base of hysteria is conflict; at the base of obsession are what Freud called reproaches (guilt, shame, hypochondria—which has a lot to do with women, *Paris Is Burning* [1990], *Eating* [1991], and *Vertigo* to radically crosscut genres). Both are the result of holding opposing or contradictory thoughts. Both logics apply in different measures to films, constructing different thought processes, different subjectivities.[78]

Paris Is Burning

If we look elsewhere, the secret that is sex, the enigma, the *unheimlich* (un-canny), has become a sad and sweet parody of masquerade, a transvestite fantasy of the high-fashion celebrity of *Vogue* or *Harper's Bazaar* strangely elided with middle-class suburbia. Jennie Livingston's 1990 documentary *Paris Is Burning* takes the myth of femininity seriously indeed. African and Hispanic American gay men form families around balls, masquerade balls, where they dress up as celebrity dream girls, *GQ* corporate types, or marines. Passing, mimicry, is the key to winning the contest. The prize is a statue, local fame, and community.

Two romances coalesce: to be a famous model, a superstar, and to be married and live in suburbia. Celebrity and fashion are taken *literally*, im-portantly. *Singin' in the Rain* becomes one's lifework. Just as in musicals, fame will take the men out of the conditions of big-city poverty and into a coupled family. The masquerade of glamour, fueled by the desire to be taken care of, is imposed over poverty, class, race, and sex. Masquerade, being a gorgeous white woman, is identity, community; these men want to be the Beverly Hills women of *Eating*. The fantasy becomes all-consuming. They enact feminist film theory, becoming objects of the gaze, lovingly ap-plying makeup. Sexual disavowal is the goal, not its repression. Loneliness and poverty are, for a few moments, denied, as is age.

This is the reverse of my desire to be a boy, a dream of adventure and action. Or is it? Both are fantasies of escape. This poignant, fascinating film is deeply sad—one performer makes it into rock videos, another is killed, the rest are trapped in poverty and in an impossibility. Or was I sad that their dream was to be a model or a movie star or a middle-class sub-urban wife? Within the conditions of these men's daily lives, suburbia, my world, is a dream world. Heterosexual men want to have the dream girl; homosexual men want to be the dream girl; feminist theory wants to de-mystify her. For women, where is the difference? Fantasy women are all that matter.

Eating

As Henry Jaglom's infuriating and fascinating film *Eating* (1991) suggests, food has replaced sex as women's obsession. The obsession is exacerbated, perhaps triggered, by the delusions of romance—that men, beauty, and possessions make women's lives meaningful. In *Eating*, self-help meets up-per-class anthropology; Overeaters Anonymous goes Hollywood. An arty surveillance camera is wielded by a male witness in the treacherous wilds of a Beverly Hills home, filled with fairy-tale princesses of all ages, like a Grimm sorority reunion. Women at a birthday party are almost an alien

species of obsessional neurotics. Only one bingeing twenty year old and a seventy-five-year-old mother (Candace Bergen's real mother) eat any of the six cakes. Here all the women are full of blame, self-pity, self-hatred. Women are only their vacant bodies, bingeing, aging, dieting. In spite of their apparent beauty and their variety, they are ensnared in common self-loathing.

If the Cinderellas, Rapunzels, and Snow Whites had spoken, is this what they would have said—that women's lives are obsession and addiction, verging on parody? Hearing men in the audience laugh at women, and at bulimia, was very painful. At the same time, listening to thirty-eight women talking about their fears and anxieties and seeing so many women together are great experiences. After the film my friend Sharon and I went to a café. She smoked; I ate carrot cake. Because none of the women in the film smoked, the locale could only be Los Angeles.

The Match Factory Girl

Aki Kaurismäki, a Finnish film director, and Chantal Akerman, a Belgian director, revise romance as obsession with reference to the dark side of fairy tales. Kaurismäki's *The Match Factory Girl* (Finland/Sweden, 1990) is, like his other films, about the working class, a proletarian tale told in Kaurismäki's minimalist yet ominous, threatening style. His camera anticipates rather than follows his characters' movements. Often the camera and the editing wait, as if something could happen. Since it usually doesn't, our expectations are deflated. And then something does happen. This is a style of the drab, of the mundane; a style, like the film's characters, without expectation; a style without spectacle, which equates scenes of murder with doing laundry. For Kaurismäki, life is a series of everyday occurrences rather than of dramatic highs and lows.

The heroine works in a match factory run by machines. There are no humans here, only assembly-line hands. Her world is dull, endless, without emotion or human connections. Her flat life is one of repetition, of sameness, of no future. She is trapped, like Phil in *Groundhog Day;* but it's not funny, it's class. The film repeatedly includes close-ups of her face, watching, disconnected, painfully lonely. She has few dreams, fewer hopes, and still fewer opportunities. She observes life, an outsider, while living with her horrible parents, who watch international news on television with no response. Tiananmen Square, the Pope, and various international disasters become the only life. No one talks or feels or cares at home.

She goes to a nightclub. No one asks her to dance. She is alone at the automat, silent. She buys a new dress; her parents say she looks like a whore. She is picked up at a bar by a middle-class man with a nice apartment, who takes her out to dinner. Because romance hinges on the end-

ing, could this be the fulfillment of Cinderella's dream? Will she be rescued?

He dumps her. At work, she vomits. She is pregnant. The man rejects her with a check; her parents kick her out. With nowhere to go, she buys rat poison. Again, the premises of melodrama and romance intervene. Will she kill herself? No, this is Kaurasmäki. She poisons the guy (returning the check), another man at the bar who tries to pick her up, and, after cooking them a terrific dinner, her parents. The police arrest her at the end, at work with the repetitive, antiseptic machines where the film began. This bleak, spare film is not, after all, a love story but a stringent critique of romance—of the novel that she was reading early in the film; for romance has much to do with economics, class, and capitalism.

Night and Day

Chantal Akerman calls *Night and Day* (France, 1991) a "new romance." Critics call it a feminist homage to *Jules and Jim* (François Truffaut, France, 1962) and *A Woman Is a Woman* (Jean Luc Godard, France, 1961). I call it obsession, a tale of boredom (which is often Akerman's topic, one she approaches through repetition). Julie is a languorous, sensual young woman, an adolescent, vapidly, dreamily in love with Jack, a taxicab driver. They spend all their time together in their flat, in bed, never sleeping, barely speaking. For them, sex is sustenance, sex is air, sex is all there is. After a while, sex becomes banal; Julie grows restless, as did I during the film. When Julie meets Joseph, another taxicab driver who looks remarkably like Jack, they "fall in love at first sight." Julie spends her days in bed with Jack and her nights in bed with Joseph—sex all day, sex all night. The boredom and banality intensify. Obsession is boring and intense, taking up more and more time. As with most film boredom, it could transform suddenly into, let's say, violence. For Akerman this is a good bet, as it was for Kaurasmäki.

Like other Akerman films, *Night and Day* is predicated on repetition and the banality of the everyday. Rather than sex being titillating, the big climax, the central moment that everything leads up to, Akerman makes sex the entire story, and then repeats that. Sex is subjected to the Akerman style—which is beautifully monotonous, measured, perfect—like an obsession. The characters are young, naive, thus their conversation is less than scintillating; in fact, it is only about themselves and their love. As in other Akerman films, the end is intriguing, an inversion of the conventions of old romance. Julie leaves both men.

Besides loving, Julie's only activity was walking. The ending is a release from the confines of the protagonist's world, no larger than her bedroom. Thus the ending is a liberation, an assertion. "In Akerman's world, walk-

ing out is a happy ending." "Women may dream of all-consuming love but it's an adolescent dream and one that's destined to disappear as they grow up."[79] Growing up is the key notion. Romance is, finally, an adolescent fantasy that becomes claustrophobically boring.

Obsession—so central for an analysis of *Vertigo* and so operative in contemporary U.S. culture—shifts from desire to anxiety, from the unconscious to the conscious, moving away from Oedipus and castration and toward loss and the female subject. This is a model of anxiety rather than pleasure, an economics of money more than libido, and a logic of contradiction that, for me, captures aspects of women's representation and experience in commercial culture. This is an epistemology we need to break through; this is what keeps us captive to the desires of others, to the illusion of liberation through sex and difference.

As the recipients of the double standard, juggling two or more jobs, subjected to the "you are everything and nothing ploy," women have embodied and been subjected to contradictory logic for years. Comparable to these logics is the "diphasic" quality of obsessional neurosis, what Freud calls, in *Inhibitions, Symptoms and Anxiety*, "the power of ambivalence": "One action is canceled out by a second, so that it is as though neither action had taken place, whereas, in reality, both have."[80] This both-and logic of creation and cancellation causes the difficulty in perceiving apparent contradictions—the "as if" they hadn't occurred: "An action which carries out a certain injunction is immediately succeeded by another action which stops or undoes the first one." It might explain why women's history, and women's absence, would not be noticed.

AGE TWO

Irascible Feminism

Vertigo

Protofeminists

While I prefer fast-talking women, the heterosexual dream girl is shaping up—building muscles and getting physical. When male directors wanted to represent strong women in Hollywood films in the late 1980s and in the 1990s, they looked to working-class or tough women and gave them a gun, a drink, a swagger, a limited vocabulary, and savvy but unschooled minds—primitive, protofeminists.[1]

The good news is that patriarchy is the enemy. Women's narrative obstacle is raging sexism. In the end, "she" saves herself. The 1990s protofeminist tales are sensational, right out of the tabloids and in line with the discoveries of early film feminism, although not necessarily appreciated by feminist critics. (Since 1991[2] killer women have become fashionable. The books *Men, Women, and Chain Saws* and *Fatal Women* update Freud and Lacan for the 1990s, focusing on male masochism and lesbianism.)[3]

As in intellectual feminism, women enter a man's world, the arena of male subjectivity. They often move the narrative, take action, and possess "the look." Sometimes the famous and axiomatic male gaze of feminist theory is under siege, starring as the enemy. Sexism is uncovered, often via a tactic of role reversal. Rarely in the end is "she" coupled. And she exists across genres.

In *Switch* (a 1991 Blake Edwards comedy) the feisty protagonist, the sexy Ellen Barkin, is really a man and therefore sits with her legs apart, cannot walk in heels, and resents being looked at. Because "she" is a "he," her feminine body collides with her masculine mannerisms. Because "she" is a "he," the film can be as exhibitionist as it wants—it's comedy, right? The problem with *V. I. Warshawski* (directed by Jeff Kanew, 1991), the film of Sara Paretsky's Chicago female detective, is a split between the gaze, which is not really from V.I.'s (Kathleen Turner's) point of view, and her tough voice, which talks back and has such great lines as "never underestimate a man's ability to underestimate a woman." (Like the other tough-

women films, in this one class is paradoxical—working-class masquerade.)[4]

In the drama *Impromptu* (James Lapine, 1989) Judy Davis as George Sand relentlessly pursues Chopin (Hugh Grant), who is wan, afraid of sex, and has fainting spells while she is aggressive, tough, desirous, urging him to take strength from her (which men have been doing for years). In James Cameron's *Terminator 2: Judgement Day* (1991, science fiction), Sarah Conner's (Linda Hamilton's) fury at being incarcerated by a male psychiatrist who doesn't believe her story of *The Terminator* (James Cameron, 1984) turns to vengeance of the sweetest and most violent kind. She wants to kill this wimpy shrink who patronizingly won't believe her. She has no qualms about aggression and, like *La Femme Nikita* (Luc Besson, France/Italy 1990), has trained herself for it. Her motive is the highest: to protect her son. Her hard body is a weapon rather than a lure, a pleasure to watch.

In *La Femme Nikita*, after blowing away a cop and brutally employing her gorgeous and savage body as a weapon, Nikita (Anne Parillaud) becomes a trained and skilled assassin, until the narrative trips her up. First femininity (taught her by Jeanne Moreau), then romance, and finally a bungled hit take her to the straight and narrow. Fortunately, she escapes true love and both men in the end and abruptly is missing from the movie, presumably going off on her own. Watching both of these great and unruly bodies—Sarah Conner's and Nikita's—is a delight. However, the message of *La Femme Nikita* is double—tough but tamed by femininity.

Hollywood re-created the French film, starring Bridget Fonda (*Point of No Return*, John Badham, 1993), but signaled her savagery by filth and a neanderthal hair style. Her recovery from unfemininity is not complete, however, until she shaves her armpits later in the film. That she is initially pretending is signaled by a shot of her arms raised over her head, unshaved! (In addition, her teeth become Hollywood white; in her unredemptive stage, they are a normal white-yellow.) Although many of the scenes and virtually all of the "actions" are right out of the original, many subtle Hollywood conventions create a different version. It has a Pygmalion feel to it—men molding women to fit male romantic scenarios.

Catwoman from *Batman Returns* (Tim Burton, 1992) wants to murder her boss, who underpaid and then attempted to kill her. This secretary realizes the fantasy of *Nine to Five* (Colin Higgins, 1980), enacting doubled identities and rage. Don't mess with Catwoman—she will entertain no fantasies of men rescuing women. She is not deluded by romance or fairy tale endings and overtly refuses that conclusion to this film. The last image of the film is of Catwoman, alone and alive, *after* turning down Batman and his castle. Like historical feminism, which keeps rising from the ashes every twenty years or so, she has nine lives—each one stronger. The dream

girl, Michelle Pfeiffer, has become a superhero who will not settle for safe, predictable dreams.

Thelma and Louise (Ridley Scott/Callie Khouri, 1991) begins after "happily ever after" has gone sour. While the women's revolt against sexism is doomed by their narrative—their progress impeded by their bungling—their rage is real and logical. They kill a rapist, rob a store, capture a cop, and blow up a gasoline truck. They leave femininity, rely on friendship, and achieve fearlessness.

THE QUICK AND THE DEAD

The *Quick and the Dead* (1995) puts Sharon Stone at the center of the western. Sam Rami, a director never content to leave well enough alone, exaggerates the now-hoary conventions. The bad guys are so unrelievedly bad, the many shots of the town clock so foreshadowing, the close-ups of faces and eyes "looking" so intensely tough that the first half is funny.[5] *The Quick and the Dead* parodies a parody, *The Good, the Bad and the Ugly* (Sergio Leone, 1966).

The frontier town is dark, dirty, dusty, and disgusting. It is a place of repression, claustrophobia, and tyrants rather than freedom, open spaces, and heroes. This corrupt, unsavory town is populated by ugly men—big-bellied blowhards, unshaven slimebags, uncouth convicts. All are repulsive, with bad teeth, dirty underwear, and no humility. They strip bodies for gold teeth while nasty young boys throw horse manure and yell epithets. So much for men and masculinity!

Repeated close-ups of Stone's luminously beautiful (presumably natural, not masquerade) face, framed by her Stetson or her unruly hair, are in high contrast to this grotesque male space. Her face is a soothing respite from the repulsiveness. In the background are anonymous townsfolk, white and Hispanic, all cowards, with prostitutes and onlooker women as a passive audience. Who would *ever* want to rescue this wretched place? But the overblown style eventually settles down, thanks in part to Gene Hackman's steadying presence as ruthless evil in the shape of Sheriff John Herod. There is nothing funny or buffoonish about this amoral killer.

The Quick and the Dead parallels two plots (both belong to Stone). The first is Herod's quick-draw-to-the-death competition. The second is Stone's past, a revenge tale, told in flashback. This memory is also the film's motivation, an Oedipal story of her father, a lawman, killed by his young daughter as she tried to save him from Herod. Although the flashback is incomplete until the last sequence, sound links Stone's character, Lady, and Herod at first sight. Every time she sees him there is a low rumbling sound, along with close-ups of his boots and spurs. Ominous indeed!

Stone as the generic or, indeed, mythic "Lady" possesses "the gaze" and a flashback memory (consequently, knowledge); she is given put-down retorts and the last word. This powerful woman of few words and a fast draw moves the action. The film begins with her mythic ride into town and concludes when she rides out, her job of restoring law and order over. Her centrality is emphasized by repeated close-ups of her face and hat throughout. (Not surprising, in that she was the executive producer *and* the star, but these close-ups are both a relief and a great pleasure. Shots of the horrible men are very aggressive; they repulse the spectator.)

Her movements reveal how sensual the costume and gesture of the western male hero have been all these years. The hetero-codes of the old West barely disguise the homoeroticism and narcissism. Just think of Henry Fonda/Wyatt Earp slowly leaning back in his chair, his spurred boot on the hotel railing, as the very boring Clementine Carter arrives in *My Darling Clementine* (John Ford, Twentieth Century Fox, 1946). It's Fonda we watch, Fonda who is the turn-on, as we hear "Oh my darlin', Oh my darlin', Oh my darlin' Clementine." Or we can think of his first meeting with Doc Holliday (the muscled, consumptive, wavy-haired Victor Mature) at the bar. Earp's long walk to the final shoot-out at the OK Corral is unhurried, commanding. Doc will give his life for another man, Wyatt Earp, which is something men do regularly.

Or consider Clint Eastwood in his Leone westerns, graceful, sensual, slow gestures followed by quick action, a verbal retort, and a return to composure. Eastwood spends much of the films watching, waiting, posing for the camera, existing in close-up just for us (as did Marlene Dietrich). When he talks it's in words, not sentences. Despite their eroticism, the bodies of these heroes belonged to them, as did the surrounding space. The opening of the films established both male freedom and spatial dominance, the mark of the hero and a state to which he returns at the end.

What makes *The Quick and the Dead* such a great watch is Stone's taking back bodily movements and other genre conventions that have belonged to men for over one hundred years of film history. (However, she doesn't take their facial wrinkles, signs of character for men.) Wearing a long, dusty coat and a hat, *she* rides into town in long "master" shots intercut with center-framed close-ups, surveying more than looking. She commands the visual terrain and landscape and, particularly, the music. She is dominant, mobile, in charge of space, with sound tied to her actions.

In town, she moves slowly, deliberately, leaning on the bar, slouching in her chair, a spurred boot on the rail or on the table. Her body is languorous, relaxed, unhurried. (Unlike most female characters, she doesn't have to look good for him or bustle about waiting on him or others.)

Stone's voice is husky and low, her speech barely inflected. Although desired, she is not available or interested. She is not on display. Stone's body and her thoughts belong to her.

When she first rides into town, her character is further established in a series of tests. The saloon keeper replies to her request for a room, "Whores next door." She tells him to repeat his words. When he does, she knocks the wind out of him in a lightning-fast maneuver, then downs a glass of whiskey. This woman is no whore! A black-leathered cowboy enters the saloon,[6] orders champagne (which, along with the flowery embroidery on his outfit, lets us know that he will not last the film), and asks her to play cards with him. She looks him over and caustically replies, "Looks like you're having a good time playing with yourself." (This clip was in the TV promo.)

Running the gamut of male vanity (which thinks it has rights over and access to women and imagines that male desire is a blessing, not an irritation or assault), she rebuffs another, fat, unshaven thug. "You're purty." Stone: "You're not." To his "I need a woman" she says, "You need a bath." Male desire is of no interest to her. She has no need to please or flatter or be nice—women's greatest curse is being nice at all costs.

The female hero is also different from her male counterpart: she has ethics and feelings, including fear. She takes no pleasure in killing; she is not the best shot in the film; she knows her limitations, and thus she uses her brain along with her gun. When Cort, the ex-fighter turned preacher, is initially being taunted (strung up in a reprise of her childhood trauma), the men in the saloon either are emotionless or jeer on the torture. She can barely look, reacting as she watches. But she is not stupid and doesn't act from (male) ego—the significant difference. She enters the men's contest. After hearing "Women can't shoot for shit," she shoots his hanging rope and saves him.

The thrill of killing is at issue. At his Victorian mansion that night, Herod commends her for "passing a test." She replies, "It doesn't excite me as much as you." He asks, "Have you killed anyone? How far are you prepared to go? There is nothing on this earth that frightens me." Meanwhile, Lady cannot kill Herod with the tiny gun concealed in her stocking. But is killing a thrill or a sign of heroism? Is it a masculine perversion or a badge of courage?

Cort, the reformed gunslinger turned pacifist, refuses to fight and is punished for this refusal. He is chained outside and tortured. He is the masochist to Herod's sadist, Herod in black leather and spurs, Cort in chains with wounds on his body—literally! Herod acts, inflicting pain; Cort refuses, receiving pain.[7] This couple, now at odds, have a long, perverse history together. In the film's end, to save and help Lady, Cort

demonstrates his remarkable gun prowess—killing with a moral and with a purpose. Order is restored to the town and to masculinity by a woman.

Lady doesn't get pleasure from pain, whether watching, inflicting, or receiving. Her first killing is in self-defense. The child molester she demolishes in a fist fight refuses to quit, even after she shoots him in the testicles (in close-up, with a huge increase in sound volume). Afterward she leaves town, in remorse and angry frustration. In the John Fordlike cemetery scene on the outskirts of town, she confesses her fear to the town doctor: "I'm scared, scared of dying." Flashback: she is a little girl. Men, led by a younger Herod, are dragging her father the marshal outside, putting a rope around his neck, standing him on a stool, as Herod did with Cort. Lady mounts her horse and goes back to town for Herod.

All the braggart men, including an African American and a Native American, have been eliminated (perhaps for bad fashion; their outfits were just too obvious, too exhibitionist). To up the Oedipal ante, Herod has killed "the Kid," his illegitimate son, in the semifinals. The Kid, played by Leonardo DiCaprio,[8] looks remarkably like Lady, suggesting crossover gender roles, a hip view of "emerging" masculinity as perpetual male adolescence. (I wonder: Has Sam Rami been reading feminist film theory?) This up-and-coming, sensitive male actor is given lots of close-ups, soft lighting, and empathy. He is loved by the townsfolk and the movie audience, despite his brash male ego. (He also desperately and for no good reason wants the approval of father Herod. That old saw of the illegitimate son desiring his rightful and legal place is self-destructive.)

After blowing up the town, with Cort as her accomplice, the music swells, Lady emerges from swirls of dust and money, the avenging angel in a low-angle shot. "Who are you?" asks Herod. (This question is rare for women in this genre, so clearly defined by their costumes.) She throws the marshal's badge at him. White flash.

The flashback finally concludes. Herod had made her watch her father being strung up, then gave her a gun and three bullets to shoot the rope and save him. The little girl cries, "I can't do it, I can't do it." And then shoots her father in the forehead. Herod laughs. Zoom back to the present. Herod: "You're not fast enough for me." Lady: "Today I am." After killing him on the second round, she puts her gun away and gives the badge to Cort: "Law has come back to town." After vanquishing male perversions (and successfully going through the Oedipus complex herself, something only men have been able to do in cinema and in life), Stone gets on her horse and rides off into the sunset, free, independent, and alone.

I loved the film—in spite of its head-slamming obviousness; in spite of Oedipus; in spite of Stone's not getting the hero's walk right; and in spite

of the fact that she has no women allies, only young boys and a masochistic pacifist.

Imagine a film with all these women—a *Dirty Dozen*, a *Seven Samurai* for the 1990s.[9] Irascible feminism is not this extreme. Words are the only weapons. But if words could kill, the academic death toll would be high. Hitchcock and other male experts yield answers that are used against them—with wit and with anger. The fascination is male subjectivity, which feminism can dominate and then replace. Virginia Woolf and Monique Wittig advocated changing systems along with personnel. We thought this was what we were doing as we complained about generic men or skewered famous men. While anger initially served as a motivation, we learned little about women except that we hadn't been invited to the party and were furious. But rage has its limits. It doesn't really change things. (Its effectiveness is overrated.) It aims at reclaiming "lost ground" rather than staking out "new territory." Anger is not authority, it is a "demand"—asking for rather than taking something.[10] Ages One and Two remain within the terms of the theories they critique—an uneasy consonance.

OEDIPUS AND THE ROBOT
IN *METROPOLIS*

Metropolis was the first film in which, in 1975, I traced the psychoanalytic trail of male desire. I was not happy with what I discovered.[11] The story dominated not only the film, but most of the criticism of German cinema (especially Siegfried Kracauer's *From Caligari to Hitler*) and auteur accounts of Fritz Lang's life and films; ditto for the accounts of modernism and modernity. Lang's great 1926 German expressionist film (which his then-wife Thea Von Harbou collaborated on, including writing the screenplay)[12] portrays an Oedipal logic determined by the duplicity of female sexuality, the virgin/whore duality. Ironically, while criticism of the film invokes "contradiction" (a bad thing, not a logic) as the explanation for the film's inconsistencies (and those of the entire film movement), rarely is female sexuality, elided with technology, mentioned as the film's central dilemma.[13]

Metropolis is a masterful film of dualities that organize the narrative: worker/master, physical/mental, hand/brain, machine/human, science/alchemy, Christianity/mysticism, age/youth, men/women, ad infinitum. The narrative tries to contain these oppositions through complex rhymes and repetitions and by the wondrous reconciliation of the film's conclusion. The end reunites father and son, Freder and Fredersen, thereby

restoring the family and the law. Although wearing constructivist clothing and moving in avant-garde choreography, the workers are a faceless uniformity, marching in downtrodden order after their brief rebellion. Nothing has changed. The workers are in the same condition. The end spirals back to the beginning with one difference: Freder (son of Fredersen) is now a man rather than a boy. He is wearing long pants, not knickers. He has triumphed and saved Maria.

The problem with male Oedipal dramas is that they are played out over the divided female body: the agrarian, maternal Maria preaching on an altar of distorted crosses in the primitive catacombs; and the lusty, sensual robot Maria who embodies sex and the threat of castration in the high-tech modern city. (See page 123.) Because the lusty Maria is also a glistening electric robot adorned in heavy mascara, the other paradox of the film, technology is elided with the female body. I analyzed this collapse as the equation of technologies of power with technologies of sexuality. Both are simultaneously celebrated and condemned. Disavowal, the maintenance of contradictory beliefs, thus functions through technology and female sexuality. However, the avoidance of female sexuality in criticism of the film illustrates a tactic analyzed by Foucault: "reinterpreting the deployment of sexuality in terms of a generalized repression."[14]

The crisis in the film is identifying the "real" or proper Maria. Parallel editing cuts between father and son, Fredersen and Freder; Maria and the robot, the virgin and the whore. Actually, there are four Marias: machine, whore, virgin, and mother. The narrative's job, the story of Oedipus, is the proper deployment of alliance with the deployment of sexuality. When Freder sees Maria preaching in the catacombs, he says in an anguished intertitle, "You are not Maria." Just before the escape of the children from the flooded city, Joseph says, "Yes, you are the real Maria." The struggle for poor Freder to name the object of his desire, to erase the desire for mother and relocate it, continues during the pyre sequence as he yells, "Maria!" still uncertain. After the fire has destroyed the false Maria, he yells, "The witch! The witch!"

It is important to remember that when *Metropolis* was made, film was high technology, an artistic medium radically altering time and space, a virtual reality of illusionism, and a weapon in an international economic, corporate battle. The German film industry, particularly through the auspices of UFA (Universum Film Attiengesellschaft) and Erich Pommer, used technology (of sound *and* image) both to preserve their film market from U.S. dominance and to capture the lucrative U.S. market. Given the astonishing devaluation of the mark, however, the German economic situation was highly unstable. And Hollywood could pay its quota by making films in

Metropolis

Germany that were never released. (The Hollywood major studios had divided up the nonsocialist world by 1924, with international distribution outlets dominating the world's screens with U.S. films.) The involvement of artists from particularly painting and theater in the film industry served to place this film and others styled "German expressionism" within both art and popular culture. Perhaps more important, "art" differentiated the film from other film products. The special-effects city not only resembles New York, which Lang told us: it copies Bauhaus architecture for modern workers' apartments.

The figure of the robot is a good example of quite specific art references. Three figures by Max Ernst—*The Preparation of Bone Mucilage, Immaculate Conception,* and *A Woman, an Old Woman, a Flower*—depict woman as machine. *Bone Mucilage* looks a lot like the robot. The lusty Maria resembles representations of the femme fatale (the equation of woman with death) by Gustav Klimt (*Judith* [1901], who looks like Joan Crawford), Edvard Munch (*Madonna* [1893]), and Oscar Kokoschka. The sensual woman was a deadly woman.[15] Oskar Schlemmer's costumes for a Bauhaus performance, *The Triadic Ballet,* also resemble the robot goddess, the perfect sex machine. Schlemmer's *Variations on a Mask* drawings for a class on stage theory duplicate the face in Besongye (African) sculpture of a female. For modern artists, "the primitive" was literal.

Schlemmer praised the splendor of using precision machinery, "the scientific apparatus of glass and metal, the artificial limbs developed by surgery, the fantastic costumes of the deep sea diver and the modern soldier." He and others at the Bauhaus stated these figures would be "the personifications of the loftiest concepts and ideas, made of the most exquisite materials."[16] The robot in *Metropolis* is an exquisite object of male desire, the *kunstfigur* so compelling to Schlemmer, with its strong tradition in Gothic German literature. In E.T.A. Hoffman's "Der Sand Man," from the *Nachstucke,* the mad physics professor, Spalanzani, has a daughter, Olympia, who is a machine. (In "The 'Uncanny,'" Freud relies on this tale.)

Other theorist-practitioners of dance and theater influenced the choreographed bodily movements of the leads as well as the workers in *Metropolis.* Through Otto Laban and Mary Wigman, the theories of François Delsarte entered German cinema. Delsarte focused on the body and emotion, the aesthetic body of art and spirituality, while F. W. Taylor and Frank Gilbreath measured the body and work, the efficient body of time and money. (More on Delsarte later.) The body becomes a formal element in the composition, a precision machine *and* an expression of emotion. (That *Metropolis* still has currency is apparent in Tim Burton's two Batman films, which directly re-create the spectacular dark enclosure of the studio

world. *Metropolis* was also given new life in 1984, rereleased as a musical—songs by Pat Benatar, Bonnie Tyler, Adam Ant, Loverboy, Billy Squier—in commercial theaters with a rock score by Giorgio Moroder [now the codirector, with Lang], with previously cut footage included.[17]

In addition to the problem of naming and containing female sexuality, the terms of the drama are visual. The first look of desire is ours, our drama of vision with the film, which is repeated within the film. For example, with lights flickering over his face, Fredersen watches the destruction of the city; he supervises the underground city of the workers on television (a precursor of interactive, two-way TV, as well as a model for TV surveillance).[18] In another instance, the robot Maria incites the orgiastic revelers to "watch the world going to the devil."

Electricity, a new technology, is repeatedly contrasted to candlelight. The real Maria possesses only a candle. Rotwang ensnares Maria with his flashlight in the dark, rocky tunnel. Fredersen captures the priest in his office with a flashlight beam. (The fragmenting of space by light, or the sudden spot lighting of a character, was influenced by Max Rheinhardt in theater.) In Freder's vision of Moloch (a version of Cronos, the literal Oedipus, a mythical god who devoured his children so they wouldn't kill him), flashing lights on the optical track assault him.

The film's drama of vision, much like the Freudian scenario, is constant. The first look within the film is Freder's look at the maternal/virgin Maria. He stares. She looks. Love at first sight. Later, they exchange passionate glances in the catacombs. Then comes the terror of the primal scene, as Freder sees the robot Maria with his father. Freder cries, "Maria!" and is attacked by a montage of abstract lights. He loses his balance and shields his eyes. A shot of his miniature body falling through black space, into the unconscious of sleep, concludes with a fade to black. The image fades in. He is in bed, asleep and ill. (See pages 126, 127, 128.) Going through the Oedipal drama is traumatic for poor Freder. While he sleeps, the fake Maria is dancing at Rotwang's party, stared at by a circling montage of multiple eyes. Freder awakens, sees the figure of death, and screams. Fade to black. Sex and death are joined—female sex is deadly indeed. *Metropolis* can be read as Freder's Freudian moment. But being an object of desire was dangerous for Maria as well—trapped in a flood, and then burned at the stake in the form of her robot counterpart. What is burned is female sexual desire. And this is what continues to enrage women.

Sigmund Freud was alive and writing in Austria when *Metropolis* was made. Thus the influence of his well-known concepts on German cinema is logical and historical. In his essay "The 'Uncanny'," based on Hoffman's "Der Sand Man," Freud speaks about sleep, vision, and castration; the use

Metropolis

of doubles; mechanical dolls or robots; artificial limbs; and virtually every other image in the film. In fact, it is a perfect analysis of the film and indeed could pass as the treatment for the film. But it is not this way but rather historically that I want to use Freud.

More precisely, Freud wrote a history of the family within a time and political-social context comparable to *Metropolis*. Although as theory, Freud used metaphors of vision from optics throughout his work, the drama of vision for Freud was that of the Oedipal tale with its singularly male subject. Which has much to do with economic history. His tale mattered more because of money and property, which he was sanctioned by law to make and to own. The film's use of Moloch, the machine that devours the workers, further suggests the contemporaneity of an Oedipal reading.

Equally central is another variance from current assumptions. For Freud the unconscious was dark, deathly, a scary place, not a good thing. Sex and death were found there—where they should remain. At any moment they could erupt through the decorum of civilized behavior and unleash chaos like that of *Metropolis*—the flooding of the city, the unruly mob, the death of the children. This eruption of the archaic (deadly sex) was the problem, not the goal. However, for surrealist artists of the period, inspired by André Breton, the unconscious of dreams and madness became the sought-after goal, a rather scandalous place of liberation and rebellion. Rationality was the enemy the unconscious could counter. This liberated use of the unconscious was a strange combination of Freud and spiritualism—"Mystic Freud." Surrealists tried to get to the unconscious through insanity, drugs, hypnosis, shock, sex, wit, any means possible.

This surrealist interpretation of the unconscious as a good thing, including unrepressed sex, is the reading of Freud that many feminist film critics have taken up. I suspect the origin is film feminism's inheritance of the countercultural/avant-garde art-world values of the 1960s. Sexual liberation was beneath much criticism. Largely past in Europe, surrealism had migrated to the U.S. art scene in the 1960s, where it was given new life. If I am right, it would also follow that the surrealist's depiction of woman as ideal and muse also had an (unnoticed) effect on film feminism's analysis of female representation in cinema.

Metropolis's drama of vision also occurs through special-effects technology. The film celebrates and stars its own technology, particularly the Eugen Shufftan process, at the same time decrying the dehumanizing effects of technology within the film's narrative. Thus sexual disavowal over the body of the virgin/whore is elided with the visible–invisible paradox of special effects, also predicated on disavowal. One fetish, the woman/the robot, meets another, technique.

Special effects were always in cinema. They involve materials and techniques basic to movies, such as fades, dissolves, even cuts (in Georges Méliès's films). Matte shots that included two places in one scene were present from cinema's early years, for example, in *The Great Train Robbery* (Edwin S. Porter, Edison, 1903). Being placed in a *special* category is thus intriguing: effects are special only in relation to the spectator, to the hold of the narrative. Like *female,* the term operates according to a division: enhancing film's realism and existing as spectacle. Special effects also have the function of correction, in postproduction, of "errors"; the effects mask, create, and erase. This is uncannily similar to women's empty space, as well as the apparatus theory of, for example, Christian Metz, Jean-Louis Baudry, and Jean-Louis Comolli.[19]

Ironically, special-effects "wizards" have provided a model akin to that of psychoanalysis. Practitioner Frank Clark defines special effects as "any technique employed during motion picture production to enhance reality, create illusions of actions, or simulate events too difficult for film for reasons of safety, convenience, cost." As with the classical style, the success of special effects depends on masking their work. Like the enigma that is produced as sex, they are constantly there in cinema yet contained as "the secret"—by perspective, matching action, continuity, consistency, accuracy, and balance. Special effects "either cinematically create something never seen or recreate something quite real." The best special effects are those the spectator cannot discern: "Whether fantasy or reality, no special effects experts want anything to look faked, especially if the audience already knows it must be."[20] Another special-effects wizard repeats the process of avowal/disavowal: "If a special effect is obvious, then it has not succeeded in its prime function which is to fool us."[21]

Metropolis stars a special technique, the Shufftan process, named after the technique's inventor and the film's special-effects coordinator, Eugen Shufftan. This is a complex system of mirrors and miniatures with painted sets, photographs, or rear-screen projection. The camera shoots at and through a mirror, compressing separate images into one. Because a portion of the mirror's silver has been removed, it is actually a window/mirror. Illusion necessitates "the permanent" alignment of "camera, mirror, and reflected miniatures."[22] If the camera moved, it would reveal that it was shooting through/at the glass/mirror. The screen reflects a reflection through/on a glass/mirror.

A simpler mirror, a superimposition plus mechanically moving electric tubes, was used to create, then destroy, Maria the robot. Rotwang, the scientist/alchemist, makes a woman by electricity. He controls the machin-

ery that creates the illusion of female sexuality, of sexual technology. The creation of sexuality is the film's problem; its destruction, a public solution—burning the "witch" at the stake, the first ending. And then bringing the happy couple together is the second ending. However, the final ending is the uniting of father and son.

Like special effects, which can be covert or overt, which can declare or conceal, which can be noticed or remain hidden, cinema's techniques overall can be noticeable or not to the spectator. They are often visible (sometimes depending on knowledge and education) and always experienced! Jean-Louis Baudry argued that the illusion of continuity depends on the denial of differences: "The mechanical apparatus selects the minimal difference and represses it in projection" (Baudry, 43). (Or masks it by matching action, eye-line matches, and cause–effect logic.) For Baudry the camera was the inverse of the projector, akin to a psychoanalytic process of double vision. We (the spectators) were the beam of light, projecting outward, and we were the filmstrip, being imprinted. Both the film apparatus and the spectator were analogous to Freud's mystic writing pad. The spectator was where images were simultaneously permanently imprinted (the filmstrip) and continually erased (the screen's surface). Baudry's influential essay, published the same year as Laura Mulvey's, led to analyses of the classical continuity style.

To Baudry's psychoanalytic model Comolli (the other Jean-Louis of 1970s film theory) added Marx and economics, along with other film processes (including chemical). He argued the flaws of making the camera stand in for film in its entirety. This *image* of the camera as the whole represses other elements, other processes, including the capitalist desire to make a profit. The fetish of Freud began to converge with Marx's commodity fetish. Comolli's emphasis coincided with a view of U.S. film history as business history, paradoxically argued through neoclassical economics yet taken as neutral.

In retrospect, what is striking is what Baudry and Comolli (and I, after reading and loving these essays when they were first published) didn't mention. Neither theorist noticed the biggest difference—sexual difference. And sexual differences are not minimal in cinema but maximal; in fact, sexual differences are not concealed but proclaimed. Nor was sexual difference important to early or late formulations of the classical style or to models of money and finance, whether neoclassical or Marxist. For me, the question is: What served in the 1970s to hide sexual difference, present but not noticed or acknowledged by so many film scholars? What serves the same purpose in the 1990s? Sexual difference, argued through vision, is covered up by thought. A logic overrides its spectacular

visibility. It is that logic, that epistemology, that we must uncover and then change.

As I saw Oedipus everywhere my anger grew, leading me in another essay to a snotty attack on Lacanian film theory, *It's a Wonderful Life* (Frank Capra, RKO/Liberty, 1946), *Yankee Doodle Dandy* (Michael Curtiz, Warner Brothers, 1942), and writings on "the cinematic apparatus" and "trucage" (a term for special effects).[23] "It becomes blindingly apparent that this version of the 'cinematographic establishment' excludes women except as origin of the lack, the source of both terror and pleasure" (94). For these theories, "'going to the movies' is akin to going through the Oedipal drama, Little Hans revisited. . . . Through the magic of cinema, the male scenario of birth, castration anxiety, and finally fetishism can be re-enacted weekly as a game."[24] What did this have to do with women in the audience? Nothing. I was thoroughly indignant, even comparing historians with male gynecologists, "operating over the body of woman."

Analyzing Lacan's essay on Edgar Allan Poe,[25] I charged that "orgasm is the narrative and psychoanalytic trajectory of this essay, usually noted only for its visual schemata" (95). But the angrier I became, the worse I felt. Self-pity crept in. I concluded that, "like Susan Alexander [in *Citizen Kane*], endlessly putting together jigsaw puzzles in a mansion of isolation and plenitude, women readers encounter the same versions of their absence, of denial" (96), in theory and in history. Women's job is "to read against the grain of great enunciators."[26] I combined what was, for me, a sewing metaphor with Adrienne Rich's idea of "re-vision": "This is more than a chapter in cultural history; it is an act of survival."[27]

Finally, I asserted that "'woman' is not the problem. It is history, the cultural histories which Freud, for example, heard but refused to record or acknowledge as important" (Mellencamp, "Film History," 102). I began with an argument similar to my position today: "The female body is *there* and has always been there in history as a presence rather than a trace, fantasy or absence. Women are always more than masquerade, mother, or mystery—that *lack* of clarity and truth" (Mellencamp, "Film History," 92).

My coeditors voted not to include the essay in *Re-Vision: Essays in Feminist Film Theory*, perhaps because they thought it was mediocre. Maybe it is.[28] But I had no idea how fascinating Lacanian psychoanalysis was to feminists, how invested women were, and continue to be, not in its unraveling but in its reraveling. For example, in 1994, Teresa de Lauretis and Lynda Hart repositioned their arguments in relation to it—lesbian revisions.[29]

Today I still take inspiration from Adrienne Rich. Rather than becoming fascinated or infuriated by women's absence in men's texts, I prefer the

delight of finding women in history, which is ongoing, in the present. However, I think I was right about Lacan and feminism and early film theory, which ignored women of all colors.

IN RETROSPECT

It was 1980. Little had changed. Historians and most theorists still ignored women. It was virtually impossible to find publishers for critical theory, let alone feminist criticism. The six previous years of intense organizing and conferencing that had taken up so much of my energy should have had more impact. I had lost hope, to say nothing of my sense of humor. Like Dorothy Hewett, "I was already well on the way to becoming that most dangerous and humourless of creatures, a martyr to a cause."[30]

I didn't heed the good wolf, the Virginia Woolf, who forcibly talked money, work, and knowledge in *Three Guineas* (1938), rather than sex and power, and urged us to "shut the bright eyes that rain influence, or let those eyes look elsewhere."[31] Or the wizard Foucault, who saw through repression as the invisible cloak of sex—the emperor Freud wearing no clothes. Deleuze and Guattari railed against Freud's singular answer of Oedipus and castration for everything. Rather than sex being repressed, as Freud argued, we were obsessed by it, speaking about it constantly.

Context, however, was critical. The 1970s was a time of opposition, of dualities, the Right or the Left. Either you were for the war or you were against it. Other political and personal choices then fell into line. It was also an era of secrets, lies, surveillance, and cold war paranoia—to say nothing of the deceptions about Vietnam. Because nothing was what it appeared to be (for men, this included women), we needed to dig beneath the surface. Theories of the 1970s were systems to decipher these narrative codes, and paradoxically, theory was itself a lingo, a new code that needed deciphering.

Let me briefly set a theoretical scene. Recall the emphasis Roland Barthes placed on secrecy at the core of the hermeneutic code: story meant secrets, usually sexual secrets linked to identity.[32] For men, women were the secret, or were duplicitous. The secret triggered the pursuit of the truth, which was delayed, hidden. The job of narrative was to conceal; the job of critic and psychoanalyst alike was to extract the latent story from the unconscious through clues. Psychoanalysis, the talking cure, favored narrative, not performance (symptoms like those of hysteria), or what Barthes disparagingly called the "proairetic" code.

What fascinated Lacan in Edgar Allan Poe's "The Purloined Letter" was not what Poe's master detective, Dupin, told us but what the story didn't tell us.[33] In Poe's tale of a letter that passes among men in an attempt to

blackmail (and then save) a woman, the contents of the letter, which are never revealed, don't matter to the story or to the reader. That the letter is hidden in plain view, amid other letters (Poe's lesson and moral), was of little interest to Lacan. Lacan focused on what we didn't know, what we didn't see, to a degree one-upping Poe by not being fooled by his sleight of hand. Thus the realm of the imaginary signifier—linked to women, to female sexuality, to duplicity, to secrecy—was inaugurated. In this realm, like the CIA in U.S. foreign policy, the (male) critic was omnipotent.

Taking our clue from Lacan along with Hitchcock (who had his own magician's sleeve, "the MacGuffin"), we imagined that women were all form, signifiers of glamorous mystery, a masquerade. Females represented conceit and deceit. We presumed that the thoughts and emotions and actions of our daily lives didn't matter. We watched hard-working actresses on the screen while declaring women's absence as subjects. Our focus on the sexual economy and women's lack was, however, only half the story. We avoided the money economy, leaving that up to men, film's (business) historians. We were off chasing dream girls and sexual secrets. Ironically, our focus was on men, on male subjectivity, on men's thoughts. Like the romantic heroine, our thoughts were preoccupied with "him."

Instead of Lacan's (and Barthes's) emphasis on the form of secrecy, I prefer Deleuze and Guattari's analysis of the form and content of secrets, linked to psychoanalysis and Oedipus: "The secret as content is superseded by a perception of the secret . . . an eminently virile paranoid form. . . . After the secret has been raised to the level of a form . . . an adventure befalls it. . . . The news travels fast that the secret of men is nothing, in truth, nothing at all. Oedipus, the phallus, castration . . . that was the secret? It is enough to make women . . . laugh."[34]

Or as Wittig sees the "psychoanalytic situation": "When the general state of things is understood (one is not sick or to be cured, one has an enemy), the result is that the oppressed person breaks the psychoanalytic contract." For her, the psychoanalytic contract (which covers political and social institutions) "was not a contract of consent, but a forced one."[35] Seeing ourselves as the seen rather than the seer, as the object rather than the subject, might not have been as empowering as it initially appeared to be.

Cryptofeminists

SPECTATOR OR SPECTATRIX?

In 1987 or 1988, *Camera Obscura* wrote to many feminist film critics, asking for our responses to the current status of "female spectator," a concept being challenged, as feminist principles are wont to be. Now, seven years later, my answer would be the same. Here is what I sent.[36]

Enunciation, the theoretical and real connection between text and spectator, still makes a great difference, particularly now that feminism has been declared old hat by postfeminists. White women and women of color in the audiences of films and television, often across national boundaries, know when they are included—rare experiences of recognition and shared identifications. If the female spectator has been deemed a weary notion, then I have missed the outpouring of works that have specifically addressed women. I want to preserve but alter this female spectator, perhaps changing her name and adding new adjectives to better describe her. Contrary to Freud's admonitions to a woman "no longer young," the female spectator is not too old to yield new insights or to change.

The eternal female spectator, whether theoretical or historical, like the female star is still unwrinkled, smooth—in short, young. A calculus of difference of at least ten years functions to women's disadvantage. Men, unlike women, have mobility across the generational divide, as the sanctified coupling of the older man with the younger woman illustrates. She is thin and, as women of color and literary feminism began pointing out, white. Another issue for me has been the place of "mother," as well as "daughter," and the complexities of being both at the same time—the discursive void for Freud and much of cinema.

Spectator, derived from the Latin *spectare*, "to behold," "one who sees or beholds a given thing or event without taking an active part," has the same etymology as spectacle: "something to look at . . . presented to view as extraordinary." The definitions include denotations of active/passive and

elide subject and object, the looker and the lookee. What Mulvey did, after Freud, was to split and gender these terms, turning the extraordinary thing or event into a woman and the beholder into a man. Taken together or seen as contradictions, subject and object can shift in a mutual tension between actant and object (obstacle or goal)—as happens in shot–reverse shot.

Even more intriguing is the term after spectatorship, "the act of spectating." Gender appears as *spectatress* or *spectatrix*, "a woman spectator," revealing that *spectator* is a masculine construct, in need of an adjective to instate difference. I wonder why "spectatrix" has never been adopted. Perhaps it suggests sadomasochism (as does the Freudian model). Perhaps "spectatress" is too close to the subservience of "mistress." Perhaps it would reveal oversights and blind spots that notions such as "audience" or "spectator" or "viewer" cover up, smoothing over social, historical, racial, chronological, economic, cultural, and sexual differences. I rather like the thought of being a spectatrix, affected as it at first seems. As Virginia Woolf, older and angrier, ironically and insistently wrote in *Three Guineas*, trained differently in mind and spirit as we are from men, we see the same world, but we see it with different eyes.

However, we still need an adjective; for me, a white spectatrix, the act of spectating is not the same as for a spectatrix of color. When I am in my fifties, it will change even more. Over time, my relations with the same movie will also change. When I am seventy, I will see *Stella Dallas* (Samuel Goldwyn, 1937) very differently. With whom will I identify? Perhaps no one. But I am sure I will empathize with loss, with being alone, and with letting go. I will always experience great discomfort during the scene when Stella makes a fashion spectacle of herself, wearing all the wrong clothes; for in that drama of class difference (and upward mobility) between the mother and the daughter, great emotions, great unfinished dramas, lie.[37]

Spectacles also means "a pair of lenses . . . worn in front of the eyes to improve the sight or correct errors of refraction." It would be nice if we could correct the errors of history with new optical prescriptions. At the least I would urge women to take off their rose-colored glasses. My interest in spectacles, explored in my first published essay, "The Spectacle and the Spectator," began with glasses, which, cross-eyed child that I was, I wore from the age of one. I wore my glasses when my grandmother read bedtime fairy tales to me, in order to hear her properly, suggesting the fallacy of separating spectator from auditor. The deep bias of film theory is its singular dependence on the dominance of vision, linked to power and knowledge, where "to see" means "to understand."

I am always amused by Hitchcock's linkage of women and glasses, knowledge and narrative, with the mystery of male sexuality as the female character's narrative enigma. In the opening scene on the train in *Suspi-*

cion (RKO, 1941), Cary Grant's look at Joan Fontaine is emphasized by two intercut tilts. The first begins on her practical, laced shoes and moves up her legs, stopping to focus on the book she is reading, *Child Psychology*. (The imaging of men as perpetual adolescents has been as great a problem as women being equated with their bodies. But they do seem to go together.) His glance resumes on the book, concluding with her face. She is wearing glasses and is thus asexual. Throughout the film, which investigates his character, she refers to him as a child. Right on; psychoanalysis is determinedly a theory of childhood—perhaps explaining the outpouring of male regression films in the 1980s, where the difference between the men and the boys is only genital.

In Hitchcock's *Spellbound* (David O. Selznick, 1945), Ingrid Bergman, a psychiatrist, investigates male mental illness—or sexuality (maybe impotency)—by putting on her glasses, going to her library, and reading psychology books on the Oedipus complex. In *Stage Fright* (Warner Brothers/ABPC, 1950), Jane Wyman begins her investigation of male perversion (and Marlene Dietrich's female sexuality, with Hitchcock restaging Josef Von Sternberg's mise-en-scène from *Blonde Venus*) by donning glasses with wildly distorting lenses. Teresa Wright as Charlie in *Shadow of a Doubt* (Universal, 1943) doesn't wear glasses, but she takes a frightening, edited, crescendoed, shadowed walk to the library to research Uncle Charlie's sexual perversion of murdering wealthy widows. Like Hitchcock's adventurous women in the 1940s films, feminists have donned their glasses and gone bravely to the *Standard Edition* to research male subjectivity.

However risky these 1940s encounters with male sexuality, feminists should be even more forewarned by Hitchcock's later films (which are *very* different). We know the increased risks for women of looking and knowing in *The Birds* (Universal, 1963), where Melanie is reduced to hysterical catatonia; in *Vertigo*—after the film shifts to Judy's look of knowledge, her death follows—and in *Rear Window* (1954), although Lisa does get the film's last look at the fashion magazine. Lisa isn't dead because Grace Kelly was too respectable, too thoroughly upper-class really to have anything to do with sex. Besides, what could Jeff do anyway, encased in his body cast as he was? Kim Novak and Tippi Hedren were, at heart, less classy women. Exploring male sexuality à la Freud, the terrain of much feminist research, can be dangerous or unhealthy.

SILENCE OF THE LAMBS

In *Silence of the Lambs* (Jonathan Demme, 1990), the notorious "male gaze" of feminist film theory is menacing.[38] Seeing as aggression—wielded on characters in the film and on us, the spectator—is so pointedly repre-

sented that vision itself becomes a character, a loose cannon, terrifying us with hints of sights we might and don't want to see. Each fearful sight assaults us with a sudden, loud sound (along with death, the only primal, real source of fear). Prior to the autopsy scene, Clarice Starling (Jodie Foster) is trapped by the gaze of the policemen who surround and tower over her. During the autopsy, we are threatened by potential film cuts to the mutilated body.[39] But the film doesn't look until Starling has control of the situation. Before that it only teases, frightening us through sound (of flash-bulbs popping and body bags being unzipped) and image (close-ups of men's faces looking at what we fear we will have to see).

Hannibal Lecter deduces much about Clarice from her appearance, from the way she looks (pun intended). At the film's end, Starling looks for Buffalo Bill in his dungeon, a set out of Dante's descending circles of hell. The killer can see in the dark with his special glasses. He turns off the lights and she cannot see anything. From inside his face (or under his skin), we hear him breathe and watch him pursuing her.

Vision—which also enacts *aversion* (at the movies we look *and look away*)—provides thrills and clues. But vision is partial, yielding symptoms not explanations. Vision is of little help in the dark. And we cannot see beneath the surface of the body (except with sonar, X-ray, iconoscopic, or magnetic technology), which, like vision itself, provides only clues, not answers. The body becomes evidence, with photographs of mutilated corpses and decayed bodies. The body is a sack of skin that Buffalo Bill is flaying and stitching together—a perverse masquerade. The body has little to do with identity and sexuality.

I suspect, however, that first-generation feminist film theorists might disagree. Vision, tied to sexuality, continues to dominate the texts (and minds) of subsequent generations. Carol Clover's *Men, Women, and Chain Saws* is a lively expansion of psychoanalytic film theory—through horror/slasher films.[40] Through the relation of male spectators with female victim-heroes in the horror genre, Clover presents a model of male masochism. She updates (a make-over) the film spectator who, like MTV, crosses over gender boundaries. Male spectators' process is "feeling-through-the-woman" (235), presumably an improvement over groping her body in the movie theater.

Going back to a well-known passage from Christian Metz's *The Imaginary Signifier* in which he presents a model of double vision, of projection *and* introjection, Clover asserts that Metz, and then feminist film theory, failed to develop the second half of his model—introjection. The real investment in horror/slasher films is "in the introjective position, figured as both painful and feminine" (212). She ties this to Freud's "repetition com-

pulsion" and then to masochism[41] (paralleling projective looking's elision with sadism).

However, while not emphasized in Laura Mulvey's short essay, *Visual Pleasure and Narrative Cinema*,[42] this doubled process was central to notions of the cinematic apparatus, a cornerstone of contemporary film theory developed in the early 1970s. (Mulvey's was one of several influential formulations, e.g., those of Baudry, Comolli, Stephen Heath, Peter Wollen). Particularly pertinent to feminism was John Berger's 1972 doubling of vision for women—both looking *and* watching oneself being looked at—along with Foucault's figure of the panopticon that depicted the prisoners *and* the central tower, shot–reverse shot.

Perhaps in the period of cinema that Metz (and most first-generation feminist film critics) drew on, Hollywood in the 1930s and 1940s, the "introjective look" was not as prevalent a style. I suspect that the technique has as much to do with film history as with genre. The introjective model has historically appeared as (1) *spectacle or attraction*, a staple, if not defining trait, of early cinema (the appended shot of the cowboy shooting his gun out at the audience in *The Great Train Robbery* [Edwin S. Porter, 1903]), (2) *the close-up* (slashing the woman's eye in the first twelve shots of *Un Chien Andalou* [Luis Buñuel/Salvador Dali, 1928]), and (3) *the fragment and partial view*, more than the overview and master shot (the establishment shot) that locate, rather than dislocate, us in space.

Technology and technique are economic lures used to attract competing audiences. During the 1950s, comparable to the period of early cinema, the film studios and movie theaters used color, wide-screen, and 3-D films to compete with television for audiences. For exhibitors the 1950s was another period of cinema attractions. The look back or out was perfect for 3-D, in shots, like those of Hitchcock's *Dial M for Murder* (Warner Brothers, 1954), that reached out and grabbed the audience by the throat. Viewers reported being scared by images coming out at them, as did the viewers of early cinema. Not surprising, 3-D is back in 1995 in an Imax film, *Wings of Courage*, directed by Jean-Jacques Annaud (*Quest for Fire* [Canada/France, 1981]), with "high-tech liquid crystal glasses instead of the old cardboard type, and the giant 80 foot Imax screen, which dissolves boundaries and makes the viewers feel like they are in the movie."[43]

Clover does not like *Silence of the Lambs*, which she describes as "the most nakedly horrific" film (232) and uses to cap her argument in an afterword.[44] It is "in your face," "aiming knife-stabs, gunshots, Lecter's lunges, and Lecter's stares straight into the camera and straight at us" (233). However, *Silence* has little to do with sexuality tied to vision—which is more of a macabre lure, a shocking attraction. The film is about male perversion

and its fascination for smart women. The unconscious is as terrifying as it was for Freud in "The 'Uncanny.'" Men's spaces are dark and threatening—FBI agent Crawford's high-tech office and plane with banks of computers and other signs of technology and power; the black, tomblike prison cell of Lector; and finally, the filthy catacombs of Buffalo Bill.

Voyeurism and exhibitionism, sadism and masochism, terms casually applied to the movies, are not innocent pastimes. They are perverse, criminal, deadly. When Clarice walks down the prison corridor to interview Lecter, psychoanalyst/cannibal, she walks past an embodiment of "the male gaze," a gamut of criminal perversity leering at her, making lewd remarks. Horror is the very stuff of psychoanalysis (and of everyday life). Psychoanalysis, like the sought-after unconscious of the surrealists, is not just metaphorical but dangerous. To realize the film theory we write would be a nightmare, a horror show.

Despite the palpable presence of "vision," of sights, theories of vision dependent on scopophilia—desirous sight—are only partially useful in analyzing this film.[45] "Epistemophilia," the desire to know, wherein *thought* becomes obsessively pleasurable/painful, drives the characters and the narrative. This is the source of Starling's, Lecter's, and our curiosity, our pleasure/fear—she as the detective, he as the psychoanalyst, and we as the film spectators/auditors. But as Peter Wollen has noted of Hitchcock films, the roles of criminal, victim, and detective constantly switch within the narrative.[46] (For example, in *Vertigo*, Madeleine/Judy is initially a criminal and then the victim; Scotty is the detective/victim, then the criminal.) Just so, in *Silence* the roles of detective, analyst, and spectator switch between characters and the audience. Furthermore, our response to vision is determined by what we know and what we expect. Wollen's three spectator relations are helpful: for mystery, we know and the character knows; for suspense, we know but the character doesn't know; for shock, neither the character nor we know.

Obsession (of the deadliest kind) drives the killer, Buffalo Bill. The film investigates the logic of serial killers who are driven to murderous repetition by compulsive thought. The thought has emerged from the unconscious, entered the mind, and been unleashed on the world. Obsession is addiction taken to its logical conclusion, which is deadly. *Silence* can be analyzed through a theory of obsession, of anxiety, not desire, a Freudian model that is predicated on thought more than vision, on fear of the dark and the unknown/the unseen more than visual pleasure. For this is what horror films produce: the thrill of terror, the unconscious as the repository of fear—of death, of sex.

Obsession does not depend on repression (and the unconscious, although Lecter and Clarice's dramas are lodged here). The same is true of

the case: everything regarding Buffalo Bill is right on the surface, hidden like the purloined letter. As Poe and Dupin, the detective in his story, know, the most brilliant tactic is hiding something out in the open. While Lacan's reading of Poe reverts to the sexual drama of vision, to scopophilia and voyeurism, Dupin, the detective, solves the crime by figuring out the minister's logic, the way he thinks.

Hannibal Lecter's pleasure comes from epistemophilia; so does Clarice's. She is taught by Lecter, who tells her, "It's all in the case book. First principles, look at what is there." The first murder, a hometown murder, contains the clues for the rest. Buffalo Bill knew the first victim. When Clarice begins to look at first principles rather than at deep structures, she finds her answers. Serial killings operate on the compulsion to repeat, exactly, again and again. They cannot stop; they must continue. Clarice returns to the scene of the first crime, a primal scene, and finds the killer.

The sexual pleasure of thought drives obsession—and this film. Two brains, Lecter's and Starling's, are matched against each other. Lecter manipulates and controls through words, puzzles, and stories. He kills "Multiple" Miggs, the offensive prisoner in the next cell, through words. What excites Lecter the psychoanalyst is story as clue to the puzzle of identity — the quid pro quo he extracts from Clarice. He understands the strength of transference and the hierarchy of "the talking cure." His superior knowledge is his power.

Silence is about the centrality of knowing, listening, and hearing. While this is a film of extreme close-ups of faces, thought, more than emotions, is portrayed. Sound intensifies fear. Starling's story of the massacre of the sheep, the "silence of the lambs," is her primal scene triggered by sound, the bleating of the lambs. As we know from her interviews with Lecter, Clarice is a good listener. She remembers and pieces together clues from his words. Clarice's greatest skill—hearing—saves her. Although she cannot see Buffalo Bill, she hears the click of his gun behind her head, turns, and blindly fires, killing him.

Although at the graduation ceremony, the film intercuts an extreme close-up of Crawford and Starling's handshake, there are no other hints of romance. She refuses dates and advances, for example, from the cross-eyed moth scientist, with "Are you hitting on me?" Earlier she turned down Chilton. Clarice is not interested in romance; she is absorbed in her work, in knowledge. She is ambitious. We watch her deduce, then act. We see her think, which is her pleasure. Starling investigates male subjectivity and sexual perversion—in order to free herself from its constraints.

The investigation is not an excuse for a heterosexual love story. This woman is self-sufficient, looking to herself for strength. (Clover sees Starling as "masculine in both manner and career, uninterested in sex or men,

and dead serious about her career"—which she sees as *negative!* Just reverse the meaning—"feminine in manner and career, interested in men and sex, and barely serious about her career" and what we have are dream girls. Why would this be our goal?) Starling's relationship to men is that of a student. Lecter is her mentor until she deceives him, thereby outwitting him; Crawford is her academy teacher until she surpasses him (in a clever moment of intercutting). She is ringing a doorbell while his armed swat brigade is breaking into a house. She is alone; he is surrounded by technology. Cut inside. Cut outside. The FBI has the wrong city and wrong house. She, not Crawford, finds Buffalo Bill. She is alone.[47]

Starling uses her brains and sheer courage more than her body. Neither she nor the film exploits her appearance. Her body is strong, not agitated. From her opening and menacing jog, she is alone and becomes stronger. Surrounded by good and bad fathers, she uses her very smart mind; she is not dominated by fear or dependency or inadequacy. She is not rescued, she rescues, in the end.

But the end doesn't tie up all the loose ends, although it feels satiating. (Perhaps the "happily ever after" of the couple is so culturally determinant that it is the *only* ending of resolution.) With Lecter on the loose, in pursuit of Chilton in the Caribbean, and Clarice's memory of the slaughter of the lambs and her father unresolved, there will surely be a sequel. I suspect it will still be set in a man's world—which she will master. After all, Agent Starling has learned her lessons well and graduated. She has entered the arena of male subjectivity, law enforcement, which, presumably, she can now control.[48]

As if to answer Clover's charge of her being "masculine" (to say nothing of the many rumored "outings" of her by lesbians), Foster posed in a sultry May 1994 cover on *Vanity Fair*, "Jodie Rules: Jodie Foster Lets Loose and Takes Control," in a silk slip. The piece was publicity for *Maverick* (1994), which partially explains the accompanying glamour photographs by Steven Meisel. In one provocative shot Foster wears only black leather slacks—modestly covering her breasts with her arms. In the others she wears lingerie. But these are classic glamour shots, high fashion poses. Foster is a beautiful, attractive, *feminine* woman here. As important, Foster has taste, unlike Madonna. During the interview setting of Foster's workout walk (like the opening of *Silence*), she points out Madonna's garishly painted house to the *Vanity Fair* interviewer (170). (Meisel also took the infamous naked photographs of Madonna.) Two women in control, in very different ways.

Foster's being alone and liking it, her "adamant refusal to talk about her love life," never disclosing a romance, is the opposite of Madonna (and res-

onant of her recent film character, *Nell* [1994]). Foster has discretion, along with taste. The question is: Along with being an actress, can she "become a major player in the business"? "So far, no one ever really has" (167). For Foster, "If I fail, at least I will have failed my way. . . . The company is pretty much me" (172). Similar to Madonna's deal with Time/ Warner, Foster has her own production company, Egg Pictures, "financed with $100 million from PolyGram Filmed Entertainment" (168). She is the "third highest paid woman actor in Hollywood, after Julia Roberts and Whoopi Goldberg" (167), a record which Demi Moore appears to have beaten in 1995. "Foster's shelves are lined with scripts; five lieutenants spend their days worrying about what Jodie wants."

BASIC INSTINCT

Sharon Stone answers the old question of what women want in her analysis of her *Basic Instinct* character, Catherine Trammell: "Being able to decide what you want and being unashamed about making it happen. . . . Most successful businessmen are in that zone. 'No' is never perceived as the end of the line. 'No' just means picking a new avenue." She said of Trammell: "I never thought the character really cared abut sex at all. That's why it was so easy for her to use her sexuality—it had no value."[49] (Perhaps this is true of Jody Foster, in another way.)

For Callie Khouri (screenwriter of *Thelma and Louise*), "Hollywood is trying to resexualize its women back into submission. This whole idea that women are powerful because they're sexy is a crock. Sex isn't power. Money is power. But the women who do best . . . are complacent . . . in the role of sexual commodity, be it Madonna, Julia Roberts or Sharon Stone."[50]

Like *Silence*, *Basic Instinct* (Paul Verhoeven, 1991) has been reviled because of its representation of lesbians as serial killers. Roxy, Catherine's girlfriend, killed her brothers, while Hazel Dobkins (Dorothy Malone) wiped out her family. And Catherine Trammell (Sharon Stone) is suspected of murdering her parents and her male lovers. Lesbianism is portrayed as an attraction, a lure, a titillation. Negatively, lesbianism is a turn-on for Nick (Michael Douglas). Positively, lesbian sexual innuendo, which is all there is, is infinitely more erotic than the film's big heterosexual bangs and climaxes.

Although lesbian feminists aren't uniform in their reactions to this film any more than are hetero-fems, two critics view the film as important. "From a lesbian spectator's position, I don't think there are *any* lesbians in *Basic Instinct.*. . . Nevertheless, *Basic Instinct* is surely a homophobic film."[51] Adding race (Catherine's whiteness) and age (Nick's) to the read-

ing, Chris Holmlund, on the contrary, asserts that "lesbian audiences found it easy to 'see' the lead character as lesbian."[52]

Trammell senses the "homicidal impulse" in Nick (Michael Douglas). He is a cop who has liked killing; hence his nickname, "Shooter." (Subtlety, like clarity, is not part of a Joe Eszterhas screenplay.) At issue again is the pleasure of killing, of masochism and sadism, of being hurt and hurting sexually. The setting is San Francisco—wealth, mansions, beige postmodern spaces alternating with dark discos, muted, soft Armani tones mixed up with black leather and black sport cars. The sadomasochism is upper-class and right on the surface. So is heterosex. In this film everything is up front, including Catherine's sexuality (which is also, for men, her guilt). Nothing is hidden, except perhaps the answer to the central question—Who did it?—and lesbian sex, transforming the film's enigma into "Who did what?"

Catherine Trammell is blonde, rich, tasteful, and very white indeed. Everything around her is pastel, except places where she is with men. Bernard Herrmannesque musical tones inflect subjective tracking shots and cuts to high-angle shots; this film feels and sounds like *Vertigo*, but with a significant difference: class. Trammell has money, education, good taste, and a wise mouth. She talks back. (Madeleine rarely spoke; she existed; her crime was being working class, being Judy.) At Catherine's mansion the detectives see a Picasso; the murder victim whom they have just left also had a Picasso in his house. "His-and-her Picassos. Hers is bigger." Hitchcock must be laughing. The film has plenty of sex and drugs, addictions along with obsession. Violent sex (hetero and homo) and death go together, at least for Freudian psychoanalysis.

The first woman we see is Roxy (Leilani Sarelle), Catherine's lover, her look-alike. Although Catherine appears to be running the show, events and characters are seen *from men's vantage point* (which is very limited). For Freud, this male gaze is very threatened by women's "lack"; it suggests castration to the hapless male viewer, making this the perfect film for "apparatus theory." During the police interrogation of Catherine, she recrosses her legs and flashes her genitals. Lacan/Freud's imaginary scenario of castration becomes real! Yikes! Cut to policemen, *very* nervous.

Unlike Madeleine/Judy in *Vertigo*, Catherine tells us that she has knowledge and that she, not the detective, Nick, is writing the script. (They, and we, are not sure whether to believe her or not. Whether vision or voice is true is up for grabs.) As she says, "I know you." She is hiding out in the open. Neither does she have romantic illusions: "I wasn't dating him. I was fucking him," she says of the dead rock-and-roll druggie, murdered in bed before the film begins. Catherine is a writer, very smart (magna cum laude, Berkeley, 1983, where she majored in literature and psychology) and very

rich (she inherited $110 million when her parents were killed in 1970). Her body, brains, and especially her money and refined taste grant her power. She tells the detectives that money can buy a lot of friends and information.

As we learn from Nick's initial visit to his brunette psychotherapist/ lover, Dr. Elisabeth Garner (Jeanne Tripplehorne), he is a semirecovering addict—no drinks, cocaine, or cigarettes for three months. In a strange reverse, psychoanalysis is equated with women, who use it to manipulate men. Psychoanalysis fuels Catherine's story. Just as she published a novel describing the murder of the rock-and-roll star, so she is writing about a detective, with research on Nick, particularly his past shooting of two tourists. When Nick asks what the book is about, she replies "A detective. He falls for the wrong woman." "What happens?" "She kills him." This is Nick's trauma, as was the suicide of his wife, who knew he was on cocaine. Catherine seduces Nick with his own weaknesses, his addictions. To his "I quit" she replies, "It won't last." Soon he is smoking and drinking, particularly after sex, which is his obsession.

In the famous interrogation scene, the sight triggering fear of castration, Catherine is surrounded by the male gaze—a semicircle of policemen. However, she is like the guard in the central tower of the panopticon who can see the prisoners silhouetted in their surrounding cells. She sees through the men, deflecting their gaze. She knows them, uses their weaknesses, which include their attraction to her. They ask her to stop smoking. "What are you going to do, arrest me for smoking?" While she postures for their look, flaunting herself, she throws their desire back, taunting them as she talks of pleasure: "I like men who give me pleasure. . . . Would you like a cigarette, Nick? Have you ever fucked on cocaine, Nick?" When her lack of emotions is pointed out, she responds, "I'm a writer. I use people for what I write. Let the world beware."

Catherine refuses to be guilty, refuses to be shamed. She lures men with her body, sets them up with her mind, and then does them in. (Later, Nick will be questioned in the same space, even with the same smoking line. However, he is nervous. He is lacking. He is the romantic. He suffers.)

Nick's addictions go wild after his interrogation scene. Nick rampages around, out of control, driven by his insatiable desires. He drinks, almost rapes Beth Garner, and smokes constantly. Catherine is running the show completely, using his obsession—another name for male desire, which she understands and manipulates. Nick later says, "She's coming after me." And she is. She can outdrive him and escape him whenever she wants to. She lures him. He watches, often when she is undressing. She is like the power of an addiction. He cannot help himself. "She knows. . . . She is screwing with your head," says his partner. Catherine: "Pretty soon I'll

know you better than you know yourself." "My wife used to call me Nicky." "I know." "What do you want from me, Catherine?"

Nick, of course, believes she is guilty—until after sex, what he thuddingly calls "the fuck of the century." Denial sets in, the addict's mechanism. He falls in love and dreams of a family and children. Male ego is weak precisely because it knows no bounds. She: "You shouldn't play this game." He: "But I like it." She: "I'm not going to tell you my secrets just because I had an orgasm. You won't learn anything I don't want you to know. You'll just fall in love with me." Which, of course, he does. More important, after sex with Catherine, Nick begins to shift the blame to Beth Garner, as Catherine obviously knew he would do.

Sex and death are literally connected. Nick's partner asks him, "Do you want to die? Is it because of the tourists?" But that's the nature of drug addiction—the courting of death, the desire to die. Nick wants to "fuck like minks, raise rug rats, and live happily ever after." Romance and addiction are elided for pathetic Nick. She says that ending won't sell: "Somebody has to die." He: "Why?" She: "Somebody always does."

The film investigates Garner's college relationship with Trammell (who has finished her book). We only *hear* about their past as students, and presumably lovers, at Berkeley. Although we never see Beth and Catherine together, each tells the same story of the other's obsession. Unlike the false trail of the painting in *Vertigo*, this is the real enigma—which is never solved.

Lynda Hart's focus is the doubling and mirroring of these two central women. "It is the complicated relationship between these women that produces the film's horror. It is not so much what they do individually that makes for the film's gripping suspense as it is the mystery of their relationships with each other" (Hart, 128). For Hart, the film leaves unanswered two questions: Who took the other's identity? and Who is the killer? (In other words, Who did it?) "The identity of the killer is never satisfactorily resolved," Hart argues. But "the film's inability to detect which woman might be the real offender" is what interests her. "When we ask the film to tell us who did do it, the only answer it can give is that the *women* did it" (Hart, 130). Generically speaking, women, especially lesbians, are deadly.[53]

While I agree with Hart's insightful analysis, I also think the ending tries to make it clear that Catherine did indeed do it. (And if so, it would give Nick very good reason to "display the systemic homophobia of masculine heterosexual desire" [25, 134], which is Hart's main argument.) Catherine tells Nick the ending of her book: "She kills him. Goodbye, Nick, your character's dead." The brutal murder of his partner and then the murder of Beth lead up to the last scene, and Trammell's presumed innocence, in

Nick's apartment. This time she asks, "What do we do now?"—not a typical question for this character, her passiveness a dead giveaway. The ritual sex scene–murder that opened the film plays for the third time. No ice-pick stabbing. They kiss. Fade. Kiss again. Is this the couple together, happily ever after? The camera pans down, under the bed, to reveal, in close-up, an ice pick—the murder weapon. (Is she just using him for her gratification? Hmmm.) The end.

Or . . . a sequel? This is the economic impetus of the male imaginary—another screenplay for millions of dollars, just as Joe Eszterhas received for this one, the highest price ever paid for a screenplay. Not answering the question is a matter of men and money, not women and sexuality.

THELMA AND LOUISE

In December 1989, *Time*'s cover story "Women Face the '90s" recapitulated: "In the '80s American women learned that 'having it all' meant doing it all, and some look back wistfully at the simpler times before women's liberation. But very few would really like to turn back the clock."[54] The cover story argued that women were going backward—toward home and the family, so exhausted by work that "they dream nostalgically of the 1950s." "Is the feminist movement—one of the great social revolutions of contemporary history—truly dead? Or is it merely stalled?"

This question has persisted through the 1990s: Is feminism over or not? Feminism is accused of ignoring child care, health care, and women of color. Statistics prove that the movement was successful in women's education and work. The debate escalated, and feminism again became an event.[55] In 1991, Susan Faludi published *Backlash*, receiving her *Time* cover with Gloria Steinem on March 9, 1992, "Fighting the Backlash against Feminism." The two women wore jeans and black sweaters and posed almost like guys. The other "strong women" covers belonged to actresses: Jodie Foster, actress turned director (October 19, 1991); and Candace Bergen, a.k.a. Murphy Brown (September 21, 1992). Faludi, Naomi Wolf, and Camille Paglia became new feminist celebrities, arguing for feminism and against each other.

The time was ripe for the June 24, 1991 cover of Geena Davis and Susan Sarandon as Thelma and Louise: "Why *Thelma and Louise* Strikes a Nerve." The film was an event. It triggered impassioned pro and con debates about women and men, women and violence, whether the film was feminist or not and what brand of feminism. For Margaret Carlson it is a "male buddy movie" starring women: "For all the pleasure the film gives women who want to see the opposite sex get what's coming, it can hardly be called a women's movie or one with a feminist sensibility."[56]

Carlson misreads the film in the same way I did at my first screening. I was irritated by Thelma and Louise's bungling and stupid narrative mistakes, such as talking too long on the telephone and, the big error, not guarding the money. Carlson is furious because they "make the wrong choice at every turn," particularly regarding men. But on second and third screenings I understood differently. Only later in the film do Thelma and Louise, both working-class women, realize they can make choices and must take responsibility for their actions. Their happiness is not up to husbands, parents, or children. It is up to them. This is the self-knowledge that feminism gave me, and this is what Thelma and Louise learn.

In *Thelma and Louise* the first shot (and the last) is of the road, in the West.[57] Neither "the road" nor "the West," both emblems of adventure, has been a space for women's movement. In both genres women were static. In the western they were confined to the schoolroom, the saloon, or the ranch kitchen. Rather than taking to the open road, as male authors did, women remained behind, waiting; or they were way stations for the men along the road. But Thelma and Louise are on the move. The Thunderbird convertible becomes an icon of freedom (and Louise is a great driver). The car is a place of talk and friendship that leads to insights. Lynda Hart suggests it is also a place of female intimacy.

The black-and-white photo of the opening image turns to color, the camera pans up, the image darkens. Is this the road to nowhere or the road to freedom? Are they running away or moving forward? Or both? The film runs along two tracks: the linear narrative, the outer journey or chase, accompanied by dramatic camera work and male icons and symbols and directed by Ridley Scott; and an inner journey into feminist self-awareness, revealed by gesture and appearance and written by Callie Khouri. What the men back home imagine is different from what is happening to Thelma and Louise. They are coming together more than running away, facing reality rather than escaping it, becoming self-reliant and heroic rather than helpless and scared. The journey, more than the destination, is what matters.

The move from dependence on men to female independence is marked by numerous stylistic touches. As Thelma and Louise change, everything around them changes, even the density of the air. *Thelma and Louise* moves from clutter and confinement to open space, from noise and city trucks to silence and the desert, from high-necked blouses and skirts to open necks and jeans, from coiffed to loose hair, from stasis to movement, from indecision to decisiveness. They look and act completely different at the end. The film mirrors their internal state; it reflects their thoughts. The deafening sounds of the trucks' horns after the rape/killing outside the Silver Bullet Bar are blaring, frightening, like their confused minds. They

pass through hard-edged, loud, transient spaces—motels, gas stations, truck stops. The rock and country songs on the track play out their lives. Gradually the film becomes quieter, as do Thelma and Louise, until it reaches the solitude and soft focus of the end.

They travel through a dangerous gamut of sexism. Men have been separating women for years—a scenario replayed through Daryl, then Harlan, then J.D. They are all *bad* choices for Thelma, which she, like so many women, continues to make. Believing they cannot make it without men, no matter how pathetic the man, women give their lives away, often without knowing how it happened. Here, however, each encounter with men is a lesson that threatens their very survival. But they do learn, they do change. As "the law" and men lose control over women, they up the ante and the technology. (While debate raged over the women's small guns, there was no debate over the FBI bringing in an armory at the end.) Parallel editing to the escalating and cowardly actions of the police and Daryl (now the men are in confined spaces and the women are on the road) shows us what Thelma, particularly, is escaping.

In the beginning Thelma and Louise measured their lives and defined themselves by men's desire, which was claustrophobic. Their first shots are in the kitchen—Thelma in her brown suburban home and Louise in the crowded diner, calling Thelma on the telephone. At the country rock bar, another crowded space, Thelma flirts with Harlan, drinks too much Wild Turkey, and goes outside with him, without Louise. Male desire turns violent. Louise rescues Thelma from rape. However, Louise doesn't shoot Harlan after the attempted rape. She shoots him after she has turned and begun to walk away. Instead of being remorseful or even quiet, Harlan tries to get the last word: "Suck my cock." Louise shoots to kill. This is a conscious action that takes words very seriously.

Thelma repeats her destructive behavior, looking for meaning, for pleasure, in men by picking up the drifter/petty criminal J.D. One key error is to let men come between women. The two women spend one critical night in separate motel rooms with men. While Thelma is celebrating her first orgasm, J.D. has stolen Louise's money—which they needed for Mexico. They were dead the moment they lost the money. Romance and sex, which can be self-destructive, have serious consequences for women.

At the same time, sex is liberating; it is no longer a fantasy keeping Thelma captive or a secret key to identity. Thus she can go forward. Thelma has learned about male behavior and will imitate J.D. The women's roles shift; Thelma begins to initiate action and make decisions, learning from experience. Both women change, becoming heroic. Women's strength lies in union rather than envy, in recognition rather than competition.

The soundtrack is dense, the words few, illuminating, and intelligent. Their lives gradually come into clarity. "All he wants me to do is hang around the house." Thelma gets it, and she matures. "I can't go back. Something has crossed over." She begins to take responsibility for her actions: "We couldn't go to the police . . . no one would have believed us. I'm not sorry. . . . I'm having some fun. . . . I'm just sorry you did it and not me."

The critical choice is on the soundtrack: "Do I want to come out alive? I don't know." Women's desire for freedom, for independence, can turn them into heroes, *no matter what happens.* Louise: "We've got to decide if we want to come out dead or alive." Thelma: "I feel awake . . . wide awake." During the miraculous escape under the bridge, Thelma says, "Whatever happens, I'm glad I came with you." The key and surreal scene is the night of anguish in the desert, which foreshadows the end, daybreak, their turning point. These poetic scenes of decision wherein characters wrestle with their own conscience usually belong to men. Thelma: "It happened to you, in Texas, you were raped." After this respite, the peace before the end, the car glides silently through space. They have entered historical time. There is no one in the universe but them, moving through darkness and history.

As I stated initially, women have not moved through this open, heroic western space very often in films. They wore skirts and petticoats, sat in the wagon or made flapjacks in the kitchen. But the film's aerial shots are not like John Ford's of Monument Valley, conquering the land, triumphant over space. Rather, they almost become part of the land, neither conquered nor conquering. The huge scale of the landscape is intercut with intimate, personal shots in the car. The editing begins to dissolve shots of Thelma and Louise into each other. "You're a good friend." "You too, the best." "This is the first chance you've had to express yourself."

Grand Canyon looms before them. Women's choice is between a rock and a hard place. Louise: "I'm not giving up." Thelma: "Let's not get caught. . . . Let's keep on going." These are key words. Death allows them to "keep on going." Life would have meant confinement, in prison or in marriage. Louise: "You sure?" In a series of extreme close-ups, they are smiling, without fear, looking at each other, laughing. They hold hands; the Polaroid snapshot they took at the beginning flies away; the car is held in a freeze-frame over the canyon. In the end Thelma and Louise defy gravity, gaining mastery of themselves, becoming triumphant in death. The ending is courageous, profound, sublime.

The film's relation to history, to women's past, is comparable to Meaghan Morris's analysis of Claire Johnston: "She saw the past as a 'dynamic' vital to any struggle, but . . . this dynamic must have nothing to do with lost heritage, and everything to do with creating effective ways of ac-

tion in the present."[58] For *Thelma and Louise,* the rape initiates their journey, it pushes them forward. They become fearless and heroes. (For Yvonne Rainer's *Privilege* [1990], on the contrary, the flashback rape is a primal scene holding Jenny back and making her timid.) For Johnston, and for Thelma and Louise, "Memory was a practice . . . of becoming."[59]

REMAKES AND REVISIONS

I have always wondered how Judy felt in *Vertigo.* Only a few shots are from her point of view, and then all we know is that she knows that Scotty knows. For Judy, like Thelma and Louise, men are fatal. However, Thelma and Louise *choose* death—a heroic death, rather than a sacrificial, inadvertent one like Judy's.

What if the nun who appears in the tower during the death scene in *Vertigo* were a feminist detective and saved Judy at the end? What about Midge, surrounded by the sexy lingerie she is designing, who is barely noticed? Imagine Midge and Judy becoming friends or lovers through a therapy group on codependency. After all, who needs this crazed-looking, much older guy with all these problems?

Or what if we told the tale from the dead Judy's point of view splattered over the mission's floor? This would be a dissection of male obsession comparable to Gloria Swanson's obsession with youth in *Sunset Boulevard* (Billy Wilder, Paramount, 1950), trapped within the double standard of aging. What Norma Desmond really wanted was to work, to act in films, her profession. What if the female writer had helped Norma with her screenplay? Or if Norma had supported, maybe fallen in love with, the younger woman, not the man? This would indeed be another story.

Competition between two women for the same troubled, immature man is deadly (a scenario that occurs as the ruse [?] of *Basic Instinct*). It is the triadic structure of jealousy which is self-destructive and self-defeating. Feminists who let a man come between them are in denial. Envious desire is something that women cannot afford. Anger toward other women eventually turns against the self. With just a slight shift, envy/anger can become love of other women, of oneself—the central solution Woolf suggests in *Three Guineas,* quoting *Antigone:* "'Tis not my nature to join in hating, but in loving" (Woolf, 170). Antigone was Woolf's antidote to Oedipus, the complex she scathingly critiqued as "infantile fixation" (130).

AGE THREE

Experimental Feminism

Thriller
(Collette Laffont as Mimi)

What I Really Want to Do
Is Direct

Experimental feminism changes the point of view. Women tell stories about women's lives. Our experiences take on value. Walter Benjamin's distinction between the novel and the story suggests Laurie Langbauer's distinction between the novel and the romance. For Benjamin, "the novelist has isolated himself" from the realm of shared experience.[1] Mikhail Bakhtin values the experiential, mutual quality of carnival, which crosses "the self-conscious borderline between art and life, making little formal distinction . . . between author and co-creating reader."[2]

This priority on experience, on life, surfaces again in Deleuze and Guattari's distinction between major and minor literatures, a concept that applies to what Meaghan Morris calls *experimental feminism*. She quotes Deleuze and Guattari: "Living and writing, art and life, are opposed only from the point of view of a major literature."[3] As Morris points out, the minor is not "marginal; it is what a minority constructs *in a major language,* and so it is a model of action from a colonised position *within* a given society" (Morris, 130). Minor films are a mode of becoming with no opposition between art and life.

SALLY POTTER

Thriller (1979) and *The Gold Diggers* (1983), both by the British director Sally Potter, charted new paths for feminist film criticism. *Thriller* wonders: "Who killed me and why?" After figuring out this enigma (romantic male desire is the guilty party), it speculates: "What if I had been the hero of the story?" *The Gold Diggers* answers this hypothetical query. Both films fashion new endings for women, who reason their way out of deathly, self-sacrificial conclusions. Women work together in figuring out their entrapment in stories and in life.

In my book *Indiscretions,* from which I lifted these thoughts, I took both

films *as* feminist film theory. In fact, *Thriller* was way ahead in 1979, including race, lesbianism, local politics, and history, along with a critique of narrative romance. And it raised issues that feminist film theory is only beginning to notice—work, money, and age. The issue of aging women's suitability for romance is brilliantly addressed. *The Gold Diggers* anticipated feminists' turn toward film history in the mid- to late 1980s and critiqued the silent cinema and the star system. And a more recent Potter film, *Orlando* (1992), redefines the historical spectacle and overturns the centrality of "sexual difference." Orlando is first a man and then a woman: "Same person, no difference at all, just a different sex." In all three films, Potter sees the sexual economy *through* the money economy. Believing in the primacy of thought, not theory, she looks to her life for answers.[4]

Potter, a musician, dancer, and performer turned director, was influenced by the history of commercial and avant-garde cinema,[5] theory, and feminism in the 1970s. She dropped out of school at fourteen. She hung out in the London art scene, around the Filmmakers Cooperative and art-house movie theaters. She also became involved in political activism, as did many feminists in London.

In 1970, Potter attended her first women's meeting at the Institute of Contemporary Arts and became "totally excited" about reading Germaine Greer, Simone de Beauvoir's *The Second Sex*, and Freud, "which all, immediately, made sense." She began her collaboration with Rose English, a dancer. In 1976 she attended weekend film conferences at the British Film Institute, which had begun to engage issues of theory: Bertolt Brecht and realism, psychoanalysis, ideology, and feminism. Although she had read psychoanalysis only in patches, she spoke up.

For Potter, theory raises questions. She looks within for answers, at what she calls the "personal historical." Group therapy with friends is one avenue. Unlike psychoanalysis, her groups discussed emotions, gender, race, class, and the politics of family. Her films work along the same principle of shared self-discovery. Potter's faith in women's expertise is inspiring to viewers who participate in the same insightful process. (I like this idea of *insight* more than *sight*.)

Thriller

Thriller was made within the London independent film scene on a grant of one thousand pounds. Potter collaborated with Rose English, Lindsay Cooper, and Collette Laffont, shooting on odd days over a two-week period and editing for six months. The final version was substantially reedited for the Edinburgh Film Festival, where it was a huge success. Although most of the film consists of still photographs, the performance sequences were shot in a building that was formerly a sweatshop for women garment

workers. Women's labor history and work inform the film, along with the critical theory of Juliet Mitchell, Claire Johnston, and Laura Mulvey.

Thriller revises a famous romance, *La Boheme* (Puccini *and* Alfred Hitchcock), by including Mimi's work, class (her history), and point of view (her story). Potter's film begins where Puccini's opera ends: the screen is black, Mimi is already dead from consumption, and we hear the deathly, beautiful aria, the song of tragic romance.[6] The opera's famous climax becomes the enigma of *Thriller*, a murder mystery, not a love story. Murder is signaled by the high-pitched violin sounds from Hitchcock's *Psycho*. These few high screeches, dropping to low tones, mean "murder." The film wonders: Why do women have to die? What is thrilling in thrillers? Who is thrilled? *Why?*

Collette Laffont, the black actress/star, in voice-over says, "I'm trying to remember, to understand. There were some bodies on the floor. One of them is mine. Did I die? Was I murdered? If so . . . who killed me and why?" Potter rewrites the classical story by telling the tale from Mimi's point of view and by making Mimi a black woman. Mimi investigates romanticism, the endlessly told tale in art, opera, ballet, and the movies of singular men (particularly artists) sacrificing themselves to their own desire, for which women must be grateful and often dead.

Potter creates an alternate memory, one that is not criminal, self-serving, or masochistic. Laffont identifies first with Mimi, the good girl, and

Thriller
(Mimi and Musetta)

then with Musetta, the other woman. "She was the bad girl, the one who didn't die." "For centuries, she has been jumping into his arms, over and over again." As the bad girl, Musetta is not the heroine of the story. Thus her death would not have been the tragedy Mimi's is.

The story of the opera is told in voice-over (with still images from the opera) three times, moving from "she" to "I" to "we," which includes the audience. During the film the characters become political. Mimi reveals what the history of art, like romance, has repressed: the conditions of industrial labor and a double standard. Mimi is a seamstress who works long hours in the cold building for paltry wages. "Somehow the cold and poverty they [the artists] endure is different from mine. . . . Do they really suffer to create in the way I must suffer to produce? . . . Did they take part in my death?"

In *Thriller* the eternal woman became historical women—a turning point for feminist film theory in the 1980s. Mimi asks the central question for women: "What if I had been the subject of this scenario, instead of its object?" "What if I had been the hero?"

"Searching for an answer which would explain my life, my death," Laffont reads three twentieth-century theories of revolution, Freud, Marx, and Stéphane Mallarmé. "Was the truth of my death written in their texts? . . . By reading, she hoped to understand." Mimi throws back her head and laughs, rejecting theory. Like Potter, she looks to herself and to Musetta, to women's experience, to women's knowledge. After placing herself with, not against, women, she unlocks the mystery of the classical text and discovers the answer: "We were set up as opposites, as complementary characters, and kept apart to serve our roles. . . . Yes. It was murder."

She tells us the story of the opera for the third time. "Act 1. "There is a knock at the door. It is Mimi, the seamstress and flower maker, sewing stale flowers that didn't smell. . . . Often until the early hours working with the cold and a candle as companion. They produce stories to disguise how I must produce their goods." She skips to act 4, the necessity of her death for story: "perhaps being young, single, and vulnerable, with a death that serves their desire to become heroes in the display of their grief."

She goes on to address age: "And what if I hadn't died? I would have become a mother. . . . But the heroine of such a story doesn't just labor day and night to feed her children. And if they had let me live, I would have become an old woman. And an old seamstress would not be considered the proper subject of a love story." Precisely. Neither the Hollywood movie nor the avant-garde film nor U.S. culture allows women to be old; the ideal female body is smooth, flawless, young.[7]

Along with conventions of age, Potter challenges the dyad of envy—a structure and emotion used to keep women apart and isolated. (Films

rarely portray women bonding, supporting each other, a commonplace story for men in the movies.) The look of women is not a look of envy at other women. Thus it does not become a look of rage directed against the self. The subjects are a black woman and a white woman who unite, crossing the barrier of race along with those of history, class, and age. For Potter, the answer or solution does not lie in men's texts, which lead us to the same dead ends. The answer lies within, between, and among women, Mimi and Musetta and "I," white and of color, historical and personal, at the same time.

Thriller chooses unity over envy and self-sacrifice. In the end of *Thriller*, titled after a genre dependent on women's death and guilt (and as Carol Clover declares, a form that gives men such great pleasure), the two women survive and embrace. The film's last words are: "We never got to know each other. Perhaps we could have loved each other." By giving women the knowledge of the look, the intelligence of the voice, the value of their work, and the power of friendship, Potter has revised *La Boheme*. The revision is *thrilling* to me, for it is about freedom, that adventure rarely open to women. The film immeasurably enriched feminist film theory. Early on, Potter portrayed the great, exciting pleasure of women's thought. In fact, she is a superb thinker, demonstrated in an interview with Pam Cook, a British feminist:

> Mass cinema is deeply tied into market forces. . . . It is made to a formula to try and gross a lot of dollars . . . some slip through which are also doing something else. Independent film isn't so tied to market forces . . . and so it's free to deal with unprofitable subject matter and to experiment with form. . . . I want to communicate and mass cinema offers a vast, imaginary space in which to do that. . . . However, as women, we're generally 'allowed' to make the smaller kind of women's issue documentary film—it's more difficult to work at the larger end of the scale. So then, part of my job as a woman film-maker is to break out of the ghetto. However, I then find that the big screen space is occupied in such a way that my position, my vision and my desire, which is necessarily a revolutionary desire, is not quite going to fit in.[8]

But Potter kept trying, first with her feature *The Gold Diggers* and then with *Orlando*, a commercial success.

The Gold Diggers

The Gold Diggers investigates film history, locating the heroic quest for female subjectivity in "primitive" and modernist cinema.[9] The primal scene separating the daughter from the mother that structures the film is staged as silent cinema, with allusions to its forebears—burlesque, music hall,

vaudeville, and melodrama. Set alongside this movie history are formal concerns of avant-garde—performance art, modern music, and narrative.

Very few films made by women adhere to single genres, suggesting to me that genre definitions, so central to film studies and the film industry, have been, up to now, inherently male *and* dependent on a stable representation of women. The centrality of women to the definition (excepting the "woman's film") is not, however, mentioned or even noticed. This is why the taxonomy of attributes, presumably so apparent on first glance, makes absolutely no sense on second thought. In Hollywood genre was a structuring economic principle. Genre ensured that women knew their place and stayed there.

This may explain why one tactic of women filmmakers is precisely to demolish the rules of genre. And this may be logical more than experimental. When the point of view changes, so does the genre, necessarily. But our criticism doggedly holds onto the old formulations, not noticing that the rules have been revised—which is what "film events" like *Thelma and Louise* tell us. (It's truly amazing how obsessed most critics are with figuring out the "genre" of *Thelma and Louise*.)

The Gold Diggers is a musical, a revision of the 1930s film. This version does not exploit the female body or marry women off to appropriate men. These fictions in which women are figured as sexual objects of the male gaze and desire and conscripted into marriage or murdered in the end

The Gold Diggers

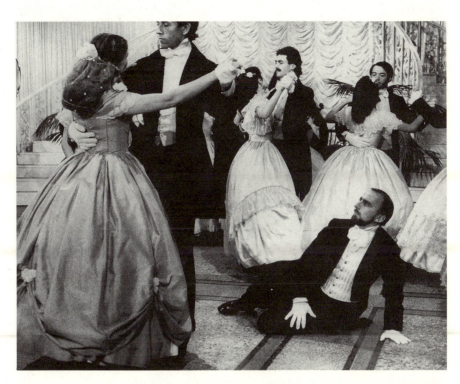

The Gold Diggers

The Gold Diggers

dwell in our unconscious (and, I would argue, in our real, everyday experiences).

Julie Christie is the glamorous female star (Ruby). The film equates her with money and depicts her as a religious icon, carried in a procession to the deserted cathedral/bank. She is worshiped and deposited along with the gold bars. She represents the sexual economy, wearing her ball gown throughout. Women and money are interchangeable; both can be exchanged, both have only imaginary or symbolic value. Collette Laffont, wearing practical clothes, plays the economist-accountant (Celeste) who leads Christie to self-discovery and rescues (joins up with) her in the end. She represents the money economy. She is the hero.

In both characters the film addresses women's work and women's thought. "The star phenomenon is an actual form of investment . . . a circulation of the face. . . . Ruby herself is being circulated and displayed, and Celeste is helping to circulate money" (Cook, 13–15). Potter is her own smartest critic and a stellar film theorist: "The star is often a manifestation of an ideal type and the part of Ruby, designed for Julie Christie, plays with these ideas." Later in the interview with Pam Cook she explains, "The Julie Christie part has to do . . . with a certain kind of glamour and blondness

and beauty. . . . In the process of the film she sheds that to an extent, it becomes evidently a form of disguise. . . . The actress is not the same as her part. . . . It's part of the hidden labour of the actress" (Cook, 19).

This character's exaggerated "whiteness" is in high contrast to Celeste. Rarely did anyone notice that Potter had charted a model of lesbian representation and race, which might also have been the film's most serious critique of feminist film theory. Like the blonde star, we were too caught up in psychoanalysis to notice; we were "in the dark," failing to see that the economics of work, money, and race were the underpinnings of film sexuality.

In a restaging of an early D. W. Griffith melodrama, Ruby is wearing heavy theatrical makeup. She looks like Griffith's female stars, Mae Marsh, Mary Pickford, and Lillian Gish. Ruby uses exaggerated, coded, silent gestures of anguish. She is too old to play a girl. Her makeup has become a garish mask. The all-male audience boos Ruby, now alone on the stage. The little girl/aging star is of no interest to the men in the audience, just as they were of little concern to Freud.

By inscribing women's rather than men's "looks," the film denies the much-analyzed male gaze any validity. As a result, cinema's (and theory's) perpetuation of a visual system of sexual difference serving as the sign of male power and desire becomes irrelevant. The ludicrousness of Freud's (and other theorists') uncanny linkage of vision with the "male organ" and fear of castration and death is clear, from women's point of view. Our experience has little or nothing to do with fearing castration, after all.

Thus the film simply undoes vision as the prerogative of male characters, along with disavowal—the gap between belief and knowledge. Among other things, women gain the power of looking as *knowing*, as *interpreting*, as *seeing*. Women are the seers, and the activists. But it's more than just this. Thought almost becomes palpable. Women reason; they have insight. The pleasure of the film, as in *Thriller*, comes from thought, from knowledge, from the *thrill* of self-discovery, from escaping the sexual economy.

Christie described the experience:

My relationship with film directors was paternalistic, completely irresponsible in the way I put myself in their hands. That's changed. . . . I've only worked with an all-women crew once. . . . It was fantastic. There was almost no hierarchy. All the carpenters, sparks, and painters were women, which meant that they all had to have gone through the same political feminist struggle to get where they were. We were all paid the same. We didn't even have to go through all the inevitable tricks and behavior that one sex puts on for the other, so it was a great relief and more restful. Women understand things men don't, like Chantal Akerman with *Jeanne Dielman*.[10]

The film was a heroic undertaking, shot by an all-female crew on location in Iceland, and a collaboration between Potter, Rose English, and Lindsay Cooper, with Babette Mangolte, an independent filmmaker, as cinematographer. *The Gold Diggers* had its problems (including disputes and fallings-out among the makers), particularly with regard to sound editing. But I often wonder what feminist film theory would be like in the 1990s if, *in 1983*, we had taken this film as our model instead of (1) recycling "Visual Pleasure and Narrative Cinema" (often getting it wrong) or (2) laying psychoanalysis over this film and burying its pertinent issues.

While Potter's history is linked to the avant-garde, she also sees herself as an entertainer in show business.

> It's true that there is a history of remarkable female cinema. . . . But still, we're in a tiny minority on the production side, compared to the vast female audience. [The paradox of women and film in the United States is that while women do a great deal of film scholarship, relatively few women have made feature-length films.] So it becomes doubly important that we reclaim universality for our own and don't accept the position of outsiders. . . . My identifications historically are with Hitchcock, Godard, Tati and other great male mentors, and the exceptions too, like Dorothy Arzner. But in cinematic history most of the filming has been done by men. I think of myself as a director and want that sense of colleagueship, of history and tradition. It gets dangerous to say that because you're a woman, you haven't got a cultural history. That's not true, that history is ours, too. . . . As an artist, filmmaker, one is on some level essentially androgynous.

Potter wants everything: "It's no good dwelling in the land of the victim. . . . There's a point of view which is extremely handy, which is to see the paradoxical advantages of our situation and to see our inner strength. . . . We've got to get out of the way this idea that anything we want to do is denied us. Nothing less than everything will do. If we want to ride in on white chargers and carry off our favourite film star, we can do that" (Cook, 25–26). This is precisely what Laffont does in *Gold Diggers*. And Potter is right. We must see our inner strength, which can take us anywhere we want to go.

FEMINISM AND FAIRY TALES

Potter endorses what she calls "the paradoxical advantages of our situation"—the contradiction between "fiction as it is lived and fiction as fiction. . . . That fictive space has formed and shaped our unconscious" (Cook, 26). In a similar vein, Walter Benjamin tells us that story is elided with personal

experience: storytellers speak of the "circumstances" they have directly learned, or they "simply pass it off as their own experience" (Benjamin, 86–87). The story comes "from oral tradition" and shared experiences. The experience can be the storyteller's or "reported by others. And [she] in turn makes it the experience of those who are listening to [her] tale." Thus the listener has a stake in hearing and in remembering the story, which exists in "the realm of living speech," of shared "companionship" (Benjamin, 100).

This living speech, forged in mutual experience, is intriguing for feminism—a hearing as much as a seeing, a "fiction as it is lived," a history as much as a fiction. *Mutual* experience creates a companionship and familiarity between speaker and listener.

"In every case the storyteller . . . has counsel for [her] readers. But if today 'having counsel' is beginning to have an old-fashioned ring, this is because the communicability of experience is decreasing. . . . After all, counsel is less an answer to a question than a proposal concerning the continuation of a story which is just unfolding" (Benjamin, 86). Rather than being over, as postfeminists declare, I see women's stories, feminists' stories, as unfolding and continuing.

Fairy tales depend on the everyday and on the present, which becomes magical, incalculable, a bit irrational. They start and end in the familiar. The everyday becomes a world of wonder and surprise, rather than the repetition and boredom often ascribed to women's daily lives. However, fairy tales can have a dark side—the familiar can also be a nightmare. (I have *never* been bored when I am at home, particularly alone. Boredom strikes only at intellectual events, often talks, or at parties.)

Fairy tales often have a critical flaw: happily ever after. Up until now, this has been achieved in one way: marriage to the prince. What Cinderella forgot to tell Thelma and Louise were the terms of "happily". To be happy, they had to stay home serving him. To be happy meant to be dependent, to rely on his opinion of them. There have been few other happy endings for women. No wonder women are revising fairy tales (and the meaning of "happy"). By changing "the end," they are changing the future.

Something to Talk About

Something to Talk About (Lasse Hallstrom, director), a summer 1995 release, begins shortly after "happily ever after." Grace (Julia Roberts) and Eddie (Dennis Quaid) are married and live in an upscale, tasteful townhouse in the South; they have new cars, busy lives, professional careers and a sweet freckled daughter who lisps and rides horses. Although the central couple is the narrative's focus, the film image is more about generations—mothers and daughters, fathers and daughters. Women span a

spectrum of age from six to seventy-five. They look their age and their age looks very good indeed. (Why do we think that to look good is to look young, or at least younger than we are?)

Like *Thelma and Louise, Something to Talk About* doesn't easily adhere to the conventions of genre—it's not a melodrama, and it's not a romantic comedy. It's more like a melocomedy (the sound track of southern county blues is superb, inventive, haunting). Not surprisingly, the story is told from a woman's point of view. Given this mixed form, it's also not surprising (although not mentioned in reviews), that the film company, Spring Creek Productions, that produced the film consists primarily of women: Goldie Hawn was the Executive Producer, Paula Weinstein and Anthea Sylbert, the producers, and Mia Goldman the editor. Callie Khouri wrote the screenplay which, like *Thelma and Louise*, portrays strong, loving relationships between women, along with giving women insightful, intelligent dialogue and minds of their own.

Two parallel incidents derail the "happily" of Grace's upper middle class life. Her aggressively egotistical father, Wyly King (Robert Duvall), the owner of the King horse ranch, supersedes her authority at work as the manager of the family horse business—buying a horse without telling her and making himself the rider. Grace is upset but initially does nothing except object. As Hank, the trainer and her choice for rider, tells her, she has no authority, so what she thinks doesn't really matter.

Earlier we had been given a clue about the status of daughters. It is a subtle, almost incidental and inconsequential moment but it sent chills of memory down my spine (as did so many of the exchanges with Grace's well-intentioned parents). Grace's daughter, Caroline (a miniature of Grace, Julia Roberts' mirror image), wants to ride Possum, the big horse, in the coming Grand Prix competition and tells her grandfather "I want a chance, I am ready." (It turns out that when she was a girl, Grace won, riding Possum.) Gramps (Duvall) placates Caroline with this foreshadowing comment: "You gotta learn to recognize your limitations."

This exchange in the barn is a casual, offhanded moment. There is no portentous music, there are no repeated closeups to declare that this issue is the key to the film's drama. But this space of the everyday is where the action of the film, and our lives, takes place; and in retrospect it is momentous. The consequences of these casual remarks, which we usually figure out later, comprise our history.

The second event is more shocking. It occurs when Grace, frantically running errands in her Broncho with Caroline, sees Eddie on the downtown street, meeting and embracing a blonde woman in a red coat. Later that night after waiting up until eleven p.m., Grace drives to a pub in her nightgown (with her daughter) and confronts her cheating husband. Ed-

die leaves the blond and his friends, comes outside, and takes the offense: "What s wrong with you?" She replies: "No, what is wrong with you." The logic of shifting the issue, of blaming the victim, doesn't work with Grace. She refuses to be guilty about Eddie's unfaithful actions. Later on another bit of brilliant dialogue occurs. Eddie: "I know how you feel." She, furious, replies "No, you don't know. No! You don't know how it feels to be made a fool of . . . I don't want to be this person, this wife."

But the guilt maneuver keeps sidewinding Grace. During dinner with her parents, her father crassly rebukes her for wearing her nightgown in public. "Are you trying to humiliate your entire family?" Her lip quivers, like a child, although she does talk back. Her mother, Georgia King (Gena Rowlands) remains quiet. On another dinner occasion, Wyly tells her that she is "too old to come running home," that he has business with Eddie's family and she should take Eddie back. Her mother also counsels her to accept Eddie's "straying" and "keep this a private family affair." Shifting the blame to women is the first step in convincing them to settle for less, and be grateful! This three-pronged illogical thought process—shift the issue, blame the victim, and she will assume guilt for his actions—is portrayed brilliantly in the film. This is the epistemology Grace must figure out.

Like Thelma and Louise, Grace has a rebel streak. She doesn't settle. Instead, she makes a spectacle of herself, causing a social scandal at the Junior League meeting by standing and asking the stuffy, snooty members: "Has anyone had sex with my husband? If your friends won't tell you the truth, who will? Has anyone else fucked my husband?" After breaking up the meeting, she goes home and with her wise-cracking sister, Emma Rae, watches Barbara Stanwyck being tough in a movie. Grace is getting stronger.

But her newfound insight and strength alternate with her ingrained feeling of failure, the gnawing belief that somehow this is all her fault. To her mother, she says, "I am a failure, I hate my life, I've failed." "I wasn't going to get married, I was gonna be a vet." And to Eddie: "What did I do? How did this happen to me? I was going to be an animal vet?" Giving away one's dreams (usually one's career) and then wondering where they went is a familiar story for many women, trapped in situations of their own making. The question becomes whether to settle (which has to do with fear) or to change (which is about taking risks), to stay in the same place or to move forward, to grow up or not.

Grace toys with finding another man—the film has two spare handsome guys on the margins of the story, there for feeble horse reasons. After she decides against the sexual ploy, at merely substituting one man for another, the film shifts. She begins to stand up for herself, to be a strong role

model for her daughter. After remarking that "Southern women keep their expectations low, we are bred to do this," Grace begins to assume responsibility for her actions, deciding that Caroline can ride Possum in the Grand Prix. Grace confronts her mother with her cowardice, her denial about her father's affair. Instead of being the wounded victim, the ever splendid Gena Rowlands mother takes action, admitting the truth about her husband's philandering, and kicks him out of the house. Later, at the horse show, Grace stands up to her father, going against his wishes. Rather than blaming her parents, Grace behaves like the adult she is and shows them how to treat her. She refuses to be a victim or a child and takes charge of her own life. Grace looks to herself for answers.

The film begins to end at the horse show. This scene is cut triumphantly, like a concluding, climactic resolution, replete with swelling music and fast, repeated editing, like the end of *Rocky*, or *Chariots of Fire*. Everyone watches the daughter ride—when Caroline wins, Grace gives all the credit to her. But no matter how hard the film tries to focus on Caroline, and the mother/daughter relationship, it can't keep its lens off Grace (with a fluffy hairdo and wearing a dress for the first time in the film), intercut with closeups of Eddie. Eddie looks. Grace looks. Will they get back together? is the *only* enigma. But the resolution is delayed, there are several endings, and several loose ends.

The subsequent celebration party at the ranch is another potential scene of ending. Grace dances with Eddie (everyone stops, watches, and applauds the couple) and then with her father, reconciling with both of them. Grace lets her daughter stay with Eddie and says to her father: "I was proud of you." He replies, "I was proud of you too."

But even this is not the end. At the party, Grace also slow danced with Jamey, the hunky but nice horse guy lurking around the story in the ranch bunkhouse. Eddie saw them dancing and climbs in her bedroom window. After asserting their mutual love, Grace rejects Eddie, saying "This is my chance to become someone I can be proud of and I don't want to blow it," and goes to sleep alone.

The fourth ending is brief. The horse guy is generously sent off by Robert Duvall with his horse, but only for a year. Grace goes to vet school, She has taken responsibility for her life, for her happiness, rather than relying on others to make her happy. However upbeat, this is still not the film's end, and still not the proverbial happy ending, which we finally get in the fifth ending. Grace tells a fellow student that she is having a "first date." We are surprised when she goes to her townhouse. Eddie is making dinner (for a minute we imagine he has barged in uninvited). But he flashes a sweet seductive smile (the defining trait of Dennis Quaid, Tom

Cruise, Meg Ryan and Julia Roberts) saying that he came early because he wanted dinner to be perfect. Like us, he is grateful that Grace finally accepted a date with him. Do they live happily ever after, or not? Only Callie Khouri knows. But the optional or multiple ending could be another hallmark of films produced by women.

The star system and the setting are limitations which the film cannot escape. I stopped counting the number of closeups of Julia Roberts trying not to tear-up. Granted her face is gorgeous and her performance is wonderful (she plays harried and decisive, confused and courageous), she is also surrounded by brilliant performances and fascinating faces—particularly Dennis Quaid as Eddie, Kyra Sedgwick as Emma Rae, Robert Duvall as her father, Wyly, and Gena Rowlands as her mother, Georgia. Not only did I want more of these great faces, but Grace is set apart from the others, not in relation to them. From being the privileged moment, the closeup of the star (male or female) has become the norm.

The more serious problem for me was what the setting, or mise-en-scene, of the southern ranch, represented—not only wealth and privilege but signs of slavery—the cottage with side-by-side doors where Emma Rae lives suggested slave quarters. This hint of the past was reinforced through the representation of the older family servant in the King main house. She is African-American, her maid's status and appearance are reminiscent of the Mammy figure. She is there but in the background, not really noticed in the film's margins. This stereotype which reacts but doesn't act or speak should be a thing of the past by now—particularly in a film which portrays such eccentric, outspoken women.

I loved Grace's older aunt who wickedly suggests that she cook for Eddie, an idea which Grace finds repulsive until she hears the recipe for poached salmon "that will make him as sick as the dog he is." The elderly aunt calls this "homeopathic aversion therapy. A near death experience will help him to put things in perspective." But I have left the best for last—Emma Rae, Grace's sister. When Eddie comes to the cottage, she announces him with "the lying, sneaking sack of shit is here," and then knees him in the groin. Emma Rae is sexy, funny, wise, beautiful, and right on. She is not subservient to male desire, to social standards, or to her father. She is completely supportive of her sister, although the star system and closeups of Grace/Roberts are so numerous, so dominating, that we don't get to see as much of this relationship as we would like. These two terrific women have the verve of *Thelma and Louise*.

On second thought, the film is a true fairy tale—of girls and horses and winning. Although I read about the prince, my dreams were of riding horses and of being independent. I would fantasize my mother under-

standing and then making my dreams come true. For many women, this would be a very happy ending. And this is what happens to Caroline, the daughter.

Angie

Angie (1993/94), a film by Martha Coolidge,[11] revises romance, particularly the meaning of "happily," through melodrama.[12] The film's double theme is set up in a prologue. The first concerns the past, mother–daughter and personal history. In a Brooklyn accent the voice-over of Angie (Geena Davis) tells us: "My mother left when I was three. She was a free spirit. No one talked about her." The little girl has a photograph, her memory of her mother. Angie has two desires: to know her mother and to be free. When she discovers what being a mother means, she frees herself from repeating history.

The second scenario is romance and "happily ever after." On the steps the girls play dolls, talking about growing up, getting married, and having babies. In a swish pan, they become young women, going to work in a magazine office: "We didn't grow up to be Audrey Hepburn, but at least we get to go to work in the city everyday."

The film's viewpoint is also doubled, between the audience watching Angie—her body and thoughts, her indecision and pain—and Angie looking, figuring things out. Other characters, such as her stepmother and her best friend's husband, are seen through Angie's eyes. Scenes such as the gynecological exam by the very short doctor are seen from Angie's point of view—in this case, between her knees.

At the same time we see the gorgeous face, legs, body, and movements of Geena Davis playing this character. What a delight—without the slightest feeling of exhibitionism or voyeurism. She knows when others are looking. When she walks, it is with purpose. As Noah, a man who is interested in Angie, says, he's never known anyone like her, except a teamster. She is tough, smart, sensitive. Angie tells jokes and is close to her female friends. Vinnie has been her boyfriend since high school. She used to dream of being with a stockbroker, not a plumber; but "Vinnie has a good heart."

Like Ruby in Potter's *The Gold Diggers*, Angie's memory of her mother is intercut throughout the film.[13] Mother is an ideal, a dream of freedom, of escape, that haunts the abandoned daughter. In the memory her mother picks her up and says, "Some stories just have to tell themselves." Angie decides, "I'll have to let my story tell itself." But the story is not a fairy tale, although it begins like one and even feels like a romantic comedy.

When Angie becomes pregnant, her friends, family, and particularly Vinnie celebrate, planning her wedding and her life, happily ever after. Vinnie buys a house and her father gives her a wedding dress. But Angie

watches her life, like her body, take shape without her consent. The camera insistently cuts to close-ups of Davis/Angie, who is hesitant, resistant to marriage, and unprepared to be a mother. Nothing is clear; none of the choices is simple. This film is about confusion, the difficulty of making the right choices, which are hard choices. I suspect that these "natural" events, marriage and motherhood, are disconcerting to many women. They were for me.

Angie does not romanticize marriage and motherhood; nor does it obey other conventions of the continuity style. The genre is unclear; it doesn't initially feel like a melodrama, which it becomes. Perhaps it's a critique of romance, an anti-romance. More disconcerting is its narrative unpredictability. After the pregnancy, we don't know what will happen next. Neither does Angie. Coolidge has taken us inside her head.

During the film I became aware of another movie that was going on simultaneously. It was a précis of all the conventions of romance, of happily ever after, which I had already been testing out on this film. First, Angie is pursued by a smart, funny guy who knows painting, ballet, and opera. They met in the Metropolitan Museum of Art in front of a Degas. Noah is funny, persistent, and lives in a New York loft with antique furniture and a high-tech stove. He has knowledge and taste. We think he is Prince Charming—a painter *and* a wealthy corporate lawyer with a postmodern penthouse office. To top this, he doesn't care if she is pregnant. In a scenario like that of Cinderella at the ball, high culture and an educated Irish guy appear to be coming to her rescue.

But the baby comes, and Noah (a slime bag disguised as a prince) leaves the hospital just before a wonderful and very funny birth scene. Angie is incensed about the pain, asking for an epidural. The doctor suggests singing, which infuriates her even more. Cut to her family outside the door, listening to Marvin Hamlisch show tunes while Angie shrieks. But something intrudes on this funny mood and on the audience's romantic expectations: the baby is not given to the mother right away. One arm is not completely formed. This is an extraordinary scene, moving and sad. Coolidge lets us feel complex emotions: disappointment, fear, blame, love, acceptance, courage, and hope, in that order.

From this point on Angie is not so stylish, less made-up, sometimes desperate. Noah turns out to be already married and no longer interested. The film began in the spring or summer, in sunlight, amid trains, skyscrapers, and rock and roll. Now it is autumn, raining, and dark. The music has become somber. But it's not just that our expectations for Hollywood romance conventions are being derailed, or that the film is *really* a melodrama. I began to realize that Coolidge was trying something rare. Not only was she inscribing working-class culture, hopes, and values. She was

also attempting to portray the struggle of women to define their own lives and make their own decisions. And Coolidge raises the stakes, approaching tragedy, modestly.

Like life, the story goes off in unexpected movie directions. Her baby will not breast-feed and Angie feels rejected. She is surrounded by couples, family and friends, but she is alone, outside, trying to figure out her life, knowing she doesn't want to be like the couples she knows. Her friend's husband is brutish and inconsiderate; she hates her stepmother, who is a wretched cook; and Noah, Prince Charming, betrayed his wife and her.

Angie has no idea how to be a mother, so one night she runs away, looking for her own mother in Texas. She finds her and says, "I have thought about you for so long, about this moment." But this is not the magical reconciliation and solution to Angie's story. Her mother is not a fairy godmother; she is a chain-smoking schizophrenic who cannot speak and who burns up Angie's treasured photograph of her. Angie's father never told her, wanting to preserve her dream that her mother was perfect.

This scene is important for feminist film theory. The mother–daughter relationship is usually a pre-Oedipal fantasy, and we expect mother to fit this ideal. If so, or if not, we blame our lives on her, trying not to be like our mothers but inevitably repeating their traits in spite of ourselves. It's a trap of our own making that precludes growing up and away, loving *and* separating. At the same time, insanity has been a solution for many caged women, as have addiction, suicide, depression, and resignation. Angie's mother danced in the snow and dreamed of escaping. Instead she is trapped in her own mind.

The stakes in women's struggle to have choices, to determine their destiny, to be free, are high indeed. The major battles are internal. Here is where we win or lose our lives. "I always thought you left us for something better, Momma," Angie says. "I left my baby. Now I don't know what I was thinking. I love him, but is that enough?"

So far the film has offered several endings, only to reverse them. Instead of closing, the film keeps on going. Now we are in melodrama. The baby has been hospitalized with pneumonia. Angie returns to her father and stepmother, whom she now sees, in reality, as loving. Sitting beside his bed, she begs her son to wake up, to give her a chance to be a mother. Angie has dumped destructive illusions, broken through the past, and is now taking responsibility for her life. In short, she has grown up.

During the final scene in the hospital, her voice-over reads back over the film: "I see everything like this long chain. I'm finally part of something bigger than me." Angie is not married or rescued. She is mature, responsible, independent. She has made choices and is beginning to know what she wants. For many, this is a happy ending.

Overcoming bodily and romantic constraints that figure a confusing-to-addictive lifestyle of martyred masochism called vanity, "love," or motherhood has been no small task. For me, feminism is initially an undoing, then a learning that replaces self-hatred with self-regard, worship of men's ideas with respect for women's and one's own thoughts. Feminism is knowing and valuing one's self, which leads to fearlessness, activism—what Woolf called "championing the rights of women." The standards of regard are internal rather than external. They have nothing to do with guilt or shame or the approval of others.

JANE CAMPION

In Jane Campion's Gothic fairy tales, violence, desire, and obsession are lodged in the everyday, the familiar, the family. Fairy tales unexpectedly turn into nightmares that are very real. Beneath the veneer of the family lies violence, daily horror.

In the opening of *Sweetie* (Australia 1990) we hear a cappella, eerie, magical music (the extraordinary sounds of the Café of the Gate Salvation Choir). Kay's voice-over: "We had a tree in our yard with a palace in the branches. It was built for my sister, and it had fairy lights. . . . She was the princess. . . . It was her tree and she wouldn't let me up it." The chords of the music are foreboding, enchanting. "At night the darkness frightens me. . . . Someone could be watching, someone who wishes you harm." The flashbacks to Kay's and her sister Sweetie's past and the nightmare of the growing tree place the film somewhere between Freud and the Brothers Grimm, only radically revised: the point of view belongs to women.

The meaning is embedded in quick and subtle glimpses. Kay's sad, haunted eyes watch everything but don't comprehend. Beneath the surface of everyday life are real and deadly secrets—which have nothing to do with glamour. Sweetie's masqueraded, excessive body, her violently demanding behavior, her loud clothes and voice are grotesque. She is the embodiment of every unmet female need and desire. Kay has buried pain and desire deep within; Sweetie's pain and desire are on the surface of her body. They are opposite sides of the same coin, two ways of surviving—or not—the family. Only a few moments suggest that this destructive daughter was abused by the doddering father, that the mother and daughter are in denial. Sexual abuse is there and denied. (Campion is not interested in causes, or in explanations.)

After one interprets the few and subtle clues, including a brief flashback, the film becomes (for me, not for most critics) a case study of domestic abuse denial. The experiencing of the film is therefore complex—particularly since the real victim, the excessive Sweetie, is so loud, needy,

and obnoxious that she verges on disgusting. The audience, like her family, wishes she would go away. She demands all the energy and attention. She is exhausting. At the end she is covered with mud, naked, yelling from her childhood tree house. Just as abruptly as she appeared, this archaic embodiment of sheer, raw, insatiable, and unfulfilled *need* for love is dead. But Kay survives.

Freda Freiberg perfectly describes Campion's style: "images which disquiet if not jar. Through bizarre or even grotesque framing, jolting cuts, and a mise-en-scene which often verges on the surreal, her films invest everyday, domestic, and trivial scenes and situations with an edge of menace."[14] "Edge of menace" is a wonderful phrase. Kate Sands, quoting Freiberg, describes Campion's films' narrative obsessionality as bizarre, surreal, with an atmosphere of menace, often linked with sexual obsession and sexual perversity—to say nothing of abuse.[15]

The "terrible and telling significance of minor detail" (Sands, 11) is, for me, the key. However, I do not agree that the details are minor (unless this is minor in the Deleuzian sense, as was Frank Kafka). Rather, they are embedded in a complex style—off to the side, there but not battering us over the head. High style is always in the details.

Angel at My Table

In an interview in the *Village Voice* for the opening of *Angel at My Table*, Campion ("startlingly frank for a public figure") said she had searched for "a grammar of the brain that had to do with story."[16] (I like this phrase, "a grammar of the brain.") Of the New Zealand author Janet Frame, whose autobiography the film portrays, Campion said that the "mythologies of our lives begin with childhood images," which for Frame are related to fairy tales and nightmares. For years Frame was institutionalized for schizophrenia, receiving hundreds of shock treatments, only to learn that she had been misdiagnosed. In Frame's work, the princesses and sorceresses are all locked up in institutions—another version of Rapunzel.

Frame's novels (made available in the United States after the film's release) are about the difficulty of language, of speaking. For example, in *Scented Gardens for the Blind,* Erlene Glace is either unable or unwilling to speak. Her mother, Vera, presumably writes about her mute daughter: "a living fable, with no spinning wheel to prick her finger upon, dropping blood to the snow, no underground stream where at midnight the old soldier will ferry her to the palace for dancing."[17] For Laurie Muchnick, Vera Glace is "one of the many sorcerers in Frame's work," sorceresses who can shift the point of view—and come back from the dead. The fact that Vera "has been a mental patient, childless, unable to speak, for the last 30 years," emerges only at the end. Like Campion, Frame is not "afraid of

loose ends," of ambivalence or ambiguity.[18] Contradictions remain, amid multiple narratives.

Angel at My Table is the story of Janet Frame's life. The television series was made by women—produced by Bridgit Ikin, edited by Veronika Haussler, written by Laura Jones, directed by Jane Campion—and stars the point of view of women. In 1991 it was released in the United States as a film structured as a trilogy, replicating its television origins (a coproduction with Australian Broadcasting, Channel 4, and Television New Zealand). While the production is big, with a huge cast in many locales, the drama is intensely subjective, intimate.

Part I, "The Is-Land" ("This is the story of my childhood") is, like the rest of the tale and Campion's style, told in snatches, in glimpses (which include death): of Frame's twin, who died in 1924; of the "loonies"; of extreme close-ups of a child's eyes; of chewing gum in school and being punished; of sleeping four abed in a New Zealand farm home; of Janet outside, watching. The everyday, particularly the New Zealand landscape, is magical, menacing, both strange and familiar. The rural family contains daily tragedies as abrupt, unexpected, and normal as fairy tales and life itself.

In her own autobiography, the Australian poet and playwright Dorothy Hewett wrote, "When I began to read I peopled the world of the farm with characters from . . . Grimm's *Fairy Tales*. . . . I both love and fear them."[19] Walter Benjamin said that "the first true storyteller is, and will continue to be, the teller of fairy tales" (Benjamin, 102). When I was a little girl, my grandmother read "The Twelve Dancing Princesses" to me every night. For her sake, I would try with all my might to pick another tale, but I always chose this story. It was far and away my favorite. I was delighted when, in *Angel*, Janet read this story, a metaphor for the film, to her sisters in bed. While our histories are different and we come from distant parts of the world, we loved the same story, about clever princesses who had adventures and stuck together until they were separated by the prince, with his cloak of invisibility.

"Once upon a time there was a king who had twelve daughters, each more beautiful than the other. They slept together in a hall where their beds stood close to one another. At night when they had gone to bed, the King locked the door and bolted it. But when he unlocked it in the morning, he noticed that their shoes had been danced to pieces, and nobody could explain how it happened." Although imprisoned by patriarchy, these dancing daughters escaped the king's gaze of surveillance and power. Together "they danced, every night, on the opposite shore, in a splendid light, till three in the morning, when their shoes were danced into holes and they were obliged to stop." In the film, the camera pans the sisters' shoes, on the floor—it is a beautiful moment. A bit later in the film, Janet stages the

story with her sisters in the woods at night. It is dark and scary; they wear costumes, the owls hoot. The story of the four sisters parallels that of the twelve princesses.

For the dancing princesses, something was wrong: "I don't know what it is. . . . A misfortune is certainly hanging over us." Indeed it is: marriage to a prince, which separates the sisters. A fellow had been given the usual cloak of invisibility, spied on the princesses, and was given the princess of his choice. As Anne Sexton lamented: "Now the runaways would run no more and never / again would their hair be tangled into diamonds, / never again their shoes worn down to a laugh / He had won."[20]

In *Angel*, Janet notices her older sister's growing breasts, sees her smoking, and then spies on her having sex in the woods. Death, not a prince, intervenes. After a family outing, including the four bathing beauties posing for a photograph, Myrtle drowns at the bath. Janet had been studying her, imitating her; then she was gone. Death, suddenly, in the midst of life.

Although I was a very social being who loved parties and had hundreds of dates, I recognized myself in Janet—particularly her love of books, which she holds, caresses. I felt as if I were witnessing, more than experiencing, my life. Janet is an outsider, watching, isolated. At school, the popular girls are together; she is off to the side, aware of her graceless body, her bad teeth. Being in public spaces is painfully awkward. At home, at night, is violence, the war, death. Her shyness and strangeness are misdiagnosed as mental illness. She writes, reads, and then leaves for college.

In part II, "An Angel at My Table," Janet has books but no life with people. She withdraws even from her sisters until she is alone, fearful, never fitting in. During an observation of her teaching she panics, is speechless, staring at the chalk. Finally she is hospitalized in the psychiatric ward, diagnosed as schizophrenic. Isabel, another sister, drowns in a harbor on vacation. Janet's teeth rot; she is moved from place to place and has massive electro-therapy. This is a violent assault on her body—a body that has not been glamorized, that is not the sexual body of film theory: this is an awkward, imperfect body. A voice-over tells us that in eight years, she had two hundred shocks. Then the magical event: she wins a prize for her book *The Lagoon*. Her scheduled lobotomy is canceled, and she moves into a cottage to write—her salvation. Yet she is still watching, not living, life. For experience, she leaves for adventure—and part III.

"The Envoy from Mirror City" begins with a memory of the four sisters at the sea, singing "To France." In the present, Janet travels to London, then Spain, and tries to be part of an intellectual group. She has sex with Bernard, who is from Ohio. After she returns to London, despair, and a miscarriage, she discovers that she never had schizophrenia in the first place. Nothing was wrong with her. She sees a shrink and begins to write

again. Her father dies. Janet returns home, to the spectacular New Zealand countryside. She sees the swimsuit photograph of the four sisters, the dancing princesses united, does the twist, and begins again to write. *Angel at My Table* is a "happily ever after" fairy tale—of heroic survival through writing, through work. This exceptional story is also the story of our daily lives.

In *The Audition*, a short student film by Anna Campion (Jane's sister), the mother and daughter beautifully live out the dramas of art and everyday life. Taking a ride in a car is a poignant, tense, and lovely scene that perfectly captures the not-so-gentle struggle between mother and daughter. The aging mother, portrayed in close-up rehearsing for a scene in her daughter's film (*Angel at My Table*), petulantly plays childish, mean-spirited games that her gorgeous daughter (Jane Campion) generously hears, tenderly accepting her mother.

The camera is not a curious bystander, an ethnographer of "others," but rather a knowing observer and a loving participant who walks about the house, cherishing the details and conflicts of daily life in the editing. This is not a romantic view of mother and daughter but a quiet tug-of-war for control, for independence, for freedom. The roles have shifted, been complicated, with age. The daughter, the film director, is the adult. She has made the passage into wisdom and acceptance.[21]

The Piano

Jane Campion's next film, *The Piano* (1993), is not *like* a fairy tale; nor is it a *revision* of a fairy tale. It *is* a Gothic fairy tale, complete with a journey, a forest, a cottage in the woods, a magical object, a prince, a kiss, and happily ever after, all made strange by obsession, the compelling force of thought. Terrifying occurrences happen amid the strangeness of the everyday, like the Gothic tales Freud remembered in "The 'Uncanny.'"[22]

Campion, who, like Potter, is an acute critic/theorist, calls the film a Gothic romance, "an attempt to expose the entire process including the erotic aspect by telling it from the inside out in a psychological way."[23] Her model is *Wuthering Heights:* "Hers [Emily Brontë's] is not the notion of romance we've come to use; it's very harsh and extreme, a gothic exploration of romantic impulse."[24] She notes that "it's unusual to have a woman exploring her libido without any kind of romantic attachment or sentimental quality, albeit briefly, as it is in this film."[25] Laleen Jayamanne wonders why the "Gothic in cinema is associated with the horror genre popularised by Hollywood and not with art cinema."[26] Good question, particularly for recent feminist film theory.

The setting of *The Piano* is an island with a majestic surf and tangled,

inland forests. As in many fairy tales, the forest is a scary place of dark-blue gnarled trees. The sun rarely shines. Mud is everywhere, a palpable presence and quality that threatens to engulf the Gothic heroine, Ada. The air is stormy, ominous, moist. The unpredictable intensity of nature suggests the force of the unconscious, the ferocity of desire. Beneath the "civilized" veneer lies volcanic passion and deathly struggle—visibly emblazoned in the spectacular mise-en-scène, audibly embodied by the piano.

This is the world of the spirit, of the soul, of an obsession as strong as Ahab's or Lady Macbeth's. Once unleashed, desire cannot be captured or quelled. The soul, like the sea, the wind, the rain, and the ancient trees, longs to be free. This primordial desire belongs to a small, prim woman—to a mother, Ada—and to her young clever daughter, Flora. Played by Holly Hunter, Ada is grim-faced, gloweringly impassive. With her hair tightly pulled back and her corset severely laced, her body *appears* stern with repression. But Ada is not the "hysterical woman at home in melodrama. . . . The hysteric's desire is the desire of the other." As Jayamanne writes, at first Ada is "impervious to the desire of the other," (7) she is a "melancholy subject . . . touched by a grave loss." (8) Ada has lost her voice but doesn't know why.

Ada has pulled all her strength within, to the point of implosion. Her energy is contained, focused, and very strong. She is weighted down by heavy clothes, Gothic costumes. She doesn't speak; she is silent. Her silence, however, is a force field of energy. Her daughter is a free spirit who dances, sings, and cartwheels along the beach. Flora translates her mother's signs into speech, telling fanciful stories. They talk and sleep together; they love and understand each other. In the opening sequences Ada and Flora are similarly dressed and intimately close. Together, they are one.

The film begins with a voice-over: "The voice you hear is not my speaking voice but my mind's voice. I have not spoken since I was six. . . . No one knows why, not even me. Today my father married me. . . . Silence affects everyone in the end." Her silence is her resistance—"my father married me"—to women's very real lack of control over their lives. Why speak when no one listens? Why waste energy on words that have no effect?

Her silence, however, becomes her power; the intensity of her focused mind, her strength and courage. Later, to Flora, she tells the story of Flora's father: "I could lay thoughts out in his mind. He became frightened and stopped listening." Obsession gathers its force from thought and intensifies through silence. Ada's eyes glow with energy that is clear in her piano playing. "I don't think myself silent because of the piano." Ada plays luxuriously intense melodies of longing. She plays primarily for herself but also for and with her daughter. Ada's relation (and ours) to her beloved piano and her music becomes "an auditory fantasy." The piano and her playing the piano

figure the film's desire as female desire, female fantasy. For Jayamanne the piano is "the tactile aural object, the trace of her loss, her trauma."

Mother and daughter are brought with their possessions by boat to a beach pounded by waves and framed by stormy skies. On this open space at the edge of the dense forest, Ada's piano sits incongruously. Jayamanne reminded me that the piano is a sign of European women's training and accomplishment. Women played the piano for men; it was a feminine attribute. "This quintessential European instrument of feminine domestic accomplishment is set adrift in a gothic universe to become an instrument of delirium."[27]

The strangeness of the piano and of Ada's long, heavy dress on the wild New Zealand shore is pointed to by the Maori, who look under her petticoats and study the piano, so out of place in the open space. Ada's new husband, Stewart (Sam Neill), and his foreman, George Baines (Harvey Keitel), have come to fetch them. Stewart insists on leaving the piano behind. His pragmatic decision is thoughtless, revealing Ada's powerlessness and his stupidity. Ada is devastated, and so are we. The piano has already become highly emotionally charged. The music that comes from deep within Ada is also within the audience. Rarely has the meaning of "melodrama" been clearer or more connected to women's souls, to women's desire for freedom.

Baines later hears Ada play and becomes captured by her obsession, taking Ada and Flora back to the beach and then negotiating with Stewart to buy the piano. Baines recognizes its high value, trading off land for it. With Maori help, he takes the piano to his cottage, high in the forest. As Jayamanne says, the piano is "a product of fantasy. Baines intuits this and finds it irresistible" (4). Baines wants to watch Ada play and strikes a bargain. He will sell her the piano, "one visit for every key." She bargains for black keys and begins to play. (But the cost to Ada is high indeed. The triad of mother, daughter, and piano is broken. Flora is kept outside, away from her mother, watching.)

The seduction begins slowly as Ada plays, moving from sight to sex, from distance to proximity, from fetish to intercourse. Significantly, it is Ada who produces the scene of fantasy—the piano music. While he listens to her play, Baines lies under the piano and touches a hole in her stocking. Cut to her eyes closing, the sound of her playing. He touches her arms, "two keys," then her back and neck. In close-up, she plays loudly. Ada bargains for five keys to lie beside him. "I want to lie together naked. Ten keys." Looking through cracks in the walls, or peepholes, we watch Ada undress, taking off her petticoat, hoop, and corset and getting into bed with Baines. Campion positions us literally as voyeurs, peeping Toms (or peeping Pats), and makes Baines a fetishist. Literal film theory.

But after this he breaks off the bargain and gives her the piano: "The arrangement is making you a whore and me wretched. I want you to care for me but you can't." Jayamanne says Keitel/Baines "speaks in cliches reserved for women in romantic narratives" (12). He is vulnerable. He is caught up in her desire, her fantasy, her obsession. Jayamanne is fascinated by this unusual male character, a summary of many previous film roles, including the good cop in *Thelma and Louise*. I am more intrigued by the love between mother and daughter, perhaps because that's the least understood passion.

The enchanted forest represents obsession, which has now turned sexual. Ada runs up the muddy hill, back to his house: "I am unhappy. My mind is seized on you. I can't think of anything else. I'm sick with longing. I don't eat, I don't sleep." The force of her desire has overwhelmed even her closeness to her daughter, who is angry. Flora momentarily betrays her mother and informs Stewart, the husband, who watches the lovers. Excited by sight, he tries to rape Ada in the muddy forest. Flora intervenes in the rape. Stewart boards up the house, imprisoning Ada, who is impassive. But she is in control, completely. She touches him as he lies, passively. He feels something but he understands nothing. He is a classic case of passive aggression and thus almost repellent (at least to Ada and to me).

The moment Stewart begins to trust Ada, she sends Baines a piano key with a message. But Flora delivers the key to Stewart, whose rage-filled pride erupts. On a stormy night, Stewart chops off Ada's finger with an ax—and brilliant editing. We see Ada's horror; we hear Flora's anguished screams and pleading. This scene of pure terror unites Ada and Flora.

Two expressions of female desire, sexual versus maternal, pulled me in opposite directions. It's hard to watch the mother move away from her daughter and the daughter's betrayal of the mother. But sexual desire does not separate them for long. Flora and Ada reunite against Stewart's rage during the attempted rape and mutilation. The relationship between mother and daughter is no longer a pre-Oedipal fantasy of maternal perfection. Nor is the maternal split off from the sexual, one desire warring with the other. For these are constraints that make women subservient to their children. After all, women give away their lives to their children as well as to men.

Campion, with a few strokes, has reconfigured identification's three Freudian forms: having, being, and collective identification (so prevalent at the movies). Rather than "having" Ada, Flora becomes like Ada, even going to Baines (with the finger) for solace. While sons are taught to be like the father, this is rarely the case for girls and mothers.

In the end, the force of Ada's thoughts wins. Stewart goes to Baines and says, "I heard a voice here, in my head. She said: 'I'm afraid of my will, of

what it might do, it's so strong. I have to go away. Let Baines take me and try and save me.'" Ada and Baines leave as she came, with the piano. "It's a coffin. Let it go." Baines: "She needs it, she must have it." "Only a madman would take it." As in the opening, there is a shot from underneath the boat, with the heavy piano. After a series of quick, spectacular intercuts, the piano slips overboard. Ada is pulled underwater by its weight, ropes coiling around her leg. Her billowy, heavy skirt floats up, over her face, in slow motion. It is an extraordinary image, a gorgeous and shocking image preceded by genius editing. But she frees herself from her albatross and is pulled back on board by the Maori.

The ending of the film has provoked intense debate. Some say this sea burial of Ada with her piano was the true end, that the epilogue was just tagged on for the Americans who demand happy endings. (In this reading, Campion sold out.) It is a logical end for obsession—death. Or is the logical end recovery, a second chance? Or victory for a female character who is not killed for expressing and living *her* desire? Or happiness through self-control? It's as if Ada answers Mimi's questions in *Thriller*: "Why did I die?" Ada's voice-over: "What a death, what a chance, what a surprise. My will has chosen light. I teach piano now. George has fashioned a metal finger tip. I am quite the town freak. I am learning to speak." George comes in; they kiss in their white house with curtains. The air is light, bright. Ada's voice continues: "At night, I think of my piano in its ocean grave and sometimes myself floating above it. It lulls me to sleep. It is my lullaby. There is a silence where no sound may be, in the cold grave under the deep, deep sea" (quoted from the poem "What If I Had Been the Hero?" by Thomas Hood, 1790).

In her insightful theoretical essay on the film, Jayamanne reads the last sequences "as a negotiation between the gothic and the melodramatic" (14). She began with their difference: both "evoke chaos, but only the melodrama achieves resolution." In the Gothic, "demons are raised that cannot be controlled," while melodrama, through fantasy, "conjures demons only to quash them"[28] (1). This "uneasy marriage between the gothic and melodramatic impulses . . . enables Ada to have her daughter, her man, a piano and the fetish" (14). This "odd constellation" is "very late 20th century," and a project made possible by feminism (15, 6).

What Jayamanne is looking for is "an exit" for "female subjectivity in extremis which is not that of tragic death" (5). "The law of the Gothic genre" is that the exit be "full of terror," as it was for Clarice Starling in *Silence of the Lambs*. The "Gothic woman can negotiate terror without succumbing to it." Like Clarice, Ada has "a certain will to knowledge." For both characters, "happiness and knowledge are wrested through a negotiation of the Gothic" (6). Jayamanne and Campion, like Potter in *Thriller*

and *The Gold Diggers,* are looking for different endings. "The refusal of tragic death which goes against a generic norm makes this film a contemporary parable for women, not unlike *Silence of the Lambs,* with which it shares some family resemblance." I love this analysis by Jayamanne. But *The Piano* is also a fairy tale. Perhaps this is the imperative to "live happily ever after."

Along with the ending (whether sellout or complexity or update), the other debated issue in *The Piano* is the representation of indigenous people, the Maori. Throughout the film Maori are marginal, watching, tied to nature, and outspoken about sex. They are servants and porters, but they have no lives of their own. It can be readily argued that the point of view is the colonizers', that despite the Maori script approval and participation in the project, this is history as usual. The negative take, the primitivism of the natives, is readily established, but it might be too easy for such a smart film.

Furthermore, Campion has said the film takes place "when the first white people came to New Zealand and made contact with the indigenous people. . . . It's an important moment in history for me." Jayamanne argues that "Campion redefines the Gothic by . . . including the racial other." Jayamanne's logic connects sex and race through difference, what she calls "female subjectivity in extremis" with the "colonial moment of 'first contact,' the moment when the white man meets his 'primitive' other."

Jayamanne interprets "the colonial moment" through the shadow-play scene: "This scene is used to stage the mythical moment of first contact," (17) within the history of cinema. In the performance by the townswomen of the "Gothic tale of *Bluebeard's Five Wives,*" the Maori in the inclusive audience don't recognize the difference between illusion and reality, between acting and being. They don't know about disavowal or denial or suspension of disbelief. They break up the staged production to save the woman from being beheaded. This scene values belief in fantasy, as Baines does with Ada. The unattractiveness of Stewart comes from his inability to respond to Ada's fantasy. He cannot identify with another, with a woman, and he is afraid to try.

Through what she calls the "two-way process of mimetic exchange" (19), Jayamanne emphasizes Baines as a figure of hybridity and reciprocity (with the ability to traverse self/other). "He has abandoned his cultural identity" and "become Maori mimetically" (19). Baines speaks the language. With tattoos on his face and Maori friends living in and around his cottage, he understands, respects, and lives within Maori culture—subtly so. Reciprocally, "the Maori themselves have created a hybrid identity out of bits and pieces of colonial dress" (19) and speech, a point which Cam-

pion has emphasized in her many interviews about this film. For Jayamanne, this two-way process makes Baines very modern and allows him to be fascinated by Ada's fascination. Hence Baines can share and respect Ada's desire, which remains foremost. He does not have to conquer it with his own. In the end, I am far less certain than Jayamanne.

But *The Piano* is not just *about* history; it *is*, as Manohla Dargis pointed out, history. Campion is the first woman director to win the Palme d'Or at Cannes, along with being nominated for an Academy Award (only the second woman so nominated [Lina Wertmuller was up for *Seven Beauties*, Italy, 1975] and the first for an English-language film).[29] Her screenplay won an Oscar, as did Holly Hunter for best actress.

In the United States the film opened in a modest but highly acclaimed art-house release, with big reviews in national magazines. Within weeks it opened commercially, *as if for the first time*, at thousands of screens, accompanied by a big TV ad campaign. Thus, for me, the film opened twice in the United States: once as a semi–art film, then as a commercial blockbuster, with the piano music on TV selling the film. After teaching Campion's great short films in my film courses, it was extraordinary to see commercials for her feature on prime-time TV.[30]

Campion, Frame, Potter, and Callie Khouri (*Thelma and Louise*) are marvelous storytellers (as is Jayamanne in her films). In different ways they take their authority from death. "It is characteristic that not only a [wo]man's knowledge or wisdom, but above all [her] real life—and this is the stuff that stories are made of—first assumes transmissible form at the moment of [her] death. . . . Death is the sanction of everything that the storyteller can tell. [She] has borrowed [her] authority from death" (Benjamin, 94).

Jayamanne's short and sweet film *Rehearsing* (1987) perfectly illustrates Benjamin's words. The camera passes over an old photograph of Jayamanne's grandmother, who died in childbirth. She is lying on her death bier, surrounded by family mourners. The infant is Jayamanne's mother. Birth and death in the same moment take the scene beyond Benjamin into women's territory, women's history. And indeed, Jayamanne calls the photo a "maternal tableau" that has been "generative for me. I have used it since 1979, first in an obsessively biographical mode but I've moved out of that and am able to fictionalize it. When I am stuck, that image helps me to move on. So it's not a primal scene in the Freudian sense."[31]

Rarely has "she" taken authority from death. She can do this only when she has confronted fear and walked through its terror, "negotiating it, not succumbing to it." Then identifications emerge that are empowering to women.

FEMINISM AND IDENTITY

From 1975 through the mid-1980s, "sexual difference" was the linchpin of feminist film theory. In the late 1980s, "sexual difference" divided and multiplied. Feminism's oversights were pointed out. Differences multiplied—into race, class, ethnicity, age—and split off from sexuality. Sexual difference became sexuality, which multiplied into bisexuality, transsexuality, lesbian and gay sexuality. Differences and sexualities verged on identity. The focus was still the body and sexual desire.[32]

(Regarding race: As we had cautioned men not to *speak for* women because we wanted to speak for ourselves, so I was careful not to *speak for* women of color. However, I could have *spoken about* women of color earlier; I could have noted that "women" meant white women and "sexual" meant heterosexual. Ah, the stranglehold of narcissism!)

Privilege

Yvonne Rainer's *Privilege* (1990) sincerely raises key issues for feminism in the 1990s: it addresses race, touches on lesbianism, and is about aging. However, it is a film of positions rather than experiences—a paradox, in that so many interesting women talk. Amid all the information and sharing, the film fails to listen, and it speaks for others. It can't hear because its mind is on something else: men as the central story of women's lives. (Although something is changing for Rainer, male desire is still central to this film.) Caught up in the tenets of heterosexual romance (perhaps unconsciously so), *Privilege* enacts what it attempts to critique.

Jenny is the middle-aged protagonist who discusses menopause and aging with over sixteen women, conversations interrupted by her memories of the twenty-five-year-old rape of her lesbian neighbor and of Jenny's subsequent affair with the assistant district attorney, both told in flashback. Footage from educational medical films and computer text, along with voice-over, add information on aging to the collage. Women's daily lives provide the setting—a docudrama of staged conversation. The flashback adds elements of psychodrama. But the film is without affect; it has no intensity. It feels like a treatise informed by self-help therapy manuals.

The central problem is the main character, Jenny (Alice Spivak), the film's star who has no last name—unlike Yvonne Washington (Novella Nelson), Rainer's African American alter ego. (This presumption that the African American would agree to be her alter ego is another problem.) While *Privilege* is about aging (its biology and gendered inequities), it dramatizes women's immaturity: Jenny's desire to be desired is fatally uninteresting. At heart Jenny is still a girl, wondering where youth and Daddy went and what to do without it and him. She feels empty, the romantic

heroine thirty years later (now a feminist), without a clue about how she lost or gave away her life.

A life spent in pursuit of *him* would indeed be a life wasted, a life to regret. But Jenny is not that far along. Amid fashionable political issues, *Privilege* tells the same old story: without men, women are nothing. Thus race and aging and lesbianism become subordinate to the film's real concern.[33] The big question is: "So what do I do now that the men have stopped looking at me? I'm like a fish thrown back into the sea, longing to be hooked. I still want them to look, proud of being looked at. It's a chronic disease that you never get over."

Jenny doesn't lament only once or twice about her new, imagined undesirability. "Must a woman's feelings about herself depend on a man's assessment of her body?" She sounds like a recovering intellectual feminist, in denial all these years about how much the male gaze and desire *personally* mattered while *intellectually* attacking them and the men she secretly desired. "My biggest shock in reaching middle age was realizing that men's desire for me was the linchpin of my identity." What makes Jenny pathetic is defining herself in relation to men and her body rather than her mind or accomplishments. Power and self-determination are not always taken away from women. Often women give them away, gratefully.

What is really at stake in *Privilege* is the loss (rather than the gain) of male heterosexual desire—the loss of that determination in our lives, which is almost mourned. Rainer takes this blessing, and self-realization, as a problem more than a solution. Sometimes I wonder if sex, desire, and bodies are all that *really* matter to most men *and* women. And then they die (or just stay home).[34]

Age (forty-nine) is menopause, hot flashes, hysterectomies. Biology prevails in spite of economic and social arguments. Fear of aging drives the film despite upbeat denials: "When you're young, they whistle at you; when you're middle-aged, they treat you like a bunch of symptoms; and when you're old, they ignore you." Heterosexual desire, determined by men (which, for me, is the key, not simply heterosexual desire per se), propels the women's anxiety. The double standard, linked to biology (sex, race, and age) rather than social contradiction, drives the film's logic.

African and Hispanic American women come to the rescue of the aging, white heterosexual. Like sex, race is an enigma and a solution. Digna, the Latino woman, is in the unconscious (or the backseat of the car), waiting to rescue Jenny from her heterosexual history. Class is romanticized. "Whiteness" appears as natural; it is what Michelle Wallace calls "an unmarked term." For Wallace, the film is "depressing in its inability to take seriously the subjectivities of women of color."[35] Yvonne Washington, Rainer's alter ego, rarely speaks; the African American woman is silenced

while represented—making the silence even louder. (In contrast, Digna talks so fast in translation that her words run together.)

In an interview, Rainer candidly conceded this point: "In Australia . . . there was a woman in the audience, who was Aboriginal I think. She was critical that all the material about race was mostly rhetorical or literary, and all the documentary interviews were about menopause."[36] Wallace calls this a "structural problem" and notes, "The positions from which women of color speak . . . are inferior to positions from which white women, white men, and men of color speak" (Wallace, 8). Difference operates through hierarchy, which we internalize. There is no "equality in difference." As Monique Wittig suggests, "Women should do without the privilege of being different."[37]

Also troubling is the linkage of men of color with the rape of white women—which, Hazel Carby has argued, via the 1890s journalism of Ida B. Wells on lynching, historically served white men.[38] The victim of the flashback rape is a white lesbian (too bad the film didn't star this character), but the story and trauma of the rape are given to Jenny, the witness. Wallace points out that "the historical rape of the black woman—which literally founded the African American race" is ignored (Wallace, 8). She adds, "Rainer establishes a hierarchical continuum along which the individual's potential capacity for privilege and victimization is carefully calibrated. According to this view, white men can't be victims anymore than a Latino woman of color can have privilege."

But Wallace, like me, has her blind spots. She fails to note that *Privilege* is determined by sex and male desire. Jenny used to be "advantaged sexually," but "having passed the frontier of attractiveness to men, she is now on the *other side* of privilege." (Jenny comes up with this just after her scene in bed with Robert, the assistant district attorney. While her memory is young, her body is middle-aged.) If privilege is granted to women by men, then privilege is servitude by another name. And these are not the negative privileges of history—class and race—but of sex and desire; not the privileges of work—education and profession—but of sex and attractiveness.

For Wittig, "woman" and "man" are economic and political categories: "for what makes a woman is a specific social relation to a man, a relation . . . which implies . . . economic obligations."[39] Regarding "difference," Wittig asserts: "The concept of difference between the sexes ontologically constitutes women into different/others. Men are not different, whites are not different, nor are the masters. But the blacks, as well as the slaves are. . . . But what is the different/other if not the dominated?"[40]

For me, the economics and politics of privilege also circle around money, power, and work. When women age, they move to the margins of

power. When men age, they become CEOs, presidents, making big deci-
sions and big bucks. Money and authority could change menopause.
Money and property could begin to wipe out the inequities of race. Femi-
nist film theory has heavily invested in the sexual economy at the expense
of the money economy (and in bodies more than thoughts, in appearances
more than actions). This divestiture sold off history and politics. In so do-
ing, we may have relinquished authority along with power.

AGE FOUR

Empirical Feminism

Tracy Moffatt in *Bedevil*

Archival
and Avant-Garde

One fictions history starting from a political reality that renders it
true; one fictions a politics that doesn't as yet exist starting from a
historical truth.

<div align="right">Michel Foucault[1]</div>

Re-vision—the act of looking back, seeing with fresh eyes, of en-
tering an old text from a new critical direction is, for women, more
than a chapter in cultural history; it is an act of cultural survival.

<div align="right">Adrienne Rich[2]</div>

History is usually imagined as the conservator of the past, a precious com-
modity to be preserved. History in the making is a catastrophe or crisis.
When history anticipates the future, it is politics. Because this "history as
usual" focuses on the money economy, excluding the sexual economy, the
makers of history (and politics) are men and big events. What is thought
to be the best film history is often corporate history—the truth of profits,
losses, and wheeler-dealers.

The money economy, like history, has largely excluded women. This
may explain why feminism has so rarely analyzed it. In 1920, U.S. econo-
mists decided not to count domestic labor and services in the gross na-
tional product, separating the economics of the private from the public
sphere. Men exchanged time for money, a family wage that counted.
Women's time was free (and endless); women's work didn't count. Hence
women's spaces and work have been timed, measured, and valued differ-
ently. (These valuations structure Cecil B. DeMille's *The Cheat* [1915].)

Until recently in the United States, film theory has been linked to psy-
choanalysis (the sexual economy) while history has involved corporate
economics (the money economy). Sexuality involves pleasure and specu-
lation, while money concerns labor and data. One is a micropolitics tied
to private leisure, the other a macropolitics of public work. Film theory has

been women's pastime, while history (making it *and* writing it) was men's business.

But film history no longer belongs to men only. Neither does it belong to the truth of bank balances and legal briefs. Feminist theory has reconfigured film history through popular culture. Fan magazines, penny novels, and other "cheap amusements" provide evidence, along with studio contracts. The everyday, starring women's lives, has become legitimate.

But *feminist* history is more than this. If history is a way of *counting* time, of *measuring* change, then feminists are operating another temporality, questioning the timing of history. Meaghan Morris argues that because feminism is both "skeptical" (of history) and "constructive," it is "untimely" for most historians: "To act (as I believe feminism does) to bring about concrete social changes while *at the same time* contesting the very bases of modern thinking about what constitutes 'change' is to induce intense strain."[3]

Feminism is untimely history that merges the sexual and money economies. Given the twenty-year cycle of women's history, repeating itself over and over again, and the constant activism required to retain each gain, history is never over, or over there, but always here and now. Thus history is not something to be recorded or even accepted but something to be used, something to be changed. Empirical feminism—archival and avant-garde—acts to alter the course of time.

Empirical feminism unravels, consciously, the *experience* of economic and social contradictions, including those of race, in which appearance is not a clue to buried or biological secrets and concealed meanings but rather a question—there to be seen. Sex is not the key to identity. Sexuality is neither an answer nor an enigma; it is a context. Instead of consonance with men's theory there is a disquieting dissonance. Dissonants are at odds with the history they investigate, making it their own.

MAKING HISTORY:
NOT JUST A PRETTY FACE

The first question to be asked of history, and narrative, is: What is missing? Women per se are not always missing—but what they think and do are. Not women's bodies but women's knowledge and work need reclamation. And in many ways, the dominant model of feminist film theory is wrong. Women have been watching, from the sidelines, for years. They often possess the gaze but not the economic means. They see and know, but it doesn't matter; they have no authority. Their work has gone unremembered, their lives unrecorded.

Women have been gently coerced to walk out of film history, as if it were

their choice. The story of Lela Simone, who worked on sound editing with the Arthur Freed Unit at Metro-Goldwyn-Mayer (MGM), is a missing person's tale of the 1950s.[4]

Lela Simone

"When she entered a sound stage to work, the musicians had a hard time concentrating on their music," Hugh Fordin relates. "She was a striking beauty and easily could have passed as a double for Marlene Dietrich. . . . She acquired the technique of sound cutting by observation, great flair for machinery and by her phenomenal ear" (115). This sexually disturbing woman worked on sound orchestration, mixing, and editing for twenty years in the Freed unit. "Her specialized area was everything pertaining to sound and music, both artistically and technically. She was the unit's trouble shooter, [Roger] Eden's right hand and Freed's left," (121) and she had a talent for public relations.

Simone's work involved not one job but several. Excelling at her profession was not enough. She also served as secretary, wife, mother, and sister. In Kauai during the filming of *Pagan Love Song* (1950), she had to pretend to the press that she, not Esther Williams, was pregnant, to the consternation of her husband (295). Fordin's book describes her mixing and dubbing until 2 A.M. and serving in her "spare time" as hostess, making arrangements for her bosses. In relation to her work on *Invitation to the Dance* (1954): "As an advance guard, Simone left for London. . . . She prepared for [Gene] Kelly's arrival (377). . . . She practically lived in the projection and cutting rooms . . . and it is due to her musicianship and technical skill that not one frame was wrong by the time we got to the scoring stage" (395). Musician, editor, great beauty, but still Mom, setting up the film house for Kelly.

Years later, Simone was in Paris, working on *Gigi* (1958). After she ran a screening for Freed and Alan Jay Lerner of Leslie Caron's "Parisian" number, the men sauntered out. "At the door, Freed turned to Simone, 'Try and slow it down somewhat.' And to Lerner, 'She'll do it.' Simone addressed Previn. 'For once, André, it's yours. You slow it down!' . . . This episode had triggered something off. The many years of strenuous work and the countless incidents where the impossible had been achieved began to close in on her. Not to speak of the frustration of not being able to explain the technical absurdity of this last request. . . . Getting up from the table, she said, 'I'm going home.' That was the last Freed ever saw of her" (489). She was crucial, yet apparently no one followed her out the door.

Simone's last straw was the result of being caught within a logic of contradiction: she was everything (Freed's right hand and Eden's left; beautiful and talented) and nothing (Freed never saw her again.) Thus women

experience overtly the covert logic of disavowal, receiving double messages. Simone's "choice" was, in fact, a double bind, an illusion; it is a false choice. One key task of feminism is to unravel contradiction (and its economic base) instead of repeating or internalizing it.[5]

Gloria Swanson/Norma Desmond

Chronological difference shortens women's economic span of history. For the female star, aging was her greatest fear and travesty, the *Sunset Boulevard* (Billy Wilder, Paramount, 1950) syndrome.[6] Gloria Swanson as Norma Desmond, not looking a day over forty,[7] was isolated like a preserved fossil in her mansion, encased in makeup and frozen gestures. There she watched her old movies, caught in silent film history and obsessed by youth. Desmond is the aging woman as grotesque. Erich Von Stroheim, playing her trusty valet/husband, fared better in a supporting role. Meanwhile, in a cameo, the real Cecil B. DeMille, playing himself, bald and looking seventy, was still directing films, in power at the studio.

In cinema men age with dignity and often power. Women must remain forever young or leave the stage. The film represents the older woman and the younger man (William Holden) as an unhealthy coupling. The older woman is measured against the younger woman and found repugnant. At least this is the overt reading of the film—which is also a commentary on the star system, the nature of illusion, and silent film codes.

The real tragedy of *Sunset Boulevard* is not personal, Norma's aging. Nor is it her young lover's affair. It is social, economic—a double standard that measures men differently than women and does not allow her to work. To act is what she wants; her work, her films, are her life. Not working is her tragedy, like Freud's tale of "the woman no longer young" in "Anxiety and Instinctual Life":

> I once succeeded in freeing an unmarried woman, no longer young, from the complex of symptoms which . . . had excluded her from any participation in life. She . . . plunged into eager activity, in order to develop her by no means small talent and to snatch a little recognition, enjoyment, and success late though the moment was. But every one of her attempts ended either with people letting her know or with herself recognizing that she was too old to accomplish anything in that field.[8]

Social barriers are mistaken as a psychic problem. For Freud there is "no doubt about the origin of this unconscious need for punishment," which he labels as women's guilt. Rather than social conditions, it is women's "nature." When "the woman no longer young" stops trying, it is, for Freud, a *happy* ending. Women are urged to quit when they are behind, to settle for less and be grateful! Norma refuses to quit; frustrated, she ob-

sesses.[9] And while the film suggests that a young lover is the solution, no man will ever be enough. Norma Desmond doesn't define herself through male desire. She defines herself through her work.

While female vanity stars as the flaw, it is male, not female, narcissism that is overweening in the film. The film's point of view is that of Norma's dead lover, floating in her swimming pool face down. He and the film imagine that his desire, not her desire to work, is what matters. What is extraordinary is that the film enlists the audience to view Desmond's attempts to return to work as pathetic. Everything is there—she has written a screenplay, she asks DeMille for a job, she talks about work constantly— to be heard, and then it is overturned.

This overturning of what is present enacts the both-and logic of creation and cancellation that Freud pointed to in obsessional neurosis (which I discussed at the end of Age One). No matter how apparent the contradictions are in retrospect (or once they are pointed out), perceiving them remains difficult. The structure works "as if" they hadn't occurred. "An action which carries out a certain injunction is immediately succeeded by another action which stops or undoes the first one."[10] Creation/cancellation is a logic of (male) obsession.[11]

Mary Pickford

The history of Mary Pickford is another version of this story. This talented and daring figure played young for years as "Little Mary." Guided by her mother, Pickford engaged in legendary salary disputes with Adolph Zukor (a founder and head of Paramount Studios). In 1909, Pickford worked at Biograph for $100 per week (pre–income tax, which was enacted in 1913). In 1912 her mother negotiated a contract with Zukor for $1,000 per week. It rose to $2,000 per week in 1915, making Pickford the highest-paid woman in the United States. In 1916 her salary skyrocketed to $7,000 per week, paid in cash on Friday. In 1917 the figure was $350,000 annually plus 50 percent of the profits (unheard of!), and in 1918, $1 million per year.[12] Zukor countered with a $500,000 offer for *not* acting. Pickford refused his offer. She formed an alliance with Charlie Chaplin, Douglas Fairbanks, and D. W. Griffith and founded United Artists.[13]

By 1934, in middle age, Pickford had "retired" from the screen, too old to play "Little Mary," a character of sixteen. Her last film in 1933 was ironically titled *Secrets;* she was forty-one. She continued to be involved in the business, however. This may have been her downfall, along with aging (and perhaps alcohol). Most accounts of her business talents are, at best, ambivalent to condescending. A woman taking up the reins of production and finance may have been a travesty greater than growing old. In *Singin' in the Rain* (MGM, 1952) there is a reference to Pickford: when Lina La-

mont is blackmailing R.F., the producer, in his office, she quotes Pickford reviews as her own. (Tino Balio supplies a sample of the original reviews: "Miss Pickford is an artiste of the highest rank. . . . She is one of the three brilliant stars in the motion picture firmament.")[14] In this scene, Lina takes control of her own career through the legal terms of her contract. But she goes on to suggest taking control of the studio. Lamont, the butt of the film, is duly humiliated in the end, and in fact, throughout the film.

Scott Eyman's 1990 biography of Pickford replays *Sunset Boulevard*.[15] He describes her Hollywood home, Pickfair, after her retirement: The "wall [that] had been constructed to keep the world out" would now "keep Mary in" (228). "Mary began to do what all the Pickfords did. She began to drink." After lunch she would be "indisposed" (230). Eyman's description of her home after her death in 1979 recalls Norma Desmond's house all the more. "Pickfair had changed little over the years"; it was filled with "heavy" French and English antiques. "Although the mistress of the house had mostly kept to her third-floor bedroom . . . in nearly every room, there were oil paintings of Mary, most of them representing her as she looked in the heyday of her career" (309). Like Norma Desmond, Pickford joins the ranks of the sensitive, nervous woman, the victim of self-destruction, of obsession, rather than of a social and economic double standard.[16]

(*Postcards from the Edge* [Mike Nichols, 1990], from the Carrie Fisher book about recovery, revises the scenario of the pathetic aging actress. The film takes addiction to the surface, rather than burying it in romantic accounts of aging as vanity and immaturity. In the touching scene near the end, Shirley MacLaine faces the camera—and her daughter [Meryl Streep]—without makeup, allowing us to see beneath the masquerade.)

CONTEXTUALIZING THE
IDLE WHITE WOMAN

Paradoxically, while powerful, working women have existed all along in film history, particularly on-screen, the figure of the passive (white) woman has had a long run in the United States. She dates back directly to the nervous, "sensitive woman" of George Miller Beard in 1869. Lacanian theory gave new life to the idle woman by endowing her with sexuality and duplicity. What is puzzling is that the idle woman was adopted by feminist film theory in the 1970s, during a period of women's activism.

The idle woman is white, young, often middle-class. She has been defined by her body, not her work; her image, not her actions. Because she has been built by male analysts, it is not surprising that *his* desire has been the measure of her identity and worth.

I want to place the idle white woman within history (including psycho-

analysis) and economics, seeing her as a working woman, and to suggest her relation to race and women of color.[17] I begin with a film that perplexed me for many years: DeMille's *The Cheat*, a 1915 melodrama popular with French artists and intellectuals in the cine-clubs in Paris.[18] Contemporary U.S. criticism, sometimes called history, picked up this early artistic celebration of DeMille's "Rembrandt" style.[19] But it ignored what is most striking about the film: the representation of women, race, and consumerism—all negative, all tied together.

I wanted a context other than DeMille the artist, the early Hollywood industry, or recycled film history, so I looked to popular movements and trends of the period suggested by the film. Among the most pertinent are neurasthenia (George Miller Beard), the Woman's Club Movement (Mrs. J. C. Croly), the scientific management of the home (Mary Pattison), and the bodily movement craze (the gestural system of François Delsarte).[20] (The male writers focus on the body. The women's projects emphasize women's knowledge.) The antilynching activism of Ida B. Wells (-Barnett) provides a direct route into the relation between the idle white woman and women of color, at the turn of the last century.

Each writer cites the influence of Charles Darwin, implying the existence of facts, empirical data carefully observed and compiled. Invoking Darwinism was a claim for the truth of science through direct observation, cross-cultural analysis, and tabulation. (The field of visual anthropology was in the making.)

Through the case study and foreign travel, physicians applied these "Darwinian" methods (underwritten by "the theory of natural selection") to the body—a living, cross-cultural miniature of evolution—and its work.[21] Some bodies were considered more advanced than others. Hence "brain workers" and "muscle workers" had different ailments; those with "moral fiber" suffered differently than "degenerates"; and the medical plight of the "civilized" was vastly different from that of "savages" or "primitives."[22]

The racist and classist misuses[23] of evolutionary principles are unnerving, as are the presumptions of progress inherent in evolutionary thought. "Higher" or advanced pursuits were war, technology, and politics, a hierarchy of values challenged by women activists of the period—who also used Darwinian thought. In fact, the influence of Darwinian thought on all fields of thought is incalculable.[24]

Along with natural history, Darwin's theory came from statistics and economics, particularly the economic principles of Adam Smith. In fact, Stephen Jay Gould[25] calls the theory of natural selection "an extended analogy . . . to the laissez faire economics of Adam Smith" (66). Briefly stated, Smith's "rational economics" proposes, "If you want an ordered economy providing maximal benefits to all, then let individuals compete and strug-

gle for their own advantage. . . . Order arises from struggle among individuals, not from higher control" (66). (At least for men.) The three key premises of "Smith's classical economics" are (1) that people *will* behave rationally; (2) that the economy is a separate realm, with a life of its own; (3) that the economy, or the market, is "natural," not a construct. (Smith's ideas, now referred to as "neoclassical economics," echo internationally in the 1990s in arguments for corporate deregulation and state privatization.)

The market, the place of commerce and self-interest, was the diametrical opposite of the home, a spiritual haven of love and mutual support. Men's space was the market; women's was the home. Paradoxically, the market, dependent on consumption, relied on the female consumer and targeted her home. There is little difference between home and market, except payment (and status).

But in 1978, Barbara Ehrenreich and Deirdre English said it so much better. Their book is still a landmark, maybe even more relevant in the 1990s. The title says it all: *For Her Own Good: 150 Years of the Experts' Advice to Women.*[26]

The Cheat and the Consumer

George Miller Beard, the eminent nineteenth-century neurologist, writes about "the sensitive white woman—pre-eminently the American woman . . . living in-doors; torn and crossed by happy or unhappy love; subsisting on fiction, journals, receptions . . . needing long periods of rest . . . carrying the affections and the feelings of youth in the decline of life."[27] The sensitive white woman resembles Norma Desmond, Mary Pickford, Freud's "woman no longer young," and Edith Hardy, "The Butterfly," star of DeMille's *The Cheat*. Sumiko Higashi describes the film:

> Edith Hardy, an ambitious and extravagant socialite, quarrels with her husband Dick about her spendthrift habits. She confides her plight to Haka Arakau, a wealthy Burmese merchant who belongs to the smart set, and flirts provocatively in response to his attentions. [The original character was Japanese, named Mishuro Tori but there were protests in California.][28] As treasurer for a charity event, Edith is responsible for ten thousand dollars but secretly gambles it on the stock market. When the speculation fails, Edith agrees to a liaison with Arakau in exchange for money.
>
> Meanwhile, Dick has been speculating himself but unlike Edith, he has won a fortune. The Burmese merchant refuses her repayment. . . . A struggle ensues. . . . Edith shoots and wounds him. Arriving on the scene, Dick protects Edith by confessing to the police."[29]

During her husband's trial in the last sequence, Edith confesses and the couple is restored. The film's system is complicated in that Arakau/Tori at-

tempted to (or did) rape Edith Hardy, branding her on the shoulder with a hot iron/seal that he used to brand his possessions. Edith shot him in self-defense and let her husband nobly take the blame.

Fanny Ward plays Edith, the upper-class woman of clubs, Red Cross fund-raising parties, and excessive spending on high fashion. As Jeanne Allen writes of this period, glamour and consumer values united "around the image of woman as the ultimate product for consumption and mark of social class distinction."[30] Clothing was the key to the person, the star, and the character. Jane Gaines has pointed out, "Silent film costuming . . . restat[ed] the emotions which the actress conveyed through gesture and movement."[31] Edith is as frivolous and extravagant as her clothes. Her work for charity organizations is seen as merely social climbing. As homemaker, volunteer, and investor, Edith is viewed as childishly ineffective.[32] Women's work (which includes consuming), like women themselves, is devalued.[33]

The opening credits divide the film world into earners and spenders, producers and consumers, men and women. Richard Hardy is in his office with a ticker tape, working; Edith Hardy is at home with a large dog, posing in high fashion and feathers. Edith shops. She is a spendthrift, with exorbitant clothing bills. When she invests (with money "borrowed" from her club, of which she is treasurer), she loses. The film depicts these as Edith's problems.

But there is another way to look at her dilemma. Edith's lack of and desire for financial independence is the problem. Amid the melodramatic sexual blackmail, the quandary of women's lives—their dependence upon husbands for money—is difficult to recognize. Within a narrative that "precludes . . . women's economic and sexual self-reliance . . . women's clothing becomes the ground of struggle, both literal and figurative, for control of women's bodies" (Allen, 122).

Instead of being portrayed as trapped within an economic contradiction, Edith is branded, raped, tried, found guilty, and forgiven for sexuality—all this for asserting her financial independence. In the opening Edith's head is held high, her eyes look out. After the trial her clothes are in tatters, her head bowed, her eyes downcast, and her shoulders drooping. The excessive female body of high fashion has been punished and women's independence contained. For women, the "happy ending" is resignation.

The Cheat demonstrates that the money economy has been reserved for men. Women were held to the sexual economy, which worked through a double bind: the female consumer so crucial to the money economy was courted and disdained. Like women, shopping is "Original Sin: forbidden, guilt-inducing, titillating, alluring" (Allen, 124).

The double economic standard also works through race. Shopping versus investment, spending versus earning, women versus men is also Asian versus Caucasian. Eastern businessmen—Arakau/Tori, the Burmese ivory trader—are perverted. Western businessmen—Richard Hardy, a Wall Street investment banker—are honorable. Racism comes to the surface as the courtroom spectators turn into a lynch mob attacking Arakau/Tori (Sessue Hayakawa), accused by Edith of rape. The money, sexual, and racial economies become inextricable.

Higashi concludes the brief analysis of the film with "DeMille succeeded in composing a world in which aesthetics, eroticism, and wealth were intertwined by manipulating the visual imagery to create a spectacle" (Higashi, 29). For Charles Woolfe, "the expressive potential . . . of his 'Rembrandt lighting'" is used to invoke "emotional hysteria."[34] Historians invoke art and Freud to describe "style." But they deny what is right in front of their eyes.

NEURASTHENIA:
GEORGE MILLER BEARD

While evolution served capitalist expansion (and white men), it extracted a price—neurasthenia. For George Miller Beard, men and woman both suffered from emotional excess.[35] *Neurasthenia* was his 1869 term for this middle-class, white-collar disease (a precursor of obsession), fostered by industrialization.[36] Beard argued that neurasthenia occurred more in the "brain working" than the "muscle working classes,"[37] and "that woman has suffered more from civilization than man."[38]

Although anyone could be afflicted by neurasthenia,[39] class and gender determined different causes. Professional men suffered from overwork while lower-class men had profligate habits. For women, this was inverted: overwork was the cause of nervousness for working-class women, who were competing in a man's world by earning money; for middle-class women who remained at home (for F. G. Gosling, presumably "not working"), biology, or "female problems," was the cause.[40] Women in domesticity were imagined to be free from economic fear and the strains of labor. But I think Gosling misreads Beard. Beard places women within the late stage of neurasthenia (insanity or melancholia): "Under this class come not a few women—house-wives who are over-worked; mothers, worn by repeated child-bearing" (Beard 1894, 164).

The diagnosis dominated U.S. medicine until the 1920s. Unlike Freud, who looked back to childhood and the family, Beard linked nervousness to adulthood and the modern world. "The one great predisposing cause" (Beard 1898, 33) was civilization—market competition, scientific/timed

management, mass production, cities, transit, popular culture, electric technology and techniques of communication (telegraph and telephone)— in short, modern, urban life. Modernity "intensif[ied] in ten thousand ways cerebral activity and worry" (Beard 1894, 254). Neurasthenia was the result of economic more than sexual, technological more than familial, causes. (A recent essay argues that through "the law of least effort," neurasthenia brought about modernity.[41])

For Freud, infantile sexuality was the singular cause of nervous effects manifested by the body. For Beard, sex was only one of four causes; the others were exhaustion of the brain, spine, and digestive system. Beard also saw sexual dysfunction as a problem for men as much as women: "The relation of the male genital function to the nervous system . . . has been for too long neglected" (Beard 1898, 208).[42]

The differences between Beard and Freud can also be seen in their relations of sexuality to class (or race). Beard's muscle workers "are not tormented with sexual desire [as] the hysterical, the nervous—those who live in-doors and use mind much and muscle little." His examples are North American Indians, "the savage and semi-savage, negroes, and farming population [who] are not annoyed by sexual desire when they have no opportunities for gratification" (Beard 1898, 103). This is precisely the inverse of the lynchers' accusations of lustful black men raping white women (yet it is an extension of the same premises of evolutionary separation and hierarchy). The highly sexed stereotypes of African men (bucks) and women (lustful temptresses) do not appear in Beard.

Freud, by contrast, links female sexuality to race (as dangerous)—apparent in his use of the phrase "dark continent" (in "Essay on Lay Analysis," 1926). Female sexuality is tied to the colonial black—a sexuality of exoticism and pathology. As Patrick Brantlinger assesses, the "dark continent" was a Victorian myth (excuse) predicated on the fear of social regression (217), which has a strong sexual dimension: the lifting of repression would result in the breakdown of civilization.[43]

The dark continent was thus a myth about empire that involved "a psychology of blaming the victim," one that was employed in slavery. "The first abolitionists blamed the Europeans, but by mid-19th century, the blame had been displaced onto Africans." Slavery then "fused with sensational reports about cannibalism . . . and shameless sexual customs" (Brantlinger, 217). Economic exploitation and subservience were both cause and result of all this mythology, an illogical structure of blaming the victim operative in domestic abuse of women of all colors.

Contemporary critics such as Gosling and Tom Lutz[44] unequivocally declare that Beard's "neurasthenia was a highly gendered discourse," with different causes and different treatments, including "gender segregation."

Yet while Beard divided the mind from the body and the intellect from affect, he often equated men and women. Both "the power to reproduce the species and the power of abstract thought" were viewed as advanced evolutionary stages. "Labor of the intellect of the higher sort saves us from friction of the emotions of the lower sort" (Beard 1894, 187, 188). The more intellect, the less emotion, "as true of men as of women" (Beard 1894, 189). For Beard, emotions were not a good but rather an exhausting thing. (I tend to agree, as does postmodern medicine. In fact, several of Beard's conceptions are currently accepted, particularly his analysis of obsession based on fear.)

Beard's defining difference was not sexual but class difference, signified by work: the "brain worker" as distinct from the "muscle worker." His mental/manual distinction replicated the management/labor, owner/worker divisions of corporate capitalism and, later, F. W. Taylor's "scientific management." In fact, all of Beard's texts focus on work, economics, knowledge, technology, and the body as analogous to the machine.

Male scholars of Beard, however, focus on the "leisure-class" wife, what they see as a new and difficult role of "enforced passivity" (Lutz, 35). They connect neurasthenia primarily with middle-class women. Despite these writers' scholastic expertise, I have hesitations about this analysis. My first is that, as feminist historians of the period note, these leisure wives were rare. Second is the failure to acknowledge mothering, housework, and volunteer work *as work*. Finally, Beard's analysis of male dysfunction is largely ignored by male critics of neurasthenia, who prefer to focus on women.

History—and feminist theory—might have been different if one of Beard's ideas had been remembered. Beard died while writing about male impotence. His book *Sexual Neurasthenia* includes many case studies with forthright descriptions: "Cases of sexual exhaustion in the male, on the contrary [to women], are not suspected from the history given by the patient" (Beard 1898, 26). The severity of impotence had not been noticed because men didn't talk about it, a limitation of Freud's "talking cure."

Beard was suspicious of the talking cure. He challenged "mental therapeutics" that turn the patient's "own mental force on his body to cure it" (Beard 1898, 222). He predicted that "when the relation of nervous diseases to the male genital apparatus is as well understood as their relation to the female genital apparatus, it will be regarded as an oversight . . . not to inquire and examine . . . this local condition" (Beard 1898, 29). (Now you understand the humor in the film theory phrase of the 1970s "the cinematic apparatus.")

I wonder if reading Beard's books, with the many descriptions of impotence, might have been the source of Freud's great "fear of castration."

Beard's treatments included medicine, rest, marriage, and travel. But a favorite was "faradization," electric shocks to the genitals. Beard describes seminal emissions and impotence in detail, arguing against excess, one sign of which was "eye trouble" (Beard 1898, 136). Could this be Freud's linkage between castration and vision? I wonder if impotence, visible and verifiable, is the repressed of Freudian psychoanalysis—replayed as the "fear of castration."

An emotion central to both Beard and Freud is morbid fear (the basis of all theories of obsession). Beard's *Practical Treatise on Nervous Exhaustion* is a taxonomy of phobias, concluding with phobophobia, the fear of fears. "The fear of overcivilization was often accompanied by fear of overwork and, especially, overproduction" (Lutz, 28). But the general fear of change was not specific to the early 1900s, as Lutz suggests. It is alive and well in the 1990s. The accompanying fears, however, today are almost the opposite: fears of lawlessness, no work, and slowed production. Fear triggering anxiety links neurasthenia and obsessional neurosis (and 1990s addiction therapies).

Freud's model of obsession as a logic of contradiction was linked to consumer capitalism at the turn of the century and connected in "The Rat Man" (1909) to money and anxiety more than sex and desire.[45] (After Freud delivered his U.S. lectures at Clark University in 1909, the same year he published his study of obsession, a change in analysis and treatment began in the United States.) It is a model of subjectivity closer to Beard's, one that might more accurately describe our response to *The Cheat* and other films of this period.

While physicians were inventing a cause–effect logic of the body loosely drawn from Darwin and Isaac Newton, Hollywood was perfecting the continuity style, a narrative of chronological cause–effect logic that plays itself out through the film body. Just exactly what was cause and what was effect, however, was disputed. The debate over the emotions (Darwin wrote a book on expression and emotion) was central—whether bodily gesture caused emotions or whether affect produced gesture; whether the body was a cause or a symptom, a depth or a surface.[46]

Modernity linked cinema, a new machine of the visible, with Beard's ideas. His metaphor of the civilized body (opposed to the primitive body) was a modern machine.[47] The "neurasthenic" was a "dam with a small reservoir," a "small furnace, holding little fuel," a "battery with small cells and little potential force," or "an electric light attached to a small dynamo" (Beard 1898, 61). "Brain workers" had "exhausted their stock of nerve force and became victims of nervous prostration" (Beard 1898, 62).

As with the classifications of François Delsarte and other taxonomer/evolutionists of modernity, Beard's body zones resembled a tree, an ar-

borescent, Darwinian logic also used by "scientific managers." At the same time, the symptoms were rhizomatic, unpredictably moving around the body. Lutz points to neurasthenia's "heteroglossia," "inclusiveness" (Lutz 15–17). Equally widespread were the cures: "Patients often need a new kind of treatment as they need a new suit of clothes" (Beard 1898, 209).

Lutz draws the very interesting conclusion that "neurasthenia was imbued with the logic of economics"—mainly neoclassical economics, I would add. Differentiation and diversity were the earmarks of the disease. "Neurasthenia was . . . a sign of the times." The centrality of the economy, signaled by Freud's linkage of money and obsession in "The Rat Man," is apparent. The connection between Darwin and Adam Smith plays itself out in Beard and in *The Cheat*.

From 1869 to the concept's demise in the 1920s, neurasthenia was widely diagnosed by gynecologists, alienists, oculists, electrotherapists, surgeons, pharmacologists, and neurologists. In the 1920s Freud's theory of the neuroses and psychoses achieved supremacy, as did medical specialization, with specialty boards and training instituted after World War I. Alienists, later called psychiatrists, dominated the "therapeutics of emotional disturbance," while neurologists treated nerve injuries. Other practitioners withdrew from the field, but neurasthenia entered popular culture and was portrayed in films.

The Nervous Wreck

In a 1926 film directed by Scott Sydney, an Al Christie comedy for Universal, an easterner (a nerd) wearing a small suit and glasses and driving a car goes west. This neurasthenic, a precursor of Woody Allen, is a hypochondriac who believes he is dying. "The Nervous Wreck" carries a doctor's bag full of pills, potions, and throat atomizers. At Jud Morgan's ranch he meets Sally, the lovely daughter who fancies him at first sight. She persuades him to drive her to Tucson. They set off on a journey and comic romance in the Arizona desert—culminating in a fight scene and chase sequence. Adventure, the easterner's newfound masculinity, and romance cure his neurasthenia. Marriage (and sex) is one cure that Hollywood administered over and over again.

Feel My Pulse

In 1928, Gregory LaCava remade *The Nervous Wreck*—with a female protagonist, Bebe Daniels—for Paramount. Barbara Manning is a rich, young woman who has been surrounded all her germ-free life by doctors, literally living a rest cure and worrying about her heart. In *Feel My Pulse* she constantly monitors her symptoms and medicates her body. Her cigar-smoking uncle arrives on her twenty-first birthday, suggesting that she go

out west. She avoids this by going instead to a family-owned sanitarium. Unbeknown to her, it has been taken over by "rum runners," led by William Powell. (Prohibition was enacted in 1920 and repealed in 1933, although many states had prohibition laws much earlier.) LaCava, a serious alcoholic, thereby links alcoholism with insanity (and neurasthenia, as did Beard).

Manning/Daniels also carries her doctor's bag of pills, popping them obsessively and offering them to the criminals, who are pretending to be patients. During one long scene she and a rum runner get very drunk—he on her medicine, she on his illegal booze, which she thinks is medicine. After this scene she has a hangover. Her room is lighted with shadows and angles. Powell, impersonating a doctor, becomes menacing and tries to attack her after a pseudo-examination. This is a dark, discordant scene for a comedy. Getting drunk brought on this real nightmare, a prelude for chaos. Hijackers turn the sanitarium into a loony war zone. In another quite extraordinary scene, Barbara-the-plucky fights off the bad guys. She lobs a bottle of chloroform at the criminals. In slow motion the men stagger and fall down, as if they were drunk, in a balletic fog.

In the end, Barbara is cured of neurasthenia by adventure and romance. A reporter had disguised himself as a criminal and has fallen in love with her. The last image is the word *Yes* written on the screen, her answer to his marriage proposal. The William Powell character, the displaced site of alcoholism, is not saved.

By the 1920s neurasthenia had become comic—ubiquitous, heterogeneous, inclusive. For 1990s critics like T. J. Jackson Lears, its offense was being middle-class, linked to women. But Beard had anticipated Lear's critique, arguing that in spite of its middle-class nature, neurasthenia was serious and real.

THE WOMAN'S CLUB MOVEMENT:
J. C. CROLY

The mid- to late 1980s' turn to film history and the consumer (rather than to the narrative and the spectator) had late nineteenth-century precedents—for example Mary Pattison's principles of domestic management. Then, as now, the economic status of women's unpaid labor—within and outside the home—bears scrutiny. As Anne Firor Scott argues, the long history of women's volunteer organizations has—in spite of the fact that detailed records exist, due to each organization's electing an official historian—remained an oversight of official history, concerned as it is with war and politics.[48] In 1898, "Mrs. J. C. Croly" attributed this blind spot to Dar-

winism's influence on history: "the development of military leaders, the acquisition of military power, and the centralization of property."[49]

Croly argued that the first associations of women grew from their "protest against the use and abuse of power by men." From their initial purpose as refuge, women's associations developed because of the "desire for study, the acquisition of knowledge" (2).[50] In 1868 women's organizations flourished: for example, the Young Women's Christian Association, the Women's Christian Temperance Union (WCTU), missionary societies, and woman's clubs—a mix of literary societies and civic reform. (Edith Hardy in *The Cheat* is the officer of a woman's club that does missionary work.) As Scott argues, all of these organizations led to women's suffrage, although many members did not call themselves suffragettes.

Croly's 1898 history of woman's clubs begins with the foundation of her own club in New York twenty years earlier. Her first prediction still has not come to pass: "When the history of the nineteenth century comes to be written, women will appear as organizers, and leaders of great organized movements among their own sex for the first time in the history of the world" (Croly, 1). The idea of a club for women—one that did not have a specific goal, such as fund-raising or reform—was very radical: "There was little sympathy with organizations of women not expressly religious or charitable." "What is the object" if not raising money or sewing garments (Croly, 9)?

Knowledge was the object—and the cause of men's bewilderment. For middle-class women, "knowledge" was superfluous. Croly traces the clubs' intellectual roots to Goethe and other German thinkers. "The crusade against slavery, the recognition of the human rights of women and children" (Croly, 9), . . . "initiated the demand . . . for education; for intellectual freedom" (Croly, 11). Women's "educational advance" (or equal opportunity), women's rights (such as suffrage), and opposition to slavery were interrelated issues.

The purpose of the club was to enable women "to think for themselves . . . their right [and] their duty," to seek "new avenues of employment to make [women] less dependent," and to enhance women's self-esteem, "to lift them out of unwomanly self-distrust" (Croly, 21). The founders believed that "one of the great needs of women is for mental activity" (Croly, 27). The clubs addressed "the lack of ability [and opportunity] among women for free discussion" (Croly, 40).[51] The structure was not hierarchical but collective. Woman's clubs had no leaders: "The essence of a club is . . . expressing all shades of difference" (Croly, 13)[52]

The club was "caricatured, criticised," the subject of "sneering comment" by men (Croly, 26). The first president resigned due to neurasthenia resulting from these attacks. Despite widespread scorn toward *knowing* women, clubs were founded all over the United States, meeting the first

and third Monday of each month. Today, the Milwaukee Woman's Club stands on its original site, still limited to two hundred memberships.

DOMESTIC ENGINEERING:
MARY PATTISON

Along with fostering knowledge and women's support, club members wrote constitutions; kept records; invented a collective, efficient structure; and organized national events. One project of the New Jersey club was *Principles of Domestic Engineering*, written in 1915 by Mary Pattison.[53] In 1911 Pattison had read Frederick Taylor's *The Principles of Scientific Engineering*, which she described as a "system devised by man for man's pursuits, but equally applicable to woman. . . . It all seemed to fit beautifully as far as it went, but more was needed" (148).[54] Pattison added the scientific management studies of Frank Gilbreth, the "twelve principles" of Harrington Emerson, the results of the experimental station [their "test" house], and her experience of women's everyday lives to her book (171).[55] It is the last of these that sets her project apart. In the preface to her book, Pattison's work is compared with Darwin's *Origin of the Species* and Newton's *Principia* (both were sources for Beard). She is described as an "engineer" and her field as "household engineering."

Pattison agreed with Taylor that adding the "scientific method" to management theories caused "a complete change in the mental attitude of the worker" and management "toward each other, and toward their . . . duties and responsibilities" (150). Scientific management promoted cooperation and independence, "impossible under the philosophy of the old management" (150).[56]

Applying Taylor's principles to the home, Pattison asserted that the purpose of housework was to achieve independence and self-satisfaction: Science (technology and method) would transform "drudgery" into satisfaction: "It is perfectly possible to take the crudest and most primitive of occupations and perform with the attitude of a scientist, . . . noting the facts, studying the parts, and relating them to the whole" (97).[57] The same system of "modern industries was applicable to the home . . . Standard Equipment, Standard Conditions, and Standard Operations" (93). Standardization would lead to freedom rather than conformity.[58] Standardization of procedures and professionalized training would enable "anyone with a general knowledge of housekeeping to take charge of the average home."

Comparable to the women's clubs, the goal of household engineering was personal freedom, "the object of family life" (174). "The dependent wife is . . . less efficient and less happy than the one who is . . . responsible for herself, her own manager, and her own master. And the man who

would make of his wife a dependent darling is selfishly inclined" (173). (This view of women's independence is quite different from the economic dependence of Edith Hardy in *The Cheat*.)

The "Housekeeping Experiment" in Colonia, New Jersey, was a "scientific project," a rebuttal to the criticism that the work of club women was dilettante. The experiment addressed an urgent issue, "the Servant Problem"—for Pattison, analogous to the anti-slavery campaign. The use of household servants was a system in which the rich exploited the poor, degrading housework and other kinds of labor in the process. She recommended eliminating the "servant class"; only 8 percent of the population employed servants. (Edith Hardy's servant is an exception, quietly in the film's background.) While "competition" fostered "advancement" in public affairs (as Darwin and Beard asserted), there was little progress in the home: "House work and house-workers are classified at the very bottom of industrial occupations." Housework had not "evolved" as had other occupations. While she adopted Darwinian premises, Pattison also took Darwin and contemporary theorists like Taylor to task for ignoring women's work. She criticized the social divisions of work—an issue of gender and class.[59]

But Pattison ignored a key feature of Taylorism—his emphasis on high pay for efficiency and productive work. Pattison did not think that money should be determinant.[60] She also did not question that domestic work was women's work ("In 90% of the families in this country, the mother and daughter are doing all of their work without the aid of a servant" [15].)

Other reformers disagreed. Charlotte Gilman Perkins challenged the value or progress of the woman in the private home, advocating that housework be industrialized, with profit incentives.[61] Using Darwin, she suggested that domestic work was only a stage in evolution: "All industries were once 'domestic'" (Strasser, 221). After suffering from neurasthenia and undergoing the cure of isolation, Gilman learned that equality could come only when "men stopped supporting women, the over-developed sexual prisoners of a parasitic economic relationship." Women must "follow men out of the house" and into social production[62] (Strasser, 222). Women, like men, must also be producers, not just consumers.

Pattison did argue against "mother dependence," where everything falls on mother's shoulders, a situation that encouraged "nervous exhaustion" (Pattison, 59), a problem of early leaders of the Woman's Club Movement. But she refutes the "sensitive" woman of Beard, a "small class of over feminine and unnatural beings," and paints a picture contrary to DeMille's idle white woman: "We find the very large majority of women looking forward with dread to any such possible break-down."

The legitimacy of women's work was at stake, including their role as

consumers, the "business of purchasing." In a nice rejoinder to Freud, Pattison declared that women "must know what they want and not merely desire" (Pattison, 66). The business of purchasing was work that contributed to the economics of "each community and city." Consumption was, for women, a "big subject": Purchasing "is the woman's work of the future." This figuration of the female consumer is vastly different from the wasteful shopper DeMille portrayed in Edith Hardy.[63]

In the end, Pattison was right: women's work has "produced a new kind of history," a revision that includes women, who were there all along.

Cheaper by the Dozen

Scientific domesticity returned in 1950 in cinema as men's work—*Cheaper by the Dozen*. Directed by Walter Lang for Twentieth Century Fox, "This is the true story of an American family." Lamar Trotti wrote the screenplay from the autobiography of Frank Gilbreth, Jr., telling the story of his father and namesake, who was a colleague of F. W. Taylor. Clifton Webb plays the energized center of the film, the force around which everyone circles. However, while father is always in center frame, the figure of authority, he is never in control. Mother (Myrna Loy), holding a baby, doing laundry, or assisting Dad, is the real power—the great woman behind the man. Strangely, the film is told from the daughter's (Jeanne Crain's), not the son's, point of view.

The family is run like a democracy, with children doing work around the home. Efficiency and science dominate: learning, bathing, and dressing are scientific. Tonsillectomies are filmed and timed; surgery is mass-produced, entrepreneurial. The ultimate goal is saving time. When asked why he wants to save time, Webb replies, "For pleasure." The home is a place of rugged individualism, with no show of affect or emotion. However, sexuality upsets efficiency—the young women want to be attractive for men and wear the new fashions of high heels, makeup, and camisoles.[64] They want to be consumers.

While Dad, old but still professionally upwardly mobile, is off to an international conference on scientific management, Mom is off to the hospital for a baby. Men's work is production, women's work is reproduction. However, he suffers a heart attack and dies, leaving Mom to take over (which she does in the film sequel).

WORKING GIRLS

In *Never Done*, her history of housework, Susan Strasser writes, "In a society where most people distinguish between 'life' and 'work,' women who supervise their own work at home do not seem to be 'working'" (Strasser,

4). Thus women's lives and women's work are both devalued. Because Fordism targeted the household for consumption, this disdain is paradoxical.

Strasser's history of mass marketing and Susan Porter Benson's history of the department store document the shift from producer to consumer, dating it much earlier (1910–1920) than the post–World War II period argued by most male historians.[65] This divergence is due to Benson's focus on what is missing: women. Benson asserts that to understand the workplace dynamics of service industries in general, a central place must be granted to "the ambiguities and subtle dynamics of class and gender" (288). Fordism and neo-Fordism "sought the relatively cheap and supposedly docile labor of women. Simultaneously, women at the other end of the economic spectrum flocked to colleges and universities" (177–178) for professional careers. Education, or class, like color, separated women, divisions built into and erased by, the department store.

Saleswomen were "both sellers and buyers, workers and consumers" (239) in the workplace, seeing themselves as "working class, cajoled by the rewards of mass consumption to see themselves as middle-class" (271). The simplicity of a domination/subordination model is complicated by inscribing women's experience: "The lessons of department-store selling, then, surpassed simple precepts about women's subordination to men and included validation for female values and competence, bolstering women's confidence and self-esteem" (289).

Another double whammy was that salespeople were to be both "deferential and authoritative"—the central contradiction of women's lives in general. This is a no-win, and deeply familiar, logic (often buried in women's unconscious, which explains women's inadvertent complicity in their own secondary status). While "in the formal hierarchy of the store saleswomen were near the bottom in pay and authority, they in fact wielded enormous influence over the daily operations of the store" (289). They were everything and nothing. Significantly, the women were white: "Virtually no department store . . . would knowingly hire a Black woman as a saleswoman, although they were sometimes employed as elevator operators" (209).

The department store was different from the general store and the specialized shop. Diversification rather than specialization was the key, with "diversified stores" relying on impulse buying (15). Unlike the film studios, which adopted both specialization and differentiation, vertically integrated monopolies did not arise, and the branch or franchise store was also rare. Prior to World War II, the stores did not rely on national brands, retaining localism. Like the motion picture theaters, stores sold an array of pleasures and services in addition to products: luxurious rest rooms, air

conditioning, baby-sitting, workout facilities, hairstyling salons, and rest-aurants.

The store, like the motion picture palace (and later, the shopping mall); was a space of congregation. It was a place that instilled middle-class values—tasteful decorating, entertaining, and fashion, "dynamic museums . . . attuned to style and propriety" (22). The store did not merely sell what the manufacturer produced but was an agent for the consumer, creating an "atmosphere for selling that would encourage consumption."

Challenging the veracity of any history that excludes women, Benson's account represents the department store as a new kind of public space for women that expressed "the saleswoman's three identities—worker, woman, and customer." In this new space, "gender characteristics and conduct were a matter of daily struggle" (9). The shift from producer to consumer involved a serious trade-off: "homemade," formerly the product of women's work and skills, became devalued, a reproach (76). Along with the reproach, "women as consumers in department stores had a power out of all proportion to their power in the society as a whole" (94).

Consumption was tied to anxiety (79). Shopping was suggested as a "cure for neurasthenia," with shopping a part of "the new therapeutic ethic" (17). Fashion, which unsettled the predictability of purchase, "injected a new note of uncertainty." Yet while the stores trained consumers and were key players in the shift from production to consumption, managers never could understand "the difficulties of integrating women's culture with business culture" (167).

FACE

As consumers, women were lured by the fruits of Fordism and then castigated as irresponsible spendthrifts. As workers, they adopted Taylorism to professionalize their domestic labor but ignored the issue of payment for their work. As wage earners, they accepted status and pay lower than men. But at the movies, things were different. For the movie star, the female face (and body) was a profitable commodity, exploited by male producers. Historians have credited close-ups of the youthful female face as the basis of the star system. The female face launched corporate expansion and firmly anchored a binary economics of heterosexual difference, apparent at a glance (or first sight).

As one story goes, after Jesse Lasky and Adolph Zukor, the founders of Paramount Studios, read reviews that Lillie Langtry photographed "like an overweight old woman," famous stage actresses like Langtry vanished from lead roles. They were replaced by a "look" resembling "the Griffith Girl." This ethereal child-woman resembled the drawn cover-girl face of

Penrhyn Stanlaws. As *Harper's Weekly* argued in 1915, Stanlaws "standardized the girl face: For years, the Gibson, Fisher, Christy, Flagg, and Stanlaws factories have shared the same pattern of eye, nose, mouth, ear and chin . . . assembled at each factory according to its own secret formula."[66] This is, of course, standardization and differentiation applied to women's bodies.

What is compelling about the phenomenon of the face is its normalizing role: "faces that do not conform" are rejected.[67] Anything that eludes normalcy becomes deviance—for example, African and Asian Americans. One way to achieve normalcy (uniformity) is makeup. Cosmetics came first to the movies (from theater) and from there into the marketplace and respectability. As Kathy Peiss writes, "Once marking the prostitute and aristocratic lady as symbols of rampant sexuality and materialistic excess, cosmetics became understood as respectable and indeed necessary for women's success and fulfillment."[68] Cosmetics entrepreneurs reshaped the relationship between appearance and feminine identity by promoting the externalization of the gendered self" (157). Makeup promised the true self.

The early face of cinema, epitomized by Mary Pickford, was not that of a woman but that of a young white girl with a teeny, rosebud mouth; darkly rimmed, round eyes; wispy, long hair caught or swept up when in public. Her body was thin, so light that it appeared to float rather than walk. Mae Marsh, Lillian Gish, Blanche Sweet, and Fanny Ward were look-alikes, modeled on a facial prototype of airy delicacy that had circulated from magazine drawing to soft-focus film-insert close-up.

One startling shot in *Way Down East* (D. W. Griffith, 1920) demonstrates how carefully manufactured this face, particularly its age, was. During the chase across the ice floes in the snowstorm, Griffith intercuts a close-up of Gish, shot on location outside, that reveals circles under her eyes and lines on her face. For just a startling instant she looks much older than the girl of the other, insert glamour shots. As Norma Desmond knew so well, the close-up of the female face was the big event. This carefully orchestrated apparition of lighting and makeup was the moment we waited for. For women, self/other calculations have as much to do with image, with the face, as with narrative.

Unlike men's, the profitability of women's faces was limited by age. Women were held to generational difference, with virtually no spectrum of age. Female characters were either young or old, single or married, stars or secondary characters. The counterpart to the girl face was also standardized as an old face—lined, with grey hair drawn into a severe bun atop a heavy body, drooping shoulders, large breasts, and dull clothes. The face and body of Mother were outside the circuit of desire and sex. To play a mother was to be old (often a masquerade, upon closer inspection). How-

ever, unlike contemporary cinema, the early films at least represented Mother—after a period of women's activism that gained the vote for women in 1920.

Lois Weber and the Changing Face of Mothers

In Lois Weber's *The Blot* (1921), Mother is married to an absent-minded, underpaid professor. ("The blot" of the title refers to the low salaries of college teachers, which led the mother to an attempt, which her daughter saw, to steal a chicken from her neighbor. The film begins with "Men are only boys grown tall." In all of Weber's titles she editorialized freely.) This tense woman is fretful, exhausted, poor, and hardworking. In fact, the film portrays women's domestic labor—cleaning, cooking, and shopping (purchasing)—*as* work. Intercut shots of threadbare furniture, rugs, and especially shoes inscribe a point of view that is women's. But never is the possibility of Mother earning wages even suggested. Weber portrays the "ideology of woman's place" differently than Alice Kessler-Harris would (see the discussion in Age One), but the logic is still intact.

The Blot addresses class, money, and ethnicity (the neighbors are boisterous Italian immigrants) more than sexuality. Although marriage comes to the rescue in the end when the beautiful daughter, a librarian, and a handsome, wealthy college student become engaged, this solution is economic. The central relationship is between the mother and daughter, the film's real love story. At the end of the film, mother and daughter cry and hug. As progressive as this is, the happy ending (marrying the rich playboy, not the academic suitor) will also take the daughter out of the labor market. The daughter's wealthy fiancé, not her job, rescues this family.

Too Wise Wives, written and produced by Weber in 1921, begins with the intertitle "Most stories end 'And they lived happily ever after.' Shot of a sunset. "Our story should begin that way but . . . " The film depicts two marriages. In the first the wife is a martyr, sewing, tidying up while her husband reads and smokes. She is obsessive, afflicted with neurasthenia. He remembers another woman, who didn't nag or obsess. Weber's style of intercutting close-ups of domestic details—for example, the husband's shoes—reveals discontent. The wife puts on his slippers; he hates her cloying attentions.

The second marriage portrays a wife who is "very successful," with an older and richer husband. The two women meet at a Twenty-fourth Amendment speech, a prohibition rally. They go window-shopping. Realizing this is "the other woman" of her husband's daydreams, the obsessive middle-class wife goes nuts with jealousy and spends lots of money. Weber is exploring marriage, not romance, again dealing with issues of class

and domesticity. She represents women's activities such as shopping and critiques consumerism, along with "happy endings." But she doesn't go beyond women's economic subservience to, and dependency upon, men.

After *The Blot,* Weber's films didn't make money. "She found herself a box-office failure, unable to find work. Weber's marriage broke up, she lost her company, and she had a nervous breakdown." Neurasthenia, no doubt. She was the rare woman in a man's business of film directing. "After a brief comeback—at the age of 44!—and then sad attempts to start businesses that failed, Weber died in 1939, alone, impoverished, forgotten."[69] At least she is given the tragic ending of romanticism. But, like Freud's "the woman no longer young," she was too old at forty-four to accomplish anything.

This wasn't always the case. As Lois Banner points out in "The Meaning of Menopause," this period of feminist activism was the age of the "new woman" (1890 to 1920), who was "not only a young woman." This "renaissance of the middle aged" provided "new opportunities" for aging women "to go outside the confines of the home and family"; the negative "spinster" became the positive "bachelor woman."[70]

Women's appearance was also different: "At 50 the woman of today (1920) looks like her predecessor of 35 a generation ago." Banner observes that the "pouter pigeon" fashion "resembled nothing so much as the sagging breasts of an aging woman without a foundation garment to support them," a busty style derived from "the figure types of aging women," (15) before the 1920s' passion for flat-chested thinness.

In *Dancing Mothers,* a 1926 silent film about an upperclass family directed by Herbert Brenon, Mother is beautiful, thin, fashionable, and mature. Taken for granted by her husband and flapper daughter, who party at night, Mother resolves to have her own social life. During an evening out with another woman, she meets and is subsequently pursued by the same dapper male her daughter, Kittens (Clara Bow), fancies. Mother is not interested in the playboy, but her daughter thinks she is having an affair. Rather than feeling guilty or apologetic, Mother realizes she is capable and independent. Despite the entreaties of her daughter, she turns her back on her now-contrite husband and, in the film's end, walks out the door (not into the arms of the other man). I was completely surprised by the ending—a rare challenge to the meaning of "happily ever after."

Clara Bow's most ardent fan was Louise Brooks the silent film star. In 1957, when she was working as a film scholar at the Eastman House Museum in Rochester, New York, Brooks campaigned for Bow's reputation and her inclusion in film history. In 1964 she said, "Clara made three pic-

tures which will never be surpassed: *Dancing Mothers*, *Mantrap*, and *It*." Brooks's efforts on behalf of her film idol led to the revival of Bow's sound films and eventually to the discovery and rerelease of her surviving silents. She knew that "Bow's identity derived entirely from her professional activity: without work, she was without an identity" (261).

It and Elinor Glyn

In *Dancing Mothers*, Clara Bow had a secondary part. But she is completely compelling to watch. Her defining and starring role was in *It* (1927), an "Elinor Glyn Production" directed by Clarence Badger for Paramount. Bow played Betty Lou, the "it" girl—as Bow's Brooklyn accent emphasized, "a woikin' goil." As the intertitle said, "'It' can be a quality of the mind, as well as physical." Glyn defined "it" as more than sexual attraction: "it" was "a magnetism which attracts both sexes. He or she must be entirely unself-conscious and full of self-confidence, indifferent to the effect he or she is producing, and uninfluenced by others. There must be physical attraction, but beauty is unnecessary. Conceit destroys 'it' immediately."[71]

Betty Lou (Clara Bow), a working-class "girl" ("woman" was reserved for middle-class or older women), works at Waltham's, the "world's largest department store." All the clerks (women) line up for inspection when the owner (a handsome, rich, upper-class man) passes by. Betty Lou looks and desires: "I'm going to get my wish." This self-confident woman is beautiful, plucky, resourceful, smart, poor, and honorable. (She takes in an unwed mother and her baby, despite the scandal.) She can transform an ordinary dress into a designer creation with just a few tucks.

However, Betty Lou's goal is to be successful not in the retail business but in marriage to a wealthy man. After a date with Waltham at an amusement park (and some plot complications), they end up on his yacht, he with his upper-class fiancée, she with his older, upper-class playboy friend. But after Waltham rescues Betty Lou from the ocean, the predictable ending occurs.

I was completely surprised by one scene. Mid-film, the formally dressed, middle-aged, stout producer-author, "Madame Glyn," appears in the nightclub scene. This cameo raised my curiosity. I wanted to find out more about this older woman, powerful and famous enough to be recognized by historical film audiences but obscure enough to be almost unknown to me. What happened to her, historically speaking? I had heard of her best-seller *Three Weeks* but knew little else.[72] So I did a bit of research.

Glyn's productivity and celebrity in the 1920s were extraordinary. In spite of this (and the fact that she was a screen writer-producer, which was rare for women and men), her name is missing from the new and pre-

sumably improved film history books—based on archival research, on "facts," not anecdote. Then I looked at some old, dated, disrepuded histories. Lewis Jacobs mentions Glyn after DeMille. In Kevin Brownlow's *The Parade's Gone By*, there are several references to Glyn's films and books. Molly Haskell briefly cites her in *From Reverence to Rape*. But it is Marjorie Rosen in *Popcorn Venus* who includes Glyn as more than a sidebar in film history.[73]

Rosen quotes Samuel Goldwyn, who said, "Elinor Glyn's name is synonymous with the discovery of sex appeal in cinema" (117). By 1920, "Elinor Glyn, despite the fact that she was fifty-six and of another era and culture, had become the nation's arbiter of love." But Glyn was as much concerned with manners as with passion, glorifying "the nobility of sacrifice." In Rosen's assessment, Glyn was a conservative viewed by the public as revolutionary. She had a "remarkable ability to appear . . . risque while actually expounding a conservative philosophy" (118).

Despite the undeniable romanticism and superficiality of Glyn's imagination, Rosen asserts that her films were "jewel cases for the most sophisticated heroines of the screen, Norma Talmadge, Norma Shearer, Florence Vidor, and Swanson" (120). She discusses Glyn in the same category as DeMille (and even Ernst Lubitsch), noting their commonality—a belief that "style, not sincerity, was the foremost virtue" (117)—but suggesting that "Glyn's women, rich and poor, offered an appealing alternative to the DeMille wives."

Women scholars are currently studying the films of DeMille, while Glyn has dropped from sight. I wonder why. Perhaps Andrew Sarris inadvertently explained her dismissal in his 1988 review of a Clara Bow retrospective, where he put Glyn in parentheses, calling her "a ridiculous '20s combination of Dr. Ruth Westheimer and Jackie Collins."[74] History has a way of turning men (like DeMille and countless others) into serious geniuses (or at least, serious directors) and women into foolish eccentrics or grotesque parodies.

An incredibly prolific and independent woman, Elinor Glyn wrote over 250 articles under the column title "The Truth" for the Hearst press, and along with writing screenplays, she published many novels. *The Elinor Glyn System of Writing*, her how-to book, included "the nineteen plots to be avoided" (which are *very* funny). Known for her influential and famous friends, Glyn was an intrepid world traveler who had lived mainly in England. Her connections to nobility impressed Hollywood.

She got there through her novel *Three Weeks*. Jesse Lasky of Famous Players—Lasky (later to become part of Paramount) offered Glyn ten thousand dollars plus expenses to come to Hollywood, write the scenario or a film version of the novel, and supervise the film's production. Glyn left for

Hollywood in 1920. "She had never been one to miss an opportunity for travel or adventure. . . . She also had the prospect of making a lot of money" (Anthony Glyn, 273). Despite the glamour and celebrity, money and work were central, never incidental, to Glyn's story.

"Her first film, *The Great Moment* (1920), written for the screen starred Gloria Swanson" (Rosen, 118). Glyn was a close colleague of DeMille and through him became friends with Swanson and Marion Davies, which led to parties at William Randolph Hearst's San Simeon and the regular column. The film version of *Three Weeks* didn't appear until 1924; it had great box-office success but never made it to the talkies. As with other famous authors, it is said that Glyn's "stories were rewritten and completely altered either by stenographers and continuity girls of the scenario department . . . or by the leading lady, or by anyone else" (Anthony Glyn, 275). (I doubt this is completely true. If it is, the history of the stenographers and continuity girls is missing. But what a good movie this history would make!)

Along with producing and screenwriting, Glyn also began to publish novels set in the United States (unlike her earlier work). "In the American novels, the woman is not the inspiration; she is the end in herself, without whom all the triumphs of the hero's career are as dust and ashes. The heroines, from whose point of view the stories are always told, are usually distressed and unhappy. . . . They are fenced with, dominated and finally tamed" (Anthony Glyn, 289). Glyn knew how to sell her books through her celebrity and was no flaky eccentric, even publishing her concept of romance in *The Philosophy of Love* (Anthony Glyn, 292).[75] The book sold a quarter-million copies in the first six months and led to appearances in vaudeville in 1923. Glyn gave ten-minute talks on love for five hundred pounds per week (Anthony Glyn, 293). From 1923 on she began to produce films for Metro;[76] production coincided with the publication of the book.

Glyn's last three Hollywood films were comedies for Paramount: *Ritzy*, *It*, and *Red Hair*, the last of which again starred Clara Bow and was directed by Badger. As Rosen notes, Glyn's "best and most successful films were her last two" (Rosen, 119). In *It*, "once again there was no obvious resemblance between the film and the original story except the title. But this time Elinor wrote the screen-play herself." In the book, the male had "it"; in the film, the girl did. The film was a comedy, the book a "tense study in human relationship." The film version of *It* made more than a million dollars.

"Few authors have [promoted] themselves so successfully as Elinor Glyn. . . Having written a book called 'It', she proceeds to get a picture produced explaining what 'It' is, and appears in the picture and tells the hero

what 'It' is. Then for the past year she has been lecturing on '*It*', and the new cult has spread across the continent" (Anthony Glyn, 306). Glyn also wrote numerous articles listing who had "it" and who didn't. This is more than clever; it is brilliant marketing!

Glyn was sixty-two when she wrote the screenplay for *It*. Anthony Glyn's account could be describing the prototype for Norma Desmond: "Ever since her girlhood she had devoted much of her time . . . to preserving her beauty. . . . She fought all her life a grim, implacable delaying action against old age. . . . She arose early in the morning to complete her elaborate toilet. In 1926, she had undergone a facial treatment so painful that her arms had to be strapped to her sides for ten days" (304). But unlike Desmond, Glyn profited from her obsession, as she had profited from romance. In 1927 she published *The Wrinkle Book*, another best-seller.

In seven years in Hollywood Glyn had spread her "romantic ideals. . . . She had made her fortune. . . . She had re-established her fame. Now, at last, she could afford to retire and lead a more leisured existence" (307–8). She returned to England and became involved in spiritualism (314). She also formed a production company in England, at Elstree, but her films flopped. To support herself, she wrote four popular novels in the next four years. "The complete canon of her work numbers 39 volumes, with 25 books of fiction" (327).

In a speech Glyn said, "I write about rich environments and lovely women and handsome men and perfect love. . . . It isn't a bit clever, but people do seem to like it" (329). She published her autobiography, *Romantic Adventure*, in 1936. The book documents her aristocratic friends, her adventures, her trials, and her courage, but mainly, the "sheer slogging hard work that lay behind her success" (332). As a reviewer wrote, "*Discipline—discipline—discipline—* that is the rhythm of Elinor Glyn's life. Mental discipline as well as physical" (332).

Glyn died in England in 1943, just before her seventy-ninth birthday. The *Times* obituary read: "She defined romance. . . . She lived an adventurous life. She was a vital and courageous woman" (342). From her many writings, it would also seem logical that she had something to do with the profitable marketing of romance—perhaps the most lucrative U.S. commodity.[77]

The romance of Hollywood films and popular novels, including Glyn's, owes a great deal to the tradition of courtly love, developed in Europe in the twelfth century. This tradition regarded sexual love as an ideal worth great effort; it was ennobling and promised a lasting unity. Love had rules, as well as aesthetic and ethical dimensions, but courtship rituals were not necessarily related to marriage (the tradition's greatest divergence from Hollywood conventions).

When romanticism picked up the principles of courtly love in the late eighteenth and the nineteenth centuries, *feelings* of love took precedence over ritualized behavior, and the reciprocity of partners was emphasized. The partner makes up for one's deficiencies, so the couple is complete, the partners becoming one with each other and with God (Hendrick and Hendrick, 39).

By the Victorian era, romantic love had to come to terms with new ways of life: rapidly growing cities, the emerging middle-class, and a flourishing money economy with a new emphasis on paid work and business affairs conducted outside of the home. Although women had never had the social and political status of men in their social class, the nineteenth century saw the development of a new politics of women's subservient status; there were "many contradictions," of course, but women were generally regarded as physically weak and "delicate of mind" and thus unfit for paid work or education. Work done in the home, women's sphere, was not worth much, and respectable (i.e., middle-class and elite) women's lives were largely limited to their homes. Women could run the household, making it a retreat for the husband from the horrors of the urban and commercial world outside, and they could raise children, training daughters to be respectable women and sons to be honest and obedient (until they would be turned over to men to be trained in the ways of the world). (The prescriptions were quite a bit different for working-class women, who were rarely lucky enough to escape wage work; a society that wanted delicate elite women had to have hardy working women to do the heavy chores. But lower-class women did not become leading characters in romances until much later.)

Hollywood adopted these conventions of romantic love as mediated by Victorianism—complete with the contradictions related to women. This is not surprising, given that studies have repeatedly revealed "that men were more romantic than women" (Hendrick and Hendrick, 61). The five premises of "love" are (1) love at first sight; (2) there is only one "true love" for each person; (3) love conquers all; (4) true love is absolutely perfect; (5) we should choose a partner for love rather than for other (more practical) reasons (Hendrick and Hendrick, 61). These sound suspiciously like the philosophy of Elinor Glyn.

FRANÇOIS DELSARTE

The faces and bodies of early cinema's girl heroines were standardized through casting, lighting, makeup, costume, and expression. As "scientific" systems of gestural movement became popular, the repertoire of bodily affect was also calibrated and standardized into such gestures as

swooning, having the vapors, clutching one's bosom, raising the back of the hand to the forehead in anguish, and countless pursings of lips, dartings of eyes, lowering of lids, and raising of brows. Women's faces and bodies were surfaces for the play of emotion.

The gestural system of François Delsarte was a major precursor to, and influence on, the linkage of women, movement, and emotion. Imported from France to the United States in the late nineteenth century, it contributed to a trend that saw movement as concerned with worship more than work. Unlike the material time/motion studies of F. W. Taylor and Frank Gilbreth, "Spiritual" systems of movement had to do with affect more than efficiency.[78] Just as women were spiritual ideals, so feelings were the embodiment of the heart and soul. The gestures for worship could be irrational; those for work were logical. Religion—the unseen—manifested itself in aesthetics, in art, an accompaniment to the scientific emphasis on the observable: "The labourer's job is to work with material objects, the actor's to work with his own body."[79]

Delsarte's system is uncannily close to early cinema's codification of bodily gesture: "Gesture is the manifestation of feeling. . . . The most powerful of all gestures is that which affects the spectator without his knowing it. Outward gesture [is] only the echo of the inward gesture."[80] Gesture came from the heart, speech from the mind. Like the continuity style,[81] gesture would "affect" the spectator unknowingly.[82]

Delsarte saw himself as a scientist (an inductivist, like Darwin) in harmony with Christian religious teachings. As Ted Shawn describes, instead of seeing the body as nervous or hysterical (or melancholic), as a symptom of illness, Delsarte presented a positive, athletic model that viewed the body as healthy. He collected firsthand observations of the body under the stimuli of emotions. He trekked to disasters to record the expressions of victims, dissected corpses to understand anatomy, and recorded the play of children. He drew up tables, graphs, and lists, describing, taxonomizing (16). His was a "science" of "human expression" in which emotion produced movement—leaving "the body in a position which was also expressive of the emotion" (46).

The lectures of this famous French academician who taught at the Sorbonne in the 1860s were introduced to U.S. theater by Steele MacKaye, through a system MacKaye called "Harmonic Gymnastics." Although Delsarte's scientific system overall was complex, rigorous, and spiritual, anyone could use Harmonic Gymnastics, which included "decomposing" (relaxation exercises) and instructions for statue posing. Like Beard, Delsarte became a popular culture craze from around 1890 to 1920.[83] (Neurasthenia was a popular affliction, with decomposing as one of its treatments.) Hundreds of products appeared, including Delsarte corsets (loose and

without whalebones, unlike the Victorian corset), cosmetics, gowns (free-flowing "classics"), self-help books (with one publishing company printing only books with Delsarte in the title), and even a Delsarte wooden leg (18).

Delsarte had an extraordinary influence on modern dance through Isadora Duncan, Ruth St. Denis, Genevieve Stebbins, and countless women dance teachers, as well as women involved in the physical education movement (revolutionary for women). The body practicing Delsarte's system was not corseted, not confined, but instead was freely inscribed in the space around it. Duncan wore the free-flowing robes of the Greeks, a style of clothing also worn in the physical education movement. Delsarte also deeply influenced the movement systems of Rudolf von Laban in Germany and Mary Wigman, his student, effecting the stylized gestures of German expressionist cinema and theater. His principles fascinated activist or radical women, often feminists and "free thinkers" involved in the birth control and suffrage movements.[84]

One Delsartean popular activity that is no longer familiar, "statue posing"—the tableau staging of famous paintings, Greek statues, or great moments in history—was widespread as private entertainment and as public performance. This amusement was carried over into the live (and filmed) prologues of "presentation cinema" in motion picture palaces from around 1916 to the end of the 1920s (and longer in metropolitan theaters). Although postmodern film histories have recently documented a myriad of popular influences on early cinema—vaudeville, county fairs, music hall, magic, science, world fairs, expositions, and amusement parks, as well as melodrama, well-made plays, the nineteenth-century novel, and the short story—rarely has the women's practices of posing been included. (Perhaps it is considered too middle-class for many historians.)

Delsarte divided the body into "Three Zones: Head, Torso, and Limbs," which were connected to different values and emotions. The head was divided into (1) the back of the head, (2) the top of the head, and (3) the face (anticipating Deleuze and Guattari, who divided the face from the head), the last of which was, in turn, subdivided into three zones: (1) forehead and eyes, the mental zone; (2) nose and upper cheeks, the emotional-spiritual zone; and (3) mouth, jaw, and lower cheeks, the vital-physical zone (Shawn, 27). "The eyes in turn have three apparatuses—the eyeballs, the eyelids, the eyebrows." (Four-hundred-and-five combinations of these three eye "apparatuses" are listed in Harmonic Gymnastics [28–46].) The torso is "the moral-emotional" zone. Under Delsarte's "Doctrine of Special Organs," expression is linked to the parts of the torso; purer affections proceed from the middle zone, pride from the upper, and baser affect from the lower.[85]

This is a system based on evolution. The imperialist and racist trope of

evolution (as advanced civilization versus primitive tribes) valued the mind, dividing the loftier intellect from the baser emotions and segmenting the body into regions.[86] For Delsarte, the head was the evolved center of thought and spirituality, the torso the lower region of sexuality. This hierarchy eventually would separate men (the mind and rationality) from women (the body and emotions).

The Money Economy's Pure Logic:
Georg Simmel

A comparable distinction between intellect and affect arose during the Victorian era via the money economy. In 1909, in *The Philosophy of Money*, Georg Simmel distinguished between objective culture and the culture of subjects.[87] "The broadening of consumption is dependent upon the growth of objective culture," linked to money and the division of labor which separated the product from the producer and created the consumer. All of these divisions gained momentum from scientific management. Simmel argued, "It is quite erroneous to believe that the significance . . . of modern life has been transferred from the individual to the masses. Rather, it has been transferred to . . . the objects . . . an immense abundance" (483).

The money economy, or the culture of objects, is an inversion of means and ends (482): "Countless things, like education, that are ends are degraded to mere means." In many ways, for Simmel, the money economy is an epistemology, a way of thinking in which money measures and determines value—objectivity. All elements are transformed into means, "sequences that ended no longer end, and everything is subject to calculable rational relationships."

The money economy produces "intellectual energy," not "emotions, or sentiment." What Simmel calls "objective intelligence" excludes the "interference of emotions" (431). Intellectual functions are "calculative" functions (443). He calls this a "pure logic." These are the premises of Adam Smith's "rational" subject. For the rational subject, the intellectual subject, "only self-interested action is considered 'logical.'" Self-sacrifice and devotion are proof of lack of intelligence (439). Pure logic is unaffected by character, by respect, by kindness (434).

Three institutions—the law, intellectuality, and money—"are characterized by their complete indifference to individual qualities." All have "the power to lay down forms for contents to which they are indifferent . . . [injecting] those contradictions into the totality of life" (442). The result is "confusion and the feeling of secret self-contradiction," which "characterizes the style of modern life" (443). Intellect belongs to the money economy, affect to the sexual economy—a division that would be extended to

men and women and to whites and "nonwhites" The money economy subsumes the sexual and racial economies.

The money economy's association in the early 1900s with negative values is critical for understanding domestic reformers and women activists. It was this association that led Pattison and others to maintain that the home should not be tainted by women's connection to money. In *The Cheat* this is Edith's crime—her desire for more money, her bad stock market investment, and her resultant compromise of values. She brazenly imagined that the money economy was her realm. She was chastised and held to her subservient place within the sexual economy, the narrative of so many Hollywood films (particularly musicals). This false separation of the home from money is what Lois Weber critiques in *The Blot*. Charlotte Gilman Perkins would agree.

BODY

One can imagine a history of cinema moving from the female face to the body and from Beard and Delsarte to Freud and Alberto Vargas, engaging sexuality. The female body would eventually be saturated by sex, defined as interchangeable with sexuality. That sexuality has saturated our theory since the 1970s is not insignificant. As Foucault pointed out years ago, this sexual body was both a class and a racial body.[88] "Sexual selection," a key subsidiary to "natural selection," was central to Darwin: "He attributed much of the racial differentiation . . . to sexual selection, based upon different criteria of beauty."[89]

The transformation from Beard to Freud is apparent in representation. Delsartean images of the ethereal, unconfined female body moving through space in dance or sport were replaced by the pinups of Alberto Vargas in the 1920s, static fetishes defined by sex. The girlish facial style was vamped, replaced by the drooping eyelids, the archly plucked brows, the wider mouth, and the heavier gait of Theda Bara, then Marlene Dietrich, Greta Garbo, Joan Crawford, and Barbara Stanwyck (all sketched and standardized by Vargas). The Varga girl wore black stockings, lace lingerie, and high heels. Emphasis wandered from the face and body movement to focus on lower zones and fragments of her body, particularly legs and feet.

Throughout the 1930s she was flat-chested, short. She grew taller, leggier. In the 1940s the glamorous face was given a big, friendly smile; she was a nude draped by veils, suspended in space. This pinup surfaced in men's places: barbershops, corner garages, tobacco shops, and World War II fighter planes. Like Penrhyn Stanlaw's girl she was a drawing, airbrushed of all wrinkles, hair, moles, and other "imperfections." Vargas

worked for *Esquire,* patenting the Varga Girl as his invention. His draw-ings are best analyzed by Foucault: "The individual body becomes an ele-ment that may be placed, moved . . . a fragment of mobile space . . . in or-der to obtain an efficient machine."[90] Jane Russell looked like Rita Hayworth and the Breck shampoo girl.

Foucault's (and Deleuze and Guattari's) metaphor of the body as a ma-chine resonates with the images of Beard—the efficient machine of capi-tal that traded on the sexed female body. She could be hung up on a cal-endar, folded into the fragments she was and carried around in one's wallet, or dropped on Hiroshima. She was tall, thin, leggy, and young, at-tracting even Andre Bazin to her analysis. In his essay "Eroticism in the Cinema" he added, "But what troubles me most about the fine logic of my argument is a sense of its limitations. Why do we stop with the actors and not bring the onlooker into the argument?"[91] (It is at this point that psy-choanalysis and feminist theory take over, fashioning models of specta-torship and subjectivity almost in answer to Bazin's question.)

The female body became literally a site of debate over creation and own-ership when *Esquire* sued Vargas for the rights to this body and lost. As the story goes, after the suit he was selling charcoal drawings on the street to passersby, a poor man, until, voilà, Hugh Hefner came to his rescue, hir-ing him for *Playboy.* The centerfold was created. The draped nude now grew *huge* breasts atop a tiny waist and slim legs, and the fifties—50-D, that is—were born. The spiritual ideal had become a sexual ideal very dif-ferent from the heavier body of the early 1900s, the pouter pigeon style of huge, sagging chest, hefty posterior, and large shoulders; an older woman style. Everything was thin in the 1950s look except the breasts—which were gravity-defying.

In the 1960s skinny returned (a.k.a. Audrey Hepburn and Twiggy), a fleshless ideal developing into anorexia or into the worked-out, taut, mus-cular body of the 1980s and 1990s. Fat has not been fashionable for years, although large breasts are once again "in"—another contradiction for women. In the 1990s breasts must adorn slim, muscular bodies—a real contradiction for the worked-out body, which erases breasts. Breasts now must, like Jane Fonda's, be implanted.

Amid the changing fashion there is also a constancy to sexual differ-ence. The representation of men's bodies has remained relatively stable, with a wide variety of styles, sizes, and shapes. Contrasting this stability is the female body, which has been rebuilt and sensuously redefined each decade, rendering it unstable, malleable: bustled and breasted, fattened and thinned, shortened and heightened, with eyes rounded and then widened, lips puckered, thinned, and, finally, collagened.

The "faceism" index distinguishes the face from the body through the measurement of still photographs. After 1920, photographs of males represented more of the face and head than did photos of females. "The essence of a woman is thought to reside more generally in her body, while the essence of man is in his face."[92] Like ageism, faceism is a way of calculating sexual difference. The gender gap in the faceism index is linked to occupation: women in politics "received the same facial prominence as men, while actresses, a frequently depicted female occupation, received substantially less" (Sparks and Fehlner, 70).[93] Women, it would appear, historically lost face.

FACE AND RACE

Webster's first definition of "face" is "the surface of a thing, . . . the side which presents itself to the view of a spectator."[94] There is nothing especially human or even animate about "face," though the "spectator" of "face" could be. For apparatus and feminist film theory, "spectator" has, to a degree, been the determinant. "The surface" can be a mask, a masquerade, a mimicry, a camouflage. The tenth definition is one of worth or value. What is a "face" worth?

Deleuze and Guattari's concept of "faciality" in *A Thousand Plateaus* is analogous to the black-and-white close-up of silent films. In fact, their "machine of faciality" is cinema: "that is the definition of film, black hole and white wall, screen and camera."[95] In *Sunset Boulevard* the female star close-up *is* cinema; the rest is only a frame for this encounter. The close-up is the moment Norma Desmond longs for—and the ironic end of *Sunset Boulevard*. As she glides down the stairs into her close-up, her "gazeless eyes" see nothing. She is completely absorbed in her movie past. Her close-up emblazons and then swallows her.

For Deleuze and Guattari, faces are "engendered" by a machine of faciality. Unlike the "cinematic apparatus,"[96] the machine of faciality inverts the dominant system of "the spectatorial look" so central to feminist film theory.[97] The "gaze" is "secondary" to the "to the gazeless eyes, to the black hole of faciality." Another central premise, the Lacanian analogy of the spectator to the child in front of the mirror, is also overturned: "the mirror" becomes "secondary to the white wall of faciality" (171).

For Deleuze, the image, not codes of narration (the focus of feminist film theory), orders cinema.[98] At the intersection of "significance" and "subjectification" is "a face: the white wall/black hole system" (167). To simplify things, between representation and subjectivity, the screen and the audience, is a face.

Deleuze and Guattari distinguish the face from the head, from the body: "The face is a surface . . . the face is a map" (170).[99] Assemblages of power sometimes require the production of a face, a univocal system, unlike primitive societies, which are collective, polyvocal, corporeal. Citing masks and adornments, they state, "Primitives have the most human of heads, the most beautiful and most spiritual, but they have no face and need none. . . . The reason is simple. The face is not a universal. . . . The face is the typical European" (176).

The key move by Deleuze and Guattari is to tie face to race: "The first deviances are racial"; "Racism operates by the determination of degrees of deviance in relation to the White-Man face." Racism has nothing to do with the other, only with "waves of sameness." "The Face" represents "White Man himself"; "the face is Christ" (178). I think of the messianic ending of D. W. Griffith's *The Birth of a Nation* (1915), with the superimposition of Christ over the two white couples and the entire nation. "The End" eliminates African Americans from the picture; "happily" applied only to white couples. This film established conventions of representation intact for decades. These attributes of the "continuity style" are not detailed in the historical-critical accounts.[100]

I see the face of "early cinema" as a soft-focus close-up of a young, delicate white girl. The star face served as a cover-up for cinema's racism, which elided the sexual (embodied by women) and racial economies. The linkage in early cinema between rape and race(ism) leads to this connection between face and race.

The sexual jeopardy of white women—in danger and thereby in need of rescue by white male heroes—is a recurring story in many films, blatant in *The Birth of a Nation*. First is the suicide of "little sister" after the implied (through editing) threat of her rape by Jake, a black soldier (a white man in black face); then Silas Lynch's capture of Elsie Stoneman (the superstar Lillian Gish), intercut in breathless, rhythmic editing to form a cause–effect logic for the formation of the Ku Klux Klan. To say nothing of the families in a cabin fighting off rebel "negroes."

Face must be protected from race, a prohibition made legal. It is critical to remember that Item II.6 of the Motion Picture Production Code of 1933 read "MISCEGENATION (sex relationship between the white and black races) is forbidden."[101] *In the U.S. film industry, racism was official and mandated.* The violence of the concluding courtroom scene in *The Cheat* is extraordinary, unexpected. Upon Edith's confession/accusation, a sea of enraged white men surge forward to lynch Arakau, an Asian. The judge barely protects him from mob violence. Although Arakau (Sessue Hayakawa) is Asian, not African, and "Yellow Peril" racism was not the same as

racism toward African Americans, the courtroom threat is a displacement of lynching African Americans in the United States.

Ida B. Wells-Barnett

Hazel Carby led me to *Southern Horrors: Lynch Law in All Its Phases*, written by Ida B. Wells, a black intellectual writing around 1890. As Carby polemically argues, Wells's central thesis was "that white men used their ownership of the body of the white female as a terrain on which to lynch the black male."[102] For Wells, the protection of white women was a falsehood, an excuse for white men to lynch blacks.[103]

Ida B. Wells (later Wells-Barnett) was a teacher, journalist, and lifelong political activist. She began her career in Memphis, Tennessee. By 1886 her "reports on black life in Tennessee" appeared in prestigious papers (in 1880 there were almost two hundred black newspapers published each week).[104] Wells wrote during a period in the South when segregation was becoming the rule, with blacks barred from restaurants, parks, and theaters and separated from whites on trains. "Separate but equal" became law through lawlessness, which including lynching. Blacks were terrified into submission to white dominance.

In *A Red Record*, Wells traces the history of the white defense of lynching in the South. The first excuse for "the murder of unoffending Negroes" was to stamp out "race riots" (RR 7–8). The second excuse, put forward when blacks began to vote, was the prevention of "Negro domination." As Wells argued, "Negroes were made citizens" but their rights "could not be protected" (RR 9). Then "the murderers invented the third excuse—that Negroes had to be killed to avenge their assaults upon women" (RR 10). The premise for Southern white men went as follows: a "voluntary alliance" between a Southern white woman and black man was "impossible," therefore "the fact of an alliance is a proof of force" (RR 11). Lynching applied only to blacks, a "*class*." "Punishment was not the same" for whites and blacks (Wells, 96).

As Wells would argue again and again, through detailed statistics, only one-third of the blacks who were lynched had even been charged with rape. But she went further in *Red Record*, refuting specific charges of rape and revealing many cases of consent. "Wells's investigation convinced her that the majority of the so-called rapes that led to lynchings had actually been affairs between consenting adults." She was treading on shaky ground by questioning the purity of Southern white women—"like attacking God and country" (Sterling, 82). Taking her statistics from the *Chicago Tribune*, Wells published a list of the actual crimes that led to specific lynchings: "stealing hogs," "being saucy," or quarreling with a white man.

"Colored men and women are lynched for almost any offence" (Wells, 11). To strengthen her credibility, she based her stories on "compilations made by white men. . . . Out of their own mouths shall the murderers be condemned" (RR 15).

Wells's pieces evoked the horror of lynching, a public spectacle of excruciating cruelty. Her passion was personal as well as political. In 1892 one of Wells's close friends was lynched in Memphis. Fear became so rampant in that city that many blacks left within two months time. (A bit later, Wells would move to New York to write in exile.) Wells's research found that "728 black men and women had been shot or hanged, others burned alive or savagely dismembered. Often whole towns turned out to watch" (Sterling, 80).

Many of Wells's newspaper columns were brutally, poignantly graphic. Her account in *Red Record* of the murder of Henry Smith in Paris, Texas, rivals any violence I can imagine. His "clothes were torn off and scattered in the crowd" (RR 29). "His eyes were burned out, a red hot iron was thrust down his throat" (RR 35). "The Negro rolled and tossed out" of the fire, to be pushed back by onlookers. "Every groan . . . every contortion of his body, was cheered by the thickly packed crown of 10,000 persons" (RR 29). It was 1893, in the United States.

Wells was also a fearless spokesperson against lynching, speaking all over the east coast and in 1893 sailing to England and Scotland, where she inspired activist groups. She went to Chicago and assailed the lack of black involvement in the World's Columbian Exposition. In 1895, when she was thirty-three, she married a lawyer and moved to Chicago. She continued to organize locally and nationally until her death, speaking at national conventions: "To refute the shameless falsehood that Negroes are lynched to protect womanhood, she spoke about hundreds of lynchings for other actions" (Sterling, 104). She traveled to cities that had race riots and wrote "pamphlets" about what she saw; *Mob Rule in New Orleans* (1900) was one result. In 1929 this tireless activist ran on the GOP ticket for state senate in Illinois. She was sixty-seven. She died in 1931.

While Wells-Barnett's focus was on lynchings of blacks, she raised other issues. "Every southerner freely admitted that white men had relations with black women." "Rape of helpless Negro girls, which began in slavery days, still continues without reproof." "The crime committed by white men against Negro women and girls is never punished by mob or the law" (RR, 67). In *Ain't I a Woman*, bell hooks quotes Eugene Genovese, a contemporary historian, who supports Wells: "Rape meant, by definition, rape of white women, for no such crime as rape of black woman existed as law."[105]

In her chapter "Sexism and the Black Female Slave Experience," bell hooks revises history to focus on slavery and on women (15–49). "Racist exploitation of black women as workers either in the fields or domestic household was not as de-humanizing and demoralizing as the sexual exploitation. . . . The female slave lived in . . . perpetual fear that any male, white or black, might single her out to assault and victimize" (24). She was often a young slave, between thirteen and sixteen.

Imagine a big-screen remake of *The Birth of a Nation* from the point of view of the African American characters, played by black actors. Imagine setting the family scenes within the slave quarters. Imagine the concluding ride of the white robed Klan as the horrifying lynch mob it is, rather than the narrative rescuer of white women in jeopardy. This film would be shocking—and true. Griffith's "happy ending," the victorious parade of the Klan down Main Street, would be the nightmare it is—the beginning of thousands of lynchings, to say nothing of segregation laws and practices.

Within Our Gates

One powerful answer to *The Birth of a Nation* came in 1919. *Within Our Gates*, by the African American filmmaker Oscar Micheaux, concludes with a lynching story intercut with the attempted rape of a black woman by a white landowner. The recent emergence of this film—discovered in the national archive of Spain as *La Negra*, identified by film scholar Thomas Cripps in the late 1970s, deposited in the Library of Congress in 1989, and released on video in 1993—reveals how film history is made from absences, how history is always partial.

What I find extraordinary about the film are its fascinating portrayals of African American women (and two white women). I marveled at the beauty and subtlety of the performance of Evelyn Preer, the actress who stars as Sylvia Landry. While the gestural codes of silent cinema are apparent, they are refined, transformed. Sylvia Landry is an educated woman who believes in the power of knowledge. This Southern teacher negotiates the divides of North and South, black and white—her movement becoming metaphorically, not just narratively, significant. She takes action in the film, moving and surviving the narrative. Her movement through the film embodies a politics.

Sylvia travels north twice, first to visit her cousin, then to raise five thousand dollars for her Southern school. The first visit involves her in a triangle of jealousy, as one of two women who both love the same man. During her second journey she deals with white women: the older, benevolent philanthropist/activist from the North, and a middle-aged Southern racist. This is another kind of triangle, one of political positions. Because the film is *presented* as a female melodrama—of coincidental meetings, evildoers,

overheard conversations, several lovers, and misplaced letters—Sylvia suffers at the hands of the narrative. On her first visit she is set up and betrayed by her cousin and abandoned by her fiancé, Conrad (who was transferred to Brazil, after almost strangling her). During her second visit she is hospitalized after saving a boy from an automobile accident.

But this is not the *usual* cause–effect logic of the continuity style. For Micheaux, events are not accidental; they serve a purpose and embody a lesson. The automobile accident led Sylvia to her wealthy female benefactor, the owner of the automobile. One good deed led to another. Conrad's departure from her life clears the way for Dr. Vivian, another version of black upward mobility. Conversely, Efrem, who informed on Landry, is lynched by the mob along with his victim. For every action there is a reaction. In Micheaux's world, things happen according to the laws of destiny.

The same is even true of the flashback rape scene. After Sylvia fights off her white attacker, Armand Gridlestone, with ferocious energy, an intertitle tells us that after Gridlestone discovered that she was his *legitimate* daughter, he paid for her education. However, because we see this sequence only at the film's end, as part of a story told by her repentant cousin, the assault doesn't define Sylvia or serve as motivation. Instead incest and interracial sex and marriage become historical, not sensational, explanations. Because Sylvia's past comes only at the film's end, we see her as a strong woman, not a victim. Micheaux thus preserves the important distinction between *being* a victim and *becoming* a survivor.

Sylvia's rape is intercut with a brutal lynching sequence of her adoptive parents (Southern sharecroppers). They are strung up and then burned at the stake by an unruly mob that includes white women and children. Because this sequence (remarkably similar to a photograph in Wells' *Red Record*, 55) was shot largely on location in the country, its style is quite different from the rest of the studio-bound film. The scene is still horrifyingly real, its effect shockingly immediate.

For Jane Gaines, the "lynching story" initially is "structurally tangential, rather than central"; it is not "integral to the narrative."[106] It's "a film-within-a-film, . . . so complete, it is as though one were viewing an entire D.W. Griffith short dropped down within a silent feature. The lynching narrative owes its basic formal structure to Griffith, even while its rhetorical structure produces the antithesis of *The Birth of a Nation*" (52). Rather than "owing" Griffith, Micheaux "uses" or "appropriates" conventions in order to overturn them, to say something completely different.

"The accusation of 'primitivism' is turned back onto White Southern culture," and this prompts Gaines's second take on the sequence: the "portrait of the lynch mob is his signal achievement in this film," for he shows

"what Blacks knew and Northern Whites refused to believe . . . the barbarism of the White mob" (54). But Micheaux also shows us the goodness and fear of the black family who are lynched, their escape to the swamp, the terror of violent irrationality from their viewpoint, of being without protection, without recourse—which is the unspeakable horror that comes from lawlessness. In this scene, for African Americans there is no cause–effect logic and no satiating, last-minute conclusion. The innocent are not rescued in the end, and the guilty are not punished. Deathly violence is the last step of the logic of blaming the victim.

The rape/lynching sequence must be read back over the rest of the film, for it is neither the film's climax nor its spectacular attraction. It functions as historical explanation. This is the criminal history that cannot be acknowledged within the American (and film) mythology of heroism, brave deeds, and war. Thus the scene is embedded within a familiar genre, which becomes unsettled retroactively.

The affect of the flashback overrides the film's "happy" ending, a quick two-shot scene uniting the couple (Landry and Dr. Vivian) that comes immediately after her attack. The next shot is of Dr. Vivian, the eye doctor, comforting Sylvia. (Although the flashback happened years earlier, they appear to be connected by the cut in a cause–effect logic.) Dr. Vivian tells her to be proud of her country. Sylvia is morose and looks downcast and away. Dr. Vivian cites glorious stories of Negro soldiers in U.S. wars.

But history or the image is too powerful for this patriotic conclusion and overrides his words (although this may not have been the case for audiences in 1919, during World War I). His stories of glory and sacrifice don't apply to her. United as a couple, they are divided politically. But I finally understood all the scenes in Dr. Vivian's office, with its eye charts on the walls. Although a knowledgeable, upwardly mobile guy, Dr. Vivian needs to have his vision checked. At the very least, he needs a change of glasses. The date, 1919, is important, a year before women's suffrage, and a time of activism by African-Americans: supporting the right to vote by African-American women meant support for black men. It was the black woman's duty to help her race and its men. Thus it has been argued that Black Victoria was a stereotype in the service of black men, which might explain the film's end.

Gaines points out that lynching displaces economic concerns onto sexual concerns; the protection of property shifts to the protection of white womanhood. Thus the economic motive behind lynching becomes unspeakable (54). (But this, concealing or denying economics, has happened to women, white and of color, for years.) However, Gaines' argument applies to men only. In the case of black women, their *sexual* exploitation, tied to the economics of slavery, could *not* be spoken. This film speaks *that*

crime. Not only does the film make lynching and raping historical, but it links them inextricably and reverses the erasure of black women, inscribing African American women in a political story that includes complex issues: religion, education, suffrage, and prejudice. Romantic melodrama is the dramatic frame for polemical, pedagogical issues.

Haunted History

JULIE DASH

The "Victorian shift away from the image of white woman as sinful and sexual to that of the white woman as virtuous lady occurred at the same time as mass sexual exploitation of enslaved black women," bell hooks argues. She extends Wells's dispute with the WCTU's defense of white women: "Most white women regarded black women who were the objects of their husbands' sexual assaults with hostility and rage," believing that "the enslaved black woman was the culprit and their husbands the innocent victims" (hooks, 36). This logic of blaming the victim has been repeatedly used against black women, emerging once again in the 1990s in welfare reform debates (black unwed mothers are blamed and presumed not to be working). Women, white and of color, have internalized this logic, blaming themselves for domestic abuse and for rape.

The question in hooks's title, "Ain't I a woman?" is a phrase from Sojourner Truth asked years later—the black woman still an oversight of history. What faceism, like history, did not measure was the absence of black women. History is made by absence as well as presence. While there were black films shown in black theaters for black audiences during the first half of the 1900s, particularly in the 1930s and 1940s, these films (many directed by Spencer Williams) were the exception.[107] Rarely were black characters anything other than stereotypes in Hollywood films. With the rare exception (the light-skinned Lena Horne), black women were not stars. With the present exception of Whoopi Goldberg and Angela Bassett, little has changed in 1995.

It is in the context of this ignoble oversight that Julie Dash's *Illusions* (1983) and *Daughters of the Dust* (1992) must be seen. For Dash, history is haunted by strong, beautiful women talking, thinking, and working together—perhaps "descendants" of Spencer Williams's female characters,

233

who were also beautiful, often dominant, holding everything together. I suspect the independent, low-budget black films of the 1940s influenced Dash as much as (or perhaps more than) Hollywood. This noble history of independently made films by black filmmakers featuring black women continues into the 1990s, stronger than ever.[108]

Illusions

Mignon Dupree is a powerful woman, a hero. This light-skinned African American passing for white in Julie Dash's *Illusions* is an executive assistant at National Studio in Hollywood. Mignon has status and influence at the studio—which she is willing to risk. She is given the difficult task of salvaging a musical that has lost sync in the production numbers. A young black singer, Esther Jeeter, is brought in to dub the songs for the blonde, white star, Leila Grant. Esther recognizes Mignon's heritage; they become friends and speak freely to each other. Mignon negotiates a fair deal for the singer's work.

Meanwhile, racist comments from the white secretaries surround Mignon. The white studio boss's son, a soldier on leave who hangs around the office making passes, pursues and harasses her. After finding a photograph of Mignon's black boyfriend, Julius, the boss's son confronts her with his knowledge of her secret. Rather than back off, Mignon fearlessly acknowledges that she is passing. She speaks passionately against the industry that has erased her participation. The point of view and the voice-over narration that frames the film both belong to this beautiful and powerful character.[109]

The setting of this 1983 short film is a Hollywood movie studio in the 1940s, during World War II. The historical re-creation of the time period is remarkable for such a low-budget film. Details of Mignon Dupree's story resemble that of Lela Simone, sound editor with the Arthur Freed Unit at MGM, who walked out during the postproduction of *Gigi*. Unlike Simone, Dupree determines to remain in the industry and change things. Mignon wants the studio to make important films about history, including the contribution of Navajos during the war—their language could not be deciphered by the Japanese code breakers.[110] Dupree is impassioned about the importance of film: "History is not what happens. They will remember what they see on screen. I want to be here, where history is being made."

Despite Dupree's faith in change, *Illusions* has no illusions, no "happily ever after" of romance, whether marriage or a climb to stardom for Ester Jeeter or a promotion to producer for Mignon Dupree. This is an empowering and uplifting film about women's work and thought. The star is an African American woman who is ambitious, intelligent, and supports an-

other African American woman. She is neither flattered by men's desire nor bullied by their gaze. Mignon's goal is to change film history.

Illusions revises Hollywood studio history which erased African American women from representation and history by syncing their offscreen voices to the faces of on-screen white women. Women of color were heard but not seen or recognized. When women of color were there—on the soundtrack, passing as white, or serving as domestics and other marginal stereotypes—they were not recognized, not noticed, or not even remembered. *Illusions* inscribes the point of view missing from U.S. film history, that of African American women (on screen and in the audience), granting visibility *and audibility* by syncing image to offscreen voice. *Illusions* also charges Hollywood, and the nation, with hypocrisy and racism—for not making films about people of color during World War II.

Illusions is a substantial revision of *Singin' in the Rain*, the 1952 MGM/Arthur Freed musical that mythologizes the coming of sound to Hollywood in 1927 and turns economics—both sexual and monetary—into romance. While both films concern the problem of synced sound, *Singin'* gives us fiction as history; Dash reveals history as fiction. She reveals what is repressed by the "cinematic apparatus": black women (women's work and thought), along with sound.

Sound editing and synchronization—the dilemma of holding sound and image together in a continuous, seamless flow, of giving voice to face, of uniting the acoustic and the visual—are not just techniques and not just played for laughs in *Illusions,* as they are in *Singin'.* Sound editing and synchronization are *strategies*[111] that conceal the politics of racism. Sound editing produces the seamless union between image and sound, face and voice, with voice subservient to face (as black women are in film to white women). Voice, upon which the film's musical depends, paradoxically seals the dominance of face, of the visible. The film questions the truth of vision and of theories dependent on vision. The MGM screen, like history, is not full, complete. It is haunted by camouflaged figures who were erased but left their mark.

Illusions also corrects absences in film theory. The denial of *Singin'* (that some of Debbie Reynolds's songs were dubbed by another singer) becomes the repression of race in *Illusions.* Like the seamless continuity style that conceals its work (e.g., editing, processing), Hollywood cinema has concealed, erased, and prohibited the work of people of color, on and off screen. Thus Dash's film revises and complicates the psychoanalytic mechanism of the spectator—disavowal, denial, and repudiation[112]—at the base of film theory and the key to the feminist model of sexual difference. It is a mechanism used to repress and ignore race, as Homi Bhabha has argued with regard to colonialism.[113]

Instead of the white male star (co-director), Don Lockwood/Gene Kelly, who dominates *Singin'* in center frame, close-ups and voice-over as well as performance numbers and the story, this film stars a black woman as a studio executive. She is given the voice-over, the center frame, the close-ups, and the story. Whereas the dilemma of the 1952 musical was love at first sight and romance—celebrating the coupling of the proper white woman (the good girl) to the male star—this film concerns women's professional work and thoughts. Mignon Dupree's power does not come from sexuality (although she is glamorous, beautiful) but from talent, ability, high purpose, and self-confidence. Unlike Cathy Selden/Debbie Reynolds, she makes it on her own, not through the intervention or love of men.

Singin' divided women against each other—Cathy Selden versus Lina Lamont (Jean Hagen)—and humiliated Lamont in public. *Illusions* unites black women. Men pursuing women is sexual harassment in *Illusion*, whereas in *Singin'* it is romance or true love. The problem in *Singin'* was syncing the proper white female voice with the white female face, portrayed as backstage film history. *Illusions* says this momentary repression is only the tip of the iceberg, which *Singin'* conceals through its partial revelation. *Illusions* declares that behind white faces were black voices—the source of pleasure and profit. Black performers were in history but they were not remembered; there and simultaneously erased. The studios profiteered from this presence/absence, from the lack of stardom and publicity black performers endured. No wonder African American feminists are so distraught with Anglo feminism's focus on white women and lack—one is metaphorical (imaginary), the other material (and real).

On the theoretical level, just as the work of the soundtrack has historically been subservient to the image track, so women of color were subordinate to white women at the movies. And in the rare instances when actresses of color were on screen, their roles could only be stereotypical: lustful temptresses, servants, or "mammies." Black women were, and often still are, off to the side, marginal to the star's center frame and hence barely noticed. Often masquerade would make women of color white, Anglo—as happens in *Singin'* to Rita Moreno (Hispanic), who plays Zelda, the starlet. Being beautiful meant looking white, and especially young, thin, smooth.

The dubbing sequence in *Illusions* is thus a very powerful revision of this white aesthetic of face. With Mignon looking on, and reflected on the glass wall of the sound recording booth, *Illusions* intercuts the blonde actress with shots of the black singer dubbing her song. Jeeter is given glamour shots and the last, lingering close-up, while the white no-talent Leila Grant has only a bit part. Without voice she has no substance. Dash reverses the blonde standard of the star system.

This sequence has also been seen negatively, as one of disavowal: the

voices of Mignon and Esther "become unanchored from their black bodies and are harbored within white female bodies. . . . Their work requires the decorporealization of the black female voice . . . to render docile, the threat of the black body" (Hartman and Griffiths, 368). But I suggest on the contrary, that this is true of Hollywood film, not this film. This scene has double vision, secured by voice. By inscribing the presence of black women, the lie of absence is revealed. It is the white body that is unanchored, particularly from the star system. Black women are given center screen, the narrative, and voice. White women are banal and boring—particularly Leila Grant.

Along with film (and national) history and the work of sound, the "illusion" of the title refers to the practice of "passing."[114] After the film, an older woman in my class, Darcy Raney, described this troubling practice: "Throughout our history, whether through necessity, a means to an end, or denial of oneself, 'passing' has and always will leave a bad taste in the mouths of some African-Americans. It is a reminder of not accepting who we are, imitating and wanting to look like those who have oppressed us for centuries. 'Passing' is still to some the ultimate in self-hatred."[115] I can address only the "theoretical" implications.

Illusions complicates the relation between sight and knowledge, working through a process of double vision: white characters see Mignon as white, African Americans see her as black. Seeing depends on experience, on knowledge.[116] Passing has to do with seeing (or not), interpreting (or misinterpreting), and knowing (or not)—with seeing (or not) what is visible (or not), there to be known (or not). Passing depends on whites not seeing, misinterpreting, and not knowing. The knowledge for double vision comes from race, from experience.[117]

Passing is hiding, out in the open. Rather than being buried beneath the surface, the "secret" is immediately visible but misinterpreted.[118] Thus passing resembles camouflage and mimicry, along with masquerade. Near the end of the film Mignon says, "Now I'm an illusion, just like the films. They see me but they can't recognize me." "We" see what we know, "waves of sameness," until someone shows us something else.

At one moment, Mignon's camouflage is in jeopardy. Dupree looks apprehensive that Jeeter's remarks will give her away to the other women in the office. But she is immediately reassured by Jeeter, who says, "Do you pretend when you're with them? Don't worry, they can't tell like we can." For the spectator, pronouns take on identity, "they" and "we."

Dash uses words brilliantly. *Illusions* makes intellectual arguments through the soundtrack, through pronouns that define and address subjectivity. The white female secretary says to Mignon, "You certainly are good to them [black performers]. I never know how to speak to them."

Mignon replies, "Just speak to them as you would to me." To her mother, on the telephone, she says, "I am still the same person. . . . They didn't ask and I didn't tell. I was hoping that after the war things would change . . . and I wanted to be part of that change. If they don't change in this industry, then they won't change at all." Who is "we" and who is "them" depends on what one can see and understand, on experience, and on history, which includes race.

When the soldier finds the photograph of Julius, Mignon's African American boyfriend, his ardor cools. His desire depended on knowledge. Thus breaking the linkage between scopophilia and epistemophilia has great possibilities for feminism. Rather than intimidating Dupree, the revelation empowers her: "Why didn't I tell you I wasn't a white woman? I never once saw my boys fighting. . . . You have eliminated my participation in the history of this country. We are defending a democracy overseas that doesn't exist in this country." Whiteness is not neutral, natural, or real but a system, a "racialized" convention of the continuity style of Hollywood cinema.[119]

Illusions, however, is paradoxical. The film aspires to Hollywood while taking Hollywood to task. Hollywood is both problem and goal, as it is for many African American filmmakers.[120] If measured by Hollywood technical standards, the soundtrack is limited, perhaps due to postproduction costs of mixing and dubbing.[121] Dash's visual editing is also slightly off, if measured according to the conventions of "continuity style." I would love Dash to make a big budget version of *Illusions;* this would be a *Singin' in the Rain* for the 1990s.[122]

Illusions concludes with a prophecy in voice-over: "We would meet again, Jeeter and I. To take action without fearing. I want to use the power of the motion picture. . . . There are many stories to be told and many battles to begin." Mignon Dupree is a film ancestor of Julie Dash. And indeed, they soon meet again.

Afterthoughts

S. V. Hartman and Farah Jasmine Griffin have serious reservations about *Illusions.*[123] Although Dash "attempts to make Mignon a figure with whom black viewers identify, . . . Mignon facilitates Esther's consumption by the cinematic apparatus. Esther's own agency seems confined to witnessing and pretending" (371). The authors conclude that "to identify with Mignon would be to accept our position as subordinate to her, to engage in an act of self-hatred. Though Dash attempts to establish a relationship of equality between Esther and Mignon, between the black woman viewer and Mignon, that relationship is a farce. . . . Our only healthy response to her is ultimately one of rejection" (372).

This analysis completely upset me. Was I so far off? Was my identification with Mignon's courage and compassion and with the sisterly bond between the two women proof of the film's disavowal of black women? Did the film ultimately address white women? I fell into the quagmire of determinism: a "white" response and a "black" response.[124] I was white, hence off base.

But then I remembered that in more recent criticism Toni Cade Bambara, bell hooks, and I were in agreement. Bambara seconded my positive response: Mignon's goal is not to "advance a self-interested career . . . Mignon stands in solidarity with Esther. Unlike the other executives who see the Black woman as an instrument, a machine, a solution to a problem, Mignon acknowledges her personhood and their sisterhood."[125] According to hooks, the "bond between Mignon and . . . Jeeter is affirmed by caring gestures of affirmation . . . the direct unmediated gaze of recognition."[126] For hooks, "*Illusions* problematizes the issue of race and spectatorship. White people in the film are unable to 'see' that race informs their looking relations" (301).[127] But *after* the film, this is what white people would understand (or "see"), if they/we were listening.

These are exemplary analyses, particularly in their emphasis on history and memory. "Looking and looking back, Black women involve ourselves in a process whereby we see our history as counter-memory, and use it as a way to know the present and invent the future" (hooks, "The Oppositional Gaze," 302). However, in addition to these critics' visual analyses, I would emphasize sound—the issues of enunciation/address, voice, and authority. Mignon possesses authority. She speaks up fearlessly. Her voice claims history and a place in it. For me, both Mignon and Dash outrun theoretical models of vision. After all, the phrase of the 1990s is "I hear you."[128]

Daughters of the Dust

Daughters of the Dust has made history. It is a successful commercial feature by an African American woman. Dash has said of her production, "All the distributors turned it down. I was told over and over again that there was no market for the film. . . . I was hearing mostly white men telling me, an African American woman, what my people wanted to see . . . deciding what we should be allowed to see."[129]

Dash took the film on the festival circuit in 1991, beginning with Sundance in Utah. (After seeing an earlier trailer at a PBS "weekend retreat at Sundance," American Playhouse and then the Corporation for Public Broadcasting funded it to the tiny tune of eight hundred thousand dollars.)[130] Unlike the features by African American men, this is a tale told from the multiple points of view of women of all ages, including the spir-

its of the unborn—modern women, present-day women. *Daughters* is about love and respect rather than fear and anger.

History is the setting of *Daughters*—the Sea Island Gullahs off the coast of South Carolina at the turn of the century. Dash calls this the "Ellis Island for the Africans" (DBh, 6), the main dropping-off point for Africans brought to North America as slaves. Due to its isolation, Africans maintained a distinct culture that is re-created, recalled, recollected. Dash wound the camera back to 1901 and began another film history, from another perspective.

A voice-over of the old woman Nana Peazant, the powerful head of the family-clan speaking through the ages, says, "I am the first and last, I am the whore and the holy one. . . . Many are my daughters. I am the silence you cannot understand. I am the utterances of my name."[131] Age is wisdom, age is strength, age is to be respected.

After invoking the ancestors and the spirits of the unborn, the film goes to Ibo Landing, the Sea Islands of the South, in 1902. The landscape is paradise, a splendid tranquility composed of pastels—pale blue sky, golden beach, azure ocean—and sounds of water and wind. The scene is a family celebration, a beautiful and bountiful feast for this extended, rural community.

For Bambara, the island setting is complex, a reference to present spaces (urban *and* rural) as well as historical places: "Occupying the same geographical terrain are both the ghetto, where we are penned up in concentration-camp horror, and the community, wherein we enact daily rituals of group validation in a liberated zone—a global condition throughout the African diaspora, the view informs African cinema." For her, the beach is not "a nostalgic community in a pastoral setting. They are an imperiled group. The high tide of bloodletting has ebbed for a time, thanks to the activism of Ida B. Wells" (Bambara, 121).

Yellow Mary, the prodigal daughter, is arriving by boat, returning home from the mainland. With her are her female friend/lover, wearing yellow (Trula); her Christian sister, in gray (Viola Peazant); and a male photographer (Mr. Snead). The Peazant family—gloriously dressed in pure white—await her on the beach. Some revile Yellow Mary as a prostitute; most accept and love her, particularly Eula, the young mother of an unborn child. Mary accepts them all, as she has accepted her past, her difficult life on the mainland. Hers is the tolerance of experience. This is a celebration not of her homecoming but of the extended family's departure from this island for the mainland. Coming and going, their paths cross. The photographer has come to record the auspicious event. His is modern history abetted by photography, not memory; by images, not spirits or words.

Dash was initially fascinated by a series of photos by James Van Der Zee of turn-of-the-century black women. These images and ideas combined and grew into this feature, a series of striking portraits, of faces of beautiful African American women of all ages. For John Berger (like Andre Bazin), photographs are relics, traces of what happened.[132] To become part of the past, part of making history, they "require a living context." This memory "would encompass an image of the past, however tragic . . . within its own continuity" (57). Photography, then, becomes "the prophecy of a human memory yet to be socially and politically achieved" (57).

The hint of the story to come "replaces the photograph in time—not its own original time for that is impossible—but in narrative time. Narrated time becomes historic time," which "respects memory" (61–62). The film begins from something remembered—as Freud says in *Inhibitions, Symptoms and Anxiety*, "Every affect is only a reminiscence of an event"[133]—then begins to construct what Berger calls "a radial system" around the photographs in "terms which are simultaneously personal, political, economic, dramatic, everyday, and historic" (Berger, 63). This lovely essay suggests some of the richness of Dash's film.

But these are not the aims of the photographer in the film. His camera represents history as usual. For Dash, Mr. Snead had "a secret mission. He has another agenda," in which the people are "primitive." "For me, he also represents the viewing audience." Hooks states that through the characters of Viola, the anthropologist, and Snead, the ethnographic filmmaker, the film "becomes a kind of critical commentary on the ethnographic film" (DBh, 38).[134]

A young girl's voice sets up the drama in voice-over: "My story begins before I was born. My great-great grandmother . . . saw her family coming apart." The girl continues as the storyteller—"The old souls guided me into the new world"—as the camera pans the house. Thus the tale is of the past, of history, a story of memory or of remembering what Toni Cade Bambara calls "cultural continuity." It is an ending and also a beginning—like life itself. Things end, only to begin anew. Like their ancestors from Africa, this family is beginning a journey to a new land.

Poised at the moment of the move from agrarian life to the migration to the city, the film, "reminds us that there was some richness to that agrarian life." hooks refers to the sense of loss that came with the migration, what she calls a "psychohistory" (DBh, 42). For her it is emblematized by St. Julian Last Child, the Native American in *Daughters,* who stays behind with his African American bride. This is also a recovery of the history of intermarriage between African Americans and Native Americans, a connection briefly referred to in *Illusions*. "That intermarrying has never been depicted on the screen, a Native American and an African American mat-

ing, bonding, creating a life together that wasn't just built upon some lust of the moment" (DBh, 47). Dash later asks, "Where have you ever seen a Native American win in the end and ride off in glory? When have you ever seen an African American woman riding off into the sunset for love?" (DBh, 49). For Dash, film history exists in this film: "I was drawing on what I had experienced watching films by Spencer Williams, films from the 1930s, like *The Blood of Jesus* and *Go Down Death*" (DBh, 28).

In an interview with Zeinabu irene Davis, also a wonderful filmmaker, Dash said: "The whole film is about memories, and the scraps of memories, that these women carry around in tin cans and little private boxes. . . . African Americans don't have a solid lineage that they can trace. All they have are scraps of memories remaining from the past" (Davis, 112). Nana Peazant, the great-grandmother, is the historian, the guardian of legend and the spirits. History comes from oral tradition, from experience. It lives through stories. "We carry these memories inside us. We don't know where our recollections came from."

But there is a tragic reason for recollection: "They didn't keep good records of slavery. . . . We had to hold records in our head. The old souls could recollect birth, death, sale. Those eighteenth-century Africans, they watch us, they keep us, those four generations of Africans. When they landed, they saw things we cannot see." This is the history of survival, not defeat.

In *Daughters* the spectrum of women spans several generations; they wear white. But the elder, Nana, wears dark blue as did her ancestors, slaves who worked planting the cotton, dying the cloth, staining their fingers dark navy. That past of slavery haunts the present, enacted in scenes of dark blue intercut into the pastel tranquility of the family celebration. Although Dash's historical adviser on the film, Dr. Margaret Washington Creel, told her that the indigo stain would not have remained on their hands, Dash says, "I was using this as a symbol of slavery, to create a new kind of icon around slavery rather than the traditional showing of the whip marks or the chains." For hooks, this is a tactic of "defamiliarization" (DBh, 31).

At the same time, history became deeply personal for Dash, *familiar*, with the word's Latin etymology of "pertaining to a household, domesticity." After her child was born, Dash thought about "what it would be like to have a child . . . taken away, sold away in slavery. I mean, exactly how would that feel? . . . How do you maintain after that kind of personal tragedy? What happens to you?" (Davis, 112).

Nana Peazant believes in the spirit more than the body: "Respect your ancestors, call on your ancestors, let them guide you." Power doesn't end

"with the dead." Nana responds to her grandson's anger about his wife's rape: "Ya can't get back what you never owned." Nana's attempt to fortify the family for their journey, to give them their heritage, is also the film's gift to the audience and to African American history: "I'm trying to learn ya how to touch your own spirit . . . to give you something to take north with ya. . . . Call on those old Africans. Let the old souls come into your heart. . . . Let them feed you with wisdom." Nana calls upon the spirits carried by the wind. We glimpse the young girl as yet unborn, running. Then we see this spirit enter her mother's body. The spirits can be felt, experienced.

An aesthetics of history is inscribed on bodies that dance, stroll, gesture, talk, and listen—a choreography of grace-filled movement, poetic voices and words, one group leading to another, then shifting the players. The beauty is a remarkable achievement in twenty-eight days of "principal photography" shot with only natural "sunlight" (DBh, 10) and 170,000 feet of film edited in Dash's living room. The film is lush with group shots and close-ups of beautiful African American women, talking, listening, laughing. "I saw Africa in her face," says Nana. The film caresses these faces of many styles and ages, taking time to let us see them, to cherish their presence and experience what they might be thinking. They are so different, yet connected, "unity in diversity." For hooks, the film "breaks new ground in its portrayal of darker-skinned black people" (DBh, 54).

Although much history is not recorded in print or film, particularly in indigenous and slave cultures, it cannot be erased. Like age, we carry our history, our forebears, on our faces, their spirits indelibly imprinted in our bodily memory. This is history of recognition. The actresses in the film represent this history, women's history. "I really tried to use the actresses who had worked . . . in Black independent films," Dash said, mentioning Cora Lee Day (Nana Peazant) in Haile Gerima's *Bush Mama*, Kaycee Moore (Haagar Peazant) in *Killer of Sheep*, Barbara O (Yellow Mary) in *Diary of an African Nun*, and Alva Rogers (Eula) in *School Daze* (Davis, 113). "These people worked months on films for little or no pay at all; so, now that I was finally able to pay them . . . why look somewhere else?" (Davis, 114).

In their conversation about the making of *Daughters*, hooks and Dash recall the "ritual of dealing with hair grooming," the pleasure of "sitting in": "It was a joy." Different West African hairstyles have specific meanings, for example, "married, single, menopausal." The family "hairbraider" would braid "the map of the journey north in the hair design" (DBh, 53). Nana Peazant's most powerful *gris* was a lock of her mother's hair—often, during slavery, the only thing children had of the mothers.

The film asks that we listen carefully; there is much to hear on the

soundtrack. Dash's screenplay is poetic, instructive. Listening to these words spoken from the heart is inspiring. The music, composed by Butch Morris to "incorporate South Carolina field cries and calls" (Davis, 114), is haunting, rich. The film respects its oral traditions; it talks poetically, it speaks historically. "Talking back," hooks writes, meant "speaking as an equal." In "the home . . . it was black women who preached. There, black women spoke in a language so rich, so poetic, that it felt to me like being shut off from life . . . if one was not allowed to participate. It was in that world of woman talk . . . that was born in me the craving to speak, to have a voice . . . belonging to me. . . . It was in this world of woman speech . . . that I made speech my birthright . . . a privilege I would not be denied. It was in that world and because of it that I came to dream of writing, to write. Writing was a way to capture speech."[135]

History is in the conversations that tell the story of our lives. Mary talks about the rape of "colored woman," as common as fish in the sea. The voice-over spirit says she needed to convince her father that "I was his child." The men recall the slave ships. Mary tells the story about her baby, born dead, so she nursed another baby. Nana—shown in close detail, often apart from the group, old, wiry, tough, a survivor—cannot understand how the family can leave.

The family is divided, momentarily, historically, over spirituality versus Christianity. Nana's daughter-in-law says, "I am educated. I'm tired of those old stories. . . . They pray to the sun, the moon, they ain't got no religion. I don't want my daughter to hear about that stuff." We hear the voice of the spirit girl: "We were the children of those who chose to survive." Shots of clothes being dyed are intercut. The young spirit speaks again: "I was traveling on a spiritual mission, but sometimes I would be distracted. . . . I remember the call from my great, great-grandmother. I remember and I recall. I remember my journey home."

For many viewers, the film feels like "a journey home." Like finding oneself after a long wandering, "coming home" is recognizing oneself in others. The film comes to understand and accept that "we are part of each other . . . we are all good women. We are the Daughters of the Dust." Although the family separates, four generations of women remain together. Yellow Mary becomes active in antilynching. The spirit's voice over concludes this extraordinary film: "My mommy and daddy stayed behind, with Yellow Mary. We remain behind, growing older, wiser, stronger."

Toni Cade Bambara calls *Daughters of the Dust* "oppositional cinema" because of its "dual narration" and "multiple point of view camerawork." The style is a "nonlinear, multilayered unfolding" comparable to the "sto-

rytelling traditions" of "African cinema" (DBh, xiii). Dash compares the film's structure to that of an African griot: "The story would just unravel . . . through a series of vignettes. . . . The story would come out and come in and go out and come in . . . go off on a tangent . . . and back again" (DBh, 32). Like a rhizome.

For Bambara, *Daughters* is "Africentric" (DBh, xiii). In an essay she says that the "storytelling mode is African-derived, in a call-and response circle" (Bambara, 124). "The spaciousness in DD is closer to African cinema than to European and Euro-American cinema. People's circumstances are the focus in African cinema, rather than individual psychology" (Bambara, 136). For hooks, the film is an interrogation of "Eurocentric biases that have informed our understanding of the African American experience" (DBh, 39).

"I wanted the look of the film to come from a rich African base," Dash said. The production design and set "were done by artists [e.g., Kerry Marshall, Michael Kelly Williams, Martha Jackson Jarvis, and David Hammond]. . . . All . . . are nationally known African American artists" (Davis, 114). The costumes (the way the scarves are tied mean different things) and gestures (e.g., turning the head "slightly to the left when listening to an elder") all derive from West African culture. "The men have these hand signals [which] were derived from secret societies in West Africa. . . . I wanted to have a connection to the past. . . . Afrocentrism . . . is that your actions are derived from West African culture rather than from . . . Europe" (Davis, 116).

Thus *Daughters* revises the history of photography and film, creating a moving picture that shows what could have been, what might have been, and, now, what *is* on record. This is history as a becoming, where the photographs are brought to life, made to speak, and surrounded by context and story. But this is not the same old story. This story focuses on mothers and daughters. Their centrality—their visibility and audibility— changes the past.

Dash considers that she was addressing "black women first, the black community second, white women third" (DBh, 40)—a hierarchy that is reflected in her empathic portrayal of black men in the film. As hooks replies, "To de-center the white patriarchal gaze, we have to focus on someone else for a change. . . . The film takes up that group that is truly on the bottom of this society's race-sex hierarchy. Black women tend not to be seen. . . . *Daughters* de-centers the usual subject—- and that includes white women" (DBh, 40). She also suggests that "people will place *Daughters* in a world not only of black independent filmmakers, but also in the larger world of filmmakers" (DBh, 65).

I agree. Stronger experiences than "being white" drew me in—being part of a large, rural family; of being a mother and a daughter, whose wiry, thin, powerful 102-year-old grandmother, Rose Sedlacek, although much older, resembles Nana Peazant. On the level of memory and affect, I felt kinship with the community of this diverse family, the pain of separation, the wisdom of aging, and the nourishing companionship of strong women. I remembered staying on my grandparents' farm in northern Wisconsin, in a house with straw mattresses and no electricity. Hard, physical labor in the fields and in the house was the source of happiness. They raised and preserved all their food and made their clothing. Prayers were at 4 A.M., milking by hand began at 5 A.M., and bedtime came after evening prayers, with darkness. There was so much joy and talk, so much abundance of *faith*, that I never noticed there were few possessions and little money. I recalled summer feasts during community harvesting, the beauty of the noon meal. I recollected the differences between rural life and the city. Sunday on the farm was different from every other day: we got dressed up, went to church, and did no work other than visiting, talking all the day. My memory of Sunday is like hooks's: "Girlfriend, growing up as a Southern black woman, in the 1960s, my family felt that you should not work on a Sunday. . . . it was a day of rest" (DBh, 43).

hooks argues that "viewers [of *Daughters*] who are not black females find it hard to empathize with the central characters. . . . They are adrift without a white presence in the film" (*Black Looks*, 130). While our response is surely different, I have much to learn from women of color. And I agree with hooks that it is wrong to assume "that strength in unity can only exist if difference is suppressed and shared experience is highlighted" (*Black Looks*, 51). However, experience shared can lead to differences understood. To paraphrase hooks, there is a difference between "cultural appropriation" and "cultural appreciation."

hooks wonders why "white women" are not starved for these images, as she is. I, too, am starved for portrayals of women of all colors, of women who love and identify with other women, of women who are intelligent *and* powerful, of women who are compassionate, wise, and joyful. White women have few memories of these experiences in films. For me, *Daughters* has much to teach women of all colors. As hooks says in her analysis of "contemporary black women," the "struggle to become a subject" is also linked to *my* "emotional and spiritual well being" (*Black Looks*, 50).

When hooks asks, "Why is it that feminist film criticism . . . remains aggressively silent on the subject of blackness . . . disallows . . . black women's voices? It is difficult to talk when you feel no one is listening" (*Black Looks*, 124–125), I must concur. The blind spots (or deaf ears) of film feminists regarding women of color are glaring. Now we have films to show us the

way and books to point us in the right direction. It is time to listen, time to learn.

Afterthoughts

I initially wrote about *Daughters of the Dust* after seeing it in February 1992 in New York with my daughter, Dae. It came at a turning point in our lives and spoke to us on deeply personal levels. Although my interpretation has changed little since that first, wondrous time, recent analyses deserve attention.

Bambara's detailed analysis of *Daughters* posits three qualities of Dash's work: women's perspective and women's validation of women; shared space rather than dominated space; and glamour/attention to female iconography (Bambara, 120–121). She points out that "the Peazants are self-defining people. Unlike the static portraits of reactionary cinema [where characters never change but remain their stereotypical essence], the Peazants have a belief in their own ability to change and in their ability to transform . . . social relations" (Bambara, 123). Bambara concludes that the next stage of independent cinema will be "pluralistic, transcultural, and international," with an "amplified and indelible presence of women" (Bambara, 143).

In his introduction, "Black American Cinema: The New Realism," Manthia Diawara emphasizes what he calls *Daughters of the Dust*'s "religious system" (18), which he states is African, leading to "a Black structure of feeling" (19). He links this to Cornel West's recent call for a politics of conversion, of feeling, which Dash's system of "ancestor worship" resembles (18–19). West passionately claims that "black existential angst derives from the lived experience of ontological wounds and emotional scars."[136] Black Americans face a "nihilistic threat" whose symptoms include a "sense of worthlessness and self-loathing," a "kind of collective clinical depression," "an eclipse of hope." For West, recovery from nihilism is analogous to recovery from addiction; all are "diseases of the soul."

For West, "any disease of the soul must be conquered by a turning of one's soul. This turning is done by one's own affirmation of one's worth, an affirmation fueled by the concern of others. This is why a love ethic must be at the center of a politics of conversion." This "love ethic [which is 'universal'] has nothing to do with sentimental feelings or tribal connections." Rather, it is generating a "sense of agency" (43)—to which I would add self-love. Against the premises of corporate enterprise and romance, universal spiritual practices illustrate that strength, happiness, and high purpose come only from within, from the heart. Spirituality teaches that, instead of lacking (the premise of desire) or wanting (the premise of obsession), we are greater and more self-sufficient than we imagined.

hooks speaks of *Daughter's* "truth of spirit," the "spirit of unity" (DBh, 48). However, she finds this spiritual truth in Native American and black traditions, what she sees as the "historical overlap between ideas about nature, divinity, and spirit in those two cultures" (DBh, 49). Like hooks, I prefer "spirituality" to religion. Spirituality surpasses the exclusions, intolerance, and differences of religious institutions—squabbles represented in *Daughters of the Dust*. And I suggest that the film's spiritual qualities have great affinity with Hindu, Buddhist, and Muslim practices (and Kashmir Shaivism, my personal practice of Siddha Yoga), as well as with traditions of Christianity.

Spirituality invokes the divinity, the greatness, and beauty within everyone. Through diversity and individualism, spirituality invokes unity and community. For me, the spiritual basis of the film, eliciting what Sergei Eisenstein would first call *pathos* and later *ecstasy*, is unifying and inspiring—providing another way to think and feel and change history. Spirituality—in the character of the unborn child, on the soundtrack (in the wind and the music), in the values of love and compassion, in the formal structure—enables an identification with something greater than race or gender or nation. This "ethics of love" is *Daughters of the Dust*'s "truth," which can be felt, experienced, and known.

BLACK AESTHETICS: WHY SERGEI EISENSTEIN AND GILLES DELEUZE?

There are at least three obvious ways to approach independent films by transnational women of color: through theoretical analyses of "third cinema" and concepts of the postcolonial and diasporic cinema (for example, Partha Chatterjee, Teshome Gabriel, Clyde Taylor, Gayatri Spivak, Benita Parry); through the representation of race (for example, bell hooks, Michele Wallace, Toni Cade Bambara); and through feminist film theory—my vantage point, which takes certain films *as* theory.[137] The work (on film and in writing) of two filmmakers—Isaac Julien of the British Sankofa group and Trinh T. Minh-ha—in the 1980s and into the 1990s opened up spaces and minds for contemporary debates among these approaches, in the context of a developing transnational cinema.

The reasons I have chosen the eclecticism of film feminism, Gilles Deleuze, and Sergei Eisenstein to illuminate radically different films made in the United States and Australia by extremely diverse women of color (an Aboriginal Australian and an African American) need some explanation. First, the obvious: Deleuze and Eisenstein are *film* theorists who have influenced Tracey Moffatt, Laleen Jayamanne, and me. Although our histories and contexts are radically different, women have transnational film

theory in common. The international history of film theory belongs to women filmmakers and feminist critics, white and of color, just as much as to men, white and of color.

Diawara disputes my tendency to interrelate disparate thinkers. In a critique of this material, he asked, "Is this not a way of effacing? The universal, being like Deleuze/Bazin, obliterates the local, the originality of Dash's films." (One could add hooks's or Diawara's writing.) I hear what he means. For me, however, it's not a question of either-or, with women granted the local and white male theorists the global. The global also belongs to women. I wonder also why Diawara presumes that Deleuze, for example, is of higher magnitude.[138]

Now the more complex, polemical reasons. Just as Eisenstein is central to Deleuze's theory of cinema and affect, so are Eisenstein's arguments embedded in contemporary precepts of "third cinema." (A body of thought that overlaps with concepts of Deleuze and Guattari—and no wonder: Deleuze and Guattari do not think in Western polarities. Although their major sources are Western, their thought and their values are thoroughly influenced by Eastern philosophy.) And just as the issues of women and race concern Deleuze and Guattari, recent critiques of third cinema have paralleled or been deeply influenced by feminism. Teshome Gabriel, Homi Bhabha, Clyde Taylor, Kobena Mercer, Stuart Hall, Manthia Diawara, Geeta Kapur, along with other critics of the postcolonial and the post-aesthetic, are asking comparable questions to and using the same theoretical models (particularly Mikhail Bakhtin and Michel Foucault) as have feminist film theorists from the late 1970s on. While I have learned much about films and histories from third-cinema analyses, the theoretical principles are not new to me.[139]

Through contemporary theory, the realm of "aesthetics" has figured prominently in recent writings on black cinema. This makes historical sense. The *tactics* (techniques inflected with politics) of aesthetics are debated during periods of transformation—for example, in the Soviet Union during the revolution (1914 through the 1920s) and in post–World War II European cinema, particularly Italian neorealism. These radical issues reemerged in the West during the 1960s around Jean-Luc Godard's Dziga Vertov group in France and, in the 1970s, migrated to England and the United States around avant-garde cinema and feminism.[140]

The politics of aesthetics have been reinvigorated by black film critics, shifting away from Europe to Africa, from the North to the South, from a "national" aesthetic (the debates of the 1960s) to "diasporic," international post-aesthetics. What has been called third cinema argues that a "Black diaspora links these developments internationally." This idea is derived from England, "where black independent practitioners were challenging the old

'race relations' paradigms and experimenting with new forms of (black) representation."[141]

Clyde Taylor critiques the Eurocentric bias of aesthetics. From Taylor's U.S. vantage point, "aesthetics" is synonymous with Western aesthetics; thus "aesthetics [is a] doctrine destructive to the cultural orientation of black people."[142] His critique of Griffith's *The Birth of a Nation* details the problem. Although the film was seriously attacked by the National Association for the Advancement of Colored People (NAACP) upon its release, male historians have been upholding it as a "great work" for years. They make their case through aesthetics, through art separated from politics: yes, the film is racist, but it created the aesthetic canon of cinema. "It is this mystifying aura orchestrated by the art-culture system that has deterred the recognition of *The Birth of a Nation* as one of the most accomplished articulations of facism, of twentieth century evil."[143]

For Taylor, "the Black Aesthetic" of the 1960s in the United States has grown conservative, separating aesthetics from politics, taking art away from its social and material conditions. Rather than aesthetics, Taylor advocates what he calls postaesthetics. The text is not autonomous but is connected to "other texts and to everyday life." The aim is "satisfaction" from "the production and exchange of liberating knowledge, not the pleasure of the text" ("Another Hero," 83). Citing the African films of Ousmane Sembene and the U.S. films of Alile Sharon Larkin and Haile Gerima, Taylor identifies postaesthetics as transcultural, transnational, translinguistic ("Another Hero," 84).

In this light, the theoretical premises begin to shift—to feminism, to Mikhail Bakhtin, to Deleuze and Guattari, to Eastern thought, to Africa. To build black cinema, we must first make "a break from the repressive doctrine of aesthetics." The post-aesthetic that is "assimilationist" (here Taylor cites the irony of Julie Dash's *Illusions*) is a shift away from what Taylor calls the "seductions of aesthetics" in favor of "liberative strategies." For him, "modernism for Blacks is hardly over, has in fact hardly begun. Blacks can only dubiously be postmodernists since they were never permitted to be 'modernists' in the first place."[144]

Repeating Linda Nochlin's famous question "Why have there been no great women artists?" Taylor wonders why, in the history of aesthetics, no great non-Western thinkers or artists have become centrally important. He looks to Africa for a political aesthetics: the first step is to "separate Afro-modernity from modernization-westernization" ("Another Hero," 80). Diawara, Bambara, Dash, and hooks claim an Afrocentric aesthetics—yet Taylor might critique the "accommodating formalist grounds of oral narrative, folklore and griotology—important, valid, but rear-guard" ("Another Hero," 81).

Homi Bhabha invokes Foucault's history and Bakhtin's social theory of hybridity and heteroglossia to advocate a similar space of hybridity: "the construction of a political object that is new, neither the one nor the Other . . . a sign that history is happening, a tactic of negotiation rather than negation."[145] "This negotiation of contradictory and antagonistic instances . . . opens up hybrid sites and . . . destroys those familiar polarities between knowledge and its objects" (118). Bhabha's "contradictory," "ambivalent" space of enunciation represents what Jayamanne calls the "space of contamination." Her 1985 film *A Song of Ceylon*'s "economy is post-colonial in the sense that is enamored of corruption, contamination, hybridisation."[146]

Bakhtin has influenced Kobena Mercer, as well as Stuart Hall, who invokes Mercer's concept of a diasporic aesthetic.[147] This is a hybrid, dialogic culture. Hall echoes the Sri Lankan filmmaker Laleen Jayamanne, who advocated a cultural model of "post-colonial hybridization" despite what she calls "the efforts of chauvinistic forms of nationalisms to erase such heterogeneity and regress into some mythical ideal of pure identity, whether of nation or gender."[148]

That Bakhtin's culture (the Soviet Union at the time of his writing) was hybrid, culturally and racially diverse, a collection of republics spanning Eastern and Western traditions, makes the application of his ideas (drawn from literature) to film pertinent and logical. An even stronger case can be made for Sergei Eisenstein, a Russian film theorist whose thought was inflected by Eastern culture along with Western cinema. Eisenstein's analysis of the political differences between techniques of U.S. and Soviet montage is in the same spirit as Teshome Gabriel's list of film techniques particular to third cinema, a taxonomy in the political tradition of Bazin's analysis of, for example, post–World War II neorealism and the aesthetics of "spatial realism."[149] Long takes capturing the rhythm of life; crosscutting for simultaneity, not suspense; close-ups not used for individual psychology; panning shots for integrity of space; the concept of silence; and the concept of the hero are the hallmarks of "third cinema style."[150]

Bambara's analysis of Dash's use of space resembles Deleuze on Orson Welles but reaches different conclusions. Dash's aesthetic is a style of "shared space (wide-angled, deep focus)" rather than "dominated space," space which portrays conflicts that are "systemic," not merely "psychological" (DBh, xiii). Consider in relation to Bambara Bazin's contrast of what Dudley Andrew called "spatial realism" with "psychological realism," the Hollywood continuity style.[151] Spatial realism consists of moving camera shots, in depth, of long duration. Thus the spectator has the freedom to look around, to make relations within the mise-en-scène. Cuts are not motivated by the cause–effect logic of continuity style or character psychol-

ogy, including point of view. Italian neorealism was a classic example of spatial realism, as were the films of Jean Renoir.

As invaluable as Bazin's aesthetic was (and is), this was an Anglo (not just Western), Eurocentric political aesthetic, suitable for post–World War II white liberals and humanists. It had little to do with women and nothing to do with people of color. Neither did Eisenstein's aesthetics, for that matter. But though this history ignored us, it still belongs to us. Women critics must *extrapolate* (infer, estimate from the evidence) more than interpret.

Although similar on the surface, Bambara's "shared space" and Bazin's "spatial realism" are, paradoxically, both close and world's apart.[152] Who is in the space and what they are doing there—what Dash calls Afrocentric actions—make all the aesthetic difference. Among other things, the performative can share or take precedence over the narrative, the private over the public, the everyday over the extraordinary. Aesthetics are filtered through feminism and African cultural traditions.

Diawara, a scholar of African cinema, posits two aesthetics of black American cinema: one is based on time (linear, not simultaneous), the other on space. "Spatial narration" reveals and links "black spaces that have been . . . suppressed by white times" and validates "black culture." "Spatial narration" is "cultural restoration, a way for Black filmmakers to reconstruct Black history."[153] In contrast, the "time-based narratives" are "performances of Black people against racism, and genocide," linking the "progress of time to Black characters." The time structure is linear, the spatial is circular—*Boyz N the Hood* (John Singleton, 1991) compared to *Daughters of the Dust*.

This distinction echoes that of continuity style versus spatial realism, the latter akin to what Diawara calls "new realism" and Bambara "shared space." But Diawara also revises continuity style, pointing to "the pathological space reserved for [blacks]" *and* spatial realism. The space must be "re-invest[ed]" with "modernist humanism" (different from Bazin's "revolutionary humanism"). Black cinema reveals "the space omitted or silenced by Eurocentric definitions. . . . Blackness is a way of being African in modernity, . . . a way of being human in the West."[154]

I also like Deleuze's distinction between time-movement and space-movement, which I elaborate later. Dash and Moffatt are inventors of time images that are transformative. Politically, they are what Deleuze calls "mediators," who create images, producing new thought, rather than imitators, who recycle old thought.[155]

Teshome Gabriel's political aesthetic directly comes from Deleuze and Guattari.[156] Their figure of the nomad becomes the model for "an alternative aesthetics of black independent cinema." To paraphrase Gabriel's po-

etic comparison: black people and nomads are united through their use of "symbolism, metaphor, music, space, and performance." Both are marginalized, de-territorialized peoples. Both value collective memory, which evokes images and sounds and invades everyday existence, over official history. Both reject the idea of closure. Both are synthesizers of surrounding cultures they pass through. Both live in the industrialized world but do not belong to it: mythical and spiritual homes are as important as physical homes. Both are obsessed by the very essence of freedom (70).

"Black filmmakers cross borders, they are not oppositional (to Hollywood) but pro-active, they create their own aesthetic terms in film discourse" (71).[157] This nomadic aesthetic often deals with the motif of a journey: "The search has gone far beyond opposition; it is a search for a newly born cinema, with its own discrete identity, the development of new, emergent tendencies. Not a cinema of otherness—the notion of the other is to be part of the same system" (72–73). Gabriel calls nomadic cinema traveling cinema. "An authentic black cinema cannot be but a new, newly born, post-cinema" (73).

Like 1970s British film theorists, Gabriel argues for the importance of popular memory, "the oral historiography of the Third World," and folklore, which comes from "people's primary relation to the land and community" (Gabriel, "Third Cinema as Guardian," 54). But the importance of "the folk" depends on context. The British avant-garde films of Isaac Julien, along with the work of the collective Sankofa, come from a metropolitan context and have another goal.[158] Instead of the folk and the land, Geeta Kapur argues that the third cinema is about self-representation, about the articulation of the colonised individual . . . into history."[159]

There has been a divide between those who wrote about race and the third world and those who wrote about women and the first world. When read through feminism, as Jayamanne does, both groups of theorists are revised and claimed for and by women. In fact, the work of Moffatt, Dash, and Jayamanne supersedes feminist film theory, fashioning new models of history, politics, and subjectivity for transnational women, for inter-national culture. For me these films *are* central theoretical constructs that outrun any application of theory.

Jayamanne and Moffatt were influenced by two filmmakers—Isaac Julien and Trinh T. Minh-ha—who addressed in their work and their words the racist premises of anthropology and ethnography. In their writing they pointed to the racist politics of style, along with aesthetics. Their films radically revised these conventions (and I do mean "radical"), portraying aesthetic options.

In the early 1980s, Isaac Julien engaged the debate about "realism" and race: "Up to now there have only been linear narrative films and realist

documentaries . . . natural and accepted types of film for black filmmakers to make. We have to create space for other kinds of intervention—because black people are not all the same, there are many black communities."[160] For Julien, the focus of black life that sells has been on "social problems or exotica." But something else is going on now: "A different perspective has emerged, [one] that has been more critical because we've been allowed the space to think—and that is a luxury for a lot of black people . . . to have the time to discuss, the time to look at films, and to be critical about what we are looking at."

In a *Camera Obscura* interview in 1985, Trinh T. Minh-ha said of her first film, *Reassemblage,* that its "strategies question the anthropological knowledge of the other. . . . If there is one thing that would always invalidate anthropology, it is precisely its claim to scientific knowledge. . . . It pervades all the writings throughout the evolution of anthropology."[161] She incorporated many facets of contemporary theory in her work. "But if I am interested in Barthes, in Western contemporary music, in feminism, in post-structuralism it is because these ways of thinking do not *exclude* and therefore appeal more to non-Western thinking. . . . I think post-structuralism is what it is today thanks to non-Western thinking" (97). I agree. Deleuze is appealing for "black aesthetics" because his thought is *not* exclusive.

In 1986, Minh-ha edited an issue of *Discourse* titled *She, The Inappropriate/d Other* that included her important essay "Difference," which draws on a rich blend of influences, including black American writers (for example, Alice Walker).[162] "Difference reduced to sexual identity is posited to justify and conceal exploitation. The Body . . . remains the safest basis for racist and sexist ideologies. . . . The search and claim for an essential female/ethnic identity difference today can never be anything more than a move within the male-is-norm-divide-and-conquer trap" (32–33). This brilliant and eccentric theorist, writer, and composer materializes her thoughts in beautiful films of formal intensity. Her films don't so much represent women as let "representing women" speak for themselves and with us, all seen and heard through the fine-tuned eye and ear of Minh-ha.

I can hear these theoretical arguments (along with those of other critics) resonate in the personal and critical remarks of Dash, Bambara, and hooks, as well as Jayamanne and Moffatt. However vernacular and chatty, this is sophisticated theory. For example, Moffatt's acutely smart rejoinder—"Yes, I am Aboriginal, but I have the right to be *avant-garde* like any white artist"[163]—raises many issues: the relations between "style" and identity, identity and experience, experience and understanding, and the distinction between "insider and outsider knowledge" are just a few. Her comments and her films suggest that perhaps in the late 1980s and 1990s,

aesthetics can determine identity in ways more interesting than those in which identities determine taste.

Moffatt's "right to be avant-garde" speaks volumes about the prejudicial linkage between documentary realism and the representation of blacks. It is also a serious critique of the white, middle-class maleness of avant-garde cinema. Her remark "I don't believe in talking down to Aboriginal people"[164] speaks to the unstated racism of the belief that avant-garde is too difficult for ordinary folks. *Theory* has been taken into these women's lives and comes out in their films as politics and aesthetics. I repeat: The history of film theory, like film history, belongs to women, white and of color, as much as to men, white and of color.

I have placed this feminist work in tandem with Deleuze for several *specific* reasons. The first is contextual: Deleuze (and Guattari), rather than Freudian psychoanalysis, has been central for postmodern Australian feminism. The second is rhetorical: Deleuzian thought, which critiques Freudian psychoanalysis, is not a binary logic; rather, it argues for a third term, a logic akin to Eisenstein's that can invent subjectivities where none existed, a logic that moves away from Cartesian cause–effect linearity, erasing opposition between art and popular culture, mind and body, intellect and emotion (or thought and feeling), the seen and the unseen, and even the past and the present. The third is logical: Deleuze's cultural object is cinema; as with Eisenstein, who for me is the key to Deleuze, cinema *is* modern thought. However, by reading Deleuze and Eisenstein *through* Moffatt's films and Jayamanne's comments, their theories are revised by and reclaimed for feminism.

The influence of Deleuze on Australian feminists has been more direct than in Britain and the United States—at least until now. Deleuze has been slow coming to America. Meaghan Morris writes, "In the 70s, I learned very little from British feminist film theory; I was not interested in psychoanalysis, and so my own work looked instead to Gilles Deleuze and Michel Foucault" (Morris, 127). (For most U.S. and British feminists, even Foucault was endorsed much later, while Deleuze is still held in abeyance of disregard.)

Since the mid-1980s, Australian feminists have taken issue with the limits of U.S. and British feminist film theory, weary of its relentless focus on sexual difference and psychoanalysis. As Lesley Stern has said, "There's a kind of generic predictability about the enterprise that has to do with academic disciplines," a "restrictive repertoire" to which Stern developed "an abhorrence."[165] Jayamanne calls this "subservience to theory" a "failure of the imagination" that refuses to "let films surprise and unsettle the feminist doxas of film theory. . . . A limited number of theoretical propositions are plastered on to a variety of texts coming up with more of the same."

She made *A Song of Ceylon* "in a context of thorough dissatisfaction with this state of affairs" (Jayamanne, 153). This earlier film, like Moffatt's work, *is* postcolonial theory and a revision of feminism, of the most sophisticated, moving kind.

Regarding affect, feminist film theory has an extremely limited model. Strange that given the many pages devoted to "the film spectator," we didn't think to ask what or how she was *feeling*. Pleasure (or desire) is the only rubric (how did we miss fear?), a catchword that has become almost meaningless. Thus I look to Eisenstein and Deleuze for an initial theory of affect, a model that includes sound along with vision.

EMPIRICAL AVANT-GARDE

> Empiricists are not theoreticians, they are experimenters: they never interpret.
>
> Deleuze and Parnet[166]

The film theory and avant-garde films of the 1970s repudiated Eisenstein's affective logic—his valuation of emotion and the importance he granted to sound and to vertical montage. The new, radical style denied identification, defused story, and minimalized affect. What Eisenstein called "contemplative dissection" (of "uncrossed parallelisms" and of oppositions) ruled our response. The formal aesthetics of art and theory that we thought would change society—the famous model of the cinematic apparatus—were strictly rational and visual, an ethics of duality, like cold war logic.

In contrast, what I call the empirical avant-garde of the 1980s and 1990s was interested in neither ontology nor first principles. Indeed, logics of purity and origin excluded these artists or were used violently against their culture and race. While empirical avant-gardists speak to history, it is with the wary skepticism of those whose stories have been eradicated or forgotten. As Laleen Jayamanne notes, we must prevent "the erasure of memory and of our capacity to remember."[167] "I, too, am in search of the debris of history," hooks writes. "I am wiping the dust off past conversations" (*Black Looks*, 166). "To bear the burden of memory one must willingly journey to places long uninhabited, searching for traces of the unforgettable, all knowledge of which has been suppressed" (*Black Looks*, 172). "As red and black people decolonize our minds we cease to place value solely on the written document. We give ourselves back memory. We acknowledge that the ancestors speak to us in a place beyond written history" (*Black Looks*, 193).

Thus, rather than history (or anthropology and ethnography), this "liv-

ing speech" of memory—real and imagined, factual and fictional, experiential and experimental—sketches what Deleuze calls a "geography of relations."[168] This geography can recall what has been ignored or gone unrecorded, fashioning what Deleuze calls a "logic of the non-preexistent": "Future and past don't have much meaning, what counts is the present-becoming" (*Dialogues*, 23).

Similarly, Meaghan Morris notes that "most feminisms" have "an experimental approach to the present, a desire to shape the future, and an enterprising attitude to representing the past" (Morris, 127). The empirical avant-garde destabilizes history through the experimental, granting women the authority of the experiential (which includes knowledge and memory). The self—of the maker, of the audience, and of the ancestors—is invoked in a spirit of cultural continuity rather than rupture. The focus is on *becoming*, on *relations*, what happens between experience and thought, between "sensations and ideas," between sound and image, between cultures, between women. This is not a logic of either-or; nor is it a logic of cancellation, both-and. It is a logic of "and"—of connections, of actions, of affections. Becomings, according to Deleuze, "are acts which can only be contained in a life and expressed in a style" (Dialogues, 3).

This sublime style, a beautiful aesthetic, is not pop or postmodern. It is a transformation that is brilliantly formal. Adrian Martin echoes Eisenstein: "Form can move content through a whole series of complex attitudes and contradictory positions"[169]—not the least of which, I would add, is the struggle between mother and daughter, the ground on which national, racial tragedies are staged in the work of Dash and Tracey Moffatt.

Dash calls her history *what if*, "speculative fiction"—what Jayamanne, after Deleuze, calls virtual history. This is what Eisenstein calls ecstatic history, a history of pathos. Across very divergent cultures, Moffatt and Dash balance the experimental and the experiential, making *affective* history, a history of presence inhabited by the audience and the filmmakers. Their lives are spiritually connected to their forebears—as if they know and love them.

For both women, history confers subjectivity. Although personal and painful, having history is always empowering. By locating issues of race and gender within specific contexts that are simultaneously historical and experiential, these films expand the contours of female subjectivity—both on screen and in the audience—to include women of all ages and appearances, complex emotion, and collective identification.[170] When the enunciation shifts into women's minds and into history (which includes our experience and memory), we cease thinking like victims and become empowered, *no matter what happens*. "Being the hero" is a state of being as well as action. Being the hero is, precisely, *not* being the victim.

Cultural difference more than sexual difference provides the context. (As hooks and many critics have pointed out, the concept of "sexual difference" at the base of feminist film theory is "racialized" [hooks, *Black Looks*, 122]). The local (differences of appearance, custom, law, culture) illuminates the global (our commonalities of family, fiction, thought, feeling). The local, women's history, becomes the ground of the global, feminist theory. Thus we learn about differences *and* experience the recognition of sameness. We feel history as presence, passed on from grandmother to daughters and sons—a living history that is nourishing, not diminishing.

TRACEY MOFFATT

Australian filmmaker Tracey Moffatt has been deeply influenced by the history of cinema, including Hollywood movies: "I learned to make films by watching them. A childhood spent glued to the television, then a diet of very commercial cinema through to avant-garde films." *Mary Poppins* (Disney, 1964) had "very high production qualities, quite artificial and cartoon like. I remember *Mary Poppins* (because Daphne, my real Mother took us out to see it). There were the B-grade Hollywood Biblical epics—Anglo Saxon actors wearing lots of eyeliner and darkish pancake makeup to look 'middle Eastern.' The sets were minimal and lighting hard, very stagy. I'd stare at these images for hours. I don't know why I liked them."[171]

These images are refracted in the mise-en-scène, the affective geography, of Moffatt's film *Night Cries* (1990) in which Hollywood and the 1950s are read through the Australian film *Jedda* (Charles Chauvel, 1955) and the work of the Aboriginal painter Albert Namatjira. As Moffatt says, "Whatever sort of film it is, whatever it's about, it's showbiz."[172] In this tradition of Australian independent film the energy lies, Adrian Martin points out, in its "impulse to incorporate—in however dislocated or perverse a way— vivid fragments of the cultural environment—TV, music, cinema." Unlike "deconstruction," this tradition is "less overt critique and more emotional" (Martin, 98).

For me, the key phrase is "more emotional." These filmmakers understand deeply the affective quality of photography, of composition and of the close-up. Moffatt is a still photographer, well known for her serial installations, which are influenced by movies. Similarly, every frame of her films is a composition, a portrait, a still life.

For Moffatt, like Dash, still photographs lead to sound, to story, and comprise an affective logic. Instead of "contemplative dissection," they aim for what Eisenstein calls "emotional fusion." These films exist in the intersections between sound and image, history and experience, art and life, filmmaker and audience. Their affect and their intellect emerge from

the relations among women. Rather than a logic of ontology or duality, they operate according to what Deleuze calls "the Anomalous"[173] and Jayamanne and others call "the hybrid," a tactic of assimilation, not, that is, from the point of view of the colonizer. (This tactic, of course, is political—these are films by women of color.)

Moffatt lives simultaneously in at least two cultures which are industrially and technologically divergent. If time is measured by industrial development (as it is in linear histories of progress), she also lives in two time periods. She remembers, speaks from within, colonial experiences. Moffatt is matter-of-fact about the past: "My people grew up on an Aboriginal mission outside of Brisbane. . . . I was fostered out to a white family along with my brother and two sisters. . . . It wasn't against my mother's will" (Rutherford, 152).

Laleen Jayamanne's self-analysis could apply to Moffatt: "I do not see this as impoverishing. . . . I am neither marginalised nor in a state of deprivation. I straddle two traditions with a degree of comfort and a tolerable degree of discomfort. I like it."[174] Although Jayamanne advocates ambivalence, there is nothing ambivalent here. Theories of *bivalent* (doubled) knowledges are more accurate than current theories of difference as lack or ambivalence (conflicting). As Moffatt says, "My work may feature brown faces but it could be anybody's story." She wants to be taken as an artist, not as an Aboriginal artist. "Yes, I am Aboriginal, but I have the right to be *avant-garde* like any white artist" (Murray, 21).

Moffatt's films return to the compelling, colonial moment, cast as scenes of childhood memory. The past, a question of memory *and* history (which is intimate and emotive), haunts the present of her films like a primal scene. I am thinking not of the Freudian primal scene but of something he could never understand: the mutual struggle of women for independence, of mothers and daughters to love *and* to let go, to be together *and* to separate. This lifelong journey, away from *and with* the mother, is taken into history, resulting in what Eisenstein would call a "qualitative leap"—"a transition from quantity to quality," to "emotional quality."[175]

Eisenstein, read through feminism and Deleuze, reverberates in the work of Moffatt and Dash. And this is logical. His is a theory of affect, of emotional intensities, a theory permeated by Eastern *and* Western culture. Colonial subjectivity is hybrid, like separate hieroglyphs fusing into ideograms (30), or akin to yin-yang, "each carrying within itself the other, each shaped to the other . . . forever opposed, forever united." This "emotional fusion" (251) is what Deleuze and Guattari call "the one in the many" and what Eisenstein calls "unity in diversity."

Jayamanne's theoretical comments illuminate Moffatt's work—the tactic of "post-colonial hybridization" despite the "efforts of chauvinistic

forms of nationalisms to erase such heterogeneity and regress into some mythical ideal of pure identity, whether of nation or gender" (Jayamanne, "Do You Think," 55). The larger project is to render visible cultures undergoing transformations, to "use the messy inheritance that is exacerbated by the introduction of electronic media into postcolonial societies" (Jayamanne, "Do You Think," 57). With cinema, one cannot work with the "pristinely national" any longer. Moffatt's films are a politics and an aesthetics of assimilation—"matter of method and also of survival . . . survival not in a cultural ghetto but in the market as well as in the domains of cultural visibility and legitimacy" (Jayamanne, "Love Me Tender," 4). Hybridization/assimilation is history that is neither pristinely indigenous nor completely other.

Nice Colored Girls

Nice Colored Girls (1987) is a short film by Moffatt that tells the story of two teenage Aboriginal girls who get a middle-aged white man drunk and then gleefully steal his wallet. This contemporary scene of nightclubs and restaurants (actually painted sets) is disrupted by history, made strange through images from the past. Aboriginal paintings cover the walls, the camera dollies past the set, the color of the film image fades, and an Aboriginal woman looks at us from the past, centuries ago. The present is permeated and sanctioned by the past—the 1780s exploitation of Aboriginal women by white men is reversed in the 1980s.

History speaks in several ways in this film: in the voice-overs, in the painting/photograph of the British colonizers' landing in Australia, and in the fragmented bodies (hands, arms, legs) of the Aboriginal women over this image. The assault on the image and on representation is an attack on the doggedness of colonial history. But the image is almost indestructible. The historical image is sprayed with black paint, the glass is smashed with a rock, and finally the wall on which it hangs crashes over. Revising the history of representation takes years of direct assault.

The founding legend of Australia, the landing at Sydney Harbor (or conversely, the white invasion), is told in voice-overs taken from diaries of explorers, one of whom is William Bradley, who wrote in 1788. The colonizers resemble ethnographers; as one critic of the film said, "Indigenous women were viewed by the colonisers as inferior but challenging, or as exotic victims. . . . In the guise of ethnographic study, relations between 'explorers and researchers' and indigenous women were coveted and prized," becoming the "basis of thought" during colonization.[176] The founding story becomes the backdrop, the performance scene, for telling the tale from another point of view, one that was not recorded in print.

This story is performed by Aboriginal women in the present on the

Nice Colored Girls

streets and in the bars of Kings Cross in Sydney and as avant-garde in front of the photography hanging on the wall, the historical image. The dyads of "exploited/exploiter, predator/prey" are inverted (McNeil, 2). Moffatt undercuts and remakes colonial history through an intellectual, vertical montage. Sounds of water are cut into Sydney streets; the historical, the indigenous, is always there, waiting to be remembered.

The point of view of teenage Aboriginal girls reminds me of this brief footnote in Freud: "'Childhood memories' are only consolidated at a later period, usually at the age of puberty. . . . This involves a complicated process of remodelling, analogous in every way to the process by which a nation constructs legends about its early history."[177] The gleeful, wicked girls of the film who go to King's Cross, pick up a "captain" (the Aboriginal word for sugar daddy), and roll him caused an upset within the Australian Aboriginal community. The girls' vengeance is autobiographical. As Moffatt says, "I used to do it, I used to do it with my sisters. . . . We're not little angels. [I'm part of a] generation that feels comfortable in talking about Aboriginal society" (Rutherford, 152).

Just as Moffatt breaks the painting's frame, so the fourth wall of the studio is broken. Space is not empty but full of meanings—particularly the black space of the frame in *Night Cries*. Space is filled with history, Aboriginal landmarks we (or I) cannot see, and is haunted by sound. It is the space out of which a forgotten figure from the 1950s, Jimmy Little, a popular Australian singer, can emerge and into which he recedes again. It is a space of becoming, a space in between. For Moffatt—and for Dash, too—history is an empty canvas of light, full of forgotten actors, a cast waiting to be remembered, recollected, assembled. Like Eisenstein, Moffatt "com-

poses for the frame, even making *Night Cries* look like a painting. . . . I wanted it to be my big canvas" (McNeil, 2). The frame resembles what Eisenstein called the "Dynamic Square" (a screen space that would vary in size during projection of the film).[178]

Form and story become equivalent in value, and include the collision between sound and image, the formal work on the minimalist, intense soundtrack. As Moffatt puts it: "It's not enough to just be black and a film maker and right on, you have to be responsible for exploring film form at the same time" (McNeil, 2)—not to reveal the "apparatus" but to invoke memory, to configure the past with a logic "of the non-preexistent." As Jayamanne critiques anthropology, Moffatt reacts against ethnography, the realist tradition of representing black Australia: "It's black, we can't experiment with form. . . . It was always a gritty, realist approach representing black lives" (McNeil, 2); "I don't believe in talking down to Aboriginal people" (Rutherford, 153). (Similarly, for bell hooks, Dash's *Daughters of the Dust* becomes "a critical commentary on the ethnographic film" [DBh, 38].) As Moffatt says, "I am not concerned with verisimilitude. I am not concerned with capturing reality, I'm concerned with creating it myself" (Rutherford, 155).

For women of color, the history of representation, a geography of women's lives, is being made. By inscribing what has been there but not visible to everyone, by telling the tale from the point of view of women, the landscape changes. The struggle is complicated by mixed race and age in Moffatt's later, extraordinary film *Night Cries: A Rural Tragedy* (1990).[179] The images of the old, dying, withered, unseeing white mother and the voluptuous, middle-aged Aboriginal daughter are intercut with scenes of the daughter's childhood memory of the two of them (along with little brothers) on the beach, when both were both young. Now mother and daughter are trapped by history in a dry, orange mise-en-scène of a desert saturated with intense color. The affect is high (experimental) pathos, loss and longing. The experiential crashes into the historical; painting and photography meet.

Night Cries: A Rural Tragedy

For U.S. audiences of *Night Cries*, cultural knowledge of Australian history, although not essential, benefits reception. Australia's policy toward Aborigines into the 1920s was extermination—comparable to the U.S. policy toward Native Americans. Segregation of Aborigines on what were called "reserves" came next. This policy included taking children away from their families to stop the growth of a mixed-race populace. Aborigines had a curfew of sunset to sunrise.

In the late 1930s assimilation became the new policy. "Full-bloods"

were distinguished from those of mixed descent. As Cecil Cook said, "We have to absorb the Aborigines, as well as protect them."[180] Aboriginal children were taken away from their parents and given to white foster parents; the race would thus be absorbed by intermarriage when the children grew up. While this appears to be the opposite of the miscegenation prohibition in the United States, the intent and the effects of both policies are horrifying.

Night Cries refers to this history by remaking *Jedda* (1955), a big Technicolor, Cinemascope film directed by Charles Chauvel. *Jedda* begins in the ranch home of a cattle station, an Australian homestead. Jedda is the adopted Aboriginal daughter, living with her mother, father, and Joe, the ranch hand, a "half-caste." Like Jedda, this good guy wears Western, not Aboriginal, clothing. Like Jedda, he has been "civilized." Wilderness surrounds the "civilized" culture of the ranch. The space—the bush—inhabited by untamed Aboriginals, is the space of the unknown, desire, danger, and death.

Robert Tudawali, an Aboriginal actor, was Marbuk, the lead character. For the 1950s, this is a politically significant casting decision. But Marcia Langton, the lead of *Night Cries*, points out that although played by an Aboriginal actor, the character of Marbuk is still the "primitive." The narrative depicts what she calls "the inversion of the truth": Marbuk is "condemned to death by his own tribe" not by the white colonizer.[181] Marbuk performs rituals and seduces Jedda, who is overwhelmed by impulses, tormented by internal tribal chants. (In an early scene, she is playing the piano in the ranch house and sees an Aboriginal painting; "native" chants overwhelm her until she pounds the keys and covers her ears in agony. This use of the piano is the inverse of *The Piano*.) Marbuk "lures away Jedda," who follows him into the bush "where he performs a magical rite, to which she has no resistance." The rest of the film is a chase scene through the desert landscape—the attempted rescue of Jedda by her father and Joe (or conversely, the pursuit of the Aboriginal by white men)—until Jedda dies, "dragged over a cliff by Marbuk" (46).

Stuart Cunningham, an Australian film historian and critic, has called Chauvel "Australia's most prominent 'classic' film-maker." For Cunningham, Chauvel's work is "high" melodrama, the "excess" being his "vision of nation."[182] (The use of "excess" has become almost a trope for male film historians.) For Langton, an anthropologist, Aboriginal activist, and national political leader who plays the Aboriginal daughter of *Night Cries*, *Jedda* expresses "all those ambiguous emotions, fears and false theories which revolve in Western thought around the spectre of the 'primitive' . . . as if none of the brutality, murder and land clearances occurred" (Langton, 45–46).

Night Cries is concerned only with *Jedda's* prologue, with its portrayal of the very brief relationship between Jedda, the Aboriginal daughter, and her white foster mother in their ranch home. For Chauvel, this scene set within women's space is only a prelude to the capture, chase, and death of Jedda: Jedda's relationship with men determines her life, her identity. For Moffatt, in contrast, the mother is the central figure in women's history: "I took two of the film's characters, Jedda, the black woman, and her white mother, and aged them as if thirty years had passed. In the original film, Jedda is thrown off a cliff and killed. I wanted to resurrect her" (Murray, 22). The actress who played Jedda in Chauvel's film remarkably resembles Moffatt: "As I developed the script, the film became less about them and more about me and my white foster mother. I was raised by an older white woman and the script became quite a personal story. The little girl who appears in some of the flashback sequences looks a lot like me. That was quite intentional" (Murray, 22).

In *Night Cries*, an aged white woman is facing death in a landscape that is almost deserted. Her middle-aged Aboriginal daughter (Marcia Langton) cares for her—wheeling her to the outhouse, feeding her, first tenderly, then aggressively. The flashbacks of the little girl on the beach with her mother are terrifying. When she can't see her mother, the beautiful child, with seaweed wrapped around her neck, panics. Her sobbing captures all the pain and fear of childhood—of separation, of loss, of death. This is a terror that can paralyze us, haunt us, no matter how our bodies mature and age. This terror comes from the fear of leaving and the horror of staying, of being trapped in one's life and in history. When the mother dies, the daughter (clearly not played by Langton and thus a rather strange

Night Cries

Night Cries

scene) reenacts the pain of this incalculable loss, in a scene that remembers birth.

The painted landscape of *Night Cries* is filled with memory, including childhood remembrances of Hollywood movies. As Australian film critic Ingrid Periz explains, space is "inhabited by memory—of a once great cattle station fallen victim to a changing agricultural economy, of foregone hope, of resentment and familial obligation."[183] Moffatt's inscription of memory is very economical: "a brief shot of old photographs, an abandoned railway platform, echoes of a ghost train, and flashbacks to childhood. . . . Memory constricts this space, a space of recollection." The film opens with a quote by Rosalind Russell, who starred in *Picnic* (Columbia, 1955), a film that suggests a stifling scenario of entrapment, of failed expectation, of waiting. Periz concludes, "Dreaming of escape, they wait for whatever life will deliver them. . . . *Night Cries* shows what happens after *Picnic*."

As Jayamanne suggests, the question is "universal"—the "call of duty" (and love) and the desire for separation and "another life" (Jayamanne,

"Love Me Tender," 2). Moffatt puts it another way: "I like to think that my film is universal. . . . It's about a child's being molded and repressed. . . . It could be the story of anyone stranded in the middle of the desert having to look after their ageing mother" (Murray, 22). This would make the film a feminist maternal melodrama—which it is. Yet as the subtitle *A Rural Tragedy* suggests, *Night Cries* is vast, a *King Lear* for women. The tragedy of mother and daughter is also the tragedy of national history, with epic dimensions.

This sublime aesthetic comes from granting the everyday a brilliant, formal, claustrophobic intensity. It also comes from death. As Walter Benjamin writes: "Death is the sanction of everything that the storyteller can tell. He has borrowed his authority from death."[184]

Jimmy Little, the popular Australian performer whose song, "Royal Telephone," played in this film, was a big hit in the 1960s, is a far cry from Robert Tudawali—the first Aboriginal star who played Marbuk, who lured and captured Jedda.[185] Images of Jimmy Little singing are intercut throughout *Night Cries*. It was this figure, not the drama of the old mother and middle-aged daughter or the image of the sobbing girl, that captivated Jayamanne: he is "neither pristinely indigenous nor completely other"— he is a hybrid (Jayamanne, "Love Me Tender," 4). Jimmy Little interrupts the scene of the daughter cracking the whip outside while the mother viscerally "registers every lash," "thrilling and chilling. . . . He sings silently, 'Love me tender, love me true'" ("Love Me Tender," 5). He returns again during the beach scene of torment. As the little girl cries, he sings a lullaby in close-up, silently; we see his lips moving, but there is no music on the soundtrack.

Night Cries

For Jayamanne, Jimmy Little "embodies cultural assimilation," the "mimicry of camouflage"—"the point of which is not to be able to tell if you are there or not. Now you are there, now you are not, it all depends on how you look" ("Love Me Tender," 6). Assimilation is, as Jayamanne points out, a matter of survival, a kind of cultural tactic. Jimmy Little is mediated, constantly lip-synching; his words are dubbed. "So Jimmy Little 'mimics' his own song in a hybridizing gesture which assimilates its own history and performs its dual temporality (1964 and 1989) which is now shot through and through with the 'unspeakable' historical tragedy he has witnessed and helped to signify" ("Love Me Tender," 8). At the same time, Little's smooth presence suggests "the era of the mission school, where black Australians were re-educated and re-clothed in an attempt to make them more 'white'" (Murray, 19)—similar to Tracey Moffatt's own experience in a mission called Cherbourg outside of Brisbane.

For Langton, *Night Cries* "can be read as an autobiographical exploration of Moffatt's relationship with her own foster mother. The film asks questions about the role of 'mother' in adoptive mother/daughter relationships" (Langton, 46). But Langton, who possesses the cultural knowledge of experience, interprets this relationship differently than white interviewers and critics: "Moffatt's inversion of colonial history is to play out the worst fantasies of those who took Aboriginal children from their natural parents to assimilate and 'civilise' them. Perhaps the worst nightmare of the adoptive parents is to end life with the black adoptive child as the only family, the only one who cares" (Langton, 47).

Langton argues that "Moffatt's construction of that nightmare is subversive because the style and materiality of the homestead set is so reminiscent of Aboriginal poverty." She continues, "Chauvel's once privileged homestead now resembles the inside of a humpy." The white ranch/homestead ("extracted from the slave labour of the Aboriginal men and women on the Australian pastoral station") now turns to "Aboriginal poverty. . . . All the excesses of the historical/economic moment of the Australian cattle station are collapsed" (Langton, 47).

She also inscribes a subject position based on cultural difference: "What Moffatt was trying to *correct* in the text of *Jedda* is the Western fascination with the 'primitive.' Moffatt's inversion forces the audience to look not at the desire of Chauvel's *Jedda* but at death, and at the consequences of Western imagination of the 'primitive'" (Langton, 47).[186]

Moffatt's style is suggested by the horror of the whipping scene, which is then followed by the softness of the daughter washing the mother's feet. There is no dialogue in the film. The only spoken words are Jimmy Little's lyrics. Thus the key function of sound is complex in its relation to image.

Eisenstein has never been more applicable: for the sound, it is "not strictly fitting to say: 'I hear.' Nor for the visual overtone: 'I see.' For both, a new uniform formula must enter our vocabulary: 'I feel.'" This is the "Filmic Fourth Dimension" (Eisenstein, *Film Form*, 71). Moffatt's films have found what Eisenstein calls "an inner synchronization between the tangible picture and the differently perceived sounds."[187]

Night Cries's use of close-ups evokes Eisenstein's essay "Dickens, Griffith, and the Film Today."[188] This 1944 essay—which includes an analysis of the differences between the close-ups of D. W. Griffith and Eisenstein—is a key text of Deleuze's *Cinema 1* and becomes, I think, the basis for Deleuze and Guattari's notion of faciality in *A Thousand Plateaus,* a concept that links face, race, and cinema. There is a close affinity between "faciality" and "photography."

For Deleuze, cinema is thought: "The great directors of the cinema may be compared . . . with thinkers" (*Cinema 1*, "Preface to the French Edition"). For Eisenstein, "montage thinking is inseparable from the general content of thinking as a whole" (*Film Form*, 234). Moffatt *thinks* through montage. Her films and her series of photographs embody what Eisenstein calls "an inner unity," not the "outer unity of story" (*Film Form*, 235).

One key distinction between Hollywood cinema (specifically, Griffith's cinema) and Eisensteinian montage revolves around the meaning and the use of the close-up. For the Americans, the close-up signified viewpoint. For Eisenstein, it meant "large scale," rather than nearness. It referred to significance, "to *the value of what is seen*" (*Film Form*, 238). This explains *how* Moffatt signifies historical scope and why her work elicits such strong responses. We don't just witness history, we *experience* history *as memory*.

For Eisenstein, the close-up does not "*show* or *present* as to . . . give meaning"; rather, it "creat[es] *a new quality of the whole from a juxtaposition of the separate parts,*" a "qualitative leap," the "montage trope" (*Film Form*, 238–40). The shots of the old woman in *Night Cries*—her gnarled hands, her swollen foot, her unseeing eyes—fashion such a trope. This is the "secret of the *structure of emotional speech*"—*affective logic*, "inner speech," "sensual thinking" (*Film Form*, 249–51).

In this film without dialogue, Moffatt works on a deeply emotive level akin to the affective logic of inner speech. As she so splendidly described Jayamanne's 1985 film *A Song of Ceylon*, Felicity Collins might call this a "cinema of gesturality," an ecstatic cinema that moves "into another time frame, another condition of knowledge."[189]

Eisenstein's distinction between "contemplative dissection" and "emotional fusion" (*Film Form*, 251) helps me understand how Moffatt's work differs from the usually male, romantic avant-garde. Contemplative dis-

section concerns contrasts, juxtapositions, before and now—what Eisenstein calls *un-crossed parallelisms.* "They are united neither by a unity of composition nor by the chief element, emotion" (*Film Form,* 252). "Emotional fusion" involves "some *new quality*" (*Film Form,* 251). This "qualitative leap" is enabled by feminism.[190] Despite the many interpretations of Eisenstein, this radical possibility has not been noted.

In *Cinema 1,* Deleuze theorizes the "Affect-image," inflecting Eisenstein with Henri Bergson and Charles Sanders Peirce. For Deleuze, the face is a reflecting surface and a series of intensive micromovements.[191] The face thinks or it feels. The thinking face is compared to an outline (the Griffith close-up); the feeling face to an intensive series of movements (the Eisenstein close-up). For Deleuze, the intensive face expresses a pure Power, the reflexive face a pure Quality. One feature can express the same intensity as a whole face, and parts of the body are as expressive as the face. Objects also may elicit affect.

Peirce's distinction between images of "Firstness" and "Secondness" is interesting. In the latter, things exists in relation to something else, which leads to action. For Peirce, firstness is *felt* more than conceived; it "concerns what is new . . . fleeting . . . eternal" (Deleuze, *Cinema 1,* 98). For Deleuze, affects, or "quality-powers," can be grasped in two ways: either as actualized in a state of things or as expressed by a face or a proposition. Paraphrasing Peirce, Deleuze writes: "Affection images . . . refer to firstness"; he talks of a "nudity of the face much greater than that of the body, an inhumanity much greater than that of animals" (*Cinema 1,* 99). The "affection-image" is impersonal, radical; it fractures space and history.

Although Deleuze distinguishes historically between cinema of movement and, later, cinema of time, this way of thinking about cinema is cinematographic, not psychoanalytic. Movement is not limited to cause–effect logic of the narrative or to figures "moving" through space or to cameras dollying, tracking. Action is only one kind of movement; the others are perception and affection. He took the distinction "self-moving thought" from Henri Bergson, what Deleuze calls "one of the most difficult and finest bits of Bergson's thought. . . . I don't think it's ever been quite absorbed" (Deleuze, "Mediators," 281).

Deleuze points out that these thoughts came to Bergson when cinema was "taking shape"; they coincide with, rather than reflect upon, cinema, specifically a cinema of narration. Later, particularly after World War II, came "time images," which "have nothing to do with before and after, with succession. Succession was there from the start as the law of narration. Time images are not things happening in time, but new forms of coexistence, ordering, transformation" (Deleuze, "Mediators," 282–83). Al-

though Deleuze cites Italian neorealism and the French new wave as illustrative of time images, Moffatt's films are even a better example. Her time images transform history, giving us new forms of coexistence.

Bedevil

Bedevil, "A Trilogy of Designer Spook,"[192] is Moffatt's 1993 feature-length film. "The first story is on a swampy, mosquito-infested island in Queensland. The second story is in a desert with location stuff. The third story [is a] decaying dockland area."[193] Past and present, youth and age, Aboriginal and white Australia, the personal and the national "coexist," albeit uneasily, one transforming the other. Place is haunted by time and the inequities of the money economy.

The film has little to do with linear narration and "succession." Time periods are superimposed on each other. Beneath white commercial culture and real estate are the ghosts of an older, displaced culture. Beneath the postmodern *surface* is a *face*, an older, darker face that haunts (and is haunted by) Australia's colonial history, which exists in the present. Beneath cinema is another image, another story. As Moffatt says, "The ghosts are real."

Bedevil begins with the post–World War II expansion of commercial culture—the white world of suburbs, stores, and popular culture (movies and particularly television). "The [three] stories are contemporary accounts of events which appear to be from the early 1950s, the early 1960s, and the 1970s, respectively," told in flashbacks.[194] (I would extend the time into the 1990s, the consumer culture of roller blading and designer logos.) "*Bedevil* comments on 1950s' consumerism, property development and cultural appropriation, but overwhelmingly it concerns articulation of place" (Webb, 32).

From the indigenous point of view, postmodernism might be the accelerating spread of white culture on Aboriginal (and in the United States, Native American) land. One culture has been pushed into the margins and badlands by another that looks away from what has happened and is still happening. The film resonates with the current Aboriginal land-rights debates and legislation in Australia—which are all about economics and the law, money and property rights.[195] Cultural relations to "the land" are not only mythical but economical: "natives" are given the myth of the land, colonizers take the property, turning it into capital, profit. In this film whites own property, Aboriginals do not. But the land does not belong to the whites; they live on it but it is not inhabited by them.

But from another point of view, that of white Australia, this island continent is an interracial nation, a hybrid culture. English colonists came first, with their penal colony; then came the U.S. military during World War II, Eastern European immigrants, and, finally, Asians. Even Moffatt appears

to endorse Australian diversity: "I have Chinese characters, Italian, Greek, and so on . . . very multi-cultural" (Conomos and Caputo, 29). But this is true only on the surface, perhaps mainly for white characters and viewers. The first clue is that the whites are *very* white. Whiteness is marked, not natural. Whites are caricatured. Like postmodernism, they are surface, without depth or insight. They don't see what is there to see and know. For Moffatt, the unseen and the unsaid are always the most significant.[196]

Aboriginal characters don't simply see or look, they *witness;* they don't so much speak, they *testify.* Blacks have depth, but they are not idealized. They also steal, get drunk, beat their children, and quarrel. Aborigines experience what cannot be acknowledged by whites. In interviews and in person, Moffatt refuses to polarize or politicize:[197] "The stories are inspired by family ghost stories I heard as a child, stories which come from both sides of my background—my white relatives as well as my black relatives." *Bedevil* is "about the mystical Australian landscape of my imagination . . . childhood memories" (Conomos and Caputo, 29). The setting is Queensland in the tropical north, where Moffatt grew up in Brisbane.

Despite her claims to equanimity and the "merely" personal, something else is going on. Ghost stories always have a double edge: pleasure and terror. Who is haunting whom depends on one's point of view. The ghost story can be taken as an allegory of "nation." The studio style vaguely resembles an earlier allegorical program, Rod Serling's TV series *The Twilight Zone.* Moffatt's imitations of TV styles reveal television's formal artifice, which has become so familiar as to be foolishly taken as "everyday."

Bedevil's settings are filtered through movies as well as television. One inspiration was *Kwaidan,* the 1964 Japanese film by Masaki Kobayashi, a film with an "abstract soundtrack" and artistic studio sets. Another was Nicolas Roeg's *Walkabout* (1971): "I saw *Walkabout* when I was thirteen and the visuals have always stuck with me. . . . I think I am the only Aborigine in Australia that will admit to loving this film . . . because of its open texture . . . its play with time. . . . The kids are in a desert one minute and walking through a forest the next" (Conomos and Caputo, 31).[198]

But these are all deeply serious, rather arty sources. There is a strong element of parody in the film—the TV commercials, the Aboriginal gourmet cooking show. "The film gets funnier as it progresses. The first story is quite hard, the second rather funny, but the third is actually comedy with slapstick" (Conomos and Caputo, 32).

The trilogy begins with an eerie tracking shot from the edge of the water, through tall grasses, to a murky mangrove swamp where three Aboriginal children are playing. (In Queensland, crocodiles hang around the roots of mangrove trees; the opening shot suggests a croc's stalking viewpoint, perfect for a ghost story.) The first story in this trilogy, "Mr. Chuck," takes place on an island off the coast of Queensland—represented by aer-

Bedevil

ial location footage and a studio recreation of a swamp. The studio scenes are connected to Aborigines' past, the documentary footage to the present.

Moffatt summarizes the ghost story: "A mad American GI during WW II accidentally drove his army duck ashore and into a swamp. He sank without a trace. It was said his ghost haunted the swamp" (Moffatt script). Later a movie theater would be built over the swamp by white Australians. The architect/builder and his two children, an identical boy and girl, are pure, blonde, very white and very clean, like a strange Aryan fantasy. Scruffy Aboriginal children, led by the young boy, Rick, observe this white family apparition or fantasy from the sidelines, across the swamp. The unbridgeable chasm between black and white is captured in this glance across cultures. Rick, the ringleader, is a thief, breaking into the theater and local homes, taking back what belongs to him.

This story is told in direct address to the camera by two characters in the present, older but no wiser. Shelley, a local white woman in her seventies who lives in a suburban housing development, sits in her bright beachfront living room. Rick, "once handsome, now a jailbird with lots of attitude," now in his "late thirties," speaks from his grimy jail cell (Moffatt script). The contrast between white skin and black skin of the tellers is boldly marked, as are the economics and class of their respective locations. Shel-

ley was kind to Rick as a child, but she ignored the beatings he was receiving: "We all knew . . . we could have helped." Rick says, "I hated that place, that island." Shelley says, "I loved the island . . . full of American soldiers."

Swooping aerial shots of the island suburbs, beachfront real estate filled with cars, ranch-style homes, and waterways, resemble commercial travelogues—garish, bright colors, cheery music. This is television culture, white culture. The tone of Rick's scenes is grey, muted.

The second story, "Choo Choo Choo," is about a ghost train and a "girl who haunt a railway siding. We meet older Ruby [in her mid-fifties] and her rowdy gang of women friends as they return to the old siding for a picnic of designer bush food." Maudie, "a very bossy chef, speaks only Aboriginal language" (Moffatt script). "These Aboriginal women confound any notion of the stereotypical TV subject" (Webb, 34). The tale opens with older Aboriginal women riding in a truck in the country, joyously singing. We are in the truck, riding along with the women. Then the point of view is disembodied. A tracking shot down city streets and past stores resembles the point of view of a civic parade. All the participants are white folks. Like the island aerial shots, this footage is sunny, bright, cheerful, without a located point of view—like the neutral cleanliness of TV and history.

An Asian man beckons to the camera: "Want to hear a spooky story?" He tells us about the strange gesture all the townsfolk were making for the tracking camera. It is about the haunted train: "Choo, choo, they hear them but they can't see them." The studio past of the flashbacks is darker, scary. The Australian plantation house along the railway siding is surrounded by weirdly beautiful shapes, rocks. The scene is unforgettable.

In this striking and ominous flashback sequence, Moffatt herself plays Ruby Morphet, "twenty five, Aboriginal, beautiful, tough" (Moffatt script). "I play my mother who actually lived out west in a ramshackle house like the one in the film. My family were gangers on the railway and at night they would hear this ghost train coming up the track, but never see it" (Conomos and Caputo, 29). At the end, Ruby sees the ghost of the blind girl who had been killed on the tracks. She is "doll-like, smiling, stick-tapping, and Aboriginal"—and she is the ghost of a *white* girl. This figure of blindness personifies the culture/race distinction that is central to "place" (Webb, 34). The image is a figure of hybridity, assimilation, and it is allegorical.

The third story is "Loving the Spin I'm In," from the famous song "That Old Black Magic."[199] A young Greek boy in roller blades sits at his window above his parents' shop and watches the warehouse across the street. In the flashbacks, he is a child. Two young lovers of mixed race tragically danced and died in the warehouse. Now they haunt it, watched over by an old Aboriginal woman who still lives there.[200] The boy's father is trying to sell the real estate to Asian businessmen. The Aboriginal family is evicted from the old building, but the ghost dancers remain.

Bedevil

In an unexpected conclusion, the boy on roller blades visits the ware-house and skates with the dancers' ghosts. The ghosts scare the two busi-nessmen (skinny and fat), who run away like an Asian Laurel and Hardy, frightened silly. The roller-blading boy and his friends skate around a shiny, spinning automobile, shot by an overhead camera—a high-tech TV commercial for Japanese cars. Rather than summing up all the previous

Bedevil

parts, neatly tying up any loose ends, Moffatt ends with this enigmatic commercial metaphor.

The ghost stories are a history and critique of economic progress as another layer of archaeology, a myth in which nothing is gained and much is lost. Commerce is spreading over the land, covering up inequalities. From the U.S. soldier in the 1950s (movies, popular culture, real estate) to Asian business in the present (automobiles, real estate), Aboriginal culture has endured and been displaced, relocated and been dispossessed. In Queensland, near Cairns, luxurious Japanese condominium developments are surrounded by golf courses and fences. Real estate concerns are moving into the rain forest along the Great Barrier Reef. The colors of the colonizers change, but the spirit of the past remains, haunted, haunting.

But I am making the film too polemic. This is not Moffatt's style; she is too complex and savvy an artist for one-sided positions. "I'm not a purist. I want to go to Hollywood and make a 'feel good' movie for money. Then perhaps I want to come back to my art movies" (Conomos and Caputo, 32). "I'm excited by the black directors like Spike Lee and John Singleton. There's something going on there—some energy I'd like to tap into."[201]

Tracey Moffatt

WHAT COMES NEXT?

But what of the relation between white women and women of color in the international world? In other words, what is a white girl to do? Marcia Langton endorses E. Ann Kaplan's call (in a good article on Moffatt's films) for dialogue: "We need to contribute to the decentering of Western culture . . . through the challenges that other cultures offer. Yet we can only enter from where we stand, unless we want simply to mimic."[202] For Kaplan, the problem is one of learning and adapting. For Langton, the "central problem" is developing "a body of knowledge on representation of Aboriginal people .. . and a critical perspective . . . drawing from Aboriginal world views, from Western traditions, and from history" (Langton, 27–28).

For Langton, experience is central—as it is to Michele Wallace and bell hooks (who are cited by Langton). "Australians do not know and relate to Aboriginal people. They relate to stories told by former colonists," a process of "stereotyping, iconising, and mythologising of Aboriginal people by white people who have never had first-hand contact with Aboriginal people" (Langton, 33–34). Equally strange are whites to Aboriginals: "Aboriginal people in remote regions develop some extraordinary theories about whites"—for example, about why whites wear sunglasses (Langton, 35).

However, Langton is not a purist any more than is Moffatt. Here her position diverges from hooks and other U.S. critics. She calls "naive the belief that Aboriginal people will make 'better' representations of us, simply because being Aboriginal gives 'greater understanding.' This belief is based on an ancient and universal feature of racism: the assumption of the undifferentiated *Other*. . . . This thinking is as much based on fear of difference as is white Australian racism" (Langton, 27).

Langton begins with a definition of "Aboriginality" that "arises from the experience of both Aboriginal and non-Aboriginal people who engage in intercultural dialogue, whether in actual lived experience or through a mediated experience" (Langton, 28). She posits three categories of intersubjectivity: "the experience of the Aboriginal" person interacting with other Aboriginal people, located within Aboriginal culture; the "mythologising of Aboriginal people by white people who have never had any substantial first-hand contact with Aboriginal people," the tactic of *Jedda* (Langton, 81); and the third is "generated when Aboriginal and non-Aboriginal people engage in actual dialogue," where they "test imagined models of the other" (Langton, 35) "to find satisfactory forms of mutual comprehension" (Langton, 81). In this third, intersubjective space we try to "comprehend each other. . . . Both the Aboriginal subject and the non-Aboriginal subject are participating. The results of this self-conscious dialogue are meanings and analyses which, ideally, do not mystify 'race'" (Langton, 83).

Subjectivity is not singular but hybrid, or "pluralistic." As Moffatt says, "Yes, I look at spaces differently because I have a background in both cultures. But I don't think you can call the stories particularly white or Aboriginal. . . . For me, Australian society is now a very mixed society, very multi-cultural—a hybrid society" (Conomos and Caputo, 28).

Subjectivity can be seen positively rather than negatively, as additive rather than subtractive, as what we are rather than what we are not, as what we have rather than what we don't have. I love Langton's call to begin *self-conscious dialogue* with a positive question: "Perhaps we should ask why are some people not racist? And then to take the anti-racist sentiment further" (Langton, 35).

In films by women of color, I see an emerging aesthetic that can stage national, political debates within the everyday lives of women; invoke emotional and spiritual values that illuminate cultural differences; and unite rather than divide through differences. It is an aesthetic of beauty: "Beauty . . . arises somehow from a desire *not* to comply with what may be expected, but to act *inevitably*, as long as some human truth is in sight, whatever that inevitability may call forth. Beauty is not a means . . . it is a result; it belongs to ordering, to form, to aftereffect."[203] Form—which is intensity, energy—infuses history with the complexity of experience and the clarity of affect.[204] In the collision *and* fusion of sound and image, a visual and acoustic space is revealed out of which forgotten figures can emerge and be heard.

AGE FIVE

Economical Feminism

Sally Potter directing *Orlando*

What Virginia Woolf
Did Tell Sally Potter

Daughter, sister, lover, wife, mother, grandmother . . . I will be sub-
orned into all of these roles . . . but I have my vocation. It is outside
sex, and yet my sex is part of it.

<div align="right">Dorothy Hewett[1]</div>

In age five, economical feminism, the crone of the tale is a savvy sorceress
with an income and time to herself. Both are precious, not to be squan-
dered. She agrees with Woolf that Antigone's problem was that "she had
neither capital nor force behind her."[2] She urges women to say what they
want and need rather than leave this up to others or history. If asked, she
will caution princesses about depending on the prince or another princess
to make them happy. The answers are within, as is happiness.

She has recovered from romance and other obsessions, which took
years. She is becoming . . . wiser. Woolf wrote *Three Guineas* when she was
older and wiser. Although she always saw the sexual economy and the
money economy as inextricable, her argument is fundamentally eco-
nomic. "She" must earn her own living. Earning (rather than being given
money) allows "her" to "express her own opinions. . . . She is in possession
of an influence that is disinterested" (17).

Early on, Woolf tackles the economic divide of public and private.
Men's work in the public sphere was paid and counted. Women's work in
private was not paid and thus didn't matter. After women in the nineteenth
century "forced opened the doors of the private house . . . the fathers . . .
had to yield, at least in private" (138). However, the public realm was an-
other matter. The "fathers in public . . . massed together in societies, in
professions" (141). Later on, Woolf writes that the "public and the private
worlds are inseparably connected"; the "tyrannies and servilities of one
mirror the other" (142).

For Monique Wittig, "woman" and "man" are distinct economic and po-

litical categories: "for what makes a woman is a specific social relation to a man, a relation . . . which implies . . . economic obligations."[3] Both women challenge sexual difference as a useful theoretical principle. Wittig's key point is that "the doctrine of the difference between the sexes . . . justifies women's oppression." Woolf caustically disputes what she calls "the dangerous theories of psychologists or biologists" (Woolf, 17). Mocking psychoanalytic explanations, Woolf argued that the fundamental issues were women's rights to knowledge, property, and work.

Woolf begins with a politics of difference and ends by exhorting a strategy of *indifference* with "a firm footing upon fact." "Outsiders" will then "shut the bright eyes that rain influence, or let those eyes look elsewhere" (Woolf, 109). Wittig tells us to be "runaways," which is just what the protagonist of Woolf's novel *Orlando* is. Sally Potter's stunningly beautiful and clever 1992 film *Orlando* is an extension of Potter's previous concerns—the relation between the sexual economy and the money economy.

Orlando is a historical film that re-creates a peerage in England from 1600 to postmodernity. One reviewer described it as "a journey through time by Orlando, who lives for 400 years, first as a nobleman, then as a woman. . . . As a man, Orlando is unwilling to kill or be killed, and evolves into a woman. As a woman—unwilling to marry and have heirs and thereby losing—Orlando finds herself. The film is produced on a grand scale, but is hardly your typical Hollywood product."[4]

The genre of the "period" spectacle film, like history-making itself, has belonged to men, to the larger-than-life ambitions of Cecil B. DeMille, D. W. Griffith, David Lean, and Francis Ford Coppola. Tales of the films' heroic making, casts of thousands, location travails, cost overruns, and obsession with accuracy have turned into legend. *Orlando*'s making can also be turned to legend. When she was a teenage dropout, this "unknown, unpretentious" maker of "experimental movies in London" would read the novel everyone else thought impossible to adapt. She would think "immediately that this could be a wonderful film." This self-taught artist "struggled for years to raise the money" and then wrote, directed, "composed original music and sang" for the film (C1). *Orlando* has been on Potter's mind almost all her life. She shares this personal history with us in the introduction to her screenplay for *Orlando*: "When I first read *Orlando* as a teenager, I remember quite clearly the experience of *watching* it in my mind's eye, as if it were a film . . . the experience was visual . . . The book remained a reference point and source of inspiration. *Orlando* became a personal catchword for work that dared to be epic, non-realistic and completely believable."[5]

Adventure Pictures is an appropriate name for the company that made this coproduction with Russia, shot with several crews on location in St.

Petersburg and Uzbekistan. But perhaps more legendary, the project realized a dream of the female director and the star who wanted to collaborate in the Josef Von Sternberg/Marlene Dietrich (particularly their film of Catherine the Great, *The Scarlet Empress* [1934]), Alfred Hitchcock/Grace Kelly tradition. Here, however, the story takes an unexpected turn. Instead of cost overruns and astronomical economics, Sony quotes a price of $5 million! Along with the gender of the director and a British-Russian co-production, this is a major revision of film history. Of equal import, Potter moved from avant-garde cinema to feature films without sacrificing formal, aesthetic, political concerns, something only a few have accomplished before her.

Regarding the tactics of 1970s film theory, "I grew up as part of an aesthetic movement that was all about taking stories apart and looking at the lies that conventional storytelling might tell. But with *Orlando*, I found myself falling in love with narrative." (x) She describes the film's logic, the changes from the book, particularly adding motivation, or reasons, for actions. For example, "Orlando's change of sex in the film is a result of . . . a crisis of masculine identity." (xi)

Orlando resembles the historical spectacle only on the sumptuous surface and in elegant details. The scope is grand and the style is opulent; Potter has transformed the genre (as have the films of Derek Jarman and Peter Greenaway.) By working with less, often with tongue in cheek, she has achieved so much more. *Orlando* is a minimalist's spectacle. Instead of piling on more and more detail and creating underdeveloped, overcostumed characters in awkward dialogue scenes, Potter turns history into irony and high-fashion shoots. That the lead, Tilda Swinton, was featured in *Vogue* in the costumes is not without a certain accuracy: history *is* high fashion, at least for Woolf and Potter.

Like masquerade, history is something that can be worn, either put on or taken off. Orlando is weighed down by history and by costume and wig. Even in the desert he wears his cascading wig and brocade topcoat. His clothes and his pale whiteness are inappropriate, out of place, as is the imperialist or colonizer he represents. The performative elements (of gesture, glance, pose, costume) are more telling than the narrative. History is in the details. History becomes something to learn from, move through, and get beyond.

Sequences are staged like a glorious series of *tableaux vivants*. The scope of the past is broad, the rituals elaborate, the gesture grand, and the costumes and set ornate. Yet another level of meaning—subtle, small—is very present: it is a world of glances and few words. Every look and sentence count. There is little redundancy of image or dialogue—although

repetition is a formal strategy. (When visual scenes are repeated—for example, the two rainstorms—it is to create metaphor. It pours both times when romance ends for Orlando—first as a man, then as a woman.)

While we marvel at the *exquisiteness* of the setting, the film cuts into a close-up of Swinton's face. Orlando leads us through the film, looking directly at us and speaking with us. "I hoped that this direct address would create a golden thread that would connect the audience, through the lens, with Orlando, and that in this way the spectacle and the spectator would become one through the release of laughter." (Potter, xiii) Orlando exists *through* time, living through Death, Love, Poetry, Politics (during which "he" becomes "she"), Society, Sex, and Birth, the seven sections of the film announced by white-on-black intertitles. The first four sections of the film are as a man. A voice-over tells us that "there can be no doubt about his sex, despite his appearances . . . just as there can be no doubt of his upbringing." In this era of male finery, clothes make the man—quite ambiguously so. The voice-over tells us that Orlando didn't want privilege; he wanted company. Orlando is reading a book.

The film moves through oppositions, juxtaposing scenes of darkness and light, ice and fire, snow and sand, cold and hot. The greatest is sexual difference: "Men and women have far more in common than we've imag-

Orlando

Orlando

ined. The differences between us have been grossly exaggerated and made the basis for pain, grief and misery."[6] When Orlando becomes a woman, she says, "Same person, no difference at all, just a different sex." Then the film demonstrates significant economic differences.

It is 1750, "Society"—parties, gossip, clever wit, soft, pastel colors. She tells the assembled gentlemen, "You speak of your muse in the feminine yet you have no regard for females." They reply, "The intellect is a solitary place . . . not for females, who must learn from their father or husband. Without one, she is lost." Orlando looks out at us.

The significant difference for Orlando is property, not sex. Early in the film, the queen gave the young Orlando the charter to property, with the caution not to age. As a man, he enjoyed his privileges and rights—until he refused to fight. When he became a woman, Orlando lost the rights to property. In the female section "Society," lawsuits are filed against her for her land. She is legally dead and cannot have property. Furthermore, she is a female, "which amounts to the same thing." Her only solution is marriage. The old archduke proposes by echoing Orlando's earlier words to Sasha: "I am England and you are mine. She: "On what grounds?" He: "I adore you." She: "I can't breathe." He: "You will die a spinster, alone." She runs through the labyrinth of hedges, into the light, then into an open field, where she falls on the ground. Piano chords crescendo on the soundtrack.

It is 1850 and "Sex." A dashing man on horseback rides in and falls off. She takes him home on horseback and washes his feet. He dreams of romance—of adventure in America, of love and war. They "fall in love." She has never been happier. But they don't see things the same way. She: "If I were a man, I might think that freedom won by death is not worth having." He: "You might not be a real man. . . . I might not choose to sacrifice my life for my children. . . I might choose to go abroad."[7]

Orlando bids goodbye to the prince *and* romanticism and, in "Birth," flees through the war zones and bombs of history, pregnant. Cut to Orlando, wearing a tailored blouse and slacks, in a modern office in the city. A manuscript is on the desk of a man who says, "It's really very good, written from the heart. It will sell, provided you rewrite it. Increase the love interest, add a happy ending." When he asks, "How long did this draft take you?" Orlando looks out at us, knowingly. From being a reader (and a man) in the film's first scene, Orlando has become a writer (and a woman), the maker of her own destiny.

A key change concerns Orlando's relationship with Shelmerdine, and the film's ending. "In the book Orlando's marriage with Shelmerdine loosely envelopes the last part of the story. In the film they meet and then definitively part. Orlando's story does not end in the arms of a romantic savior but in accepting responsibility for her own life in the present." (xii) Nor does it end, as does Woolf's novel in 1928, rather the film ends in 1992.

Potter describes the rewriting, the many drafts, and "endless diagrammatic plots to help strip things back to the bone . . . to reconstruct the story from the inside out." (x) After thinking about this book, this film, for so long, Potter concludes that *Orlando* was "a celebration of impermance, the mutability of all things and relationships. This brings with it both a sense of loss (of the past) and a feeling of joy (of a possible future.) The film ends on a similar note, with Orlando caught somewhere between heaven and earth, in a place of ecstatic communion with the present." (xiv)

The last sequence mirrors the film's opening. Orlando goes to her motorcycle and her young daughter (played by Jessica Swinton). They drive to the manor in the country. It is spring or summer. The house and lawn are draped in white fabric, like a building wrapped by Christo. Orlando sits beneath the tree again. Her daughter runs through the field with her camera—the source of handheld shots of the fields and granular close-ups of Orlando. The same voice-over repeats, "There can be no doubt about her sex," but she has changed. "She's no longer trapped by destiny. And ever since she let go of the past, she's found her life is beginning."

Like a TV interviewer, her young daughter asks how she is. "I'm free, I'm happy." Orlando has lost and hence gained everything—her freedom and company, her daughter. "At last I am free." In the end Orlando/

Orlando

Swinton looks out at us, in close-up, for a long last take: The film's concluding dedication explains much about Potter, her glorious imagination and sense of life's continuity, and the continuity of generations: "For Beatrice Grennel (1897–1989) and Michael Powell (1905–1990)." Grennel is her grandmother, the music hall performer who taught Sally that she could do and be anything. And Michael Powell is the extraordinary British film director whose film images can still take my breath away. His imaginings are so splendid as to be almost unimaginable. His visual imprint, and his belief in spirits, can be seen in *Orlando*. For Potter, and Orlando, the unearthly qualities of goodness, fortitude, creativity, and spirituality survive, like the angel at the film's end who says "I am coming! I am coming through! Coming across the divide to you, In this moment of unity, I'm feeling only an ecstasy . . . I am on earth . . . I'm being born and I am dying." As Potter says, "In order to come into the present, you have to give up the past, let go. It sounds simple but it's very hard to achieve in most of our lives. We're all driven by our histories."

Sally, Tilda, and I attended the first women's conference on film and television in 1988 in Tblisi, Georgia (then the USSR). This was an exuberant time, the first breath of glasnost and the first women's meeting in the Soviet Union. Between sessions, Georgian filmmakers and critics graciously toured us around historical sites, sharing food and exquisite Georgian dance and song. On the bus I listened to Sally and Tilda talk about

Potter directing *Orlando*

Orlando. Both had done yeomen's work, late each night, drawing up the charter for the new women's film and TV international organization. (There were no Xerox machines, computers, or electric typewriters, only one old typewriter and carbon paper—and over one hundred delegates from thirty-seven countries.)

Despite my admiration, I thought their dream not possible, at least not yet. I should have known better. Their commitment to films of political value, to collaboration, and to the project, more than fame, ensured their achievement. Like the other women, both fictive and real, in this book, Swinton and Potter are women to be emulated. (The great French actress Delphine Seyrig, the star of Marguerite Duras's films, Alain Resnais's *Last Year at Marienbad* (France/Italy, 1961), and Chantal Akerman's *Jeanne Dielman*, to name just a few, also sat with us. This elegant woman told me she had always chosen to work with great women directors because she loved and believed in those projects.)[8]

GOGOBERIDZE: PERSONAL MATTERS

Lana Gogoberidze organized and hosted the ten-day event that brought women scholars, directors, screenwriters, and actresses from thirty-seven countries to Georgia. Our mission was to found an organization that would support women and work across national lines. A graduate of film

school in Moscow and a well-known director in the Georgian Film Studio for many years, Gogoberidze has made extraordinary feature films that address the professional and personal complexity of women's lives. Her *Interviews on Personal Matters* was released in Georgia in 1978 (with subtitles in Russian.)

Like her 1986 film *Turnover* (also translated as *Turnabout*), *Personal Matters* stars middle-aged and old women and features women's issues—relationships between mothers and daughters, the difficulty of juggling roles and jobs, professional work versus domestic labor. The film shifts between roles and duties, biography and fiction, present and past, just as it shifts from documentary to narrative. This eclectic postmodern style accords with the energetic rhythm of women's work.

Sofiko, the protagonist of *Personal Matters*, a journalist in Tblisi, is married and lives with her husband, two children, and an elderly mother. (Gogoberidze also lives with her mother, daughter, and grandchild, in a penthouse apartment filled with books.)[9] Sofiko is seen on the streets of this modern city, on the run shuttling between work and home. She is dedicated to her job and to the story she is covering but is becoming increasingly aware that her husband, Arturo, is no longer interested in her. Her work prevents her from being a "real" wife—so he says. She believes that her aging is making her less attractive.[10]

She scrutinizes herself in the mirror—slowly, silently, examines her face, her eyes. The film slows down and looks quietly at the aging, slightly unfamiliar self. To make herself more attractive, she tries masquerade—wearing a brown wig and flashy clothes and talking in an excited manner at a tennis match.

The story she is working on, the title of the film, concerns a cross section of women talking about the conditions of their lives. Into that journalistic world and the film, Sofiko's past erupts. Her mother had been taken to Stalin's camps. Now, fifteen years later, she remembers the scene of her mother's return. She was a child, raised by elderly aunts. She watches an old, tired, unfamiliar woman come into the room. Her entrance is a moment when the magnitude and pain of history can be felt. This deeply moving scene is from Gogoberidze's life. Her mother was in Stalin's camps for many years, returning as an old woman. This was the first mention in Soviet film of the camps and exile,[11] and was a serious political and personal risk.

After being in Tblisi, Georgia, a beautiful city resembling San Francisco, I recognized that *Personal Matters* was set on the streets and in the offices and apartments of Gogoberidze's daily life. But the cityscape wasn't the only element of autobiography in the film. Like the journalist, Sofiko, Gogoberidze takes equal satisfaction in her work *and* her family—

her daughter, granddaughter, and mother all live with her and have appeared in her films. Since the breakup of the former USSR, this heroic and glamorous woman has been active in revolutionary Georgian politics. I have heard that she is no longer making films (Gogoberidze has a more recent film which I have not yet been able to see: *Waltz on the River Pecora*, a film set during the Stalinist 1930s.) and has been in danger due to the fighting between Georgian political factions. However, as in the past, this extraordinary woman will survive. For her, anything is possible if we are fearless and disciplined. Her life and her films say that we can have it all—work, family, and politics—although it will never be easy.

Gogoberidze has witnessed, recorded, and is now making history. Although they live worlds apart, I think she would like these words by Dorothy Hewett: "'The only unreconcilable loss'. . . 'is the loss of one's private solitude. . . . One morning you will walk into an empty room and be cheerful.' . . . Perhaps now that I have nothing I can find that empty space of sunlight, 'the clean well-lighted place' in the middle of the world" (Hewett 265).

Like the movies, the end circles back to the beginning. It's true. After some good hard work, many of us did live and die happily ever after. But this story is just beginning to be told.

Notes

TO BEGIN WITH . . .

1. Dorothy Hewett, *Wild Card: An Autobiography, 1923–1958* (Victoria, Australia: McPhee Gribble/Penguin Books, 1990), 84.

2. See Cora Kaplan's "Dirty Harriet/*Blue Steel:* Feminist Theory Goes to Hollywood," *Discourse* 16, 1 (fall 1993): 50–70. Kaplan calls the film "a running commentary on issues in feminism and feminist film theory" (52).

3. Jane Wagner, *The Search for Signs of Intelligent Life in the Universe* (New York: Harper & Row, 1986), 138. Wagner and actress Lilly Tomlin toured this play across the United States, finally taking it to Broadway for a one-woman performance by Tomlin. It also appeared, briefly, as a movie and is now in videotape.

4. Monique Wittig, "The Mark of Gender," in *The Straight Mind and Other Essays* (Boston: Beacon, 1992), 78–89. "Mark" refers to the "conventions and rules" of language that "were never formally enunciated." This is not just textual deconstruction. "But language does not allow itself to be worked upon, without parallel work in philosophy and politics, as well as in economics." For a short version, see her "One Is Not Born a Woman," *Feminist Issues* (winter 1981), 47–54.

5. Virginia Woolf, *Three Guineas* (New York: Harcourt Brace Jovanovich, 1938).

6. Appearances on TV talk shows, pro or con, follow, along with magazine covers. Thus ideas also must be suited for repetition—simple, short, immediately graspable, easily repeatable. Complex issues are reduced to either-ors, the TV talk-show mock style of minor pundits. The loudest talking head wins. And the arguing mouth is usually male. But the central paradox of the era of media proliferation is that the people and issues covered become fewer and fewer—until there is only one in 1995, O. J. Simpson, a long-playing narrative of either-or (guilty *or* innocent) with the same minimal visuals carrying billions of words.

7. Katie Roiphe, *The Morning After: Sex, Fear, and Feminism* (Boston: Little, Brown, 1993).

8. In fact, while the big TV events stage the oldest male dilemmas about women, they are scenes filled with men in suits and few women. Just think of Anita Hill versus Clarence Thomas, and now O.J. The Simpson trial challenges "the truth of vision," the cornerstone of modern media logic, and collapses distinctions among genres and media. It is high postmodernism, like the high-tech courtroom, and yet very old-fashioned. Like most recent U.S. TV events, it is about race and sex (and repetition). On political talk shows, the recent TV celebrity of middle-aged, rotund men, often print journalists, often conservatives (both lots formerly disdainful of TV, until they began cashing in), puffed up like bullfrogs and full of opposing opinions, should seem strange and, for women, alarming. But it doesn't.

9. Just because film feminism is stuck in the same groove, much like a broken record, doesn't mean we cannot move forward; indeed, we must.

WHAT CINDERELLA AND SNOW WHITE FORGOT
TO TELL THELMA AND LOUISE

1. Like many women, I always led two lives and am self-taught. When I was a girl, reading alone for weeks in the summer, surrounded by stacks of library books, was my greatest pleasure. First came fairy tales, which I will discuss later, then mysteries—"Nancy Drew," Conan Doyle (the first books I owned and still have), later, Dorothy Sayers, P. D. James; and later still, Sara Paretsky, Margaret Maron, and Amanda Cross. (How clever of Professor Carolyn Heilbrun, a.k.a. Amanda Cross, to invent Kate Fansler, professor/detective! My Australian friend, Meaghan Morris, prefers Sue Grafton, whom I also like.) I still want to be a detective and have adventures—which might explain my fondness for movies; analyzing narrative (particularly figuring out film techniques) is detection. I have always wanted to be the hero, never the princess who waits or is adored. Being adored is embarrassing. Waiting is boring.

2. "The Babe," nicknamed after a man, Babe Ruth, then married to a male wrestler, must have experienced painful contradictions. She lived her last years with a young female golfer who, as the press would have it then, became her "protégée." They were constantly together until Babe died in middle-age of cancer.

3. For many of us, our female friends have been the most significant influence and support. Why do we continue to "second-class" our experience?

In Laleen Jayamanne's Australian independent film, *A Song of Ceylon* (1985), Somawathi's rebellion against the constraints of femininity is dramatic, glamorously staged as performance and psychoanalytic exorcism; the case study meets the avant-garde. Yet her conflicting voices, those that demanded exorcism, were familiar to me. So was her middle-class milieu, although the set of my exorcism would be the U.S. Midwest, not Sri Lanka/Australia. Somawathi's cure, accepting restrictions, is an uneasy resolution of a struggle that rarely ends happily for women, who are taught not to be as great or as strong or as independent as they are.

4. For an elaboration of women and age, see Patricia Mellencamp, *High Anxiety: Catastrophe, Scandal, Age, and Comedy* (Bloomington: Indiana University Press, 1992).

5. We shared a lawyer for the divorce, to save money. My second mistake was to settle, a refusal to fight for what was right because I wanted it to be over.

6. Claire Johnston, Laura Mulvey, and Jackie Rose were in Milwaukee between 1976–78.

7. My roommate at the Betty Ford Center had another analysis. She would shake her head and say, in her tough Brooklyn accent, "Big words, big words." I still need to prove myself through mastering the big words and theories of others, usually men. But this is changing. As I see things more clearly, the world becomes simpler.

8. If told for TV, the tale would resemble the early great episodes of *L.A. Law*, with harassment suits, hearings, unsolved murders, trials, affairs, incestuous faculty, a world of intellectual gossip and affairs set in a mise-en-scène of international travel. And this is only for starters. Whoever said academics were staid and dull?

9. Meaghan Morris, "'TOO SOON TOO LATE': Reading Claire Johnston, 1970–1981," *Dissonance, Feminism and the Arts*, 1970–1990, ed. Catriona Moore (Sydney, Australia: Allen & Unwin/Artspace, 1994). Paper delivered at a memorial lecture dedicated to Claire Johnston, London, 1989.

10. Susan Dermody, "Not Necessarily a Lead Dress: Thinking Beyond 'Redress' in Women's Films," in *Signs of Independents*, ed. Megan McMurchy and Jennifer Stott (Sydney, Australia: Australian Film Commission, 1988). Dermody is a filmmaker.

11. I am referring to his "All the world's a stage, and all the men and women merely players" speech in *As You Like It*. Shakespeare begins with the "infant, mewling and puking," then moves on to the "whining school-boy," the "sighing" lover, the "bearded" sol-

dier, the justice "wise" and "modern," ending with the shrinking of old age and "second childishness . . . sans teeth, sans eyes, sans taste, sans every thing" (which I see as a good thing, as relinquishing our attachment to the body and desire in order to move forward, to gain something much greater—freedom of thought, of action, of spirit, to experience the ecstasy of Orlando in the end of Sally Potter's film). The spirit never ages, only the body ages.

12. Anger is often perceived as a good thing, an emotion forbidden to women and thus its expression one of value. While the repression of anger is negative, so is its indulgence counterproductive, an adrenaline rush that turns back on itself.

13. One of the initial forays is *Beyond Economic Man: Feminist Theory and Economics*, ed. Marianne A. Ferber and Julie A. Nelson (Chicago: University of Chicago Press, 1993).

AGE ONE: INTELLECTUAL FEMINISM

1. In an essay in *Cinema Journal* 30, (summer 1991), Deborah Linderman suggests that Freud's essay on "the 'uncanny'" can be used to analyze *Vertigo*. This essay is one of Freud's writings on obsession/anxiety (which are distinct from hysteria, the base model used by feminist film theory). Hitchcock's films are all about male obsession; in addition, Lacan's concept of desire comes close to models of obsession, which also is noted.

2. Dorothy Hewett, *Wild Card: An Autobiography, 1923–1958* (Victoria, Australia: McPhee Gribble/Penguin Books, 1990), 74.

3. See, for example, Lucretia Knapp, "The Queer Voice in *Marnie*," *Cinema Journal* 32, (summer 1993): 6–23.

4. This essay was originally published in a double issue of *Cine-tracts* (*11* [Fall, 1980] and *12* [Winter, 1981]) which I edited. Other contributors included Linda Williams, Mary Ann Doane, Teresa de Lauretis. No book publisher (or U.S. journals) would touch this "theory" stuff, to say nothing of its feminist bent. The struggle to find publishers for conference materials was very difficult, given the bias against collections of essays, theory, and feminism, a triple (negative) whammy. The only journal that wanted this hot potato was a new Canadian journal run by graduate students (especially Ron Burnett).

5. A shot-by-shot analysis of this film was done by undergraduates in my 1975 course in film theory/film criticism, which included the work of Laura Mulvey, Stephen Heath, along with Christian Metz and Roland Barthes. If anyone wants a copy . . . send money.

6. Teresa de Lauretis, "Imaging," *Cine-tracts 11* 3, 3, ed. Patricia Mellencamp (fall 1980). This essay is based on Umberto Eco's semiotics, along with Pier Pasolini. The conclusion, which I have quoted, is de Lauretis' early, short foray into feminist film theory, concluding the piece with a quote from Italo Calvino. However, she advocates "answering deviously," quoting but "against the grain."

7. In a forthcoming monograph, *Techniques of Modernity: Buster Keaton and the Machine*, I detail Keaton's play with the premises of Taylorism/Fordism, critiquing the Hollywood system itself. I also try to understand why I am so fascinated by films in which women are meaningless goals.

8. Michel Foucault, *The History of Sexuality*, vol. 1, *An Introduction*, trans. Robert Hurley (New York: Random House, 1978). This book had been out for only one year when Linda Williams and I used it. Although feminist film theorists eventually began to use Foucault, they often failed to note his critique of psychoanalysis and the close ties between Gilles Deleuze and Félix Guattari and Foucault. This may also explain why the theory of Deleuze and Guattari has had so little influence with U.S. and British film feminists.

9. Meaghan Morris, "The Pirate's Fiancee," in *Power, Truth, Strategy*, ed. Meaghan Morris and Paul Stratton (Sydney, Australia: Feral Publications, 1980), 152.

10. Kristin Thompson and David Bordwell, "Space and Narrative in the Films of

Ozu," *Screen*, Vol. 17, No. 2 (Summer 1976): 41–73. This influential essay begins with detailing a model of "the classical paradigm, the system for constructing space (the 'continuity style') has as its aim the subordination of spatial (and temporal) structures to the logic of the narrative, especially to the cause/effect chain. Negatively, the space is presented so as not to distract attention from the dominant actions; positively the space is 'used up' by the presentation of narratively important settings, character traits psychology'), or other causal agents." 42. Ozu's style is measured against this standard.

Stephen Heath, "Narratiive Space," *Screen*, Vol. 17, No. 3 (Autumn 1976): 68–112. These essays, only months apart, have influenced my thinking about Hollywood cinema as much as feminist film theory. In addition, these scholars were involved in the film conferences at the Center for Twentieth Century Studies, UW-Milwaukee, from 1976 until the early 1980s. Heath gave several lectures in my course on the Hollywood sound film, in addition to teaching seminars for our film studies program.

11. Angela Carter, *The Sadeian Woman and the Ideology of Pornography* (New York: Harper & Row, 1978), 60.

12. Roland Barthes, *S/Z*, trans. Richard Miller (New York: Hill & Wang, 1974), 188.

13. John Alton, *Painting with Light* (1949); reprinted (Berkeley: University of California, 1995).

14. Madonna and Paglia celebrate sex. They remove the blinders of romance; they also have fame and fortune. But to what end? If sex *and* money are the only gains, then we've gone backward. Real women and movie women have been capitalizing on sex for years.

15. But no matter how great her performance, a strange superimposition—of a check for three hundred dollars over her face—undermines both her achievement and her generosity toward her husband. It states that her only asset was her body. Sex was all she had to sell to Cary Grant (as a playboy, in an early and unmemorable role).

16. Alice Kessler-Harris, *Out to Work: A History of Wage-Earning Women in the United States* (London and New York: Oxford University Press, 1982).

17. Reminders of our nature were constant. In the rare instances when women were trained for skilled tasks, household work was the underlying model.

18. David Stenn, *Clara Bow: Runnin' Wild* (New York: Doubleday, 1988), 255.

19. I develop this paradox in the last chapter of my book *High Anxiety: Catastrophe, Scandal, Age, and Comedy* (Bloomington: Indiana University Press, 1992), particularly in relation to therapy culture.

20. *Vogue* (January 1995): 150.

21. *Vogue* (January 1995): 38.

22. Ross Gibson, "The Nature of a Nation: Landscape in Australian Feature Film," chap. 3 in *South of the West: Postcolonialism and the Narrative Construction of Australia* (Bloomington: Indiana University Press, 1992), 63.

23. United States Bureau of the Census, *The Statistical History of the United States from Colonial Times to the Present* (New York: Basic Books, 1976), 135, 164.

24. John Baxter, *Hollywood in the Thirties* (New York: A. S. Barnes, 1968), 50–51.

25. David Wallechinsky and Irving Wallace, *The People's Almanac* (New York: Doubleday, 1975), 226–27.

26. Lucy Fischer, "The Image of Woman as Image: The Optical Politics of *Dames*," *Film Quarterly* 30, 1 (fall 1976): 5, 10.

27. Sigmund Freud, "Three Essays on Sexuality," vol. 7 of *The Standard Edition of the Complete Psychological Works of Sigmund Freud* (London: Hogarth, 1959).

28. Laura Mulvey, "Visual Pleasure and Narrative Cinema," *Screen* 16 (autumn 1975): 1–16, esp. 11.

29. Sonja Rein-White (graduate seminar paper, 1989).

30. Siegfried Kracauer, "Girls and Crisis (1931), reprinted as "The Mass Ornament" in *New German Critique* 5 (spring 1975); Andre Bazin, "Entomology of the Pin-Up Girl," in *What Is Cinema?* trans. Hugh Gray (Los Angeles, Berkeley, and London: University of California Press, 1971), 2:158. Bazin differentiates the American product: "Physically

this American Venus is a tall, vigorous girl whose streamlined body splendidly represents a tall race. Different from the Greek ideal, with its shorter torso and legs, she thus differs from European Venuses" ("Entomology," 158). Angela Carter in *The Sadeian Woman* sees this corporate analysis differently: "Her hypothetical allure and not her actual body is the commodity. She sells a perpetually unfulfilled promise. . . . The reality . . . could never live up to her publicity. So she retains her theoretical virginity even if she is raped by a thousand eyes twice nightly" (67).

31. Carolyn Marvin, "Dazzling the Multitude: Imagining the Electric Light as a Communication Medium," in *Mass Communication Review Yearbook*, ed. Michael Gurevitch and Mark R. Ley (Newbury Park, Calif.: Sage, 1987), 258.

32. Patricia Mellencamp, "Oedipus and the Robot in *Metropolis*," *Enclitic* 5, 1 (spring 1981): 20–44. In this sad tale I analyze Kracauer's *From Caligari to Hitler*, picking on his phallic argument describing the downfall of Germany, a series of limp-penis moments. I parallel this "patriarchal" tale to that of Fritz Lang in Paul Jensen's *The Cinema of Fritz Lang*. Although this narrative is now apparent, it was not then so easy to see Oedipal structures in films. Only after feminism figured out this narrative pattern did they become obvious. I begin by citing the parable of the scorpion and frog, as quoted in Orson Welles's *Mr. Arkadin* (1955). In *The Crying Game* (1992) this same parable is told twice, suggesting how much the story of Oedipus has been revised; the parable now functions not to explain power/patriarchy, as it does in the Welles's film (a father–daughter film more than a father–son one), but to explain male heterosexuality/homosexuality which is *The Crying Game*'s love story. Also, rather than being invisible in movies, the penis has become an image (or a joke on late-night TV).

33. John Lahr, "Fearful Symmetry," *Harper's* (July 1977): 83. Thanks to Janet Staiger for this article.

34. I cannot relocate the anthology of 1940s fan-magazine commentary quoted here. By then Earl Carroll had a dinner theater that included performances by "his girls."

35. Michel Foucault, *Discipline and Punish: The Birth of the Prison* (New York: Vintage Books, 1979): 164–65.

36. These few remarks are from my essay "Spectacle and Spectator: Looking Through the American Musical Comedy" (*Cine-tracts* 1, 2 [summer 1977] 27–36), which was edited by Teresa de Lauretis. She convinced me that I was smart enough to publish an essay. This essay has been reprinted in *Explorations in Film Theory*, ed. Ron Burnett (Bloomington: Indiana University Press, 1991), 3–14. I worked on twenty-five or more Hollywood musicals for this piece (including *Singin' in the Rain* and all the Astaire-and-Rogers RKO movies and the rest of the Esther Williams extravaganzas), most of which I have never written about elsewhere.

Like Fleeber, the parodied, pompous New York University film professor in Andrew Bergman's *The Freshman* who recites dialogue in tandem with *The Godfather* during class, I sing along to musicals. Like Fleeber, I can't act or sing. (Fleeber also made his students read all his books on film.)

37. Roland Barthes, "Upon Leaving the Movie Theater," *University Publishing* (winter 1979): 2; reprinted from *Communications*, no. 23 (1975). This is Barthes's metaphor for gay cruising. I don't know whether it works for women; I suspect not exactly. Conversely, I remember fending off roving arms that awkwardly groped in my direction. Dating and cruising are quite different seductions.

38. There are notable exceptions—for example, essays by Brian Henderson and Stanley Cavell in the 1970s, Wes Gehring and James Harvey in the 1980s, and Frank Krutnik, Steve Neale, and Jerry Palmer in the 1990s.

39. Paul Gray, "What is Love," and Anastasia Toufexis, "The Right Chemistry," *Time* (February 15, 1993): 46–51; 47.

40. Erox Corporation is a new, old-fashioned biotechnology company whose first production will be perfumes with human pheromones—"the body secretions that attract the opposite sex." For decades scientists were convinced that humans had lost the sense organ that "animals use to detect sex pheromones" (*Wall Street Journal*, B1). The re-

searchers at Erox say that "they are coming up with new evidence that a tiny structure in the nose is the long-lost human sense organ that detects pheromones. . . . The organ looks like a tiny pit, barely visible to the naked eye, just inside each nostril." Pheromones cause a feeling of relaxation, of well-being, and "don't activate the olfactory system." This study has raised questions about whether rhinoplasty (nose jobs) would therefore impair sexuality. The premises, like the products, are irresolutely predicated on heterosexuality, on two sexes in opposition—necessitating only two perfumes, male and female. The new perfumes, however, will act not on the opposite sex but upon the wearer. Same-sex wearers, ironically enough, will be turned on by each other, receiving a double dose.

41. David Shumway, "Screwball Comedies: Constructing Romance, Mystifying Marriage," *Cinema Journal* 30, 4 (summer 1991): 7–23. His model comes from Germaine Greer's *The Female Eunuch* and Juliet Mitchell's *Women: The Longest Revolution* (New York: Pantheon, 1984).

42. Robert Lapsley and Michael Westlake, "From *Casablanca* to *Pretty Woman:* The Politics of Romance," *Screen* 33, 1 (spring 1992): 27–49.

43. Contrary to *Time,* Lapsley and Westlake perceive romance as "an idea that would be ludicrous to non-Western cultures" (33). Why? Because other lacks (literal ones, such as food, clothing, shelter) predominate.

44. Sounding like self-help therapists, the authors portray symptoms: "Romantic love . . . is fraught with illusion." "Lovers' estimation of their life together is deeply unrealistic." Lovers "pretend something exists that does not exist."

45. Without a mention of feminist critics until the concluding appeal to Tania Modleski and Janice Radway on romance.

46. Their analysis echoes de Lauretis: "Romantic narratives are almost invariably concerned with the obstacles in the way of its realization" (38). "The presence of obstacles" is a "means of both making the object desirable and of preventing its exposure as nothing" (40). If these guys had paid heed to over twenty years of feminist film theory, they might have realized that the "obstacle" of the classical narrative is usually a woman.

47. Feminism has also been popularized, hence its premises generalized.

48. Janice Radway, *Reading the Romance: Women, Patriarchy, and Popular Literature* (Chapel Hill: University of North Carolina Press, 1984). Tania Modleski's *Loving with a Vengeance: Mass Produced Fantasies for Women* (New York: Methuen, 1984) includes her essay on romance novels. I have also referred to her book on Hitchcock, *Women Who Knew Too Much: Hitchcock and Feminist Theory* (New York: Methuen, 1988).

49. Recently, "contradiction" has been argued as if it were new. This logic or epistemology has various forms: it can be additive; it can also be reductive. For Linda Williams it is the sum of two parts. Writing about *Mildred Pierce* (Warner Brothers, 1945), she addresses the "historical" spectator by combining two feminist arguments about the film— repression *and* reflection: "To summarize: Walsh's . . . reading of the film's enounced stresses its reflection of an ambiguous but emerging female consciousness, while Cook's psychoanalytic emphasis on filmic enunciation stresses the repression of female consciousness" ("Feminist Film Theory: *Mildred Pierce* and the Second World War," in *Female Spectators,* ed. E. Deidre Pribram [London and New York: Verso, 1988], 18). Williams's conclusion is that "the film reflects *and* represses the contradictions of the historical moment" (21). She finds both these positions in history, in the 1940s. She fails to note the present context, wherein contradiction is an *overt* strategy that only now allows us to see the double logic. *Mildred Pierce* also functions through the containments of romance, which include motherhood.

50. J. Hoberman, *Village Voice*, 11 October 1994, 61.

51. Peter Wollen, at one of his several talks at the University of Wisconsin—Milwaukee, Center for Twentieth Century Studies, from the 1970s through the mid-1980s.

52. The distribution of the film corroborates my analysis that only in a superficial way does Tarentino resemble Godard. *Pulp Fiction* was a low-budget production by industry standards ($8.7 million), released by a small distributor, Miramax. However, rather than being released in the art-house style, a few theaters at a time, Miramax

opened this film on 1,474 screens, accompanied by "a national ad campaign and a public relations blitz" (*Wall Street Journal*, 14 October 1994, B1). Miramax had the bucks for this publicity after being acquired by Walt Disney. (The money to buy TV advertising is a key factor between art-house and mainstream release.) The campaign emphasized two things: the superior film-festival and mainstream press reviews and the film's comedy. The recent selling of violence through comedy is an unsettling fashion—casual killing.

53. *Vogue* (October 1994): 208.

54. Steve Neale, "The Big Romance or Something Wild?: Romantic Comedy Today," *Screen* 33, 3 (autumn 1992): 284–99.

55. Tania Modleski, "Three Men and Baby M," *Camera Obscura* 17 (May 1988): 69–82. This issue was titled *Male Trouble* and included an essay by Kaja Silverman, "Masochism and Male Subjectivity."

56. Lucy Fischer, "Sometimes I Feel Like a Motherless Child," in *Comedy/Cinema/Theory*, ed. Andrew Horton (Berkeley: University of California Press, 1991), 60–78, esp. 64.

57. My analysis is indebted to two of my brilliant teachers; Swami Gitananda and Swami Indirananda, who taught me to see in a different way.

58. Susan S. Hendrick and Clyde Hendrick, *Romantic Love* (London: Sage Publications, 1992), 61. See Age Four for more on this.

59. Mimi White, "Representing Romance: Reading/Writing/Fantasy and the 'Liberated' Heroine of Recent Hollywood Films," *Cinema Journal* 28, 3 (spring 1989): 41–47.

60. However, unlike Linda Williams in her analysis of *Mildred Pierce* (which sees contradiction in the text and in the historical spectator more than in the critic), White notes that the present has enabled us to see this tactic of contradiction. She gives credit for this knowledge to "an emergent popular feminism within commercial narrative cinema" (42). Feminism has taught us to think, and to see, differently. But I suspect that the main difference between Williams and White is that contradiction is historical: in classical continuity style, contradictions often are covert; in contemporary cinema, contradictions are overt, often literally stated.

Barbara Klinger analyzes the harmonious presence of multiple, possibly conflicting, positions through what she terms "the digressing spectator." Promotion "diversifies" the film, with effects greater than profit making. The "success of commodification" is the ability to personalize, to privatize, what are public issues: "The individual's manipulation of commodity discourses may not testify to his/her ability to react to the system, but to the achieved strategies of these discourses." Unlike notions of subversion and resistance to popular culture, argued by many recent critics, Klinger asserts that these multiple receptions by "digressing spectators" are given to us. They are not "free-floating intertexts" which, in our genius, we ferret out. Contradiction is the logical outcome of contemporary culture, what I call *franchise culture*. See Barbara Klinger, "Digressions at the Cinema: Reception and Mass Culture," *Cinema Journal* 28, 4 (summer 1989): 3–19, esp. 10, 14, 17.

61. In their joint book *Popular Film and Television Comedy* (New York: Routledge, 1990), Steve Neale and Frank Krutnik compare the form of comedy films to melodrama. Nowhere is this similarity more apparent than in Woody Allen's *The Purple Rose of Cairo* (1984).

62. Warren Beatty remade this 1957 film in 1994 as *Love Story*, the worst movie ever made, despite Katherine Hepburn's appearance and tropical island lifestyle.

63. In *The Women Who Write the Movies* (New York: Carol Publishing: 1994), Marsha McCreadie has a long section on Ephron, from interviews with her. Ephron, like Reiner, has parents in the film industry.

64. Allen's films are cultural histories of U.S. liberals—including the political ambivalence toward women. References here include Adlai Stevenson's campaign for the presidency, the Warren Commission report (with the now ironic comment that politicians are "a notch beneath child molester"), and *Commentary* magazine.

65. Janet Maslin, *New York Times*, 23 December 1994, C6.

66. "Now for the Truth About Americans and SEX," Philip Elmer-Dewitt, *Time*, October 17, 1994: 62-70.

67. Elizabeth Gleick, "Should This Marriage Be Saved?" *Time*, February 17, 1995, 48-56.

68. Laurie Langbauer, *Women and Romance: The Consolations of Gender in the English Novel* (Ithaca, N.Y.: Cornell University Press, 1990), 2.

69. *Mi Vida Loca* by Anders is another story. The film was released in 1994, with production support from Channel 4 and HBO. It is a courageous film, dealing with Latino young women and the serious problem of gang culture in the United States, in which Anders worked with nonprofessional actors. The film is about female independence, about female friendship surviving jealousy. It portrays the struggle to achieve maturity, all set within a girl-gang cultural milieu in Echo Park, Los Angeles. Early on we hear, "We take life as it comes, knowing that what goes around comes around." Death becomes an everyday occurrence rather than a big event; it almost happens casually.

The relations between women are also not idealized. Two childhood girlfriends compete for Ernesto, both become pregnant, and their friendship disintegrates. Anders includes a generational viewpoint via an older character, released from jail, who wants to go to college and gain skills. "We're left alone to raise our kids." Anders deals with teen pregnancy, casual birth, in the same way as casual sex—just an everyday occurrence.

70. Ann Barr Snitow, "Mass Market Romance: Pornography for Women is Different," *Powers of Desire: The Politics of Sexuality*, ed. Ann Snitow, Christine Stansell, Sharon Hampson (New York: Monthly Review Press, 1983), 242–63.

71. Suzanne McGee, *Wall Street Journal*, 8 April 1993.

72. Erica Kornberg, "Heroine Addiction," *Entertainment Weekly*, no. 234 (August 5, 1994): 36–37.

73. Eleena de Lisser, "Romance Books Get Novel Twist and Go Ethnic," The *Wall Street Journal*, Tuesday, September 6, 1994.

74. Helen Taylor, "Romantic Readers," in *From My Guy to Sci-Fi*, ed. Helen Carr (London: Pandora, 1989), 58–73,

75. Anne Wilson Schaef, *Escape from Intimacy—Untangling the "Love" Addictions: Sex, Romance, Relationships* (New York and San Francisco: Harper & Row, 1989).

76. Freud, Studies in Hysteria, 280.

77. Patrick Mahoney, *Freud and the Rat Man* (New Haven: Yale University Press, 1986).

78. For a lengthy explication of obsession, see Patricia Mellencamp, *High Anxiety: Catastrophe, Scandal, Age, and Comedy* (Bloomington: Indiana University Press, 1992).

79. These quotations are from the International Film Circuit's press release for the film (20 Nassau Street, Suite 244, Princeton NJ 08542). Akerman's history reminds me a bit of Sally Potter's. Akerman was influenced by Godard. When she was fifteen, she dropped of film school and later began making her own films. When she was twenty-five, she made the great film *Jeanne Dielman, 23 Quai du Commerce, 1080 Bruxelles*, which is also about fetishistic obsession, housework, and sex. *Night and Day* premiered at the 1991 Venice Film Festival. The screenplay was cowritten by Pascal Bonitzer, a film theorist for *Cahiers du cinema* and a professor at the film school FEMIS.

80. Sigmund Freud, *Inhibitions, Symptoms, Anxiety* (1926), vol. 20 of *The Standard Edition of the Complete Psychological Works of Sigmund Freud* (London: Hogarth, 1959), 113, 119.

AGE TWO: IRASCIBLE FEMINISM

1. I take *proto* literally, meaning "primitive," emphasizing its resonances with early cinema, called "primitive cinema." The scholars of primitive cinema rarely mention women; rarely do they mention modern painting either, where the notion of "primitive" has lodged for years. For an example, see *Early Cinema: Space, Frame, Narrative*, ed. Thomas Elsaesser (London: British Film Institute, 1990). In *Woman in the Keyhole* (Bloomington: Indiana University Press, 1990), Judith Mayne responds to this absence.

2. I presented the five ages in 1991 at a terrific conference in Sydney, Australia, "Dissonance," orchestrated by Laleen Jayamanne. A book of its papers is forthcoming from Indiana University Press.

3. Perhaps most influential is Carol Clover's *Men, Women, and Chain Saws* (Princeton, N.J.: Princeton University Press, 1992). Clover taxonomizes the genre of horror films into rape revenge, slasher, and other detailed categories. Lynda Hart's *Fatal Women: Lesbian Sexuality and the Mark of Aggression* (Princeton, N.J.: Princeton University Press, 1994) is inscribed "for Aileen Wuornos," the accused serial murderer, a case interpreted via Lacanian psychoanalysis. Hart points to lesbianism within the masculine imaginary.

A number of essays on Kathryn Bigelow's films appeared in 1993 and 1994. See Cora Kaplan, "Dirty Harriet/*Blue Steel:* Feminist Theory Goes to Hollywood," *Discourse* 16, 1 (fall 1993): 50–70; Anna Powell, "Blood on the Borders: *Near Dark* and *Blue Steel,*" *Screen* 35, 2 (summer 1994): 136–56. In "Cruisin' for a Bruisin': Hollywood's Deadly (Lesbian) Dolls," *Cinema Journal* 43, 1 (fall 1994), Chris Holmlund adds race and age to the agenda.

4. Maybe mystery author Sue Grafton saw this film. Grafton says, "I wouldn't sell her [her detective, Kinsey Millhone] to Hollywood if my life depended on it." Kinsey has been around since the 1982 *A Is for Alibi.* In *K Is for Killer,* a current best-seller, Kinsey is living in 1984 and is thirty-four. By *Z* she will be forty, aging one year for every two and a half books. Grafton says, "I invented Kinsey as a way out of Hollywood." (She wrote TV movies in Los Angeles with her husband, now a professor.) I loved her description of being the child of two alcoholics: "One of my theories is that no one with a happy childhood ever amounts to much in this world. They are so well adjusted they never are driven to achieve anything." She most enjoys writing about the imperfections of her heroine: "I work to keep her flawed and inconsistent," a major part of Kinsey's character's charm. (From an interview by Enid Nemy, *New York Times,* reprinted in *Milwaukee Journal,* 14 August 1994, G6.)

5. The resemblance to Ernie Kovacs's skits in the 1950s parodying TV westerns is close. Did Rami adopt parody intentionally? If so, why? Kovacs's programs were live broadcasts, accounting for the lack of subtlety. Rami doesn't have this excuse. However, although it's a stretch, this film could be taken as a critique of the western (and not just overwrought style, battering audiences on the head).

6. I spent most of my viewing time trying to remember where I had seen this actor before, in which westerns. Then I remembered: it was in one or two of the *Alien(s)* films.

7. In *The Quick and the Dead,* the pleasure of pain is apparent, as overtly declared as in Quentin Tarentino films (particularly the hooded, chained figure in *Pulp Fiction*); in Martin Scorsese films (in *Cape Fear* [1991] and particularly *Good Fellas* [1990]); to say nothing of Alfred Hitchcock films from the 1950s on. Male masochism is definitely in high style, man to man, usually accompanied by noisy homophobia.

8. He was featured in *Time's* article "Generation X-Cellent," about young actors taking on ambitious, offbeat roles. This role is not mentioned. (*Time* [February 27, 1995]: 62–64.)

9. All the women would go to (*a*) the United Nations, and from there to Bosnia, then the United Kingdom, and on to Israel for peacekeeping; (*b*) Washington, D.C., as "the force" for poor women/heads of households; (*c*) the U.S. Congress for action of a more militant kind, clearing out the debris and bluster and corruption by whatever means necessary.

10. Ann Marlowe, "Rage to Live," *Village Voice,* January 18, 1994, 17.

11. Patricia Mellencamp, "Oedipus and the Robot in *Metropolis,*" *Enclitic* 5, 1 (spring 1981): 20–44. My critique was presented in lectures in 1976, as was my argument about *Gold Diggers of 1933.* This is very old stuff, dating back almost twenty years. This is a very short version of that essay, without all the sad elaborations of Oedipus and limp phalluses and, particularly, my sarcastic analysis of Siegfried Kracauer's *From Caligari to Hitler.* He was dead! Why did I let him so infuriate me? What good did my railing do?

12. Hitchcock's wife, Alma Reville, also wrote screenplays for him. He met her in the studio, doing continuity. The contributions of the historical wives of famous men are rarely acknowledged and, when they are, are made out to be secondary, clearly inferior,

like wives themselves. Von Harbou, to make matters worse, did not emigrate from Germany to the United States, as did the "courageous" Lang. Leaving a possible Nazi sympathizer behind is seen as yet another feather in Fritz's cap. But I wonder what the story really is? Perhaps he met a starlet, and this was his chance to dump the wife.

13. I have not referred to work on German expressionist film that came after my essay. For example, see writing by Patrice Petro (particularly her book *Joyless Streets*), Thomas Elsaesser, Michael Budd, Andreas Huyssen, Eric Rentschler, Timothy Corrigan, and Janet Bergstrom. Very recently, *Camera Obscura* and *New German Critique* have published analyses. Now that technology, cyborgs, and prosthetics are in style, *Metropolis* is experiencing yet another rediscovery. The classic book is by Lotte Eisner, *The Haunted Screen* (1952; rev. ed., Los Angeles: University of California Press, 1965). Many critics might argue that Siegfried Kracauer's *From Caligari to Hitler* (Princeton, N.J.: Princeton University Press, 1947) is also a classic.

14. Michel Foucault, *The History of Sexuality, An Introduction*, vol. 1, trans. Robert Hurley (New York: Random House, 1978), 130, 131. My original essay's sections on Foucault, including the lengthy passage that contains this phrase, have been cut from this book.

15. See Martha Kingsbury, "The Femme Fatale and Her Sisters," and Allesandra Comini, "Vampires, Virgins and Voyeurs in Imperial Vienna," both in *Art News Annual* 38: 183–221.

16. Oskar Schlemmer, "Man and Art Figure" and "Theater," in *The Theater of the Bauhaus*, ed. Walter Gropius, trans., Arthur Wensinger (Middleton, Conn.: Wesleyan University Press, 1961).

17. The great German expressionist cinematographer Karl Freund not only photographed this film but "*I Love Lucy*," a bit of trivia that makes strange sense. Rather than sharp-contrast lighting effects, Lucille Ball needed a uniform diffuse lighting to erase her real age of forty-one, taking her down to her character's twenty-nine and allowing her to move freely around the set. Both *Metropolis* and *Lucy* were studio productions that depended on perfect lighting.

18. Like so many other technologies, TV was created much earlier than it was available to buyers, being derailed by World War II and not marketed until the postwar period. As for so many other inventions, it is likely that the Germans were ahead of the United States, but we won the war, and this technology.

19. Perhaps these works are no longer so axiomatic or familiar as they were when I wrote this piece. I am referring to what had become a set of premises regarding *the cinematic apparatus*, an unattractive term indeed. See, for example, Jean-Louis Comolli, "Technique and Ideology: Camera, Perspective, Depth of Field," in *Film Reader 2* (Evanston, Ill.: Northwestern University Press, 1977); another essay by Comolli is in *The Cinematic Apparatus*, (London: Macmillan, 1980), ed. Teresa de Lauretis and Stephen Heath. The title of this collection, compiled from a Milwaukee film conference, indicates the currency of the concept. An earlier essay in *Film Quarterly* (1974) by Jean-Louis Baudry began the fashion for this theoretical model, however. It also tied in with work on the classical continuity style, which began a bit later.

20. Ron Fry and Pamela Fourzon, *The Saga of Special Effects* (Englewood Cliffs, N.J.: Prentice-Hall, 1977), 2.

21. Jeff Rovin, *Movie Special Effects* (New York: A. S. Barnes, 1977), 11.

22. Raymond Fielding, *The Technique of Special Effects Cinematography* (New York: Hastings House, 1965); 1977 reprint, 81. When I used these sources in the 1970s they were brand new. I have not kept up with research in this area.

23. Patricia Mellencamp, "Film History and Sexual Economics," *Enclitic* 7, 2 (fall 1983): 91–104.

24. I was particularly referring to Christian Metz, "Trucage and the Film," *Critical Inquiry* (summer 1977): 669, 670, 673; and to Comolli, "Technique and Ideology," 129. On p. 665, Metz presents a definition of trucage as duplicity: "There is then a certain duplicity attached to the notion of trucages. There is always something hidden inside it (since it remains trucage only to the extent to which the perception of the spectator is taken by surprise, and at the same time, something which flaunts itself)."

25. This essay was not included in the English translation of Jacques Lacan, *Ecrits*, trans. Alan Sheridan (New York: W. W. Norton, 1977). On p. vii, the translator tells us: "This selection of nine essays, representing well under a half of the material contained in the *Ecrits*, is Lacan's own." See Jacques Lacan, "Seminar on the Purloined Letter," in *French Freud: Structural Studies in Psychoanalysis*, ed. Jeffrey Mehlman, *Yale French Studies 48*, 1972, 39–72. I quote my footnote from "Film History and Sexual Economics:" "As Lacan writes on page 44: 'The first is a glance that sees nothing. . . . The second, a glance which sees that the first sees nothing and deludes itself. . . . The third sees that the first two glances leave what should be hidden exposed.' The play from seeing through interpreting and on to knowing via the glance is an important schema for cinema, a complex intersection of seeing and telling which extends the looks *in time*, through the hermeneutic staging."

26. This tactic is elaborated in "Film History and Sexual Economics" on p. 98: "Producing contradictions is the only strategy" for feminist writers in 1980. "To read against the grain of great enunciators whose dramatic narratives repetitiously chart the adventurous and brilliant journeys of great men whether scholars, inventors, cowboys or poets is 'for women, more than a chapter in cultural history; it is an act of survival'" (the latter a paraphrase of Adrienne Rich). Mary Ann Doane, Linda Williams, and I, like Teresa de Lauretis, used this phrase in our introduction to *Re-Vision*: "'Reading against the grain' . . . is less concerned with the truth or falsity of the image of woman than with gaining an understanding of the textual contradictions" (*Re-Vision: Essays in Feminist Film Criticism*, ed. Mary Ann Doane, Patricia Mellencamp, Linda Williams [Lanham, Md.: University Press of America, 1984], 8).

27. Adrienne Rich, "When We Dead Awaken: Writing as Re-Vision," in *On Lies, Secrets, and Silence* (New York: W. W. Norton, 1978), 35. I also referred to several other of Rich's essays in this volume, along with her *Leaflets: Poems 1965–1968* (New York: W. W. Norton, 1969), esp. 71.

28. In retrospect, I rather like this irritated essay, which anticipated so many arguments that have been made more recently.

29. Teresa de Lauretis, *The Practice of Love: Lesbian Sexuality and Perverse Desire* (Bloomington: Indiana University Press, 1994).

30. Dorothy Hewett, *Wild Card: An Autobiography, 1923–1958* (Victoria, Australia: McPhee Gribble/Penguin Books, 1990), 94. I had strong feminist colleagues in Milwaukee, Tania Modleski and Teresa de Lauretis, but I also had two young children, no time, little money, and no day care. This drama, profession versus motherhood, is very serious for women, particularly for low-paid women, but rarely analyzed in all its complexity, which so importantly includes economics.

31. Virginia Woolf, *Three Guineas* (1938; reprint, 1966, London: Harcourt, Brace, Jovanovich), p 109.

32. Roland Barthes, *S/Z*, trans. Richard Miller (New York: Hill & Wang, 1974).

33. Lacan, "Seminar on the Purloined Letter,"

34. Gilles Deleuze and Félix Guattari, *A Thousand Plateaus* (Minneapolis: University of Minnesota Press, 1987), 289–90.

35. Monique Wittig, *The Straight Mind and Other Essays* (Boston: Beacon, 1992), 24.

36. My original remarks can be found in *Camera Obscura* 20/21 (May–September 1989): 235–40.
By "cryptofeminism," from which I take the title to this chapter, I mean, quite literally, "secret" or "hidden" feminism.

37. What needs to be done is to revise old films, not merely remake them as the Bette Midler version, *Stella* (John Erman, 1990), did. It was updated but not revised—and revision, as Adrienne Rich has told us, is a matter of survival.

38. See Judith Halberstam's wonderful essay, "Skin Flick: Posthuman Gender in Jonathan Demme's *The Silence of the Lambs*," *Camera Obscura* 27 (1991): 37–54. Elizabeth Young's "*The Silence of the Lambs* and the Flaying of Feminist Theory" is in the same issue (5–36).

39. But this scene is mild compared with the aggression of Stan Brakhage's avant-garde autopsy film *The Act of Seeing with One's Own Eyes*, a silent film—except for the

squeamish sounds from viewers. His camera movements are nonstop, unpredictable, and relentless, like the split-second edits, as he forces us to watch what we don't want to see. The film is filled with limp penises.

40. Clover, *Men, Women, and Chain Saws.* Carol Clover points out what she considers a double silence: about masochism and about identification with the female. Clover approaches this assaultively violent genre, now tamed enough through videotapes to contemplate, as Linda Williams's *Hard Core: Power, Pleasure, and the "Frenzy of the Visible,"* (Berkeley: University of California Press, 1989) did pornography. The theatrical context for pornography, like that of slashers/thrillers, was and continues to be in the remaining venues that repell and are repellent to women. As in the brothels and cafés of impressionism, women are stars, and women are not welcome.

41. Feminists are increasingly using the work of Jean Laplanche and Jean-Bertrand Pontalis. Clover also uses an essay by Kaja Silverman on masochism and Freud's case study of a child being beaten. "For Freud, the male masochist's wish to be beaten by his father stands very close to the other wish, to have a passive (feminine) sexual relation to him." As Clover says, "The fantasy is straightforwardly homosexual." The male masochist model is perfect for the spectator of Tarentino's films, with, however, a glitch: Clover's positioning occurs between on-screen females and male viewers; in Tarentino films, women are bit-part bimbos or just not there.

42. Which has no footnotes, so she doesn't tell us who influenced her thinking then.

43. *Vogue* (February 1995): 80. Annaud also says that "actors who look good in real life" look great in 3-D. The same is not true for actors who photograph better than they really look. "A lot of actors are afraid of 3-D."

44. This upscaling of the horror genre and the consequent decline of the cheaper independents is, for her, a loss. "The trope of cannibalism" is "an apt metaphor for a film that has helped itself" to the "wares of its downscale relatives" (233). But something else can also occur. When genres have been worked and then reworked, they cross over the line and are transformed, as the western was by John Ford and then Sergio Leone, the thriller by Hitchcock, biography by Spike Lee in *Malcolm X* (1992), or the historical drama by both Julie Dash and Sally Potter.

45. Using the model of feminist film criticism drawn from hysteria and vision, predicated on scopophilia, criticism has attacked the film's homophobia and flaying of women, large women chosen as victims for their body size. Even Hannibal Lecter anticipated this critique by telling us that Buffalo Bill is not a transsexual, not a homosexual. Lecter's victims are men, the police; his next victim will be a man, the doctor Chilton, as he tells Clarice on the telephone at the film's conclusion.

46. Peter Wollen, *Readings and Writings* (London: Verso, 1982). For terrific analyses of Hitchcock's tactics, see the first chapter (18–48).

47. This scene plays on our expectations, on our knowledge of crosscutting, on conventions of proximity between edits that are matched to action. Cut to agents outside house. Cut inside the house, doorbell ringing. This editing of outside/inside cuts across disparate spaces, often a location shot for the exterior and a studio set for the interior. Only the door and the editing make us think the spaces are together. However, in using this device literally and calling attention to film's fragmented quality, the film "tricks" us, playing on expectation, elongating the scene, and setting up a comparison between Crawford and Starling.

The film is filled with similar gambits. Whenever Hitchcock's characters were in mortal jeopardy, he would abruptly cut to a high-angle shot down—as in *Rear Window,* of L. B. Jeffries when Thorwald *knows* who he is. In *Psycho* (1960), before Arbogast's murder, the shot at the top of the stairs is so high that the top of the set shows! When Demme wants to suggest threat (real or imagined), he refers to Hitchcock with a similar abrupt high-angle shot. When Clarice enters the bedroom of the first victim's house, the film cuts from a low angle of her feet on the stairs to a high-angle shot down when she is in the room. Scary. Why? Because we know what this means, whether we are aware of this knowledge or not.

48. Jana Monroe was the adviser on the film for Foster's character; she also became

the prototype. Monroe is the first and only woman special agent at the FBI Center for Violent Crime. She loves her job and used the Thomas Harris novel from which the film *Silence* was taken to get it—arguing that because most of the victims were women, a woman should be part of the investigations. "A poised career woman who just turned 40, Monroe has blond hair, blue eyes and looks that would rival those of movie stars" (Frank Aukofer, *Milwaukee Journal*, 14 August 1994, G1, G6). (Men are compelled to share their surprise that a woman working in any profession outside of entertainment or prostitution or motherhood can also be beautiful.)

49. These remarks come from, I think, *Parade*, the Sunday magazine sometime in a 1993 or 1994 essay on Stone.

50. *Milwaukee Journal* 28 March 1993, E.6.

51. Lynda Hart, *Fatal Women: Lesbian Sexuality and the Mark of Aggression* (Princeton, N.J.: Princeton University Press, 1994): 134.

52. Holmlund, "Cruisin' for a Bruisin'," 31–52.

53. Hart's next chapter is about Aileen Wuornos, the woman who killed seven middle-aged white men: "I will try repeating her story differently, in a way that perhaps can be heard."

54. "Women Face the '90s," *Time* (December 4, 1989): 3.

55. What and whom feminism represents are at stake in the TV plugs/discussions for popular books, particularly on conservative talk shows. Feminism is under siege from without but also from within: by white lesbian women, African American women, and conservative white women.

56. Margaret Carlson, *Time* (June 24, 1991): 57.

57. For a wonderful essay on this film, see Sharon Willis, "Hardware and Hardbodies, What Do Women Want?: A Reading of *Thelma and Louise*," in *Film Theory Goes to the Movies*, ed. Jim Collins, Hilary Radner, Ava Preacher Collins (New York: Routledge, 1993), 120–28. Also see, in the same book, the essay by Cathy Griggers, "*Thelma and Louise* and the Cultural Generation of the New Butch–Femme," 129–41. (Conversely, an essay on *Pretty Woman* illustrates false premises or contradictions passing as feminism. Feminism is not a contradiction; feminism is being able to understand and thus avoid being trapped by contradictions.)

58. Meaghan Morris, "'TOO SOON TOO LATE': Reading Claire Johnston, 1970–1981," published in *Dissonance, Feminism and the Arts* 1970–90, ed. Catriona Moore (Sydney: Allen & Unwin/Artspace, 1994) 7. 133. (Paper delivered at a memorial lecture dedicated to Claire Johnston).

59. For Lynda Hart, the film "assumes the primacy of emotional bonds between women . . . *who act together* in indifference to . . . heterosexual expectations." One woman "kills *for* another woman" (67). Pointing to the elision between criminality and lesbianism, she concludes, "Thelma and Louise are not criminals because they shoot a rapist, rob a store, or blow up a truck. They are criminals because they are *together*, seeking escape from the masculine circuit of desire" (79). She notes that "the film titillates spectators with the possibility of desire between them, then . . . introduc[es] male lovers in heightened moments" (77). This is a point of debate between our readings; in a way, however, both interpretations work. Like *Basic Instinct*, *Thelma and Louise* became an event and a cultural debate. Criticism was often vehement, anxious. Hart suggests a reason: "Lesbianism [was evoked] as a haunting presence through denial and negation" in criticism, which rehearsed "a history of identification between the female criminal and the lesbian" (75). Becoming independent is threatening, whether one is lesbian or not.

AGE THREE: EXPERIMENTAL FEMINISM

1. Walter Benjamin, "The Storyteller: Reflections on the Works of Nikolai Leskov," in *Illuminations* (New York: Schocken Books, 1969), 87.

2. Linda Hutcheon, *A Theory of Parody* (New York: Methuen, 1985), 72.

3. Meaghan Morris, "'TOO SOON TOO LATE': Reading Claire Johnston, 1970–1981," *Dissonance, Feminism and the Arts*, 1970–1990, ed. Catriona Moore (Sydney, Aus-

tralia: Allen & Unwin/Artspace, 1994) 129. The first quotation is from *Kafka: Toward a Minor Literature*, trans. Dana Polan, University of Minnesota Press, 1986, p. 41.

4. I included longer versions of these remarks in my book *Indiscretions: Avant-Garde Film, Video, and Feminism* (Bloomington: Indiana University Press, 1990). *Thriller* (1979) was part of the model for Teresa de Lauretis's essay "Desire in Narrative," a great chapter in her book *Alice Doesn't* (Bloomington: Indiana University Press, 1984). However, Potter addresses race, age, and lesbianism, which de Lauretis did not do then.

5. "[My films are] about a reconciliation between those kinds of cinematic spaces" (author's interview with Sally Potter aboard Aeroflot, from Tblisi to Moscow, March 1988).

6. The opera is based on Henri Murger's *Scenes de la vie de Boheme*, first published in 1845. In his film *La Vie de Boheme* (1993), Aki Kaurismäki returns to the original novel, populating it with a scruffy gang of Bohemian artists: Marcel, a writer; Schaunard; and Rudolfo. They talk, drink, fail in the publishing business, and talk some more. He must not have seen *Thriller*.

7. As film theory was arguing around the same time, the classical text repressed its work, concealing the apparatus.

8. Pam Cook, "*The Gold Diggers:* Interview with Sally Potter," *Framework* 24 (spring 1984), 28–30.

9. This is a very short version of a longer section in *Indiscretions*.

10. Julie Christie is quoted by Alexander Cockburn, "Don't Look Now," *American Film* 11, 4: 19.

11. I have admired this director for years. *Real Genius* (1985) was a wonderful film, with great politics. *Rambling Rose* (1991) came out to terrific reviews. I look forward to future films.

12. As I have said, most of the films by women shake up the boundaries of genre, suggesting that the very definitions, traits, hallmarks, etc.—the Wittgenstein test—have been gender-determined. I am thinking particularly of *Thelma and Louise* but also Jane Campion's films. *The Piano* (1993) is deliberately remaking an older genre—and it is through genre that Laleen Jayamanne reads the film differently than many critics.

13. One of the key transformations in these films, including conventions of genre, is the place of mother—particularly apparent in Campion's *The Piano*.

14. Freda Freiberg, "The Bizarre in the Banal: Notes on the Films of Jane Campion," in *Don't Shoot Darling: Women's Independent Filmmaking in Australia*, ed. Annette Blonski, Barbara Creed, and Freda Freiberg (Richmond, Australia: Greenhouse Publications, 1987; distributed by Gordon and Gotch, Sydney), 328–33.

15. Kate Sands, "Women of the Wave," in *Back of Beyond: Discovering Australian Film and Television* (Sydney: Australian Film Commission), 11.

16. Amy Taubin, "Notes on Campion," *Village Voice*, 29 May 1991, 62.

17. Janet Frame, *Scented Gardens for the Blind*.

18. Laurie Muchnick, "Up from Down Under," *Village Voice*, 13 August 1991, 60. This is a wonderful review, from which I have taken much.

19. Dorothy Hewett, *Wild Card: An Autobiography, 1923–1958* (Victoria, Australia: McPhee Gribble/Penguin Books, 1990), 16.

20. Anne Sexton, "The Twelve Dancing Princesses," *The Complete Poems* (Boston: Houghton Mifflin Co., 1981) 281.

21 This wonderful film is available in the United States from Women Make Movies, 462 Broadway, Suite 500C, New York, NY 10013. Many other films can be rented through this great distributor.

22. Sigmund Freud, "The 'UnCanny,'" in *The Standard Edition of the Complete Psychological Works of Sigmund Freud*, vol. 18 (London: Hogarth Press, 1955). In this essay Freud too vehemently asserted that fairy tales had nothing to do with the experience of "the uncanny." I think this could be true as long as the teller, the point of view, is male; for as Freud sees it, and as Mary Ann Doane interpreted it a long time ago, the *unheimlich*, (uncanny) is woman, the fearful place, female genitals. But what if the uncanny was

the misrecognition of self as other, the terror of that encounter? This is what happens when Freud is frightened by an image of an old, seedy man, then realizes it is his reflection in a mirror. This is a question of sameness *and* difference, simultaneously. See Patricia Mellencamp, *High Anxiety: Catastrophe, Scandal, Age, and Comedy* (Bloomington: Indiana University Press, 1992), for an elaboration of this scene in Freud which is about his fear of aging, told in a footnote.

23. Amy Taubin, *Village Voice*, 28 May 1991, 62.

24. I have taken this from Laleen Jayamanne's "The Post-Colonial Gothic: The Narcissistic Wound of Jane Campion's *The Piano*," (2) (paper delivered in Wellington, New Zealand at "Under Capricorn: A Conference on Art, Politics and the Law," March 5, 1994; it is forthcoming in Jayamanne's book, to be published by Indiana University Press). Jayamanne mentions *Sight and Sound* as a source. She asserts that this is common knowledge, a comment that Campion has made many times.

25. This is Jayamanne ("Post-Colonial Gothic") 3, quoting Campion, who was interviewed many times about this film, yielding many ideas that have made their way into analyses of the film. Jayamanne's source is *Cinema Papers*, No. 93, May 1993, 6–8.

The Last Seduction (1994) is just the scenario Campion describes, taken to extremes. The Linda Fiorentino character is connected to money in the opening shots. She is tough, hard, unsentimental, checking out the size of men's penises. The young male she meets talks feelings, relationships. She uses him for sex and sets up a corporate scheme for murder. His desire for her erases his skepticism. He imagines that she will make his life meaningful and exciting, that she will rescue him from small-town boredom. Talk about role reversal and romance! We discover that she is ruthless, even egging him on in the last scene to sodomize her and thus incriminate himself for murdering her husband. (She killed him.) Fiorentino's character uses an incident from the man's past that he is desperately ashamed of: on a trip to the big city, the country boy inadvertently married a cross-dressing man. When she taunts him with his ignorance and unmanliness, he goes nuts, attacking her and thereby sealing his fate. While he is raping her, an African American woman is on the 911 line, listening.

We watch Fiorentino's elongated, androgynous body stride self-confidently throughout the film. We never get inside her head; she never reveals feelings, and she has no weak spots for anyone or anything. She is also very smart and makes no mistakes. She gets off on men throughout the film, and she gets off with the money in the end. But I didn't include her in my Age Two cast of tough women, because she would also kill off women who got in her way, to say nothing of the homophobia.

26. Laleen Jayamanne, "Post-Colonial Gothic," 3. Jayamanne also notes the Gothic aesthetic in Tracey Moffatt's *Night Cries* (1990) discussed in Age Four, and *Silence of the Lambs*.

27. Laleen Jayamanne, "Colonial Gothic."

28. Jayamanne is quoting from Mary Beth Inverso, *The Gothic Impulse in Contemporary Drama* (Ann Arbor and London: University of Michigan Research Press, 1990), 9.

29. Manohla Dargis, "Down under the Rainbow," *Village Voice, Film Special* (November 30, 1993): 20.

30. The Campion short films I refer to are *A Girl's Own Story, Peel*, and *Passionless Moments*, all of which are available from Women Make Movies in New York. Campion's brilliance is immediately apparent—in the quality of performances, particularly from young performers; in the unusual framings and striking compositions; and, as I noted from Sands and Freiberg, in the details (the many close-ups, objects, looks, gestures). I also think she is an astonishing editor; in fact, one of the best I have ever seen.

31. From author's correspondence with Laleen Jayamanne, December 10, 1991.

32. Barbara Hammer's *Nitrate Kisses* (1992) stars and proclaims the radicality of lesbian and mixed-race gay sex. Bold scenes of sex between two seventy-year-old women and between a white and a black man structure the film. The most enthusiastic participant, however, is the camera—a third party. The camera frolics in close-up with the women's bodies, swooping in to record every intimate touch and cranny. The camera shoots, in close-up, through/behind a kneeling man, printing the Motion Picture Pro-

duction Code over the plunging testicles, in case the scene is too graphic to watch. This is too aggressive for me. Liberal shock quickly becomes banal. This in-your-face tactic challenges me to watch sex as my pleasure, which it isn't. I am just a voyeur.

Surrounding these climaxes are nice scenes of women socializing, old film clips from a gay silent film spectacle, and a semidocumentary section on lesbianism in Nazi Berlin, all hooked together by avant-garde techniques of optical printing. History? Perhaps. Politics? Perhaps for some. But these segments are too disconnected to make an argument. And if an argument does exist, it is that old saw that sex is liberating and the body the key to identity. Neither belief has taken us very far.

33. The first sentence of the film distribution Zeitgeist's publicity gives this away: "When I was younger, my sex life had been the object of all kinds of questioning. . . . Now that I did not appear to be looking for a man [and *appear* is the key word here], the state of my desires seemed of no interest to anyone." Not an auspicious opening.

34. In the "Funny Valentine" scene, Rainer takes her stand against masquerade. She faces the camera without makeup and applies lipstick all over her lower face. Makeup becomes a formal sign, perhaps a symptom. Whenever women in the film wear makeup, they are garish. I wonder if this technique is a critique of masquerade, of women's desire to appear young, or just an inability to apply makeup. Jenny's makeup is so poorly applied that she looks like the little girl she is inside, imitating a grown-up.

35. Michelle Wallace, "Multiculturalism and Oppositionality," *Afterimage* (October 1991): 6–8.

36. Quoted in Lynne Tillman, "A Woman Called Yvonne," *Village Voice*, 15 January 1992, 56.

37. Monique Wittig, "Homo Sum," *The Straight Mind and Other Essays* (Boston: Beacon, 1992), 55.

38. Hazel Carby, 'On the Threshold of Woman's Era': Lynching, Empire and Sexuality in Black Feminist Theory," in *"Race," Writing, and Difference*, ed. Henry Louis Gates (University of Chicago Press, 1985/1986), 300–16.

39. Monique Wittig, "One Is Not Born a Woman," *Feminist Issues* (Winter 1981): 53.

40. Monique Wittig, "The Mark of Gender,'" in *The Straight Mind and Other Essays*, 20.

AGE FOUR: EMPIRICAL FEMINISM

1. Michel Foucault, *Power/Knowledge*, ed. Colin Young (New York: Pantheon Books, 1980), 193. I have used this quotation for years. It is still rich in prophecy.

2. Adrienne Rich, "When We Dead Awaken: Writing as Re-Vision," in *On Lies, Secrets, and Silence* (New York: W. W. Norton, 1970), 35. The great essays in this collection are very current in the 1990s.

3. Meaghan Morris, "'TOO SOON TOO LATE': Reading Claire Johnston," *Dissonance: Feminism and the Arts* 1970–90, 128.

4. Hugh Fordin, *The World of Entertainment* (Garden City, N.Y.: Doubleday, 1975). This valuable and eclectic book consists of oral history interspersed with memoranda.

5. In this everyday scene, anger can turn to guilt or shame and be directed internally, rather than against social, material conditions. The victim blames herself—the victim mimics the perpetrator. Simone's walkout reminded me of Freud and Dora (his patient who walked out of analysis), particularly his completely missing her point. In effect, Freud blamed Dora for the failure of *his* analysis—one version of blaming the victim. Women's angry or frustrated response to men's behavior (or analysis) is interpreted as having nothing to do with real causes (men or material conditions), as having to do only with themselves.

6. With Glenn Close in the lead, this film has returned as a big Los Angeles-to-Broadway musical. The new trend in musicals is melodrama not romantic comedy. The production has produced gossip regarding middle-aged female stars fired from the production, one for her acting, another for her singing.

7. I can still remember Swanson's television talk-show appearances. She was an

early health advocate, promoting vegetarian food, vitamins, and exercise and criticizing smoking. Of course, her body was her prime evidence of the merits of these lifestyle practices. Rather than being just like everyone else in the United States, she was then, with habits many now consider normal, a true eccentric.

8. Sigmund Freud, "Anxiety and Instinctual Life," in *The Standard Edition of the Complete Psychological Works of Sigmund Freud* (London: Hogarth, 1959), 22: 108.

9. When one is frustrated by the outside world, Freud says this triggers "the compulsion to repeat."

10. Sigmund Freud, *Inhibitions, Symptoms, Anxiety* (1926) vol. 20 of *The Standard Edition*, 113, 119. My classic example of this logic is the TV series *"I Love Lucy."* Every week for seven years, Lucy complained that Ricky Ricardo was preventing her from becoming a star. For twenty-four minutes she valiantly tried to escape domesticity by getting a job in show business. After a tour de force performance of physical comedy, in the reversal and failure of the end she resigned to stay happily at home—until next week, when she would try again to make a break. The ultimate creation/cancellation was that Lucy was not star material. The strategy is a purloined-letter ploy—there but not noticed. This conscious logic is as difficult to discern as the unconscious functioning of disavowal. I develop this in great detail throughout my book *High Anxiety: Catastrophe, Scandal, Age, and Comedy* (Bloomington: Indiana University Press, 1992).

11. At the base of hysteria is conflict; at the base of obsessionality are what Freud calls reproaches (guilt, shame, hypochondria). Both are the result of holding opposing or contradictory thoughts. (Significantly, for women, obsession could often be predicated on reality, not on imaginary fear. The reality is, however, denied or repudiated.) This is a more complex take on the cause–effect logic of narrative, just as it illuminates different models of subjectivity. Not only does this apply to *Sunset Boulevard;* it may also explain why women's absence from history is rarely noticed.

12. See Benjamin Hampton, *History of the American Film Industry* (New York: Dover Publications, 1970), particularly chap. 8, "The Pickford Revolution," 147–70. I took my figures from Hampton, not Tino Balio (see note 13, below).

13. Tino Balio, *United Artists: The Company Built by the Stars* (Madison: University of Wisconsin Press, 1976); Balio's essay "Stars in Business: The Founding of United Artists," in *The American Film Industry*, ed. Tino Balio (1976; reprint, Madison: University of Wisconsin Press, 1985), 153–72, draws on this research but focuses on Pickford.

14. Balio, "Stars in Business," 157.

15. Scott Eyman, *Mary Pickford: America's Sweetheart* (New York: Donald Fine, 1990).

16. The April 1993 issue of *Longevity* magazine reports that Pickford was a "face-lift victim" at forty. According to Edmund Wilson, Pickford "was left unable to smile or change or expression at all" (reported in the *Milwaukee Journal*, 29 March 1993, A).

17. Her context and her status have remained the same for almost one hundred years. The 1890s saw a shift of production and machinery from the home to the factory. With the rise of the small entrepreneur in the 1990s, the inverse is occurring, as homes become offices. Consumerism was hyped in both decades as the source of the nation's ill or good "health." In each period, women and domestic space were the targets of capitalism.

18. *The Cheat* was at least twice remade: by George Fitzmaurice in 1923, and by Marcel L'Herbier in France, as *Forfaiture*, in 1937.

19. The Rembrandt style historians were proclaiming was obvious, beautiful and striking, but superficial.

I wrote about *The Cheat* for a talk at the Hawaii International Film Symposium in Honolulu, at the end of November, 1990; my essay, "Female Bodies and Women's Pasttimes, 1890–1920," appeared in *East-West Film Journal*, Vol. 6, No. 1 (January 1992). In a 1993 book, *Romance and the Yellow Peril* (Berkeley: University of California Press, 1993), Gina Marchetti deals with the same issues of representation of women, race, and

consumerism. (See, particularly, "The Rape Fantasy: *The Cheat* and *Broken Blossoms*," 10–45.) Marchetti pays careful attention to the representation of the Asian man, the actor Sessue Hayakawa, connecting the issue of race to historical social and political issues. "Both brutal and cultivated, wealthy and base, cultured and barbaric, Tori embodies the contradictory qualities Americans associated with Japan. Like Japan itself, Tori is powerful, threatening, wealthy, and enviable; however, his racial difference also codes him as pagan, morally suspect, and inferior." (19) She writes about "the visual and moral equivalence between Tori and Edith" (21); the "film teeters between masochistic and sadistic positions for both Tori and Edith." (24) At the end, she argues that Tori is "emasculated." (26)

Another important book is *Babel and Babylon: Spectatorship in American Silent Film* by Miriam Hansen (Cambridge, MA: Harvard University Press, 1991). Hansen beautifully combines film history and film theory, particularly in her ground breaking analysis of Valentino and female spectators.

20. All these "systems" are predicated on the premises of Darwin in tandem with spirituality. All concern women's daily lives, adding different contours to the cinema's "structure [or 'montage'] of attractions," as Walter Benjamin, through Sergei Eisenstein and then film historian Tom Gunning, labeled the modern, consumer world.

21. In her writings on the film industry, Janet Staiger, for example, invokes F. W. Taylor to explain the business of movies. However, his singular focus on "the body" and an aesthetics of cooperation and work is somehow lost, as is his indebtedness to Darwn and other theorists of evolution.

22. As an example, consider George Miller Beard's benevolent Victorian references to "negroes" and "American Indians" in his 1871 *Stimulants and Narcotics* (an incursion into the Temperance Movement), a cross-cultural analysis of differences in climate, religion, and drinking habits in England, Turkey, France, and Germany (*Stimulants and Narcotics* [New York: G. P. Putnam, 1871]). To evolution and biology, Beard added physics: Newton's laws of action–reaction and electricity (with inflections by early reflexology, a favored treatment). Beard's "philosophy of food" in the last chapter of *Sexual Neurasthenia: Its Hygiene, Causes, Symptoms, and Treatment*, ed. A. D. Rockwell (New York: E. B. Treat, 1891), applies Darwinism to diet: "Living beings feed on that which is below them in the scale of development, with the best food that just beneath" (271). Fruits and vegetables are "far below [man] on the scale of evolution" (278). For Beard, the leading races are meat eaters: "Brain workers . . . prefer the best of animal food. The . . . history of the food of civilization among the higher classes is a history . . . of the progress of civilization" (282). Thus he cites "cannibalism" as logical.

23. What Darwin called "steady misrepresentation."

24. It is alive and well 150 years later, in 1990s books and magazines. *Time* has been pushing biology and evolution: in Robert Wright's August 15, 1994, cover story, "Infidelity: It May Be in Our Genes" (from his new book *Evolutionary Psychology and Everyday Life*), he revives a sophomoric Darwinism that draws on anthropology and its usual distinctions between male and female. Wright argues that monogamy and family don't necessarily come naturally. However, another field gives him his evidence: evolutionary psychology.

With the popularization of Darwin, which has increased each decade since 1959 (the centenary of his discoveries), the original premises of *Origin of the Species* become less and less complex. For an analysis of Darwin's thought, I refer the reader to Stephen Jay Gould, *The Panda's Thumb* (New York: W. W. Norton, 1980), especially the chapters "The Episodic Nature of Evolutionary Change" and "Darwin's Middle Road." In the former, Gould discusses Darwin's view of history as a series of incremental changes, comparing the idea of gradual change (gradualism) with Friedrich Engels's dialectical laws, drawn from Hegel's philosophy: these laws are "punctuational . . . the transformation of quantity into quality" (184). These concepts, I argue later, are taken up by Deleuze, through Sergei Eisenstein, to map change. (In *High Anxiety* I develop a lengthy argument around "Catastrophe," including many theories of change.)

25. Gould, "Darwin's Middle Road," 65.

26 Barbara Elrenreich and Deirdre English, *For Her Own Good: 150 Years of the Experts' Advice to Women* (New York: Doubleday, 1978). This should be required reading. I was thrilled when my son recommended it to me, after he read and loved it in college.

27. Beard, *Sexual Neurasthenia* 59, 60.

28. Robert Sklar, *Film: An International History of the Medium* (New York: Prentice Hall/Harry Abrams, 1994), 86–87.

29. Sumiko Higashi, *Cecil B. DeMille: A Guide to References and Resources* (Boston: G. K. Hall, 1985), 56, 29.

30. Jeanne Allen, "*Fig Leaves* in Hollywood: Female Representation and Consumer Culture," in *Fabrications: Costume and the Female Body*, ed. Jane Gaines and Charlotte Herzog (New York: Routledge, 1990), 123. Costume could be self-expression, with early actresses often choosing their own clothes, according to Allen. Allen argues that "film viewing" was associated with "shopping as early as 1910, projecting consumer products available for sale at department stores" (125). The purpose was "to harness . . . natural female acquisitiveness to capitalist market imperatives."

31. Jane Gaines, "Costume and Narrative: How Dress Tells the Woman's Story," in *Fabrications*, ed. Jane Gaines and Charlotte Herzog, 182. She also says that costume works by a contradiction akin to disavowal—costumes must simultaneously register *and* recede. Costume must be subordinate to the character, ultimately to the narrative.

32. Charles Higham, *Cecil B. DeMille* (New York: Scribner's, 1973). Higham's biography of DeMille gossips that DeMille hired Ward because he was convinced "that she was very deceitful. . . . Considerably older than her published age, her face was so caked in makeup, which she adamantly refused to remove."

33. The scientific domesticity movement fought against the lower status of domestic labor. A recent *Time* back-page editorial by Barbara Ehrenreich raises the same issue today. Welfare mothers are not seen by men as working; thus the debate over welfare keeps arguing they should work, get jobs. She also points out that children of unwed mothers are once again termed "illegitimate" (*Time* August 14, 1994).

34. Charles Woolfe, "Cecil B. DeMille," in *American Directors*, ed. Jean-Pierre Coursodon (New York: McGraw-Hill, 1983), 1: 93.

35. The nature of one's work was a divide that applied to men and women. See Beard, *Sexual Neurasthenia*, 29. (Hereafter referred to in text as Beard 1898).

36. Neurasthenia could also be hereditary. As Beard says, "Americans, the most nervous people in all history, are also the most laborious" (*Sexual Neurasthenia*, 64). Freud picks up on this remark by Beard in an essay. (See my book *High Anxiety*.)

37. George Miller Beard, *A Practical Treatise on Nervous Exhaustion (Neurasthenia): Its Symptoms, Nature, Sequences, Treatment*, ed. A. D. Rockwell (New York: E. B. Treat, 1894), 26. (Hereafter cited in text as Beard 1894). Neurasthenia strikes "those in the professions and in the higher walks of business life. . . . In the race for place and power . . . competitive anxieties are fostered and deepened" (253). Beard also argued that "the miseries of the rich, the comfortable, and intelligent have been unstudied and unrelieved" (Nervous Exhaustion, 30). The neurasthenic was distinguished from French neurologist Jean-Martin Charcot's patients, who were "simply weakminded, mentally untrained girls." Beard furthermore disagreed with Charcot's treatment of isolation, preferring potions, rest, and "general faradization and central galvanization for myelasthenia, exhaustion of the spine."

Lithaemia is distinguished from neurasthenia; lithaemics are "unintellectual, phlegmatic, and intolerably indolent: Instead of rest, quiet, and soothing draughts, they need mental and physical activity, less rather than more food, depletion rather than repletion" (Editor's Preface, 3). This, of course, could be a working-class disease.

38. Beard, *Stimulants and Narcotics* 138.

39. T. J. Jackson Lears patronizes neurasthenia as a middle-class disease of urban professionals; F. G. Gosling argues that it permeated classes, remaining a disease of the upper classes only until 1890, when it passed into popular culture. See F. G. Gosling, *Be-*

fore Freud: Neurasthenia and the American Medical Community, 1870–1910 (Urbana: University of Illinois Press, 1987).

40. Gosling, *Before Freud*, 35. He writes, "The recognition of nervous disorders as diseases that transcended both class and gender boundaries was an important step in the transition from Beardianism to Freudianism" (161).

41. Anson Rabinbach, "Neurasthenia and Modernity," in *Incorporations, Zone 6*, ed. Jonathan Crary and Sanford Kwinter (Cambridge, Mass.: MIT Press, 1992), 178–89. The exhaustion produced by neurasthenia combined with the law of least effort, what Rabinbach calls *misoneisme*, "the protective instinct of the species to reduce action." "The law of least effort produced not inertia but innovation. If, at the outset, neurasthenia was identified by Beard and his European followers as the inability of mind and body to resist the onrush of modernity's stimuli, Ribot and Bucher made fatigue indispensable for the great achievements of modern civilization." He compares *misoneisme*'s effect on economy and efficiency to the survival of the fittest's effect on the emergence of new species. He concludes: "Fatigue does not threaten civilization—it ensures its triumph" (187). In his book *The Human Motor* (Berkeley: University of California Press, 1992), Rabinbach focuses on work, on an image of the body as a machine, at the center of modernism. Like Stephen Kern in *The Culture of Time and Space* (Cambridge, Mass.: Harvard University Press, 1983), Rabinbach places cinema at the center of modernity. However, whether focusing on time, space, or work, whether coming from aesthetics or Marx, both men completely erase even the presence, let alone the work, of women within modernity. I am always astonished that this can occur, usually without notice.

42. For women, "nervous systems may be the cause, not the result, of uterine disease," a dispute of cause–effect that Freud reverses.

43. Patrick Brantlinger, "Victorians and Africans: The Genealogy of the Myth of the Dark Continent," in *"Race," Writing, and Difference*, ed. Henry Louis Gates, Jr. (Chicago: University of Chicago Press, 1985), 217.

44. Tom Lutz, *American Nervousness, 1903: An Anecdotal History* (Ithaca, N.Y.: Cornell University Press, 1991).

45. See the brief analysis of Georg Simmel that comes later in this chapter. Simmel's economic model is uncannily similar to Freud's model of obsession, suggesting that Freud, like Darwin, was also influenced by economics.

46. In the 1920s, for example, Lev Kuleshov (USSR) argued that affect did not come from the shot but from a juxtaposition of shots. In the United States, William James argued that we do not necessarily weep because we are sad, but rather, we are sad because we weep. Darwin read affect from the face, gesture, movement; others discerned it through costume, lighting, and set—the mise-en-scène. Music was emotion's accompanist and creator.

47. Gilles Deleuze and Félix Guattari's metaphors of *machine* in *A Thousand Plateaus: Capitalism and Schizophrenia* (Minneapolis: University of Minnesota Press, 1987) remind me of Beard's late nineteenth century image of the body as a machine, including the use of comparable terms such as *energies, intensities, forces*. Beard's comparison between the "Indian squaw" and "the sensitive white woman" suggests Deleuze and Guattari's comparison between the "polyvocality of primitives" and the "univocality of whites," an inverted analogy that fuels their machine of faciality, as earlier it fueled the empirical observations of evolutionists (emblematic of "arborescent logic," that of the hierarchical tree).

48. Anne Firor Scott, lecture at the University of Wisconsin-Milwaukee, March 1991.

49. Jane C. Croly, *The History of the Woman's Club Movement* (New York: Henry G. Allen, 1898), 40.

50. The earliest organizations were religious orders that did not initially mandate monasticism, virginity, or celibacy. Women concerned with education led these orders. Religious societies were then followed by charitable foundations. Through the Temperance Movement (founded by men but taken over by women) and the push for moral reform (to abolish the double standard and aid prostitutes) and against slavery (with the

first societies formed by black women), women increasingly became involved in organizations concerned with social issues and policies in the 1800s.

51. As with women working in industry during World War II, another impetus was women's previous work on the Sanitary Commission during the Civil War: "Women had felt an increased sense of power and influence. . . . The demand for activity ceased when peace was restored" (Croly, 39). Work on the Sanitary Commission led to the founding of the New England Woman's Club, inviting "the best thinkers to present their views before it." Like feminist theory today, "the difference was only a point of view, but it changed the aspect of the world" (Croly, 12).

52. In 1974, Adrienne Rich listed almost the same correctives. In her tribute to Anne Sexton she diagnosed our problem: "not taking ourselves or our work seriously enough; always finding the needs of others more demanding than our own. Being content to produce intellectual or artistic work in which we imitate men. . . . Horizontal hostility—contempt for women—is another: the fear and mistrust of other women, because other women *are* ourselves" (*On Lies, Secrets, and Silence*, 121–25). Rich criticizes those who "have belittled and devalued the work of the housewife and mother . . . who depict the woman at home as 'not working,' as an empty-headed consumer" (262).

53. Mary Pattison, *Principles of Domestic Engineering* (New York: Trow Press, 1915), 41.

54. There are many books on the system of F. W. Taylor. See, for example, Frank Copley, *Frederick W. Taylor: Father of Scientific Management* (New York: Harper & Brothers, 1923).

55. In the ongoing debate over biology versus culture, she sided with environment over heredity, trying to alter women's domestic scene.

56. Pattison accurately predicted that Taylorism would eventually be applied "to the personal life of man" (*Principles*, 153), true enough of Vic Tanney's, McDonald's, Disneyland, and other efficient leisure pursuits. However, the goal of these operations is to make more money through efficiency, and they invert Taylor, paying workers the least amount. Taylor saw science as bringing about radical change. This view of scientific management has been revised, if not reversed, in the 1990s; and taking women's daily lives seriously and intellectually, as Pattison did, is still unusual—perhaps today more than in 1915.

57. Unlike Beard, Pattison did not separate "mind from labor" (*Principles*, 98). Time and motion studies demonstrated the beauty of labor. Movement was aesthetic and spiritual—concepts shared with Delsarte. Housework has "personal, cultural value. . . . The doing of housework may produce a new kind of history" (191).

58. Thus standardization and specialization, applied to the Hollywood system of production, were taken into domesticity.

59. She maps out what should be a university degree in household engineering—different from the programs already established at "150 colleges with departments of domestic science, household arts, and home economics" (*Principles*, 19). Comparable to the earlier shift of machinery (and manufacturing) from the home to the factory—"an epoch in the progress of women"—the return of labor-saving machinery to the home promised further liberation for women, lessening the hours of labor. The recommended tools of the trade were a Hoover vacuum, a "Fireless Cooker," a washing machine, an incinerator (a garbage disposal), and smaller items (potato peeler, bean cutter) as well as a mangle and an electric dishwasher. For Pattison, these conveniences were only the beginning. What is surprising to me is how far we have *not* come, or how much we have backtracked. The only consumer durables Pattison fails to mention are television sets, VCRs, and computers. We are still using turn-of-the century devices, a lack of invention which might astonish our activist forebears.

Pattison points out an element of Taylorism that is missing from contemporary reconstructions: that its emphasis on cooperation between capital and labor was predicated on an ideal, an aesthetic quality of work and collective goals. Yet there are notable contradictions in her thought. Pattison endorses the "Home"—defined as "the small

group of father, mother, and child"—as a "cooperative enterprise in which the importance of the individual is supreme." But while the cost of the system of "separate homes" is a foolish business enterprise, the "separate home" is still the ideal for Pattison.

60. In the name of women's independence, housework is turned into a profession: "The health and body of the family depends . . . on understanding the chemistry of food and nutrition, the intelligent practice of sanitation and hygiene, the comprehension of bacteriology." Business, or professionalism, is the result of scientific methods—conducted from the "Housekeeping Experiment Station," involving statistics, questionnaires, and testing. However, money is not included.

61. See Susan Strasser, *Never Done: A History of American Housework* (New York: Pantheon Books, 1982), 220; see Charlotte Gilman Perkins, *Women and Economics* (New York: Harper and Row, 1898, reprint 1966).

62. Melusina Fay Peirce saw "the profound contradiction between the increasingly social aspect of men's work in production and the privatism of women's work in the home" (Strasser, *Never Done*, 199). She suggested moving the work into collective spaces. Christine Frederick applied Taylorist methods, particularly standardization, to the home between 1910 and the 1920s. However, like Pattison, she disdained Taylor's key element, the profit motive, set against the idealism and spirituality of household principles.

63. Pattison disagreed with Beard on many things, including the idle white woman's life of leisure. Her knowledge came from daily domestic life and experience—a micropolitics. Regarding diets, she wrote: "Meats, fish, rich sauces, cheese, fried things, pastry and liquors should give way to vegetables and whole grain cereals; these in turn to fruits, olive oil and honey" (Pattison, 141). Hers is a diet of the 1990s. In the chapter, "Eating and Drinking," Beard described "the eating and drinking customs of the leading races and tribes of the world, of all the continents, and of all climates"—a macropolitics. Beard's conclusion was that "in extreme heat as well as in extreme cold, meat was the best food for man" (*Sexual Neurasthenia*, 282). Despite Beard's megalomaniac research claims to have studied all the world and its peoples, this diet is no longer recommended.

64. At one jarring point in the film, Mother, a psychologist, turns Planned Parenthood into a joke, assembling all the twelve children to illustrate the incorrectness of planning instead of simply having children.

65. See Susan Strasser, *Satisfaction Guaranteed* (New York: Pantheon Books, 1989); Susan Porter Benson, *Counter Cultures: Saleswomen, Managers, and Customers in American Department Stores, 1890–1940* (Urbana and Chicago: University of Illinois Press, 1986).

66. Oliver Herford, "Pen and Inklings," *Harper's Weekly* 60, 3052 (June 19, 1915), 593.

67. See Deleuze and Guattari, *Thousand Plateaus*, 177.

68. Kathy Peiss, "Making Faces: The Cosmetics Industry and the Cultural Construction of Gender, 1890–1930, *Genders*, no. 7 (spring 1990).

Rouge and face powder began with working-class women. "Paint . . . demarcated the boundary between respectability and promiscuity, bourgeois gentility and lower-class vulgarity" (146). Beauty culturists "foregrounded the *process* of achieving beauty, not just the end product," and moved this into consumer society, replacing "all-purpose creams . . . with specialized products, each designed to perform a single function."

Like many other cosmetologists, Elizabeth Arden—a name she thought "romantic and high class"—opened a number of salons in 1915. In 1918 she sold to department stores and "by 1920 had an extensive product line." From salons to national product lines was the route to fame for the upper-end market. African Americans also became successful cosmetics entrepreneurs, as did mass-market manufacturers.

69. Barbara Koenig Quart, *Women Directors* (New York: Praeger, 1988), 20.

70. Lois Banner, "The Meaning of Menopause: Aging and Its Historical Contexts in the Twentieth Century" (paper delivered at a conference at the Center for Twentieth Century Studies, University of Wisconsin, Milwaukee, 8, 9, April 1989).

71. Anthony Glyn, *Elinor Glyn* (1955; rev. ed., London: Hutchinson, 1968), 301–2.

72. Several books on Buster Keaton's films state that his short film *One Week* (1920) is a parody of Glyn's novel *Three Weeks*.

73. Lewis Jacobs, *The Rise of the American Film: A Critical History* (1939; 3d. ed., New York: Teachers College Press, 1967); Kevin Brownlow, *The Parade's Gone By* (New York: Bonanza Books, 1968); Molly Haskell, *From Reverence to Rape: The Treatment of Women in the Movies* (Baltimore: Penguin Books, 1974); Marjorie Rosen, *Popcorn Venus: Women, Movies and the American Dream* (New York: Coward, McCann & Geoghegan, 1973). Other histories mention Glyn in relation to *It* and sex, as well as the famous story about Glyn teaching Rudolph Valentino how to kiss a woman's hand, palm up.

A book that does talk about Elinor Glyn recently appeared. See Lizzie Francke, *Script Girls: Women Screenwriters in Hollywood* (London: BFI, 1994). There is also a section on Nora Ephron.

74. Andrew Sarris, "Sirens without Sound," *Village Voice*, 11 October 1988, 76.

75. Her "philosophy" divided women into three categories: lover-women, mother-women, and neuter-women.

76. Metro was also Buster Keaton's studio.

77. For a history of love and romantic conventions in Western society, see Susan S. Hendrick and Clyde Hendrick, *Romantic Love* (London: Sage Publications, 1992). This book draws on social-science research studies, including relationship research and a variety of approaches. Their ideas are taken from the three volumes of I. Singer, *The Nature of Love* (Chicago: University of Chicago Press, 1984, 1987) particularly vol. 2, *Courtly and Romantic* (1984), and vol. 3, *The Modern World* (1987).

78. Efficiency was the highest value in the time/motion studies of Taylorism. Pattison viewed movement in housework as a combination of time/motion studies (measured by a stopwatch) with a spiritual aesthetics.

79. Rudolf Laban, *The Mastery of Movement* (Boston: Plays, Inc., 1950), 45. For Pattison, this aesthetics of perfection would supply satisfaction and pleasure. While all types of movement (laborers and actors and housewives) used economy, performing involved contact with an audience, creating emotion.

80. Ted Shawn, *Every Little Movement: A Book About François Delsarte* (Brooklyn, New York: Dance Horizons, 1963), 25. Delsarte's influence on the defenders of "silent" cinema would be an interesting study. He considered that "speech is inferior to gesture because it corresponds to the . . . mind. Gesture is the agent of the heart. . . the manifestation of feeling."

81. In the continuity style, formal techniques of time and space—for example, editing—were masked, subordinated to the narrative.

82. The will to tabulate and taxonomize empirical data is at the base of Delsarte's system, along with an image of humans as godly. His two laws, "the Law of Trinity and The Law of Correspondence," elide science with religion, which in turn was equated with art (Shawn, *Every Little Movement*, 22).

Delsarte's gesture-affect relation is very different from the Kuleshov effect, wherein emotion is created between shots or in their juxtaposition. Gesture in silent films enables us to notice that bodily style and movement are historical. Along with facial style, it is perhaps the most significant index of film history.

83. Delsarte's theories were popularized in F. A. Durivage, "Delsarte," *Atlantic Monthly* 27, 163 (May 1871): 613–20.

84. These movements drew women from a variety of clubs and other movements.

85. Other books that detail Delsarte's theories include *The Essential Delsarte*, ed. John W. Zorn (N.J.: Scarecrow Press, 1968), which contains a reprint of Durivage's *Atlantic Monthly* essay. Mary Ellen O'Brien's *Film Acting* (New York: Arco, 1983) also contains a mention of Delsarte, as does G. Wilson Knight's *Symbol of Man* (Washington, D.C.: University Press of America, 1981), which has a chapter on Delsarte (28–41). Roberta Pearson, *Making Visible the Invisible*, ed. Carole Zucker (N.J.: Scarecrow Press, 1990), discerns "strong resemblances between the 'Delsarte' and other systems, and Biograph performance style"—linked through melodrama.

86. Fatimah Tobing Rony, "Those Who Squat and Those Who Sit: The Iconography of Race in the 1895 Films of Felix-Louis Regnault," *Camera Obscura* 28 (January 1992): 263–89. She calls this period "a time when medical doctors in the name of science were . . . narrativizing human history as a linear evolution from darker to lighter-skinned peoples. This fascination with race characterized much of earlier cinema" (264). These physicians, "obsessed with the body and with evolution," were "fascinated by the emerging discipline of anthropology" (265). (The essay is a strong critique of anthropology and ethnography, although this is not the stated purpose.) Rony describes the pervasive "racialization of indigenous peoples in both scientific and popular literature" (285n. 7). She focuses on this turn-of-the-century French doctor Regnault because he has been cited as a forerunner of ethnographic cinema.

Rony's very interesting essay emphasizes what she calls "the visualism of nineteenth-century anthropology," the equation of the popular and scientific constructions of "ethnographic" (referring to peoples without history and technology), and the conception of film as the ideal tool for recording movement. People are not "meant to be seen as individuals, but as specimens of race and culture" (265)—a precursor to the stereotypical representation of race in U.S. cinema that applies equally to most of early cinema, including the representation of whites. (With the use of the long shot, and static camera, and single takes, the films of the Lumiere brothers [August and Louis] in Paris do not focus on individuality.) Rony's assessment may well be more accurate than that of most white, male film historians. Why was the early period, then and even now, called "primitive" cinema? Perhaps because these early racist representations were the model for narrative conventions that evolved slightly later. (While Linda Williams has pointed out the *sexist* conventions of representations by Eadweard Muybridge—another ethnographer of the body—and Georges Melies [in 1981], *racist* conventions so far have been secondary in film criticism; see Linda Williams, "Film Body: An Implantation of Perversions," *Cine-tracts 12*, ed. Patricia Mellencamp, Vol. 3, No. 4 [Winter 1981], 19–35.

87. Georg Simmel, *The Philosophy of Money* (1909; reprint, New York: Routledge, 1990), chap. 6, "The Style of Life." 449 All the quotations are taken from this chapter of a very long book, originally published in the same year Freud published his Rat Man study. Both are models of obsessive logic, of thoughts that motivate actions.

88. The Hottentot, a black woman equated with her genitals and buttocks, was a sexual apparatus par excellence for the Victorians. While working-class women had different sexual mores, they were measured against the middle-class white woman, who became the standard.

89. Gould, *Panda's Thumb*, 51.

90. Michel Foucault, *Discipline and Punish: The Birth of the Prison* (New York: Vintage Books, 1979), 164–65.

91. Andre Bazin, *What Is Cinema?* trans. Hugh Gray (Berkeley: University of California Press, 1971), 2: 174.

92. Glenn G. Sparks and Christine L. Fehlner, "Faces in the News: Gender Comparisons of Magazine Photographs," *Journal of Communication* 36, 4 (autumn 1986), 72.

93. For women, their bodies and reproduction are their work. The faceism index also suggests that women can rarely "represent" anything except themselves.

94. *Webster's Unabridged Dictionary*, 2nd edition (1976), s.v. "face."

95. Deleuze and Guattari, "Year Zero: Faciality," in *A Thousand Plateaus*, 167–91, esp. 172.

96. I am referring to the work of Jean-Louis Baudry, Jean-Louis Comolli, and Christian Metz.

97. Deleuze and Guattari critique Freud, along with the dominance of narrative to Hollywood cinema, the virtual premise of apparatus and feminist film theory. Recent film history depends on a narrative model: for example, the production history of Janet Staiger, the stylistic continuity model of David Bordwell and Kristin Thompson, and the business history of Douglas Gomery and Tino Balio. Bordwell and Thompson

are bringing back "science" by selecting film samples randomly (the 100 films they use to construct the "classic Hollywood style") and then taking "specimens" to illustrate history.

Paradoxically, Deleuze and Guattari have much in common with feminist film theory, including mutual sources, particularly Foucault and (as initially with Peter Wollen, then with Teresa de Lauretis) C. S. Peirce. Unlike most contemporary theorists, Deleuze's primary object is cinema (Hollywood cinema).

98. What Deleuze and Guattari call "significance" is "never without a white wall upon which it inscribes its signs and redundancies," and "subjectification . . . is never without a black hole in which it lodges its consciousness, passion, and redundancies" (*A Thousand Plateaus*, 167).

99. The quote continues: "The face is produced only when the head ceases to be coded by the body, when it ceases to have a multidimensional, polyvocal corporeal code, when the body has been overcoded by The Face" (*A Thousand Plateaus*, 170).

100. Again I refer to the work on continuity style by Bordwell, Staiger, and Thompson, which has had such an impact on film history and film criticism.

101. This section, *Sex*, begins with: "The sanctity of the institution of marriage and the home shall be upheld. Pictures shall not infer that low forms of sex relationship are the accepted or common thing."

102. Hazel Carby, "'On the Threshold of Woman's Era': Lynching, Empire, and Sexuality in Black Feminist Theory," in *"Race," Writing, and Difference*, ed. Henry Louis Gates, Jr., 301–16.

103. Three of Wells's books—*Southern Horrors: Lynch Law in all Its Phases* (1892), twenty-five pages; *A Red Record: Tabulated Statistics and Alleged Causes of Lynchings in the U.S.* (1892–94), one hundred pages; and *Mob Rule in New Orleans* (1900), forty-eight pages—have been reprinted as *On Lynchings* (New York: Arno, 1969).

104. Dorothy Sterling, *Black Foremothers: Three Lives* (New York: Feminist Press/ McGraw-Hill, 1979), 73.

105. Eugene Genovese, *Roll, Jordan, Roll* (New York: Vintage, 1976); quoted in bell hooks, *Ain't I a Woman?* (Boston: South End, 1981), 35. Wells points to the irony that during the Civil War there was "not one instance" of rape reported by a Southern white woman. "It is remarkably strange that the Negro had more respect for womanhood with the white men of the South hundreds of miles away." Of the hundreds of Northern white women who came to the South as teachers she wrote, "Not once has the country been shocked by such recitals from them as come from the women who are surrounded by their husbands, brothers, lovers, and friends" (Wells, *Mob Rule*, 48).

106. Jane Gaines, "Fire and Desire: Race, Melodrama, and Oscar Micheaux," in *Black American Cinema*, ed. Manthia Diawara (New York: Routledge, 1993), 49–71. Ron Green's "'Twoness' in the Style of Oscar Micheaux" is also in this anthology (3–26).

107. These were films produced independently for exhibition in black theaters. Usually whites were the producers, just as whites owned the black movie theaters. The "conditions of production," like the money economy, are crucial to the racial and sexual economies.

Many of these black films, like much film history (including the many lost films of Alice Guy Blacle and Lois Weber), have not been preserved. Others have recently been discovered (in Tyler, Texas) and made available on videotape. A number of the films are interesting. In *Miracle in Harlem* (1948), directed by Jack Kemp, Stepin Fetchit plays the same slow, bumbling, stereotypical character as he does in Hollywood films. However, in this film, within a black context, he is brilliantly funny—a great comic performer. The same applies to the Mammy characters of Sister Hattie. The film concerns modernizing a candy business, progress versus tradition, the place of religion in life, the role of death. There is also a murder.

The films don't easily fit within 1940s genres, to say the least. However, there are elements of family melodrama in every one, with the role of the mother central and critical. *Where's My Man Tonight* (1943), directed by Spencer Williams, tells the story of a

soldier enlisting and fighting in the war and of the segregated army, including great performance numbers and some amazing narrative events. *Juke Joint* (1947) is another Spencer Williams film (and a Bert Goldberg production) in which Mother is the dominant and central character, keeping the family good and together. In Williams's *The Girl in Room 20* (1946), Daisy Mae Walker is leaving her family for the big city. Her mother prays. A saintly cab driver warns and then rescues her from evil. She finds good guys and then sings in their act. In the end, everyone goes to Texas.

The films used the stylistic conventions necessitated by the small budgets of B-movies. However, having all-black casts in narrative films is terrific in itself. A few films, such as *Scar of Shame*, have been analyzed in contemporary essays (Jane Gaines has written on this film). Thomas Cripps and Donald Bogle have history books that detail representation and history. And more books are being published every day. History is, at last, becoming history instead of myth.

108. I think here of a few relatively recent examples: *Perfect Image* (England, 1988) by Maureen Blackwood, and *And Still I Rise* by Ngozi Onworah (England, 1993), along with the animated film *Hairpiece: A Film for Nappy Headed People* (1985), by Ayoka Chenzira, who released a feature last year. I loved the portrayals of Angela Davis, June Jordan, and Alice Walker in *A Place of Rage* by Pratibha Parma (England, 1991) and Cheryl Dunye's *The Potluck and the Passion*. And I was moved by *Finding Christa*, by Camille Billops and James Hatch, and enjoyed and respected Zeinabu Davis' *A Powerful Thang* (1991).

109. For a different analysis of this film, see S. V. Hartman and Farah Jasmine Griffin, "Are You as Colored as That Negro? The Politics of Being Seen in Julie Dash's *Illusions*," *Black American Literature Forum* 25, 2 (summer 1991): 361–75.

110. In *Daughters*, Dash includes a Native American character. See the remarks by bell hooks on the connection between Native and African Americans. *Picking Tribes* (1988), a short film by Saundra Sharp, also speaks to this issue.

111. I am referring to Michel de Certeau's distinction, in *The Practice of Everyday Life*, trans. Steven Rendall (Los Angeles: University of California Press, 1984) between strategies and tactics, with strategies being institutional practices, dominant practices.

112. Disavowal, the maintenance of contradictory beliefs, is usually the only mechanism in film theory. However, Liz Grosz has complicated this to include denial and repudiation. For more on this model, see my book *High Anxiety* 142. Repudiation explains how black voice/white face would work. We know something to be true, in reality, but block it out.

113. Homi Bhabha applied the theory of fetishistic disavowal to colonial subjectivity—without, however, noting women. See *The Location of Culture* (London and New York: Routledge, 1994), particularly "The Other Question" and "Of Mimicry and Man," 66–92. For another critique of Bhabha, see Manthia Diawara, "The Nature of Mother in *Dreaming Rivers*," *Black American Literature Forum* 25, 2 (summer 1991): 283–98.

114. Unlike Jeanne Crain, a white actress/star impersonating a black woman in *Pinky* (1949), a feature film about "passing," a black actress plays Mignon.

115. Darcy Raney, summer school paper, University of Wisconsin, Milwaukee, June 10, 1994.

116. Scopophilia (the sexual pleasure of sight) is linked to epistemophilia (the sexual pleasure of knowing).

117. In his "Seminar on the Purloined Letter," Lacan describes the connections between seeing, interpreting, and knowing (in *French Freud*, ed. Jeffrey Mehlman, *Yale French Studies*). The gaze in cinema has many permutations. To the triad of the looks of the camera, character, and audience must be added seeing (and not seeing), interpreting (and misinterpreting), and knowing (and not knowing). To the representation and the audience (film spectators) can be added gender (men at men, men at women, women at men, women at women), age, sexual preference, race, cultural history, and class (although in the United States this last element can be amorphous).

Illusions complicates John Berger's 1972 distinction (in *Ways of Seeing* [London:

British Broadcasting Corporation and Penguin Books, 1970]) of women seeing them-selves being seen. Mignon watches herself being seen incorrectly. She is not merely the object of sight but also the witness, the seer more than the seen. In effect, she is seen but not always recognized. The story plays off misrecognition.

118. As colonial subjects so well knew, the surface can be the best hiding place. As Dupin, Poe's detective, tells us, "Because it was right out in the open, right in front of everyone's eyes, the letter was not noticed." The principle of concealment, to paraphrase Poe, is the excessively obvious—which escapes observation. The "intellect . . . passes un-noticed considerations too obtrusive, too self-evident." Sometimes the most "sagacious expedient" is *not* concealing something (Edgar Allan Poe, "The Purloined Letter," in *Tales, Poems, Essays* [London and Glasgow: Collins, 1952] 400–14).

119. In fact, race, its absence and its presence as stereotype, is a main attribute of the Hollywood continuity style. Along with (the prohibition of) miscegenation came seg-regation in movie theaters, dividing audiences into white or black. The system was legal for years and included the establishment of separate, black theater chains.

120. There is another way to look at this. One way to change things is to tell the story in a familiar style but switch the point of view and enunciation. Many viewers will not notice that the political ground has shifted.

121. Dash doesn't have the budget for sound editing, where the techniques of edit-ing are doubly denied, very intricate, and highly expensive.

122. There are precedents for such expansions; for example, Reginald Hudlin turned a twenty-minute student film—which secured him a job teaching film production in Mil-waukee—into a feature film, *House Party* (1990).

123. Hartman and Griffin, "Are You as Colored as That Negro?" 361–75. They argue that *Illusion*'s critical flaw is to use Hollywood conventions of narrative representation to critique dominant cinema. "Unless the form as well as the content of the passing tale is challenged, [its oppositional possibilities] remain severely limited" (371). This critique is predicated on the belief in the radicality of artistic form, the notion that aesthetics can change the world. Like many scholars (influenced by Soviet film theorists, Bertolt Brecht, and Jean-Luc Godard) who participated in 1960s activism and 1970s theory/or-ganizing, I advocated this position, as did Laura Mulvey in "Visual Pleasure and Narra-tive Cinema," *Screen* 16 (autumn 1975): 1–16. In fact, my belief in the radicality of form was the reason I did not write about this film years ago. Many of us—for example, Peter Wollen, Peter Gidal, and Stephen Heath—believed, à la Brecht and Godard, that revela-tion of the apparatus, of the concealed work of cinema, would result in political change—which has hardly been the case. Thus, as with many activists/critics writing about popular culture, my position has changed and become more inclusive. I now see radicality of form as one, not the only, option.

Hartman and Griffin express caution about the "passing tale" because "blacks occupy subordinate and supplemental positions" (370). "The traditional mulatta is a character for white audiences, created to bring whites to an understanding of the effects of racism. . . . The passing tale calls for agency on the part of the white viewer" (371). The tale "fore-clos[es] a discussion of black lives" and presents "an essential idea of blackness," defined as "a natural body." The essay does concede that "Dash successfully challenges the con-ventions of the traditional mulatta melodramas. . . . Dash's passing heroine realizes the possibilities of some of her desires . . . nor does she cease to aspire toward power and authority in the white man's world" (371).

124. Ultimately, of course, both Hartman and Griffin and I are wrong—essentially speaking. There is no such thing as a unified "black female subject" or a singular white female subject with built-in responses.

125. Toni Cade Bambara, "Reading the Signs, Empowering the Eye: *Daughters of the Dust* and the Black Independent Cinema Movement," in *Black American Cinema*, ed. Manthia Diawara 118–44, 140–41. Coming across this essay almost two years after I wrote about the film, I was pleased to find other commonalities: "The genre that Dash

subverts in her indictment of the industry is the Hollywood story musical" (141). Regarding the humiliation of Jean Hagen (Lina Lamont) in *Singin'*, particularly the film's conclusion, Bambara asks, "Does the Reynolds' character stand in solidarity with the humiliated woman? Hell no, it's her big career break. *Singin'* provides Dash with a cinematic trope. . . . The validation of Black women is a major factor in the emancipatory project of independent cinema" (141). What she does not mention is the strange displacement in *Singin'* of Rita Moreno, Lina's friend, passing as Anglo.

126. bell hooks, "The Oppositional Gaze: Black Female Spectators," in *Black Looks: Race and Representation* (Boston: South End, 1992); reprinted in *Black American Cinema*, ed. Marthia Diawara, 288–302. (I quote the *Black American Cinema* version.) She calls the film "radical, opening up a space for the assertion of a critical, Black, female spectatorship . . . new transgressive possibilities for the formulation of identity" (302). Like many proponents of black independent cinema (in ways recapitulating white critics' 1970s embrace of avant-garde cinema), hooks claims "subversion" for *Illusions:* a "filmic narrative wherein the Black female protagonist subversively claims that space." Dash's representations "challenge stereotypical notions placing us outside . . . filmic discursive practices." The film calls into question the "White male's capacity to gaze, define, and know." Mignon's "power is affirmed by her contact with the younger Black woman whom she nurtures and protects. It is this process of mirrored recognition that enables both Black women to define their reality. . . . The shared gaze of the two women reinforces their solidarity" (in *Black American Cinema*, 301). ("Subversion" is the flip side of the belief in radical action through aesthetics. However, "subversion/transgression" is linked to popular rather than avant-garde forms; it is derived from cultural studies, not the art world. Of course, art and popular culture are no longer separate turfs—if they ever were. And as with radical aesthetics in art, I think subversion overstates the effects of watching TV or seeing a movie, particularly one that accepts and admires the Hollywood "mode of production." We can think, we can change—but "subvert"?)

127. Like Diawara, hooks quotes from Mary Ann Doane, but she cites few other theorists involved in feminist film theory. (I am thinking especially of Teresa de Lauretis on narrative in *Alice Doesn't* [Bloomington: Indiana University Press, 1984] and Kaja Silverman on sound—*Dis-Embodying the Female Voice*, 131–49 in *Re-Visions: Essays in Feminist Film Criticism*, ed. Mary Ann Doane, Patricia Mellencamp, and Linda Williams [Lanham, Md.: University Press of America, 1984].)

128. Instead of "I see" to mean "I know."

129. Julie Dash, with Toni Cade Bambara and bell hooks, *Daughters of the Dust: The Making of an African American Woman's Film* (New York: New Press, 1992), 25. Hereafter cited in text as DBh.

130. Zeinabu irene Davis, "An Interview with Julie Dash," *Wide Angle* 13, 3/4 (July–October 1991): 110–19, esp. 112.

131. I wrote about the film before the book *Daughters of the Dust* came out. The dialogue is from my transcription, not the script.

132. John Berger, "Uses of Photography," in *On Looking* (New York: Pantheon, 1980), 56–63. Berger's valuable distinction between private and public photography suggests something of the simple richness of this film. The private photograph preserves context and continuity, unlike the public photograph, which is "torn from context," a "dead object" lending "itself to any arbitrary use" (56).

133. Freud, *Inhibitions, Symptoms and Anxiety*, 84.

134. Tracey Moffatt has also commented on the gritty, realistic style deemed appropriate for representing blacks.

135. bell hooks, "Talking Back," *Discourse* 8 (fall–winter 1986/87): 124. Reading this, I identified. My experience with my mother, her five sisters (and four brothers), and their mother was constant talk, never silence.

136. Cornel West, "Nihilism in Black America," in *Black Popular Culture*, ed. Gina Dent (A Michele Wallace Project; Seattle: Bay Press, 1992), 37–47, esp. 43.

137. In 1983, Robert Stam and Louise Spence published their essay "Colonialism,

Racism and Representation—An Introduction," *Screen* 24, 2 (March–April 1983): 2–20. However, what they call for is comparable to the distinction, made in the introduction to *Re-Vision: Essays in Feminist Film Criticism*, between positive images and negative stereotypes—issues of realism versus what Stam and Spence call "textual and intertextual" approaches. In his terrific recent book, written with Ella Shohat, the critique of Eurocentrism is vast. See *Unthinking Eurocentrism* (New York. Routledge, 1994).

138. Manthia Diawara, critique for *Frontiers* (1993).

139. Along with the Foucault's disciplinary regime and panoptic gaze, Bakhtin's notion of the dialogic, the place of official and unofficial culture, the performative ritual, and the enunciative horizon that includes the audience as an active participant have been central to my model of feminist film and video (see Patricia Mellencamp, *Indiscretions: Avant-Garde Film, Video, and Feminism* [Bloomington: Indiana University Press, 1990]). Not surprisingly, Bakhtin can be read in tandem with Walter Benjamin's "storyteller" and Teshome Gabriel's "folkloric." Haile Gerima's triad of community, storyteller, and activist is uncannily comparable to Benjamin. Deleuze's concept of the "minor" is along the same lines.

The other notion central to feminism and to models of the postcolonial is psychoanalytic "disavowal"—holding contradictory beliefs. This has influenced especially Bhabha.

140. Aesthetics were prominent in the 1970s debates over avant-garde cinema. We took our lead from Godard and Brecht and believed that the revelation of form was both radical and necessary for political change. We used to believe that form itself was "subversive," radical, transgressive.

141. Jim Pines, preface to *Questions of Third Cinema*, ed. Jim Pines and Paul Willemen (London: British Film Institute, 1989), viii.

142. Clyde Taylor, "We Don't Need Another Hero: Anti-Theses on Aesthetics," in *Critical Perspectives on Black Independent Cinema*, eds. Mbye B. Cham and Claire Andrade-Watkins (Cambridge, Mass., and London: MIT Press, 1988), 80–85, esp. 82.

143. Clyde Taylor, "The Re-Birth of the Aesthetic in Cinema," *Wide Angle* 13, 3/4 (July–October, 1991): 12–31, esp. 28. Taylor points to the troubling fact that films hailed as U.S. landmarks—for example *The Jazz Singer* (1927), *Gone With the Wind* (1939)— have involved negative or stereotypical portrayals of African Americans, which usually goes without mention. He also links race to sex in his analysis, mentioning feminism.

144. Clyde Taylor, "Black Cinema in the Post-Aesthetic Era," in *Questions of Third Cinema*, ed. Jim Pines and Paul Willemen, 90–110, esp. 108. His term is *popular syncretism* (105). Hybridization has been taken up in the U.S. debates as well, for example, by Tricia Rose in "Black Texts/Black Contexts," in *Black Popular Culture*, ed. Gina Dent, 223–27.

145. Homi K. Bhabha, "The Commitment to Theory," in *Questions of Third Cinema*, ed. Jim Pines and Paul Willemen, 111–32. Bhabha's model reverberates with Deleuzian thought, as well as with psychoanalysis and feminism. His essays in *Screen* have influenced film studies for more than a decade. One essay by Bhaba that I used was "The Other Question," from *Screen* reprinted in "The Location of Culture."

146. Laleen Jayamanne, "Speaking of 'Ceylon,' a Clash of Cultures," in *Questions of Third Cinema*, ed. Jim Pines and Paul Willemen, 150–69, esp. 162.

147. Kobena Mercer, "Diaspora Culture and the Dialogic Imagination: The Aesthetics of Black Independent Film in Britain," in *Critical Perspectives*, ed. Mbye B. Chem and Claire Andrade-Walkins, 50–61.

148. See Stuart Hall, "Cultural Identity and Cinematic Representation," in *Framework 36* (1989), "Third Scenario: Theory and the Politics of Location," 68–81. Laleen Jayamanne, "Do You Think I Am a Woman, Ha! Do You?" *Discourse* 11, 2 (1989): 49–64.

149. See Bazin, *What Is Cinema?* vols. 1 and 2. Bazin's usefulness as a model is particularly clear in "An Aesthetic of Reality: Neorealism (Cinematic Realism and the Italian School of the Liberation)" in vol. 2; the title says it all. Also see Dudley Andrew's biography *Andre Bazin* (New York: Oxford University Press, 1978) and the section on Bazin

in his earlier film theory book, *The Major Film Theories* (New York: Oxford University Press, 1976) 134–78. Phil Rosen's wonderful essay on Bazin and time, "History of Image, Image of History: Subject and Ontology in Bazin" in (*Wide Angle*) 8–34, brings Bazin into a closer kinship with Deleuze.

150. Teshome Gabriel, "Third Cinema as Guardian of Popular Memory: Towards a Third Aesthetic," in *Questions of Third Cinema*, ed. Jim Pines and Paul Willemen, 53–64.

151. Andrew, *The Major Film Theories*, 134–78.

152. Both share the same spirit, what Bazin called a "revolutionary humanism" (*What Is Cinema?* 2: 21). However, the context is very different. As Bazin says, "History does not repeat itself." Europe in 1947 is not the United States in the 1990s.

153. Manthia Diawara, "Black American Cinema: The New Realism," in *Black American Cinema*, ed. Mantha Diawara, 3–25, esp. 13. The book has two sections "Black Aesthetics" and "Black Spectatorship."

154. Manthia Diawara, "Cinema Studies, the Strong Thought and Black Film," *Wide Angle* 13, 3/4 (July–October 1991): 4–11, esp. 10.

155. Diawara's analysis of space and time is precisely the opposite of Deleuze's. See Gilles Deleuze, "Mediators," in *Incorporations*, ed. Jonathan Crary and Sanford Kwinter, 280–94.

156. Teshome Gabriel, "Thoughts on Nomadic Aesthetics and the Black Independent Cinema: Traces of a Journey," in *Critical Perspectives*, ed. Mbye B. Cham and Claire Andrade-Watkins, 62–79.

157. For black cinema, Hollywood becomes the problem and the goal, the enemy and the ally. Because several Asian film industries far surpass the number of films produced annually in the United States, this debate is Anglo-biased; only from the Western viewpoint are whites dominant. The term *diasporic aesthetics* has the potential to cover a vast international territory, to merge East with West, North with South, which, I think, is Gabriel's vision.

158. The important films of Isaac Julien and Sankofa, which apply avant-garde formal techniques to social issues, can be directly compared to the films of Moffatt. Ironically, it is the avant-garde that links the United States, England, and Australia—through comparably orchestrated film cooperatives.

159. Geeta Kapur, "Articulating the Self into History: Ritwik Ghatak's *Jukti takko ar gappo*," in *Questions of Third Cinema*, ed. Jim Pines and Paul Willemen, 179–94, esp. 179.

160. Jim Pines, "Territories: An Interview with Isaac Julien," *Framework* 26/27 (1985): 2–9, esp. 5. Sankofa was then funded by Channel Four. Sankofa Film and Video Collective members were Martina Attille, Maureen Blackwood, Robert Crusz, Isaac Julien, and Nadine Marsh-Edwards. The group had released the film *Territories*, its formal tactics causing great debate. The techniques of the avant-garde had been applied to social issues. (I have seen wonderful short films by Attille and Blackwood, terrific filmmakers.)

161. Constance Penley and Andrew Ross, "Interview with Trinh T. Minh-ha," *Camera Obscura* 13/14 (spring–summer 1985): 87–104, esp. 93. As in so many of the films by women in this book, Minh-ha emphasizes sound: "This is what I would like to bring out in the film: Language as musical communication and information" (90).

162. Trinh T. Minh-ha, "Difference: 'A Special Third World Women Issue'," *Discourse* 8 (fall–winter 1986/87): 11–38. See also another special issue *(Un)Naming Cultures*, edited by Minh-ha (*Discourse* 11, 2 (spring–summer 1989). Also see Trinh T. Minh-ha, *Woman, Native, Other* (Bloomington: Indiana University Press), just one of her books, and her great films, which include *Surname Viet Given Name Nam*. This woman is profoundly productive—a writer, theorist, artist, and activist, a women to be admired. Laleen Jayamanne has been deeply influenced by her work, just as Tracey Moffatt has been affected by Isaac Julien.

163. Scott Murray, "Tracey Moffatt," *Cinema Papers* 79 (May 1990): 21.

164. Anna Rutherford, "Changing Images: An Interview with Tracey Moffatt," in *Aboriginal Culture Today* (Sydney: Dangaroo, 1988), 153.

165. Lesley Stern, *Camera Obscura* 20/21 (May–September 1989), 294–96, esp. 295.

166. Gilles Deleuze and Claire Parnet, *Dialogues* (New York: Columbia University Press, 1987), 55.

167. Laleen Jayamanne, "Love Me Tender, Love Me True, Never Let Me Go: A Sri Lankan Reading of Tracey Moffatt's *Night Cries: A Rural Tragedy,*" published in *Feminism and The Politics of Difference,* ed. Sneja Gunew and Anna Yeatman (Sydney, Australia: Allen & Unwin, 1993). The essay will appear in Jayamanne's collection, *Towards Cinema and its Double: Cross-Cultural Readings (1981–1994),* forthcoming from Indiana University Press. The differences between the unpublished manuscript I used and the published essay (which I only recently received) are quite significant. In fact, the two versions often bear little resemblance. As Toby Miller says of the published version, in a reader's report of this chapter of my book, "Jayamanne makes much of the criticism she received when first presenting the paper without knowing the intellectual or popular history of her subject, and defends herself against these reactions."

168. Gilles Deleuze, *Cinema 1, the Movement-Image,* trans. Hugh Tomlinson and Barbara Hammerjam (Minneapolis: University of Minnesota Press, 1986), 56.

169. Adrian Martin, "Nurturing the Next Wave," in *Back of Beyond: Discovering Australian Film and Television* (Sydney: Australian Film Commission, 1988), 90–105, esp. 98.

170. Freud posits three modes of identification: having, being, and group. It is the third instance, so applicable to the public exhibition of film that is paradoxically ignored in film theory. See *Group Psychology and the Analysis of the Ego,* SE 18, 65–143.

171. Tracey Moffatt, correspondence with the author, December 8, 1991, and March 21, 1992. Moffatt is extraordinarily generous with information. I am deeply grateful to this quite amazing woman.

172. Shane McNeil, "Relativity, Roeg, and Radical Forms: An Interview with Tracey Moffatt," *Lip Sync* newsletter (August–September 1991): 14.

173. Deleuze and Parnet, *Dialogues,* 42. For Deleuze, the anomalous is "always at the frontier," the "Outsider."

174. Laleen Jayamanne, "Image in the Heart," *Framework* 36 (1989): 34.

175. Sergei Eisenstein, *Film Form,* ed. and trans. Jay Leyda (New York: Harcourt, 1949), 173, 32.

176. Karen Sidney, "Nice Colored Girls," *Independent Media Magazine* (U.K., 1989): 28–30.

177. Sigmund Freud in *the Standard Edition,* 10: 206n. 1.

178. Sergei Eisenstein, "The Dynamic Square," *Film Essays and a Lecture,* by Sergei Eisenstein, ed. Jay Leyda (New York: Praeger, 1970), 48–65.

179. In many ways, *Night Cries* is the inverse of *Daughters of the Dust. Night Cries* is haunted by death, while *Daughters* is haunted by birth. For *Night Cries,* history has become a nightmare of entrapment; for *Daughters,* the past enlightens the present. In *Daughters,* all the women are African American; this is not the case with *Night Cries,* which suggests hatred and love for the unseeing old white woman. *Daughters* is about an extended family, *Night Cries* a nuclear family.

180. Kate Cole Adams, "Dreams of Change," *Time* (July 20, 1992): 66–67.

181. Marcia Langton, "*Well, I Heard It on the Radio and I Saw It on the Television . . .* " (Sydney: Australian Film Commission, 1993), 179.

182. Stuart Cunningham, "The 'Sentimental Age': Chauvel, Melodrama, Nationality," *Framework* 30/31 (1986): 40–49. A reviewer pointed out that I was not being fair to Cunningham; granted, I read only an essay, not his book *Featuring Australia* (London: George Allen & Unwin, 1991).

183. Ingrid Periz, "*Night Cries:* Cries from the Heart," *Filmnews* (August 1990): 16.

184. Walter Benjamin, "The Storyteller:: Reflections on the works of Nikolai Leskov, in *Illuminations* (New York: Schocken Books, 1969), 94.

185. I believe Tudawali didn't star in any more movies; an anonymous Australian re-

viewer tells me he died of "burns received through falling on a campfire during a drunken brawl." However, that a 1950's film starred an Aboriginal is a fact of great importance.

186. An anonymous Austrialian reviewer of the manuscript suggested the following revisions and additions to my analysis:

Langton is a professionally trained anthropologist and is chair of the Australian Institute for Aboriginal and Torres Strait Islander Studies, a government institution. Thus the reviewer points to a paradox regarding governmental policy—it also supports filmmakers like Moffatt and spokespersons like Langton.

The positions of Jayamanne and Periz are very different, a disagreement that has emerged in public forums. Jayamanne distanced herself from the controversy about Chauvel and *Jedda* via her Sri Lankan perspective.

A more specific issue of representation concerns the political dispute about depriving Jimmy Little of his voice via avant-garde techniques. The reviewer remarks, "Little is unhappy about this."

These controversies are serious issues within Australian cultural debates—unlike the United States, where cultural studies have moved far afield from politics. There is, for example, relative silence in the United States regarding Native American treaty rights.

Apologies to any future Australian readers. I thank the reviewer for comments regarding this section.

187. Sergei Eisenstein, "Synchronization of Senses," *Film Sense,* ed. Jay Leyda (New York: Harcourt, Brace & World, 1942), 81.

188. In *Film Form,* ed. and trans. Jay Leyda.

189. Felicity Collins, *Screen* 28 (winter 1987): 78–90, esp. 89. I came across this essay in August 1994; "A (Sad) Song of the Body" is a superb analysis of Laleen Jayamanne's film *A Song of Ceylon*. Collins is clever, calling "the logic of the spectacle," drawn from Laura Mulvey, "the dirty look." She then investigates the fetish another way, "the loving gesture of Roland Barthes' fetishist" (79). When she compares the cinematic body to the theatrical body, moving through the tableau staging of Jayamanne, she introduces the idea of a cinema of gesturality, a cinema that separates body from voice.

190. Deleuze's terms for creators in his essay "Mediators" are right out of Eisenstein—*qualitative, new, leap,* for example.

191. This description of "face" is a bit like Delsarte's charts of movements.

192. I have taken this and other remarks from Moffatt's fifth draft script, which changed during production.

193. John Conomos and Raffaele Caputo, "*Bedevil:* Tracey Moffatt" (interview), *Cinema Papers* 93 (1994): 27–32, esp. 28.

194. Penny Webb, "Tracey Moffatt's *Bedevil,*" esp. 32 (in an Australian news magazine, jointly published in Spanish).

195. Marcia Langton is a leading spokesperson in this national debate.

196. For Penny Webb, Moffatt's concerns are "the black history of white Australia, the magic of cinema, and an evident love for strong women." Her style is "magic realism that includes the unsaid and the unseen" ("Tracey Moffatt's *Bedevil*").

197. Although she is a great interview subject, Moffatt leaves many things unsaid, including the depth of her activist politics. She is a savvy artist, talking art and entertainment, with an eye on her career.

198. For Moffatt, films should be experimental and popular at the same time, which is what Roeg's films accomplish. "The key word is unpredictability —never let the audience know what is coming next" (Conomos and Caputo, "*Bedevil*").

199. The song was written by Johnny Mercer and Howard Arlen in 1942.

200. Another ghost who witnesses all of this is a Brisbane artist, Luke Roberts, in drag as his alter ego, "a dead ringer for Mexican artist Frida Kahlo."

201. Andrew Urban, "Riders of the Post New Wave," in "The Arts: Critical Matters," *The Bulletin* (May 25, 1993): 85–86, esp. 86.

202. E. Ann Kaplan, "Aborigines, Film and Moffatt's *Night Cries —A Rural Tragedy:*

An Outsider's Perspective," *Olive Pink Society Bulletin* 2, 1 (1989): 13–17; quoted in Langton, *"Well, I Heard It,"* 24–25.

203. Eudora Welty, "The Eye of the Story," in *On Writing,* 1979.

204. As Eisenstein wrote, through "emotional fusion," the "montage removes . . . contradictions by abolishing . . . parallelism in the realms of sound and sight" (*Film Form,* 254).

AGE FIVE: ECONOMICAL FEMINISM

1. Dorothy Hewett, *Wild Card: An Autobiography, 1923–1958* (Victoria, Australia: McPhee Gribble/Penguin Books, 1990), 11.

2. Virginia Woolf, *Three Guineas* (1938; reprint, 1966, New York: Harcourt Brace and World), 141.

3. Not only do Woolf's class and economic arguments anticipate Wittig, but her critique of women's "slavery," with marriage or prostitution the only viable professions, Woolf links suffrage and abolition (*Three Guineas,* 16), issues Wittig also ties together. Woolf's "outsiders" are compared to the "runaway slaves who escaped slavery, becoming free." "Outsiders" are the forebears of the "runaways" Wittig urges us to become. Woolf advocates the formation of an Outsider's Society, where the daughters of educated men can be "working in their own class" for "liberty, equality and peace" (106). Some of us want to be "outsiders on the inside." Some of us now reserve "slavery" for its reality within African American culture.

4. *New York Times,* 15 February 1993, C1.

5. In *Orlando,* Sally Potter (London: Faber and Faber, 1994), ix.

6. In "Death," 1600, the brilliant, old, and made-up queen (Quentin Crisp) arrives at the manor in a barge, at night. The tone is red, black, dark gold, firelight, shadows. There follows a sumptuous banquet and the queen's bedtime ritual, when she summons Orlando, giving him a property deed and the admonition not to grow old. The next scene, his father's funeral procession with robed mourners, is black (trees, costumes, casket) against a white, cold snowscape.

"Love" is the Russian film section (*Dr. Zhivago* [MGM, 1965] being the obvious reference) and includes a banquet, dance, and Shakespearean play (*Othello*), all performed on the ice at night. Each scene is stunning, beautiful. This section represents romance from a male point of view. The now-melancholy Orlando has fallen in love with Sasha, a young Russian woman. "A man has to follow his heart," he declares. On her ship, frozen in the ice, he claims her: "You're mine." Sasha: "Why?" Orlando: "Because I adore you. Meet me at London Bridge. We'll fly away. There, it's decided." Women are the right of men, just as romance is driven by male desire. But Sasha doesn't show. Orlando is left holding the horses during a nighttime storm and the breakup of the ice. The shot of stockinged legs jumping across blocks of ice reminds us of Lillian Gish and Richard David Barthelmess in D. W. Griffith's *Way Down East*—that heroic scene of romance and rescue with a "happy ending," the marriage of the destined couple(s).

After this "treachery of women," Orlando sleeps—in striking portraits, a prelude to 1650, "Poetry." Rejected by romance, the lord of the manor reads and writes poetry. After his aspirations are dashed by the criticism of an uncouth poet, Orlando becomes an ambassador to the Middle East—"Politics." "The English make a habit of collecting countries." Colonialism, British imperialism, self/other, along with his attraction to a beautiful man, are etched in this section, which is really about becoming a man, becoming a nation, making a David Lean film, perhaps *Lawrence of Arabia* (1962). In the desert at night, he toasts to the beauty of women, drinks to brotherly love, and praises the virtues of loyalty and courage. The sequence concludes with an attack on the city and a challenge to Orlando to prove his friendship, to prove his love, by fighting. After seeing one of "the enemy" killed, Orlando leaves the battle. He won't kill. He cannot be a "real" man. He sleeps as if dead.

Upon awakening, Orlando is a woman. She looks at herself in a long mirror, naked,

a Renaissance painting. The history of art, in the spectacle film and in art history, is recreated as the history of style

7. After a long lovemaking scene, with soft-focus lens, gauze filters, and caressing shots of naked body parts (the most imitative scene in the film), Orlando is threatened with losing everything unless she has a son. Her lover says she is free—to follow him, which she can't do. Like Sasha, who told Orlando that he was melancholy because he lived in the future, not in the present, Orlando asks when her lover's long-delayed future will begin. He rides off on his horse. She waves a romantic goodbye and, as before, is soaked by the rain.

Orlando closes her eyes and opens them to the sound of an airplane. Time speeds up. She is learning fast. She runs through a minefield of explosions, pregnant.

8. We had just come from a theater where Delphine had starred years ago in a Chekhov play. The actors from the company all knew of this actress. Her performance had become a legend and a standard. They stood before her, holding candles. After singing Georgian songs to her, they presented her with a twenty-five-year-old playbill. A moment of personal history, right before my eyes. She was uncomfortable being so overtly the star. In Paris, she was collecting videotapes by women for the Paris archives, shortly before she died—only in middle age.

9. That aging parents live with their children has much to do with the availability of housing, as well as familial responsibility. *Turnover* concerns options like nursing homes for aging women.

10. In the middle of the film, while working, Sofiko sees her husband, Arturo, with a younger woman, triggering Sofiko's self-doubts.

11. Portraits of Stalin were forbidden in Georgia when I was there. The only local history or politics discussed came from the twelfth century.

Index

Freed, Arthur, and MGM musicals, 193–94
Freiberg, Freda, on Campion, 174
French Kiss, 96–98
Freud, Sigmund, Little Hans, 4; Dora, 7;
 sadism, 62; the fetish, 61–62; masochism,
 62–63, 138–39; beauty derived from vision,
 68; in *Gold Diggers 1933*, 57; obsession (*Inhi-
 bitions, Symptoms, and Anxiety*), 108, 112;
 "Rat Man," 108, 203; Oedipus, 132; the fam-
 ily, 129; identification in *The Piano*, 180; the
 "woman no longer young," 194–95; Freud
 and Beard, 201, on fear, 203; race (the "dark
 continent"), 201; affect and reminiscence,
 214; Deleuze and Guattari, 255; the 'un-
 canny,' 140, 163,—in *Metropolis*, 125, 129,
 —and in Campion, 177, 304n22
friendship, 98–99

Gabriel, Teshome, 248, 256; on the nomad and
 Deleuze, 252–53
Gaines, Jane, on costume, 199, 309n31; on
 Within Our Gates, 230–32
Gas Food Lodging, 100, 298n67
gaze, and aversion, 138; Deleuze and Guattari,
 225; and Lacan, 316n117
Genovese, Eugene, 228
genre, in *Pulp Fiction*, 82; *The Gold Diggers*,
 160; *Thelma and Louise*, 148; *Angie*, 171;
 Within Our Gates, 229; 302n44, 304n12
Gerima, Haile, 250
German expressionism, 121–32
gesture, in silent cinema, 220–22, 268
Gibson, Ross, 48
Gilbreth, Frank, 207, 209
Gish, Lillian, 163, 212
Gitananda, Swami, 297n57
Glyn, Elinor, 215–19
Go Fish, Rose Troche, 105
Godard, Jean Luc, 79, 80, 249
Gogoberidze, Lana, 288–90
The Gold Diggers (1983), 155, 159–64, 170
Gold Diggers of 1933, 21, 24, 49, 50–73
Goldberg, Whoopi, 233
Goldwyn, Samuel, 216
Gosling, F.G., on George Miller Beard, 200, 201
Grafton, Sue, 299n4
Griffith, D.W., 226, 229, 230, 268, 282
Griggers, Cathy, 303n57
Groundhog Day, 84–87, 105, 110
Grosz, Liz, 316n112

Halberstam, Judith, 301n38
Hall, Stuart, 249, 251
Hammer, Barbara, 305–6n32
Hanks, Tom, 87–90, 92–93
Hanson, Miriam, 308n19
Harlequin Enterprises, 82–83, 101–2
Hart, Lynda, on *Basic Instinct*, 146–47; on
 Thelma and Louise, 303n59
Hartman, S.V. and Farah Jasmine Griffin, on
 Illusions, 238–39, 317nn123, 24
Haskell, Molly, 216, 313n73
Hawn, Goldie, producer of *Something to Talk
 About*, 166
Hayakawa, Sessue, 226

Hayworth, Rita, 13, 21
Heath, Stephen, 139; narrativisation, 22–24
Hepburn, Audrey, 224
Hewett, Dorothy, xi, 2, 4, 16, 175, 281, 290
Higashi, Sumiko, on *The Cheat*, 198–99
His Girl Friday, 93, 95
history, 191–233, specifically 191–92; in *The
 Gold Diggers*, 156
Hitchcock, Alfred, 7, 15, 282; and glasses,
 136–37; in *Thriller*, 157
Hoberman, J., on Tarentino and *Pulp Fiction*,
 80
Hollywood studios, 64
Holmlund, Chris, on *Basic Instinct*, 144
homophobia, 81
hooks, bell, 10, 228–29, 233, 239–48, 256,
 318n126
Horne, Lena, 233
hybridity, 270–71

I.Q., 95–96
Illusions, Julie Dash, 234–39, 250
Impromptu (1989), 116
indifference, 288
Indirananda, Swami, 297n57
inner speech, 268
IT, 215, 217–18

Jacobs, Lewis, 216
Jaglom, Henry, *Eating*, 109–10
Jayamanne, Laleen, x, 248, 251, 253–56,
 259–60, 265–67; on *The Piano*, 178–83; *Re-
 hearsing*, 183; 321n167
Jedda (1955), 258, 263–64, 267, 276
Johnston, Claire, 7, 10
Julien, Isaac, 248, 253–54

Kaplan, Cora, 299n3
Kaplan, E. Ann, 276
Kapur, Geeta, 249, 253
Kaurismaki, Aki, *The Match Factory Girl*,
 110–11
Keaton, Buster, *Sherlock Junior*, 17–20
Keitel, Harvey, 78, 81; in *The Piano*, 179
Kessler-Harris, Alice, on working women, 39,
 42–44
Khouri, Callie, 8, 60, 117, 143, 183; *Something
 to Talk About*, 165–70
Klinger, Barbara, 297n60
Knapp, Lucretia, 293n3
knowledge, and woman's clubs, 206
Kracauer, Siegfried 7; Girls and Crisis, 65–66
Krutnik, Frank, 88
Kwaidan (1964), 271

La Boheme, as *Thriller*, 157, 159; *The Match
 Factory Girl*, 110–11
La Femme Nikita (1990), 116
Laban, Rudolf, 221
Lacan, Jacques, and divided subject, 3; lack, 4,
 75; mirror stage, 5; desire, 108; gaze, 301n25
Laffont, Collette, as Mimi, 153; in *Thriller* and
 The Gold Diggers, 156–64
Lahr, John, on the Rockettes 67, 68
Langbauer, Laurie, on romance, 100, 101